THE **AMERICAN** SCENE

PRINTS FROM HOPPER TO POLLOCK

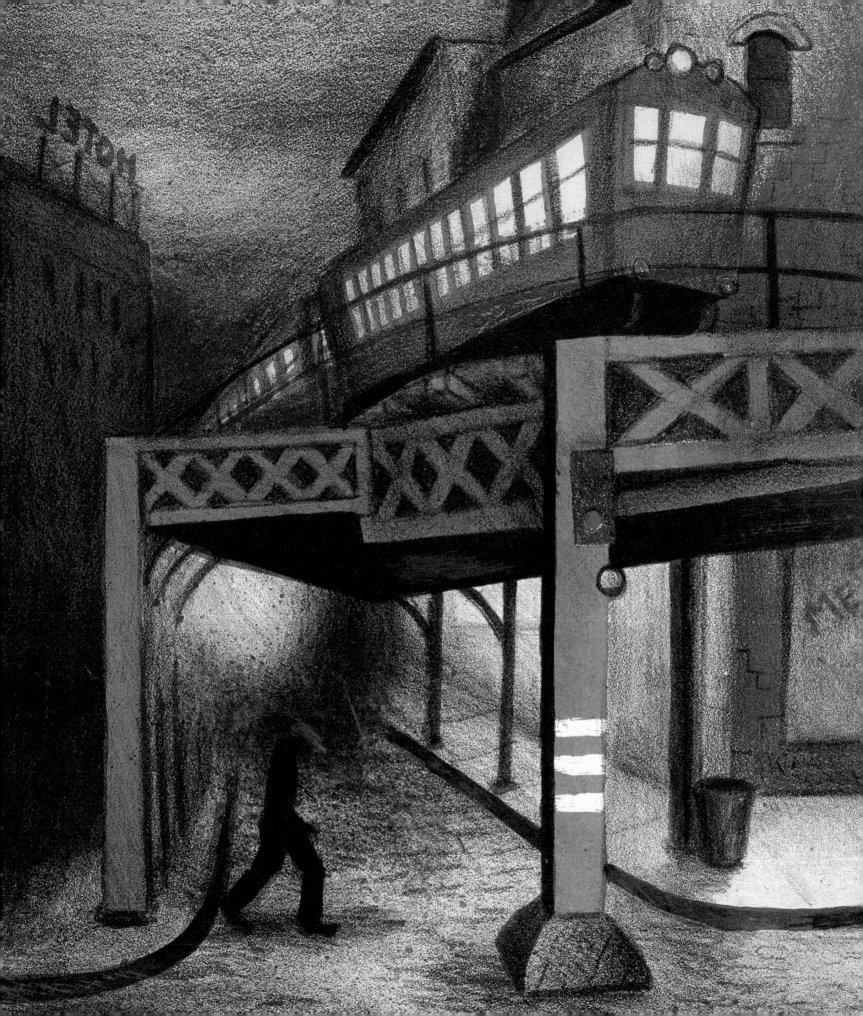

THE **AMERICAN** SCENE
PRINTS FROM HOPPER TO POLLOCK

STEPHEN COPPEL

with the assistance of Jerzy Kierkuc-Bielinski

THE BRITISH MUSEUM PRESS

Published to accompany the exhibition
'The American Scene: Prints from Hopper to Pollock 1905–1960'
at the British Museum from 10 April to 7 September 2008
and its subsequent tour in 2009 to the Djanogly Art Gallery,
Nottingham; Brighton Museum and Art Gallery, and the
Whitworth Art Gallery, Manchester

The Terra Foundation for American Art has generously supported
the catalogue publication and exhibition

Frontispiece: Leonard Pytlak, *Uptown*, 1939 (cat. 86, detail)

First published in 2008 by The British Museum Press
A division of The British Museum Company Ltd
38 Russell Square, London WC1B 3QQ

www.britishmuseum.org

A catalogue record for this book is available from the British Library

ISBN 978-0-7141-2657-9

Designed and typeset in Century Light by Andrew Shoolbred and Greg Taylor

Reproduction, printing and binding by Studio Fasoli, Verona, Italy

CONTENTS

PREFACE: COLLECTING AMERICAN PRINTS AT THE BRITISH MUSEUM

This book and the exhibition it accompanies present a selection of the highlights of the British Museum's collection of American prints of the period between about 1905 and 1960. The acquisition dates will show that almost all the works included have been acquired since 1979. The total size of the twentieth-century American collection of works on paper in the Museum is about three thousand, which is small for a school of such importance to the history of modern art. But we believe that the print collection covering the first sixty years of the twentieth century is the best outside the United States itself, and we know of nothing similar in Europe.

The American art that does exist in European collections – and there are great works of American painting and sculpture on this side of the Atlantic – belongs almost entirely to the 1950s and thereafter, the years after Abstract Expressionism first brought American painting to the attention of the whole world. The first half of the century by contrast has been and continues to be neglected, and it is extremely difficult to find significant paintings from before 1950 anywhere in Europe. It is almost certainly too late now to do anything about this: the paintings are too scarce and too expensive. But works on paper are a different matter, and prints, being multiples, can still be acquired. So it is on this area that the British Museum has focused its collecting. The collection covers the whole century, right up to the present day, but here we have concentrated on the years that are hardly known and shown in Europe.

By way of introduction, the reader might be interested in how the collection came to be put together, and this story will allow me in passing to thank some of the many people in the United States and Britain who have been very helpful and generous in making it possible. I was myself closely involved, which explains the personal tone in what follows.

The starting point was the arrival of a new Director of the British Museum, John Pope-Hennessy, in 1974. It was he who created a new post in the Department of Prints and Drawings for a curator of the modern (meaning post-1890) collection, and Frances Carey was appointed to fill it in 1975. A second post followed for a curator of the print collection (covering all countries and centuries), to which I was appointed in 1976. In the following years Frances and I worked very closely together, so much so that I have no memory of what she did and what I did. So the 'we' in what follows is both of us working together.

We found that we had inherited from one of the greatest Keepers of the Department, Campbell Dodgson, a remarkable collection of prints from Impressionism onwards, bequeathed to the Museum in 1948. He had joined the Department as a young man in 1893, and retired in 1932, developing a towering reputation in all fields of print scholarship, most especially the study of prints of the German School of the fifteenth and sixteenth centuries. His considerable private means were devoted to forming a personal collection designed to extend the Department's holdings into his own times. We used this to put on in 1978 an exhibition of French lithographs entitled 'From Manet to Toulouse-Lautrec', which proved that there was a serious foundation for a modern collection in the Department. Equally there were huge gaps: Dodgson's taste was formed in the late nineteenth century, and did not extend to Expressionism or Cubism, while little had been collected since his death. The main reason for this was the long years of post-war austerity, coupled with institutional conservatism. Governments had been unable to provide significant funds for acquisitions for decades, and what little there had been was spent in other areas. We were lucky in that the late 1970s saw a dramatic increase in the British Museum's purchase budget. John Pope-Hennessy left for the Metropolitan Museum of Art in New York at the end of 1976. His successor, David Wilson, could not have been more supportive of modern collecting, and he ensured that we had the funds we needed.

So the question was what should follow 'Manet to Toulouse-Lautrec', given that so much would have to be acquired. The focus on American prints came about largely by accident. One of the duties and pleasures of a museum career is the opportunity to accompany works going on loan to exhibitions abroad, and this took us to the United States. Frances had studied at the Institute of Fine Arts in New York and knew the country and its art well. I did not, and the discovery of American prints of the period between the two world wars was for me a revelation. It was a courier trip to Boston at the beginning of 1979 and the friendly hospitality of colleagues there, in particular of Barbara Shapiro, that took me to Childs Gallery, where in the basement was hanging an impression of Martin Lewis's *Spring Night, Greenwich Village* (cat. 42). I thought it marvellous, but it was priced at $1,200 and I had no authority to spend any money. But the Gallery very kindly let me take it on approval, and I carried it and three other American prints in the locker above my seat on the flight back to London.

To my surprise, John Gere, the Keeper of the Department, loved it, David Wilson loved it, and so did the Trustees when we showed it to them a few weeks later. How could we build on this? By chance John Gere was himself leaving a few weeks later for New York, and Frances and I put together from the minimal sources available to us a list of names of American printmakers whom we thought were of interest, as well as the names of a few dealers who might have something in stock. Armed with this, John – who had a great eye for quality and was himself a fanatical collector – went off and came back with no fewer than twelve superb prints, among them three by George Bellows, six by Martin Lewis and others by Robert

Riggs and Louis Lozowick. John had a particular love of the work of Bellows, and told me how a London dealer had for years in stock an impression of his masterpiece, the *Dance in a Madhouse* (cat. 13); when I asked John why he had not acquired it, he said there had been no money, and what was the point of buying an isolated American print without any context in the rest of the collection?

The great group of prints that John Gere brought back delighted the Director and Trustees, and led to Frances and myself being sent off again in September on a buying trip to New York. The recent discovery of North Sea oil had turned the pound into a petro-currency, and the exchange rate was very much in our favour. We knew Dick Field, a distinguished expert on modern American prints and much else, and he very kindly offered to come down from the Yale University Art Gallery, where he was the Curator, to join us for the day in New York. I still have vivid memories of criss-crossing the city in taxis, in one of which I burnt the soles of my feet through my shoes; the floor was almost red-hot, and the driver casually explained that he had been driving 24 hours non-stop. We visited Kennedy Galleries, Associated American Artists (where Sylvan Cole was extremely helpful), Pace Editions, Brooke Alexander and the Parasol Press, where Bob Feldman amazed us by his ability to produce a continual stream of wisecracks. By the end of the day we had acquired sixty-four prints, including major works by Jasper Johns, Robert Rauschenberg, Jim Dine and Richard Estes, as well as by the minimalists Brice Marden, Robert Ryman and Robert Mangold. A few days later Sylvan Cole found for us an impression of Bellows's *A Stag at Sharkey's* (cat. 12), and Brooke Alexander offered us a set of Robert Motherwell's great suite of twenty-four colour etchings with aquatint, *A La Pintura*, dedicated to John McKendry, who as Curator of Prints at the Metropolitan Museum of Art had exhibited the series on its publication in 1972. The two together cost $29,500 (then about £13,500), and we feared that the Trustees would turn them down; but we need not have worried.

The programme for the Prints and Drawings Department's gallery had an exhibition of recent acquisitions marked down for the beginning of 1980, and it was easy to persuade everyone that this should be devoted entirely to American prints. The gallery could show around two hundred works (depending on their size), and our acquisitions did not nearly constitute enough to fill it. But we could draw on what was already in the collection. We had a fine holding of works by Whistler and his contemporaries, formed in the late nineteenth century. Campbell Dodgson, by an inspired stroke of foresight, had presented four great etchings by Edward Hopper in 1926, which he had just purchased at an average price of $20 each; and John Sloan's widow had given a large group of his prints in 1965, through

(as we later discovered) the kind suggestion of Peter Morse, who had just written the catalogue of his prints. We acquired a few works by Jim Dine and Ed Ruscha very cheaply in London in June at the sale of Editions Alecto after the disastrous fire that had ruined much of their stock. Sylvan Cole found us seven more crucial works, including lithographs by Thomas Hart Benton, John Steuart Curry and Stuart Davis, and a last-minute scramble produced the screenprint of *Brushstrokes* by Roy Lichtenstein. We borrowed a few more prints from people we knew in London and some photographs from the Victoria and Albert Museum, and in this way were able to fill the gallery.

It was by now November 1979, and the exhibition was due to open the following February. Thanks to the resources of the libraries at the Tate and V&A, we researched and wrote the catalogue in five weeks, and Celia Clear, then Senior Editor at British Museum Publications, got it out in time. The show was a huge success, despite all its inevitable lacunae and the necessarily summary nature of the catalogue. We had nothing at that stage from the twenty years between 1944 and 1964, though we had acquired the giant woodcut of *Haman* by Leonard Baskin at auction in New York in October (for $132), only for it to arrive too late to include. Whole areas of production were missing. There was, for example, nothing from the Provincetown School of woodcut, next to nothing produced under the auspices of the Federal Art Project that was part of the Works Progress Administration during the Depression years – the list could go on. Conversely, some of what we did include was criticized. I remember an American colleague asking why we had bought as many as nine prints by Martin Lewis. That at least was easy to answer, as we thought that he was far better than was then generally accepted – a judgement that has since been ratified by the market, in that his prices have risen tenfold.

This left much unfinished business for the years that followed the closing of the exhibition. Fortunately the exhibition had won us friends in the United States, and we received much invaluable help. A particular support has been David Kiehl, then of the Metropolitan Museum of Art and now of the Whitney Museum in New York. His knowledge of the field is encyclopaedic, and he kept suggesting the names of artists we should include and sending us cuttings and catalogues of interest. Another great supporter has been Mary Ryan, a pioneer throughout the 1980s in discovering neglected artists and exhibiting their work in her gallery. We have also been greatly helped by Catherine Burns and Margo Dolan, both of whom exhibited for many years at the annual London Print Fair at the Royal Academy, and showed us prints that they thought we might like. It was through them that we acquired works by artists from Philadelphia and Chicago, including Benton Spruance, Dox Thrash and Charles Turzak.

It was David Kiehl and Mary Ryan who introduced us to Dave and Reba Williams, who in the 1980s began building up what has become the finest of all collections of American prints in private or public hands. They became warm friends and supporters, and it was seeing highlights of their collection in special exhibitions or on the walls of Alliance Capital Management in New York, that gave us many ideas for other artists whom we ought to acquire. They have been generous to us, and given us groups of Mexican prints (excluded from the present exhibition, which is confined to the United States) and of prints from the 1950s. The various catalogues and articles that Reba has published on American printmaking have been invaluable in compiling this catalogue.

Although the main thrust of our acquisition efforts after the 1980 exhibition had moved on to other schools, where we attempted to repeat the same formula of using a forthcoming exhibition as a spur for making the necessary acquisitions and producing a catalogue, we were nonetheless able to make a steady stream of purchases of American prints, to which were added an increasing number of gifts. Some came from artists or their families. In 1979 I had been unable to find anything about the later career of B.J.O. Nordfeldt, and wrote in the catalogue that 'he moved to the south-west and seems to have dropped out of sight'. This was completely wrong. The most important part of his career was in this later period when he taught the Provincetown printmakers, and his widow very kindly gave us an excellent colour woodcut. We managed to buy two prints by Max Arthur Cohn, an important early exponent of screenprinting, which led in 2001 to his family generously giving us seventeen more prints, so that we now have an excellent group.

Most important of all was our friendship with the printmaker, scholar and curator Jacob Kainen and his wife Ruth Cole Kainen. We had other shared interests with them in German Expressionist printmaking, and Ruth's great collection of Kirchner and others is now in the National Gallery in Washington. We maintained a long correspondence and met whenever they were in London. Jacob gave us a dozen of his prints in 1984. Later, after his death in 2001, we discovered that he had bequeathed us twenty-five prints that he had carefully chosen to fill gaps in our collection. This was both kind and intelligent: some of his gifts are in these pages, and serve to recall a learned and very interesting man whom it was a privilege to know.

Chance, too, played a part. One of the rarest and most valuable prints in this exhibition is the 1925 lithograph by Louis Lozowick entitled *New York* (cat. 25). This was bequeathed to us by Kathleen Gray. I saw it hanging in the entrance hall of her two-up, two-down house in Marlow when I went to visit her in 1985, after she had offered as a gift some prints by her late husband, an etcher who is now remembered by few. When I told her of its importance and value, she immediately told me to take it back to the British Museum as a gift (she was a very open-handed and warm-hearted lady). I refused, and told her that she must keep it. We eventually agreed that she would leave it on deposit in the Department of Prints and Drawings, with the intention of bequeathing it to the Museum, but retaining the possibility of offering it to us for sale if she ever needed the money. The reason she had the print was that she had gone to New York in the 1920s and studied for some time at the Art Students League. When she returned to London, she was given this print as a memento by an American boyfriend, and we found that it still had on its mount the stamp of the Weyhe Gallery in New York where he had bought it.

Between 1980 and 1989 we were able to add 290 American prints to the collection and fill many of the gaps that we had identified, concentrating particularly on the years before the 1960s. Some were impossible to get: Provincetown woodcuts, for example, were both expensive and rare. Prices were rising fast, and the competition for the best works put them beyond us. In the 1990s the decline in funding available for acquisitions made things far more difficult, despite a continued stream of gifts. Of these, the most important were from Mike Godbee, who had begun to collect American prints while working in New York and who generously let us select in 1997 those that best complemented our collection.

By the end of the 1990s, our 1980 exhibition was nearly twenty years in the past, and a new generation had never had a chance to see our American collection on public view. It was clear that another exhibition was needed, and this has been entrusted to Stephen Coppel, who joined the Department in 1992. He has been heavily involved in building our modern collection, and since Frances Carey's departure for another role in the British Museum in 2003, has taken over full responsibility for it. During the 1980s and 1990s Frances and I had concentrated the limited funds we had on collecting pre-1960 American prints, partly by informal agreement with the Tate whose print collection focused on the recent decades. This changed dramatically in 2003, when Alexander Walker, the film critic of the *Evening Standard*, bequeathed to us his entire collection of prints and drawings, which had great strengths in American works of the 1960s onwards. The Walker bequest was exhibited in 2004, then sent on tour to four venues around England in 2006–7.

This reduced the need to show more prints from the period after 1960, and so the decision was taken to concentrate the current exhibition on the period between the rise of the Ashcan School at the beginning of the twentieth century, and the prints of the emerging Abstract Expressionist generation in the 1950s. Stephen has brought a fresh eye to the

material we had already collected, and has made a selection of 147 prints, of which only thirty-five, less than a quarter, were included in the 1980 exhibition. Inevitably there still remained gaps that he felt we must fill if we were to make a convincing display, and in doing this we have been generously supported by American donors through the American Friends of the British Museum. Johanna and Leslie Garfield, the great collectors of Provincetown woodcuts, presented ten prints in 2003, which solved the problem of showing the Provincetown school. Patricia Hagan gave funds specifically for the purchase of desiderata for the exhibition, and to her we owe Thomas Hart Benton's *Frankie and Johnnie* (cat. 61) and Robert Gwathmey's *Share Croppers* (cat. 84). Martha Fleischman gave us Curry's *Manhunt* (cat. 68) and Leonard Baskin's *The Hydrogen Man* (cat. 137), while an impression of the other Baskin woodcut that we very much wanted, his *Man of Peace* (cat. 136), was very kindly found and given to us by his widow, Lisa. We owe to the generosity of James and Laura Duncan, Americans long resident in London, the two most recent acquisitions in the show: the coloured lithograph by David Smith of 1952 (cat. 141), and the famous print of John Brown, the abolitionist, made in 1939 by John Steuart Curry (cat. 69). Our thanks go to all these donors.

Even in its present state of development, the collection still has significant gaps. There is nothing by Paul Cadmus, Philip Evergood, Louise Nevelson, Barnett Newman and many others. We very much hope that these gaps will be filled in future years. We also need to do more to acquire American drawings. Drawings are far more difficult to acquire than prints. There are fewer of them; they appear on the market less frequently; it is less obvious when to buy and when to wait for a better example; the competition is greater, and the prices are higher. So far we have good examples by (alphabetically) William S. Anastasi, Milton Avery, Louise Bourgeois, Judy Chicago, Ralston Crawford, Dorothy Dehner, Willem de Kooning, Jim Dine, Sandra Fisher, Philip Guston, Susan Hiller, Linda Karshan, R.B. Kitaj, Franz Kline, Sol LeWitt, Edda Renouf, Joel Shapiro, David Smith, Kiki Smith and Lawrence Weiner. But there are many others whom we ought to represent.

In preparing this catalogue Stephen Coppel has been greatly helped by Jerzy Kierkuc-Bielinski, who worked here for six months as a special assistant and drafted all the biographies and catalogue entries. Our warmest thanks go to him, and to Dave and Reba Williams who made a generous gift to the Department that has supported this project and cataloguing our American prints on computer. Monica Sidhu, a volunteer working with Stephen, assembled the artists' files and bibliographies, and scanned the American print collection. All our modern American prints, as well as most of our earlier ones plus several hundred thousand prints and

drawings of other schools, are now available on the Research page of the British Museum website (www.britishmuseum.org), and anyone can find there the other works that we have not been able to fit into this exhibition. Unfortunately only a few of the records have images attached, as the rules of copyright have obliged us to withhold them. At the same time we thank those artists or their estates who have given us permission to reproduce works free of charge in this book. To them we are most grateful. The excellent photographs used in this catalogue were taken for us by the Department photographer, Ivor Kerslake. Our thanks, too, are extended to Teresa Francis, Managing Editor at the British Museum Press, and to Johanna Stephenson, external editor, for their professional dedication and encouragement throughout the production of this catalogue.

Finally, I must thank the Terra Foundation for American Art in Chicago, which has made an exceptionally generous grant towards the exhibition catalogue and the costs of presenting the exhibition in the British Museum. This has allowed us a budget for marketing and promoting it as well as arranging a public programme in association with Professor John Howard, Department of American Studies at King's College, London, and Ian Christie, Professor of Film and Media History at Birkbeck College, London. The grant will also support the costs of sending highlights of the show on a tour to three or four regional venues after it has closed in London. We are most grateful to the Foundation, as we are to everyone who has helped us in this undertaking, of which the origins now go back nearly thirty years.

Antony Griffiths
Keeper
Department of Prints and Drawings

FROM ASHCAN TO POLLOCK: AMERICAN PRINTS 1905 TO 1960

Printmaking in America in the first half of the twentieth century took place within a completely different world from the one that was to emerge in the 1960s and which has largely continued to this day. The rise of the print workshop that also acted as publisher, notably with the establishment of the Universal Limited Art Editions (ULAE) on the East Coast in 1957 and the Tamarind Lithography Workshop on the West Coast in 1960, altered the printmaking landscape irrevocably. Many contemporary artists, from Jasper Johns and Robert Rauschenberg to Sol LeWitt and Chuck Close, were invited by enterprising print workshop publishers to make prints at well-equipped, professionally run workshops; these included Gemini G.E.L. in Los Angeles, Crown Point Press in Oakland, California, and Tyler Graphics in Bedford Village, upstate New York, to name only a few that came to prominence in the 1960s and 1970s. Technically sophisticated and often deploying a combination of different printmaking techniques, the prints produced at these workshops were often imposing by their scale and were destined to compete with paintings on the walls of the art museum or the corporate foyer rather than be hidden away in the boxes and portfolios of the traditional print collector or museum print room.

The print workshops performed the dual function of acting as both principal and agent. Not only did they commission the artists and produce prints in editions of flawless consistency, the workshops also undertook the responsibilities of publishing and distributing their output. Adopting procedures established by June Wayne at Tamarind, the print workshops provided detailed documentation of each print they issued, specifying the number of plates used to make the print, the colours and order of printing, the type of paper used, the names of the printers involved at each stage of the print's creation, and a precise tally of the edition size and the plethora of proofs outside the edition (trial proofs, printer's proofs, artist's proofs, archive proofs, hors commerce proofs, etc.). This type of documentation effectively served as a catalogue record for the convenience of art museums, corporate collections and individual collectors, and an assurance of edition size for speculators. It established a standard for the technical description of prints and the enumeration of proofs at a time when the booming market for prints in America had become big business.[1]

By contrast, printmaking in America prior to the 1960s operated within a very different set of circumstances. The print world was dominated by numerous exhibition societies organized according to their specialist interest. Following the impact of Whistler and the etching revival, etching occupied a pre-eminent position in the printmaking hierarchy, and unsurprisingly the deeply conservative Society of American Etchers, founded in 1913, the same year as the forward-looking Armory Show, enjoyed a privileged status among traditional print connoisseurs.

It awarded prizes for the best etchings of the year and commissioned annual presentation prints for its associate members. When, in 1938, the etcher Armin Landeck produced his etching, *Manhattan Nocturne* (cat. 47), which showed a bank building adjoining a slum area, the associate members objected vociferously to its unedifying subject matter and the Society's president, the etcher John Taylor Arms, was called to defend its choice in a letter to the collectors, arguing that 'New York has more than one aspect, each has its own beauty, and the one Mr. Landeck has selected … is as significant a part of the great city of to-day as is Radio City, the Empire State, or any view on Park Avenue'.[2]

A more progressive society was the Painters-Gravers of America, founded in 1917, which included among its founding members the painters John Sloan, George Bellows and John Marin, who were already major figures in the print world. Among other specialist print societies formed at this time were the Chicago Society of Etchers in 1910, the California Society of Etchers in 1911, and the Brooklyn Society of Etchers, which launched its first exhibition in 1916, with prints by Childe Hassam, John Taylor Arms and John Marin, among others.[3] These societies adhered to the tradition of the black-and-white print and viewed the introduction of colour as an aberration from the conventions of fine art printmaking. In 1915 the Panama-Pacific International Exposition in San Francisco, which marked the inauguration of the Panama Canal, included a large section dedicated to prints by American artists. Arranged in five rooms, this was the first major survey of printmaking in America, with one room devoted entirely to prints in colour.[4] The exposure given to colour prints led to the founding of the first colour woodblock society in America, the Provincetown Printers in 1918, with Blanche Lazzell, the Swedish-born B.J.O. Nordfeldt, Ada Gilmore and Oliver Chaffee among its inaugural members. In 1932 the Woodcut Society was established in Kansas City, Missouri, with Grace Martin Taylor as one of its founding members.

By the late 1930s, the attitude to colour had begun to change among some artist printmakers who experimented with colour lithography, etching and screenprint, as well as woodcut, and in 1939 they formed the American Color Print Society to represent their interests.[5] With the arrival of screenprinting in the late 1930s, it was not long before the Silk Screen Group, which was first set up in 1940, expanded as the National Serigraph Society in 1944 to promote the new technique as a fine art, with Harry Shokler, Edward Landon and Max Arthur Cohn among its charter members. The print world was splintered into a myriad of specialist societies, each eager to promote a particular branch of printmaking. Although the aim was to encourage wider public interest in printmaking through exhibitions, the narrow focus of these societies tended to limit their appeal to

their own practising disciples and their associate members who received as subscribers an annual print sponsored by the society. Inevitably the effect was to produce an essentially backward-looking, closeted print culture that was at odds with the dynamism and progressive spirit of twentieth-century America.

Wider public interest in contemporary printmaking was fostered by the active involvement of art museums. The rise of interest in the colour woodcut, with American *japoniste* practitioners and the emergence of the Provincetown Printers during the 1910s, prompted the Detroit Institute of Arts in 1919 to organize the first national survey exhibition of the colour woodcut. Entitled 'Wood Block Prints in Color by American Artists', this large exhibition presented 160 prints by twenty-two artists.[6] In addition to bringing attention to this new development, Detroit used the exhibition as an opportunity to purchase a selection of colour woodcuts for its permanent collection; its purchase of Blanche Lazzell's woodcut, *The Violet Jug*, was the first museum acquisition of her work. As well as providing official recognition and encouragement to an emerging artist, acquisitions from exhibitions of contemporary prints organized by museums was to become the usual basis for museum collection-building.

Several museums and their affiliated Print Clubs established a reputation for their support of contemporary American printmaking during this period.[7] One was the Philadelphia Museum of Art, where its print curator, Carl Zigrosser, was instrumental from 1941 in promoting many artists, including Louis Lozowick, Benton Spruance, and Wanda Gág, whom he had first nurtured when he began his career as a print dealer at the Weyhe Gallery in New York in the 1920s and 1930s. Founded in 1915 by collectors, the Print Club of Philadelphia organized competitive exhibitions. In 1929 it held the 'First All-American Exhibition of Lithography' in which Benton Spruance's first two lithographs were included. In 1931 Louis Lozowick was awarded the Mary S. Collins Prize for the best lithograph for his *Brooklyn Bridge*, 1930, in the 'Third Exhibition of American Lithography' at the Print Club.[8] For two years running, in 1930 and 1931, Martin Lewis was awarded the Club's Charles M. Lea Prize for his evocative drypoints of New York City at night, *Glow of the City*, 1929, and *Spring Night, Greenwich Village*, 1930 (cat. 42), which placed him at the forefront of the American Scene etchers.[9]

From 1929 annual exhibitions of prints by Philadelphia artists were also held at the Print Club. These provided an opportunity to show the more experimental techniques of contemporary printmakers, such as the colour carborundum relief etchings developed by the Philadelphia artists Dox Thrash, Hugh Mesibov and Michael Gallagher, which were unveiled at the Print Club's 'Eleventh Annual Exhibition' in 1939.[10] Artists were invited

to hold solo exhibitions at the Print Club; from 1932 until 1944 the Philadelphia-based Spruance had five one-man exhibitions and became closely involved in the Club's activities. The British-born artist S.W. Hayter, who had relocated his Atelier 17 from Paris to New York in 1940, was given an exhibition of his prints and drawings at the Print Club in 1944. This followed the award of the Charles M. Lea Prize for his 1943 engraving *Laocoön* at the Print Club's 'Twenty-first Annual Exhibition of American Etching' earlier that year. Inspired by his innovative methods, the Print Club established a partnership with Hayter to develop monthly collaborative workshops in engraving and etching for artists; these he regularly ran in Philadelphia over the next five years, from February 1945 until his return to Paris in 1950.[11] The membership of the Print Club of Philadelphia was made up of artists and annual members who were collectors; during the 1930s membership was heavily weighted in favour of the collectors (in 1935, for instance, there were 460 annual members, as opposed to 155 artist members), but by the late 1940s the position had dramatically changed, with more artists joining and fewer collectors remaining (in 1947, the membership figures were 291 artist members and 286 annual members).[12]

Collectors formed the core membership of the Print Club of Cleveland, founded in 1919, which began to commission artists from 1923 to make prints for annual presentation to its members. Just as in Philadelphia, where Zigrosser worked closely with the local Print Club, the Cleveland Museum of Art curator, Leona Prasse, or her associate Henry Sayles Francis, wrote, on behalf of the Print Club of Cleveland, to artists inviting them to make presentation prints. Thomas Hart Benton, Lozowick and Reginald Marsh were among those who agreed, and all three made lithographs with George Miller at his lithographic workshop in New York. The Club stipulated the terms and conditions: for his lithograph *Approaching Storm* Benton was paid $500 for an edition of 200 signed impressions, with Miller's printing costs being borne by the Club; the edition was printed in April 1939 and distributed to members the following February.[13] When Martin Lewis, the winner of the Charles M. Lea Prize at Philadelphia in 1930, was commissioned by the Print Club of Cleveland to make a presentation print, he was paid $1,000 for the delivery of 232 impressions of his drypoint *Corner Shadows*, plus the expenses of hiring his printer, Charles S. White. Issued in 1930, it was the seventh print to be published by the Print Club of Cleveland, which also donated the preparatory drawings, proofs and the cancelled plate to the Cleveland Museum of Art.[14]

In 1931 the Print Club of Cleveland took the unusual step of commissioning a lithograph, rather than the customary etching, from Lozowick; his entry, *City on a Rock – Cohoes* (fig. 1), had won first prize of $1,000 at the

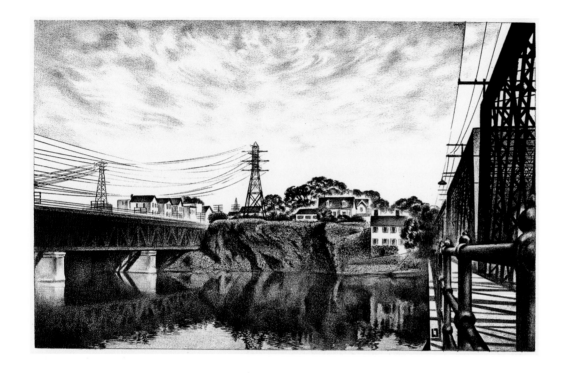

Fig. 1
Louis Lozowick, *City on a Rock – Cohoes*, 1931, lithograph,
207 x 327 mm
(British Museum, P&D 1979,0512.12)

Club's 'International Competitive Print Exhibition' and was subsequently issued as the presentation print to its members, although the industrial river scene was quite conventional by comparison with his precisionist lithographs (cats 25 and 26).

An important stimulus in raising public awareness of contemporary American printmaking in the post-Second World War period was the groundbreaking series of exhibitions at the Brooklyn Museum organized by its print curator, Una Johnson. A scholar of twentieth-century prints who in 1942 had published an important monograph on Ambroise Vollard, the enterprising print dealer and publisher of the School of Paris, Johnson brought a fresh outlook to American printmaking which was informed by her knowledge of the international avant-garde.[15] In 1947 she instituted the 'First National Print Annual Exhibition', and the annual and biennial exhibitions she organized at Brooklyn thereafter were instrumental in charting new directions in American printmaking and bringing these to a wider public audience. The award of purchase prizes at these exhibitions expanded Brooklyn's permanent collection of American prints into one of the most important in the United States and gave the museum an international status. Just as importantly, they encouraged a more adventurous spirit in printmaking by artists. At the 'First National Print Annual Exhibition' Robert Gwathmey was awarded a purchase prize for one of his colour screenprints of Southern blacks entitled *Singing and Mending*; in 1949,

at the 'Third International Print Exhibition', Josef Albers was the recipient of a purchase prize for his 1947 abstract monochrome woodcut *Multiplex A* (cat. 113). Una Johnson's long years of curatorial experience of contemporary American printmaking culminated in her book *American Prints and Printmakers*, the first scholarly overview of twentieth-century American prints, published in 1980.[16]

If Zigrosser at Philadelphia was the dealer-curator and Johnson at Brooklyn the scholar-curator, it was Jacob Kainen at the Smithsonian's US National Museum (later renamed the National Museum of American History) in Washington, DC, who could be described as the artist-curator. During the 1930s he had been a close friend of Stuart Davis and Arshile Gorky and made social realist lithographs like *Rooming House* (cat. 80) during his employment by the New York City WPA/FAP under President Roosevelt's New Deal relief programme; but in 1942, when it seemed he was about to join the New York School, he left to take up a curatorial post at the Smithsonian. As the curator in charge of the Graphic Arts Division at the US National Museum from 1946 until 1966, Kainen revitalized the collection by adding considerably to its print holdings and by mounting an innovative programme of print exhibitions of contemporary American artists, including Albers, Adja Yunkers, Lozowick and Werner Drewes, as well as of old master prints, about which he was equally knowledgeable. Imposing a rigorous self-discipline, Kainen continued to pursue his own

painting and printmaking, although his official position curtailed his full participation in the national print exhibitions. Despite the increasing responsibilities of his museum post, he taught evening classes in print-making and painting at the Washington Workshop Center for the Arts from 1947 to 1954.

A fundamental difference between the pre-1960 print world and that which followed was the practical training in graphic design that artists received, which in many cases enabled them to later earn their living. A significant number of the printmakers featured in the present publica-tion and exhibition initially trained or worked in graphic illustration and draughtsmanship. Artists like John Sloan, George Bellows, and Stuart Davis produced illustrations for the radical socialist magazine *The Masses*, of which Sloan was the editor from 1911 to 1916. Edward Hopper and Martin Lewis both supported themselves by doing commercial studio work. For sixteen years, from 1907 to 1923, Hopper worked as a freelance graphic illustrator for advertising companies and popular magazines such as *Scribner's* and *Adventure*, where he supplied illustrations for short stories. He detested this type of work, which he found demeaning, and ensured that when he could he developed his artistic practice through his etchings.

In the mid-1920s Howard Cook was hired as an illustrator for the magazine *Forum*, contributing to this publication and others such as *Harpers* and *The Atlantic Monthly* drawings and woodcuts of places he had visited, from Constantinople to Europe, as well as the American South-west. For much of his career James E. Allen, who was highly regarded for his meticulous etchings of skyscraper construction workers (cat. 53), worked as a commercial illustrator, even producing a set of dinosaur litho-graphs for the Sinclair Refining Company in the 1930s. Robert Riggs, who also worked with Allen as a contributor of illustrations for the *Saturday Evening Post*, made no distinction between his well-paid commercial drawings of athletic American types for *Life* and other popular magazines and his acutely observed lithographs of those on the edges of American society, the boxers (cat. 54), circus performers and the mentally ill (cat. 55), the last of which, incongruously enough, was a commission from a large American pharmaceutical company to advertise modern medical practice. As a medium of visual communication and persuasion, commercial illustration demanded a snappy, legible style. It is not surpris-ing then to find so many American artists of the period who worked in the commercial field adopting a realistic treatment of their subjects in their fine art practice. Commercial work often relied on the appropriation of a heavily diluted modernist vocabulary to drive home its message, and this readily transferred to the communicative function of printmaking.

The persistence of the graphic illustrative tradition in America can be attributed to the influential role of artists engaged as long-serving instructors in the art schools. Robert Henri at the New York School of Art was the inspirational teacher who urged his students John Sloan, George Bellows and Stuart Davis among others to draw from life the scenes that immediately surrounded them. In his book *Gist of Art*, published in 1939, Sloan in turn exhorted his students to

… get the healthy point of view that men like Hogarth and Leech and Cruikshank had. Do illustrations for a while. It won't hurt you. Get out of the art school and studio. Go out into the streets and look at life. Fill your notebooks with drawings of people in subways and at lunch counters. Two women gossiping over the table may be the motif for a picture.[17]

Henri, Sloan and their circle came to be dubbed the Ashcan School for their uncompromising attitude towards realist subject matter. In New York this meant observing the teeming life of the city and recording its ever-shifting scene, always with an eye for the anecdotal detail. Henri called his disciples to look to the new urban American experience rather than to the art traditions of the past. In particular, his espousal of an art for life's sake was a direct reaction to the prevailing aesthetic of art for art's sake initially propounded by Whistler and perpetuated by his acolytes.

Although Henri was not a printmaker, his teachings inspired Sloan and Bellows who both embraced graphic illustration and printmaking as a means of depicting the twentieth-century American Scene. In 1915 Henri joined the Art Students League, a co-operative art school on New York's West 57th Street, which from its incorporation in 1878 did not issue degrees or follow a prescribed curriculum but enrolled students for one month at a time.[18] In 1916 Sloan joined the League and taught there until 1938, serving as its president in 1931. Bellows also served as an instructor at the school from 1910 to 1919. The roll-call of artists who passed through the Art Students League as students is impressive for the number that sub-sequently made vital contributions to American printmaking over the next thirty years. Robert Riggs attended the League in 1915; Wanda Gág, who later made her name as an idiosyncratic Regionalist, arrived there with her then boyfriend, the satirical realist Adolf Dehn, from Minnesota in 1917; the Regionalist Thomas Hart Benton taught there from the late 1920s and Jackson Pollock was one of his pupils. Although Peggy Bacon made anec-dotal drypoints (cat. 10) of student life at the League between 1915 and 1920, it was not until the distinguished etcher Joseph Pennell, a follower of Whistler, was appointed in 1921 that the Art Students League gained its

Fig. 2
Front cover of the prospectus and schedule of classes of the Art Students League, New York, Winter Catalogue,
29 September 1930 to 29 May 1931, 234 x 156 mm (British Museum, Department of Prints and Drawings Library)

reputation for the teaching of printmaking (fig. 2). It was there that Alexander Calder learnt to etch in 1924 and in the following year took classes in lithography with the instructor Charles Locke. The Czech-born modernist Jan Matulka learnt etching at the League in 1925 and shortly afterwards taught painting to David Smith and Dorothy Dehner, later returning to the League in 1929 as an instructor in life drawing, painting and composition, where he instilled European avant-garde ideas in his students.

Outside the art schools, access to a studio for printing was limited. For woodcuts and linocuts this did not matter as they could be readily printed by the artist at home without a press, and for etchings only a small press was necessary which could be installed in the artist's studio. But lithography required a special studio with a trained printer to prepare the stones for the artist to draw, etch the finished drawing on the stone and pull the proofs through a lithographic press. George Miller, who came from a background of commercial printing where he had been an apprentice and then an employee of the American Lithographic Company, became the first port of call in New York for artists wanting to make lithographs outside the

art school. A trade lithographer, Miller branched out in 1917 when he opened the first workshop in America specifically to print lithographs for artists.[19] After a difficult start in the early years, Miller operated a thriving business by the mid-1920s from both the commercial and fine art sectors, charging a dollar for every print pulled, and nearly every lithograph made by artists of this period went through his press. But in the early 1930s Miller fell victim to the Depression and his business on 14th Street was only rescued when the publisher Associated American Artists engaged his services for printing the large editions of Regionalist lithographs which they began to sell by mail order from 1934.

The lithographer Bolton Brown prided himself as an artist who had taken the risk of travelling to London during the First World War to spend a year learning the technique at the Central School of Art and Design with Ernest Jackson, as well as studying examples of lithography in the Print Room of the British Museum.[20] After his return to New York Brown established himself as an artist's lithographer, as opposed to a trade lithographer like Miller, and formed a close collaborative relationship with George

Bellows. But when Bellows died unexpectedly in 1925 Brown largely gave up printing with other artists. There were a few other lithographic printers: in Philadelphia the German-born and trained Theodore Cuno worked with the artist Benton Spruance and others for many years until the early 1950s, where his skill as a printer of work in crayon lithography was especially prized. For the Philadelphia artist Robert Riggs, however, it was to Miller in New York that he shipped his difficult stones, knowing that he could rely on Miller's skill as a craftsman to etch and print them without incurring censure or aesthetic pronouncements. On the West Coast Lynton Kistler was the only lithographer printing for artists when he set up business in Los Angeles in 1945, where he printed Hans Burkhardt's apocalyptic gestural visions of a post-nuclear world (cat. 138).[21] His business closed in 1958, although the fortunes of lithography in America would be transformed two years later when June Wayne's Tamarind Lithography Workshop opened in Los Angeles in 1960.

Many American artists in the 1920s and early 1930s made a special point of learning lithography in Paris at the Atelier Desjobert.[22] The dealer Carl Zigrosser of the Weyhe Gallery recommended his artists to go to Desjobert's: Howard Cook went there in 1929, and so did Adolf Dehn, where he made more than seventy lithographs in 1928, returning for a second visit in 1931–2. Benton Spruance first learnt lithography at Desjobert's when he was in Paris on a travelling scholarship in 1928 and again in 1930; on his return to Philadelphia he resolved to pursue lithography as his principal medium of expression with the printer Cuno. Stuart Davis, who made his only trip abroad to Paris in 1928, took up lithography for the first time in the French capital where he made some eleven prints; in all likelihood these were done at the Atelier Desjobert.

The final element in the infrastructure of the print world before the 1960s was the dealers. In the field of contemporary American prints the most enterprising was the Weyhe Gallery on Lexington Avenue in New York. Established by the German immigrant Erhard Weyhe in 1914 as a bookshop specializing in art books, the business was expanded to include a print gallery to which Carl Zigrosser was appointed as its director in 1919.[23] Zigrosser had previously worked for the New York print dealers Frederick Keppel & Company, who handled old master prints as well as contemporary British printmakers of the etching revival such as Muirhead Bone and D.Y. Cameron. But after being exposed to the Armory Show of 1913 Zigrosser was keen to develop a market of the more progressive tendencies in printmaking. The opportunity came with his appointment to the Weyhe Gallery, where for the next twenty-two years he had a free rein in promoting contemporary prints as well as presenting other selling exhibitions, such as Daumier and Gavarni in 1919 and Picasso etchings and drawings in

1927. In 1919 Zigrosser launched the Weyhe portfolio, *Twelve Prints by Contemporary American Artists*, which announced the Gallery's commitment to the promotion and publication of contemporary American printmaking. John Sloan and Rockwell Kent were among the artists selected who remain well known today; most of the others are now largely forgotten. The portfolio was produced in an edition of a hundred and sold for $50, and with its range of techniques, which included woodcuts and lithographs as well as etchings and drypoints, it challenged the hierarchical attitude to printmaking. In his essay accompanying the portfolio, Zigrosser foreshadowed his interest in the emerging American Scene: '… one may discover in them all manner of reflections of American thought and life … how men looked in this decade, what environment they created for themselves in cities, and in the open, how they lived, and what they thought about …'.[24] For the lithographs Zigrosser used the services of George Miller, who thereafter remained the printer of choice for the Weyhe Gallery artists. A coterie of young artists was fostered by Zigrosser at the Weyhe, among them Howard Cook, Louis Lozowick, Benton Spruance, Adolf Dehn and Wanda Gág; in 1929 alone Zigrosser gave a series of solo print exhibitions to Cook, Dehn, Peggy Bacon, Arthur B. Davies and Lozowick. While being open to all techniques, Zigrosser was particularly supportive of lithography at the Weyhe Gallery. Following a trip to Mexico in 1930, he also encouraged the Mexican trio Diego Rivera, José Clement Orozco and David Alfaro Siqueiros, to produce lithographs for publication by the Weyhe Gallery.

Other New York galleries handled prints in a more informal way by including them in exhibitions of artists they represented, but rarely published them as editions. The Downtown Gallery carved a niche as a promoter of modern American paintings and drawings. Run by Edith Halpert, the gallery encouraged its artists such as Max Weber and Stuart Davis, who had left-leaning associations, to show their prints.[25] In 1927 Halpert established the American Print Makers Annual exhibitions at the Downtown Gallery, which featured progressive printmaking. To organize the Print Makers Annuals Halpert instituted a committee of artists, including Reginald Marsh and Peggy Bacon, which invited artists to make a selection of their prints for inclusion. These became notable events each December, where modernist abstract lithographs by Davis, Arshile Gorky and Weber were shown alongside the prints of the emerging Regionalists such as John Steuart Curry. As one critic remarked of the Downtown Gallery's Print Makers Annual in 1930, the prints were 'thoroughly sensitive to the contemporary scene and to contemporary ideas in aesthetics'.[26]

Among the older, more established commercial galleries it was Kennedy & Company which represented the more conservative etching

tradition. Founded in 1874 by Hermann Wunderlich, it changed its name to Kennedy & Company before the First World War and from the early 1880s had a long association with James McNeill Whistler, whose etchings were catalogued by the firm's partner, Edward G. Kennedy.[27] Like its counterpart in London, Colnaghi's, it dealt in old master prints and the British artists of the etching revival, notably Seymour Haden, Edmund Blampied, James McBey, Bone and Cameron. The etchings were nearly always black-and-white landscapes, marine subjects or architectural views. With the etching boom in the 1920s and the emerging interest in the American Scene, it was only natural that Kennedy & Company should also seek to publish the prints of American practitioners and from the late 1920s it published the evocative etchings and drypoints of New York by Martin Lewis and Armin Landeck, both of whom made their reputations as print-makers rather than as painters making prints. In the 1930s, following the collapse of the etching market after the Wall Street Crash of 1929, lithography came to take a more significant position in the print world. This was largely led by Associated American Artists, the New York gallery which from 1934 published lithographs in very large editions after paintings by the American Regionalists.

It is against this backcloth that the more progressive developments of American printmaking took place: the twelve sections that follow provide a brief historical introduction.

1 THE ASHCAN SCHOOL TO GEORGE BELLOWS

It was in Philadelphia rather than New York that the first sign of a distinctively modern American school emerged in the 1890s around the painter and teacher Robert Henri, who had trained at the Pennsylvania Academy of Fine Arts.[28] He attracted around him a group of talented newspaper artists in Philadelphia who included John Sloan, William Glackens, Everett Shinn and George Luks, all of whom knew each other as contemporaries at the Pennsylvania Academy and as illustrators for the city's newspapers. Henri, who had studied in Paris, encouraged his coterie to observe their immediate surroundings and to record it in quick sketches, as well as to recall scenes entirely from memory. This approach appealed to them as a natural extension of their training as newspaper illustrators. When in 1900 Henri moved to New York and shortly afterwards began to teach at the New York School of Art, Glackens and Luks had already moved to New York and the others soon joined him. Their informal association became more publicly recognized when their paintings of gritty urban life were shown at the Macbeth Gallery in February 1908. The group's formation was an act of defiance against the National Academy of Design (of which Henri

was a member), which had earlier rejected their paintings through its jury system on the grounds of subject matter. Three additional recruits to the group were Arthur B. Davies, Ernest Lawson and Maurice Prendergast. The Macbeth Gallery exhibition created a furore and critics dubbed the group 'The Eight', better known as the Ashcan School, a term which became widely current from the 1930s, although it appears to have been first used in 1916 in sarcastic reference to their subject matter.[29]

John Sloan, who loathed the phrase 'Ashcan School', was the prime exponent of the movement through his paintings and illustrations, but in particular through his etchings and teaching. Of all the artists in 'The Eight' Sloan was the one who translated Henri's teachings most faithfully to printmaking. Following his arrival in New York in 1904 he produced *New York City Life*, a set of ten etchings made between 1905 and 1906, which are the first sustained statement in printmaking of Henri's tenets. Prior to this Sloan had been commissioned to produce fifty-three etched illustrations for a deluxe edition of the novels of the French comic writer Charles Paul de Kock (1794–1871), completed in 1905, which gave him invaluable technical experience for the New York series. *New York City Life* presented direct, unsentimental snapshots of ordinary tenement life in Manhattan, set in identifiable locations which gave an unvarnished veracity to the scene depicted. After the series was completed he was invited by the etcher Charles Mielatz to show them at the 1906 annual exhibition of the American Watercolor Society in the rooms of the National Academy of Design. To Sloan's fury several of the plates, such as *Turning out the Light* (cat. 1), were deemed 'vulgar, unfit to show publicly, and indecent' by the exhibition organizers, provoking an outcry.[30] In 1913 Sloan tried to market his *New York City Life* prints by taking out a full-page advertisement in the magazine *The Masses*, of which he was then the art editor, offering the ten etchings with three additional prints at $2.00 each, which were reduced from the regular price of $5.00, provided that a $1.00 annual subscription to the radical magazine was guaranteed.[31] Sloan noted that not a single order was received. In 1915 he took the unusual step of doing a mail shot to 1,600 individuals and public institutions selected from *Who's Who* in which he offered signed prints from the *New York City Life* series for $10.00 each or $20.00 for three, adding in his accompanying letter that 'the prices are unusually reasonable, as I am my own publisher and all distributors' profits are eliminated'.[32] Only two buyers emerged: the Newark Public Library, and the painter and illustrator Charles Jay Taylor.

Although commercial success as an etcher eluded him until the late 1920s when print sales picked up modestly, Sloan's reputation as a teacher grew among his students at the Art Students League where he taught from 1916. His classes were the subject of several drypoints by Peggy Bacon,

such as *John Sloan's Night Class*, but more importantly his influence was felt in recording the immediate personalities and locale of the artist's life. The in-house character of Bacon's prints of art student life (cat. 10) are filled with well-observed, anecdotal detail that border on caricature and the documentary.

The other significant artist to emerge from Henri's tutelage was George Bellows, who arrived in New York in 1904, the same year as Sloan. Although he was not a member of 'The Eight', he was closely allied to their approach. He quickly established himself as a successful artist with his paintings *River Rats*, 1906 (private collection) and *Forty-two Kids*, 1907 (Corcoran Gallery of Art, Washington, DC), which gained him election to the National Academy of Design as its youngest associate in 1909. His abilities as a draughtsman found a ready outlet in lithography, which he took up with enthusiasm in 1916 when he installed his press in the mezzanine of his studio at his family house. His first lithograph, entitled *Hungry Dogs*, showing dogs rooting among overflowing rubbish bins, was almost a literal transcription of the Ashcan philosophy.[33] Initially Bellows worked on the stones himself as the artist-printer, but he was soon defeated by the technical complexities of lithography. George Miller, the trade lithographer in New York, was called in to prepare the stones and print them in the artist's studio. But his most sustained collaboration was with the artist-lithographer Bolton Brown, with whom he worked closely from 1919 until Bellows's sudden death from a ruptured appendix in 1925. In the first three months of 1921 Bellows made some fifty-nine lithographs with Brown, who provided specially made crayons that allowed the artist to obtain the most subtle tonal effects from the finest delicate lines to the deepest blacks.[34] The respective involvement of artist and printer was acknowledged on the prints themselves, such as *Business Men's Bath* (cat. 16), the first time in American lithography that the contribution of the printer, as a creative partner, was recorded. In his lithographs Bellows went beyond the everyday reportage of Sloan to explore the unsettling, darker side of the American experience: the prize-fights (cat. 12), the manic preachers, the asylum wards (cat. 13) and death by the electric chair (cat. 14). The large scale of many of these prints and their sheer quantity, almost two hundred, executed within the span of nine years, contributed significantly to the revival of artistic lithography in America and succeeded in finally emancipating the technique from its earlier commercial associations.

2 THE PROVINCETOWN WOODCUT

The outbreak of the First World War in Europe forced many American artists to return home after an extended period living in Paris. Many made their way to the art colony of Provincetown, Massachusetts, a picturesque fishing village on Cape Cod, where friendships made in Paris were renewed. Among these was the woodcut artist Blanche Lazzell, who described the impact of her first summer in Provincetown in 1915: '... the whole scene, everything and everybody was new, it was glorious indeed … Creative energy was in the air we breathed. It was in this quaint setting that the Provincetown print came into being'.[35] American friends from Paris included the bohemian couple Ethel Mars and Maud Squire, who had been part of the writer Gertrude Stein's circle which included Matisse and Picasso. Mars was an accomplished colour woodcut artist who had exhibited in the Autumn Salons in Paris, while Squire had made colour intaglio prints. Other women artists to join the group were Ada Gilmore, Mildred McMillen and Edna Boies Hopkins. That same summer B.J.O. Nordfeldt arrived in Provincetown; from Frank Morley Fletcher in England in 1900 he had learnt the difficult technique of making colour woodcuts by the Japanese method, which relied on multiple blocks, careful registration and printing with water-based inks. Nordfeldt's innovation at Provincetown was to dispense with multiple blocks; instead a single block was cut, with deep grooves to allow the uncut areas to be inked with a different colour, which would then print with a distinctive white line separating the areas of colour. The white-line colour woodcut was quickly taken up by the group of women artists in Provincetown and in the summer of 1916 the first exhibition of their work was held. Their success led to the formation of the Provincetown Printers in 1918. The technique produced bold, simplified designs in strong, decorative colour and appealed to the artists as a means of making modern-looking prints without recourse to a printing press or the assistance of a professional printer. They could be printed simply by hand, within a domestic setting.

During the 1920s Blanche Lazzell became the leading exponent of the Provincetown woodcut. She later defined its characteristics as: 'Originality, Simplicity, Freedom of Expression, and above all Sincerity, with a clean cut block'.[36] Although her subject matter was often of Provincetown locations, her treatment showed the formal inspiration of the School of Paris, particularly the cubist academician Albert Gleizes, with whom she studied in Paris between 1923 and 1925. Her still-life woodcuts of vases of flowers (cat. 19) from this period showed her sophisticated understanding of cubist geometric form and interlocking planes of colour. At this time she made the first non-representational woodcuts in America, notably

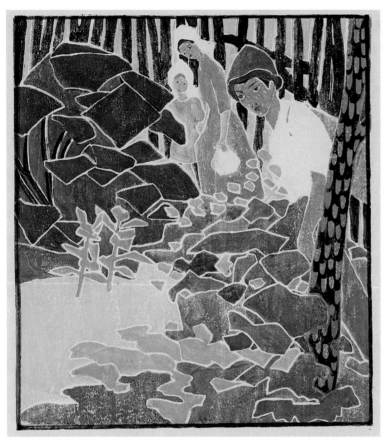

Fig. 3
Edna Boies Hopkins, *Breton Villagers*, c.1920, colour woodcut, 258 x 231mm
(British Museum, P&D 1986,0301.43)

the Provincetown Playhouse, and took up printmaking. Although the Zorachs were both members of the Provincetown Printers and valued the creative possibilities of the white-line colour woodcut, William Zorach concentrated almost exclusively on the linocut in black and white. He expressed in his prints a transcendentalist view of nature that recalled a German, late Romantic sensibility in which humanity was identified with the rhythms and cycles of nature. This union of nature and mysticism was articulated in his depictions of humble Provincetown fishermen (cat. 17). As he wrote in 1916, 'It is the inner spirit of things that I seek to express, the essential relation of forms and color to universal things'.[38] Zorach found the harmonious balance of black and white in his linocuts the ideal vehicle for the integration of form and idea.

In addition to local exhibitions, the Provincetown Printers participated on a broader national level in exhibitions at Detroit in 1919, the Boston Art Club in 1920 and in New York at the Brown-Robertson Gallery in 1921 and 1922. Although they were gaining wider recognition by the early 1920s, the Provincetown Printers as a group had already begun to break up. Nordfeldt left to join the army in 1918 and then relocated to New Mexico the following year, sending works from there to future Provincetown exhibitions. After the war Mars, Squire and Hopkins (fig. 3) all returned to France. A new generation of women artists arrived in Provincetown to continue the white-line colour woodcut tradition, while Blanche Lazzell maintained an active presence as an inspirational teacher and practitioner in Provincetown, where she was largely based for more than forty years. In all, Lazzell had made some 138 woodcuts by the time of her death in 1956.

3 AMERICAN MODERNISM AND PRECISIONISM

While Provincetown remained a rural idyll steeped in the Arts and Crafts tradition, it was in New York that modernism erupted with the Armory Show in 1913. Officially called the 'International Exhibition of Modern Art', the show opened on 17 February 1913 in the huge hall of the 69th Regiment Armory, from which it took its more commonly known name.[39] It was organized by the Association of American Painters and Sculptors, led by Arthur B. Davies, a painter of poetic arcadian visions, who possessed an open attitude to art and acute organizational and persuasive skills. Davies, who was also a member of 'The Eight', joined forces with fellow artist Walt Kuhn and the painter and critic Walter Pach to secure the loan of modern works from Europe. An exhibition of some 1,300 works by nineteenth- and twentieth-century American and European artists was assembled and presented to a shocked and confused public. Although the 430 European

Abstraction A and *Abstraction B* in 1926. Her cousin Grace Martin Taylor was similarly committed to cubist abstraction in her colour woodcuts such as *Composition No. 1* (cat. 20).

The Provincetown Printers were the only artists making colour woodcuts of this type in America. Their work should be set against the American *japoniste* prints produced by Helen Hyde and Bertha Lum among others, who had studied the colour woodcut at first hand in Japan, working with Japanese craftsmen in the first decade of the twentieth century.[37] While technically accomplished, their prints were highly derivative of the *ukiyo-e* woodcut tradition, whereas the Provincetown Printers expressed contemporary life in coastal and rural New England in a modernist idiom.

Among the artists attracted to the simplicity of life in Provincetown were William and Marguerite Zorach, who spent their first summer there in 1916. They became prominent in the community, designing stage sets for

works only took up a third of the space, they provoked a sensation, and made even the most advanced American entries appear provincial and backward by comparison. Sloan and members of 'The Eight', together with Bellows, were well represented, but their style immediately appeared dated when compared with the most avant-garde works from Europe by Picasso, Kandinsky, Matisse and the Fauves. The most scandalous exhibit was Marcel Duchamp's futurist-inspired *Nude Descending a Staircase (no.2)*, 1912 (Philadelphia Museum of Art), derided by the press as 'an explosion in a shingle factory'.[40] Even compared with Gauguin, Van Gogh and the other French post-impressionists, the Ashcan School seemed decidedly uncontroversial. Although it might be expected that the American public would react against the new tendencies in European art, the impact of the Armory Show on contemporary American artists was far-reaching. Sloan and the Ashcan School's reputation as representatives of the vanguard of American art was shattered forever. As Sloan himself admitted, 'The Armory Show undoubtedly had a strong and perhaps subtle effect on my work also. The clarion call of freedom which the ultra-moderns gave us led to a greater interest in color, plasticity, [and] geometric consciousness about form'.[41]

Although a few of Sloan's etchings, such as *Anshutz on Anatomy* (cat. 5), were included, prints remained very much a marginal presence at the Armory Show.[42] Nevertheless, the Armory Show would have an impact on American painters open to the revolutionary art from Europe in their printmaking. This was most apparent in the etchings of John Marin, who had returned to New York in 1911 after six years in Paris making architectural etchings of European landmarks. Although these had found a ready market with traditional print dealers in America, it was his encounter with the avant-garde photographer Alfred Stieglitz, who ran the 291 Gallery on New York's Fifth Avenue from 1905, which encouraged him to take a modernist direction. The cosmopolitan Stieglitz promoted the latest developments of European painting and sculpture at his 291 Gallery in addition to photography and African tribal art. Stieglitz placed Marin on an annual stipend, which allowed him to experiment with a modernist vocabulary in a series of watercolours of New York. These were shown at the 291 Gallery in 1913, where Marin proclaimed in the accompanying catalogue the importance of the modern urban landscape of New York as a subject for modern art:

I see great forces at work; great movements; the large buildings and the small buildings; the warring of the great and the small; influences of one mass on another greater or smaller mass. Feelings are aroused which give me the desire to express the reaction of these 'pull forces';

those influences which play with one another; great masses pulling smaller masses, each subject to some degree to the other's power.[43]

Marin translated these ideas most directly in his etchings of the swaying Brooklyn Bridge (cat. 21) and the Woolworth Building, which he subtitled 'The Dance', both landmarks of contemporary New York. In their intense, highly charged emotional response to Manhattan, these etchings were an amalgam of the latest European styles of Futurism and Expressionism. Whereas Sloan and Bellows had no dealer behind them to publish and distribute their prints, Marin was unusual in having the professional support of Stieglitz as a publisher of his avant-garde etchings, which were issued in small editions of between twelve and thirty impressions from the 291 Gallery. However, Stieglitz was more committed to Marin's watercolours and oil paintings than to his prints, which were placed for sale with the modern prints dealer Weyhe Gallery in the early 1920s.

Another artist for whom the Armory Show made a major impact was Stuart Davis. A contributor of five watercolours to the Armory and a devoted follower of Robert Henri and John Sloan, Davis by his own admission decided that henceforth he 'would quite definitely have to become a modern artist'.[44] While he continued to produce illustrations for *The Masses* magazine under Sloan's art editorship from 1913 to 1916, he gradually began to explore a more modernist idiom influenced by the School of Paris in his paintings and collages. In 1928 he made his one and only trip abroad to Paris where he produced a series of eleven lithographs which, despite their modern appearance, are tied to a French urban topographical tradition that Hayter, who likewise had recently arrived in Paris, was also exploring in his engravings at this time. In all likelihood Davis's prints were made at Atelier Desjobert, the first destination for American artists wanting to make lithographs in Paris. On his return to New York in 1929 he was confronted by the gigantic scale and urban dynamism of New York; he incorporated these ideas into a series of six lithographs produced between 1929 and 1931. The prints employ a pictorial language derived from Cubism and Surrealism to express a characteristically American subject matter. Davis discovered that modernism and the American experience could be seamlessly integrated to articulate the rhythms of New York life (cats 31 and 32).

Although the painter Milton Avery would only make his first visit to Europe in 1952, when he was aged almost sixty, he was also strongly influenced by the School of Paris, particularly by Matisse, whose work was being shown in the New York galleries in the 1920s and 1930s. He objected to being called an 'American Matisse', but in his simplification of form and economic handling of line, the comparison is inevitable (cat. 34).[45] During

the 1930s and 1940s Avery's drypoints were never published in editions but only printed as proofs. It was only in 1948 that the Laurel Gallery in New York published five of his drypoints in a portfolio. When a socially conscious art was being almost universally promulgated during the 1930s and 1940s, Avery's commitment to an abstracted form of the motif served as an inspiration to the younger generation of American artists such as Mark Rothko, Adolph Gottlieb and Barnett Newman.

European modernism also exerted a decisive influence on Louis Lozowick, who had direct contact with the constructivist El Lissitsky during his stay in Berlin between 1922 and 1924. He also made a visit to Moscow in 1922, where he met the Russian constructivists Malevich and Tatlin. His first lithographs were produced in Berlin and their subjects were the American cities of Chicago and Cleveland depicted as rectilinear geometric blocks, which he had recalled from an earlier trip made across the United States in 1919. On his return to New York in 1924 Lozowick produced his most important print, *New York* (cat. 25), in which cubo-futurism and constructivism were brought together to evoke the utopian modernity of Manhattan. Lozowick proselytized the new machine-age aesthetic in his published lectures on *Modern Russian Art* (1925) and in his seminal essay 'The Americanization of Art' in the catalogue for the exhibition 'Machine Age Exposition' which he helped to organize in New York in 1927. In the latter Lozowick called upon artists to embrace the epic industrial scale of America: 'the skyscrapers of New York, the grain elevators of Minneapolis, the steel mills of Pittsburgh, the oil wells of Oklahoma, the copper mines of Butte, the lumber yards of Seattle …'.[46] The pictorial language he propounded to articulate this vision was Precisionism, which he defined in the following programme:

> The artist … will note with exactitude the articulation, solidity and weight of advancing and receding masses, will define with precision the space around objects and between them; he will organize line, plane and volume into a well knit design, arrange color and light into a pattern of contrast and harmony and weave organically into every composition an all pervading rhythm and equilibrium.[47]

Lozowick's ideas were translated into lithographs which Carl Zigrosser encouraged him to make. In a prodigious burst of activity, Lozowick produced more than seventy lithographs between 1928 and 1930 in New York, where they were presented at his first one-man lithography exhibition at the Weyhe Gallery in 1929.

The artist most closely identified with American Precisionism was Charles Sheeler. Although he made only five lithographs and these were all

executed between 1918 and 1928, his earlier training in industrial design and practice as an architectural photographer informed his precisionist approach. His famous lithograph of the Delmonico Building (cat. 27) epitomizes his concern with the soaring architecture of New York's skyscrapers which he had expressed in his architectural drawings and photographs and in the experimental film *Manhatta*, which he had made in collaboration with Paul Strand in 1920. The precisionist lithographs of Sheeler and Lozowick were produced at the workshop of George Miller, whose technical proficiency could translate the finish of their cubo-realist drawings with high fidelity.

By contrast to the controlled precisionist aesthetic of Lozowick and Sheeler, a freer attitude to printmaking prevailed with Werner Drewes and Jan Matulka, who brought different forms of European modernism to America. Drewes had trained at the Bauhaus first at Weimar and then at Dessau, where he studied with Kandinsky and worked with Lyonel Feininger. After Drewes arrived in America in 1930 to escape the deteriorating political situation in Germany, he was confronted by the monumentality of the New York cityscape which he sought to express in a series of dramatic expressionistic woodcuts entitled *Ten Views of Manhattan* (cat. 30). These share an unmistakable affinity with Feininger's architectural expressionist woodcuts. Werner's woodcuts were self-printed and self-published, and never led to any commercial success.

On several trips to Europe to visit his native Czechoslovakia between 1919 and 1924 Matulka made contact with the Czech Cubists and the School of Paris, and he returned to New York to disseminate these ideas in his teaching and his prints (cats 23 and 24). None of his prints was ever formally published in a regular edition; they exist as experimental proofs and more than half of his forty-odd recorded prints were produced between 1925 and 1928. Absence of finish characterized his lithographs which were printed from uneven stones, most probably at the presses of the Art Students League where he first learnt lithography in about 1925. After 1930 Matulka stopped making prints altogether and no longer took part in print exhibitions. His abandonment of printmaking coincided with a changing attitude towards European-inspired modernism in favour of American Scene subject matter and a socially conscious art which became the prevailing mode in the 1930s.[48]

4 EDWARD HOPPER AND THE AMERICAN SCENE

The American Scene is a concept that during the 1920s and 1930s came to be applied to urban and rural subject matter found across the vast land mass of North America. For Sloan, who abhorred the phrase, American

Scene represented nothing new, but simply a continuation of the Ashcan's objective recording of everyday scenes of the urban world around them. As he wrote in 1939, 'There is so much talk today about the American Scene. As though it had been discovered in the last decade! If anyone started this painting of the American scene it was our gang of newspaper men: Glackens, Luks, Shinn, and myself, back in the Nineties'.[49]

From our perspective today the American Scene has become closely associated with the images created by Edward Hopper. Although the disguised narrative in his scenes from big city life distinguished Hopper's paintings and etchings from the reportage of Sloan, Hopper came from the same illustrative tradition as Sloan. He had trained with Robert Henri at the New York School of Art between 1900 and 1906, where he was in the same class as Bellows. In 1927, having finally shaken himself free of commercial work and embarked on his career as a painter, Hopper could look back at the training in illustration he and Sloan had received, with some justification: 'This hard early training has given to Sloan a facility and a power of invention that the pure painter seldom achieves'.[50] Nevertheless, Hopper was very clear that his paintings and his etchings were completely removed from the concerns of the Ashcan School. As he wrote in 1956, with respect to his etching *East Side Interior – New York* (cat. 40), there was 'no implication … intended with any ideology concerning the poor and oppressed. The interior itself was my main interest – simply a piece of New York, the city that interests me so much, nor is there any derivation from the so called "Ash Can School" with which my name has at times been erroneously associated'.[51]

Hopper was concerned instead with the psychological drama inherent in his scenes in which there was an implication of an event that had just taken place or one that was about to happen. In his etchings he achieved this sense of anticipation through his adept handling of the medium: densely worked etched lines are contrasted with untouched areas of the brilliant white paper, endowing the scene with an air of mystery and tension. In contrast to Sloan's observations of the everyday world, Hopper imbued his scenes with a cinematic quality that is apparent in the point of view and dramatic lighting in such etchings as *Night in the Park* (cat. 39). Hopper first learned to etch in 1915 from the Australian-born etcher Martin Lewis, who showed him the techniques of etching and drypoint, and went on to make nearly seventy etchings over the next eight years. During this period Hopper was working as a freelance commercial artist and etching was the means by which he could pursue his artistic career. Although he had sold a painting at the Armory Show in 1913, it was not until his critical success in 1924 with his first solo exhibition of watercolours at the Frank K.M. Rehn Gallery in New York that he could give up commercial work to concentrate on painting. As an etcher Hopper printed his own plates and editions himself, but after his critical recognition, at the age of forty-two, he abandoned etching altogether and only made two subsequent drypoints in 1928. Although he gave up printmaking at this time, he never forgot the important role it had played in clarifying his compositions. As he later admitted, 'After I took up etching, my painting seemed to crystalize'.[52]

At the very moment Hopper decided to stop making etchings, his erstwhile teacher, Martin Lewis, came to maturity with his drypoints of New York City from 1928. In subject matter and treatment he followed Hopper, often presenting an implied narrative in his New York scenes such as *Little Penthouse* (cat. 43), where exaggerated lighting contributed to the sense of impending drama. His drypoint nocturnes had considerable success in the early years. He was taken up by Kennedy & Company, the long-established New York gallery which specialized in old master paintings and etchings by Whistler and his followers. This enabled Lewis to give up the commercial work he had practised since his arrival in America almost thirty years earlier. His evocative night scenes of New York found many eager buyers and his editions quickly sold out. Hailed as a modern master of etching, two monographs on his prints were published in 1931, an honour which was never bestowed on Hopper.[53] But Lewis's circumstances changed dramatically when the etching market collapsed following the Great Crash in 1929 and the subsequent onset of the Depression. No longer able to afford living in New York, in 1932 he moved to rural Connecticut, where he made drypoint scenes of small-town life (cats 44 and 45). Although Lewis returned to New York in 1936, he found himself unable to adjust to the changed circumstances of the print world following the collapse of the etching market. With the demand for a socially conscious art in the late 1930s and the rise of the colour print in the following decade, his black-and-white drypoints looked completely outdated by the 1940s and his career simply petered out.

Armin Landeck and Lawrence Kupferman were two etchers associated with the American Scene in the 1930s who specialized in clinical depictions of urban topography devoid of any human presence except by implication. Landeck's architectural settings are invariably deserted (cat. 47), while Kupferman makes haunting reference to human habitation through his scrupulous delineation of domestic buildings and parked cars in his scenes of suburban Boston (cat. 48).

A different type of American Scene was presented by Reginald Marsh. A chronicler of the seedy low-life of New York, its strip-joints and down and outs in the Bowery, Marsh was the natural heir to John Sloan, under whom he had studied at the Art Students League in the early 1920s. Marsh

came into his own during the Depression years of the 1930s, when he was most productive as an etcher. His scenes of dole queues and the unemployed express the harsh reality of this period (cat. 52). In contrast to this world of unrelieved gloom and hardship down on the ground, the etcher James E. Allen presented a more optimistic view of New York in his realistic depictions of construction workers building the rising skyscrapers that were transforming the skyline of Manhattan during the Depression years (cat. 53).

5 SATIRICAL REALISM

From the theatrical realism of Bellows emerged a definite satiric strand that characterizes the work of Marsh, Robert Riggs, Adolf Dehn and Fred Becker among others during the 1930s. All four artists shared an interest in the *demi-monde*: the circus performer, the striptease artiste, the popular entertainment world of Coney Island, and the black jazz clubs and dance halls. They all expressed a heightened reality that bordered on the grotesque and the uninhibited. Marsh produced flamboyant, almost baroque, images of adults, rather than children, sailing round on carousels in escapist flight from the realities of the Depression. His etchings of these subjects (fig. 4) display a fantastic realism that is quite removed from the observed reality of his prints of the unemployed and the destitute. Marsh came from a newspaper background and gained his first-hand experience

Fig. 4
Reginald Marsh, *Merry-Go-Round*, 1930 (re-strike from the 1969 Whitney Museum portfolio), etching, 173 x 250 mm
(British Museum, P&D 1979,1006.36)

of New York street life working as an illustrator for the New York *Daily News* between 1922 and 1925, an experience he later proudly declared 'took the place of an art school'.[54] After an exhibition of his prints at the Frank K.M. Rehn Gallery in 1931, Marsh's work was critically linked to that of Sloan, Bellows and Hopper.

The strongest influence on these artists of the 1930s was Bellows, whose sudden death in 1925 left a void in American lithography. This is most evident in the work of Robert Riggs, the Philadelphia artist who worked as a commercial illustrator and who took up lithography after seeing an exhibition of Bellows's lithographs at the Print Club in Philadelphia in 1931. Over the next two years he produced more than fifty prints in an extraordinary outburst of work, half of which were boxing subjects. These were nearly all printed in New York by Miller, who had first helped Bellows to print his stones more than fifteen years earlier. In 1933 Riggs showed his lithographs at the Frank K.M. Rehn Gallery, where they prompted comparison with Bellows and drew praise from the New York *Herald Tribune*, whose critic remarked: 'George Bellows would have approved these lithographs, large and richly drawn and dramatic, which conform so closely with the standard'.[55] Riggs's *On the Ropes* (cat. 54) is a virtual reprise of Bellows's earlier composition *A Stag at Sharkey's* (cat. 12); it was so popular that half the edition sold at the 1933 exhibition. Riggs's lithographs are strongly inflected by his background in commercial drawing, from which their heightened illustrative quality derives. Technically he departed from Bellows in working on the stone from dark to light as in a mezzotint, thereby intensifying the drama and emotion of his subject. But in his subject matter and its tenebrous handling Riggs represented a continuity of the darker strand in Bellows's work. He went on to produce lithographs of the marginal world of the circus, its clowns, trapeze artistes and tightrope walkers. In these works, and in the later *Psychopathic Ward* (cat. 55), another recapitulation of a Bellows theme (cat. 13), there is an overheightened realism that verges on the semi-satirical in its fascination with the grotesque. An artist who kept an impressive collection of snakes, alligators and other reptiles in his Philadelphia apartment, it is perhaps not surprising that Riggs should be so drawn to the fringes of American life.[56]

The Bellows legacy was pushed in different directions. The darker side of Bellows's work would lead to a disquieting surrealistic mode exemplified in the lithographs of John Ward McClellan. Still undeservedly little known, McClellan produced a group of enigmatic lithographs at Miller's workshop in New York. They show formally composed scenes of figures fleeing a picnic or the discovery of human bodies entrapped by giant mousetraps (cats 56 and 57). Evoking a silent, eerie world, his compositions are impossible to decode. Whereas a Bellows lithograph

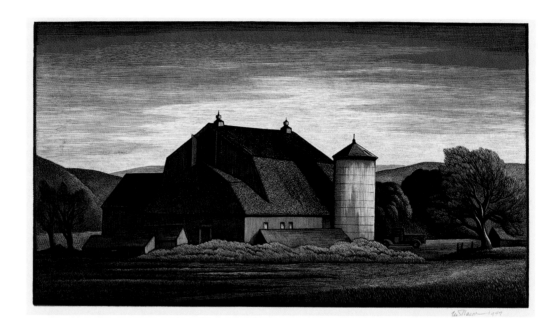

Fig. 5
Thomas W. Nason, *The Gambrel-Roofed Barn*, 1947,
wood-engraving with olive-green tone, 142 x 259 mm
(British Museum, P&D 2000,0930.14. Presented by Miles
Thistlethwaite in memory of Jane Hosford Thistlethwaite)

can be deciphered even at its darkest level, in the case of McClellan the
subjects remain genuinely enigmatic, a perplexity that is only enhanced
by their naturalistic depiction.

The semi-satirical side of Bellows, exemplified in his 1923 composi-
tion *Business Men's Bath* (cat. 16), would subsequently spill over into a
more exaggerated manner. This is clear in the lithographs of the prolific
Adolf Dehn, whose cartoon-like style captured the spirit of the jazz age
(cat. 59). Much of his time in the 1920s was spent either in Berlin, where
he befriended George Grosz, or in Paris, where he made many lithographs,
mostly of Montparnasse nightlife, at Atelier Desjobert. Carl Zigrosser
supported Dehn's zany lithographs and gave him an exhibition at the
Weyhe Gallery after his return to the United States in 1929. A compulsive
lithographer who produced well over six hundred prints of a largely
satirical character, Dehn also published a technical book, *How to Draw
and Print Lithographs*, in collaboration with the lithographic printer
Lawrence Barrett in 1950. By then, however, black-and-white lithographs
were out of fashion and there was no longer any market for Dehn's style of
newspaper cartoon drawing.

The satiric approach did not have to be confined to lithography. In the
1930s Fred Becker produced wildly expressive prints of jazz men (cat. 60)
playing their instruments which were executed in wood-engraving.
Becker's images relied on a white line against a deep black background to
evoke the lively, syncopated jazz rhythms. In the conservative world of the
traditional American wood-engravers such as Thomas W. Nason (fig. 5),

who specialized in quiet, rural landscapes, it was quite unexpected to find
Becker's sort of imagery in wood-engraving. His adoption of this technique
to depict the jazz *demi-monde* was made under the auspices of the New
York City WPA/FAP artists' relief programme, which Becker joined in 1935.
His wood-engravings were the only prints by a WPA/FAP artist to be
selected by Alfred Barr for the Museum of Modern Art's 1936 landmark
exhibition, 'Fantastic Art, Dada, Surrealism'.[57]

6 THE REGIONALISTS

During the 1930s the emphasis of the American Scene shifted from depic-
tions of metropolitan life to imagery of rural America. This alternative view
was a reaction to imported advanced European styles and attitudes that
had been gaining currency ever since the Armory Show of 1913. Known
as Regionalism, this movement sought its inspiration in the authenticity
attributed to the heartlands of rural America. Its principal exponents were
Thomas Hart Benton, John Steuart Curry and Grant Wood, all of whom
could speak with some authority as they had been born and bred in the
Midwest: Benton came from Missouri, Curry from Kansas and Wood from
Iowa, and all came from farming backgrounds. Their principal domain
was the Midwest, the great swathe of agrarian country stretching from the
western slopes of the Appalachians to the Rockies. Their subject matter
was the rural life of this vast region, its poor, hardworking families, the
routine of farming life, the horsemen and cattle ranchers, and the isolation

and the fecundity of the rolling prairies. The Regionalists were a reaction against East Coast urban cosmopolitanism, and found their voice during the Depression when the economic disaster compelled many Americans to turn to the heartlands and its folkloric traditions as standing for something uniquely American. Regionalism represented a rejection of internationalism and of outside European influences for an art that was singularly American. Thomas Hart Benton was its most articulate and aggressive spokesman. In his polemical book *An Artist in America*, first published in 1937 and revised in 1951, he stated:

> We were all in revolt against the unhappy effects which the Armory show of 1913 had had on American painting. We objected to the new Parisian aesthetics which was more and more turning art away from the living world of active men and women into an academic world of empty pattern. We wanted an American art which was not empty, and we believed that only by turning the formative processes of art back again to meaningful subject matter, in our cases specifically American subject matter, could we expect to get one.[58]

Paradoxically, all three artists had been exposed to European art early in their careers. Benton had studied in Paris before the First World War and on his return to America had flirted with different modernist styles, including the synchromist ('form through colour') style championed by fellow American painter Stanton MacDonald Wright. But he shortly renounced this route and from the early 1920s found his subject matter in the nonurban American Scene. Curry, who had worked as an illustrator of cowboy stories for the *Saturday Evening Post* and other magazines, spent a year in Paris in 1926–7 before returning to Westport, Connecticut, when he painted his first important Regionalist painting, *Baptism in Kansas*, (Whitney Museum of American Art, New York) in 1928. Wood's encounter with the works of Dürer and Hans Memling in Munich in 1928, with their hard, clear outlines and glowing colour, influenced him stylistically, as became apparent in his most iconic work *American Gothic* (Art Institute of Chicago), painted in 1930.

Benton established his career in New York as a painter of murals. His realist treatment of Regionalist themes provoked intense controversy in the New York art world where the abstractionists viewed him as an isolationist and a diehard reactionary. Although Benton was based in New York during this period and attracted many pupils, including Jackson Pollock, to his classes at the Art Students League, he found his subject matter by travelling extensively across the country, which he recorded in thousands of keenly observed drawings and sketches. In December 1934 *Time* magazine

published an article on Regionalism in which Benton, Curry and Wood were hailed as its leading advocates, and through the press they became known as the 'triumvirate' of Regionalism.[59] Wood only met Benton for the first time in 1934 and had his first solo exhibition at the Ferargil Gallery, New York in 1935, where Curry also had a solo exhibition the following year. But the persistent antagonism towards Benton from leftist groups, and the nationwide publicity that attended his work, prompted him to return permanently to his native Missouri in 1935 after he received an important mural commission for the Missouri State Capitol in Jefferson City. Curry likewise left the East Coast for his home state of Kansas, where he was offered major mural commissions for the Kansas State Capitol in Topeka in 1938. Following his return from Europe, Wood remained permanently in Iowa where he established the short-lived Stone City Art Colony, near his birthplace outside Anamosa, which he envisioned as a utopian community of Regionalism and where he first met Curry in 1933.

Although all three artists were based in the Midwest from the mid-1930s, they retained a close link to New York through their printmaking. They all produced lithographs for the enterprising publisher Associated American Artists, which had been established in 1934 as the brainchild of Reeves Lewenthal. Riding on the popularity of Regionalism, Lewenthal initially approached Benton, Curry, Wood and other artists including Dehn with the idea of producing affordable prints at low prices to a wide public. For a flat fee of $200 the artists would produce an etching or a lithograph in an edition of 250 to sell for $5 each in department stores across the country. To promote the scheme Lewenthal mounted an aggressive marketing campaign under the hard-sell tactic: 'How would you like to possess a genuine, signed original by Grant Wood, Thomas Benton, John Steuart Curry, George Biddle, Luigi Lucioni or any one of 56 other famous artists? Now you can … at a price that will seem incredible … only $5.00!'[60] This was a very different sales pitch from the traditional offer from print publishers and dealers who emphasized exclusivity and rarity. In keeping with the 1930s spirit of democratization in art, Associated American Artists (AAA) stressed the cheapness of its prints by leading popular American artists. Despite an initial discounting practice by some department stores and operating in a severely adverse economic climate, Lewenthal's scheme became a resounding commercial success when he established an effective system of distribution by mail order. Between 1934 and 1939 AAA published 329 editions of prints, and by 1949 the figure had reached over a thousand.[61] Many of these prints were lithographs by the Regionalists and were printed in New York by George Miller, which kept him in business during the 1930s.

Benton worked with Miller all his life, making some seventy-eight lithographs, which were often based on the compositions of his paintings and murals but also included studies for future paintings. The recapitulation of his themes in the form of lithographs drove home the Regionalist message to a wider public and served to reinforce its nostalgic appeal. His AAA lithograph *The Race* (cat. 63), a study for a later painting, presented a romanticized version of the prairie heartlands, evoking the age of steam trains rattling across the plains. Shortly after completing his nationally acclaimed Missouri State Capitol murals, Benton produced four large-scale lithographs based on the murals which included dramatizations of such folkloric subjects as *Frankie and Johnnie* (cat. 61), *Jesse James* and *Huck Finn*, which were distributed by AAA in editions of 100.

Grant Wood only produced nineteen lithographs between 1937 and 1940 prior to his premature death two years later. Whereas Benton and Curry both often worked on transfer papers, Wood preferred to draw directly on the stone, which the publisher Lewenthal arranged for his printer Miller to ship out to Iowa. The drawn stone was returned for Miller to etch and proof, with the results mailed to Wood for approval. Wood's lithograph *Sultry Night* (cat. 65), depicting a naked farmer cooling himself at the end of the day, incurred the charge of obscenity by the US Post Office authorities in 1939, which meant that as a banned article it could not be distributed through the post and AAA was forced to remove this print from its distribution list. In the end, instead of the regular edition of 250, only 100 impressions were printed which could only be purchased at the premises of the AAA gallery in New York.[62]

Like Benton and Wood, Curry worked with AAA throughout his career, producing over forty lithographs largely based on his paintings and murals. His most famous lithograph, *John Brown* (cat. 69), after his painting of the same year (Metropolitan Museum of Art, New York) which was derived from the *Tragic Prelude* mural for the Kansas State Capitol, presented the nineteenth-century anti-slavery campaigner as a thunderous champion of the oppressed, whose fiery message could raise the elemental forces of the midwestern tornado and prairie fire.

From today's standpoint it might be tempting to think of Regionalism as entirely a regressive tendency. But for Jackson Pollock, the son of a cattle ranch foreman in Wyoming, who had spent his early childhood moving around the rural west, an apprenticeship with Benton in New York must have seemed a natural starting point for his career. Pollock was inspired by Benton's example to produce a group of twelve Regionalist lithographs between 1934 and 1937. These were printed by Theodore Wahl, a printer working for the Federal Art Project, whom Pollock had befriended. Only one of these, *Stacking Hay* (cat. 64), was published in an edition, but

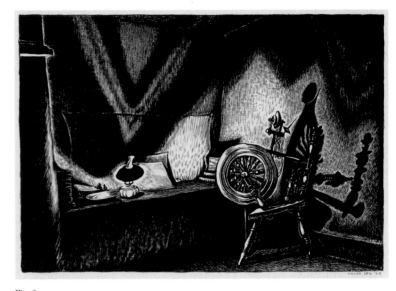

Fig. 6
Wanda Gág, *Evening*, 1928, lithograph, 206 x 303 mm
(British Museum, P&D 1967,1219.2. Presented by Carl Zigrosser)

not by AAA for whom Pollock would have been considered an artist still too unknown to warrant publishing.

Wanda Gág and Doris Lee represented a form of Regionalism which expressed the folksy and the homespun. Gág, originally from Minnesota, established herself at her ramshackle farmhouse, called 'Tumble Timbers' in Glen Gardner, New Jersey, where she produced many prints, primarily in lithography, with Miller serving as her printer from the start. Using a quirky, agitated line, she revelled in depicting haunted rustic interiors at night (fig. 6) or bizarre incidents on remote farms (cat. 72). Her work was supported by Carl Zigrosser at the Weyhe Gallery with regular exhibitions from 1926. Lee, who came from rural Illinois and settled in Woodstock, New York, in the Catskills Mountains, made her national reputation with *Thanksgiving*, 1935 (Art Institute of Chicago), a naïve painting of a traditional American theme, which won the Art Institute's Logan prize. Published by AAA, her lithographs of folksy rural life (cats 73 and 74) were close translations of her paintings. Her imagery remained popular into the 1950s long after Regionalism as a movement had receded into a backwater following the rise of Abstract Expressionism.

7 THE DEPRESSION AND THE WPA

After the boom years of the 1920s, the Great Wall Street Crash of October 1929 plunged the United States and the rest of the world into the most serious Depression the twentieth century was to experience. As in every

aspect of commercial life, the Depression seriously affected the art market and many artists suddenly found their livelihoods destroyed. This was particularly the case with those etchers like Martin Lewis who depended on the existence of a specialized collectors' market for their work. The collapse of the prestigious etching market from its high speculative status in the 1920s resulted in a complete loss of confidence in the print market.

In 1933 Franklin D. Roosevelt, the newly elected President, fulfilled his election promise of a New Deal programme of unemployment relief for the American people. Several programmes were initiated for the relief of artists among the different bureaucracies created under a vast programme of national reconstruction. The first of these was the Public Works of Art Project set up in 1933, when Stuart Davis was one of the first artists to register. This was followed by the creation of the Works Progress Administration (WPA) in 1935 and the setting up of a division within it called the Federal Art Project (FAP) in the same year. The FAP ran from August 1935 until it was wound up in June 1943, following America's entry into the Second World War. The estimated overall cost of running the FAP was about thirty-five million dollars and at its height just over five thousand artists were employed.[63] At its start, five regional directors were appointed to administer the Federal Art Project across the nation; Audrey McMahon was responsible for the largest, New York State, which included New York City as a separate entity, as well as New Jersey and, briefly, Philadelphia.[64]

The WPA Federal Art Project had a major impact on the revitalization of American printmaking. A Graphic Arts Division was established within the Federal Art Project and by 1936 the first workshop had been set up in New York City and was quickly followed by others in different parts of the United States; five were in New York and four in California, with Connecticut, Florida, Maryland, Michigan, Ohio and Pennsylvania each having its own print workshop.[65] The creation of these workshops set in train a huge production of prints. Artists were paid a modest wage of $23.86 a week to produce a specified number of prints each month in small editions of about twenty-five, with three impressions being allocated to the artist.[66] Distribution was guaranteed as the Federal Government placed these prints in public institutions such as hospitals, schools, libraries and courthouses to show the public benefit of its scheme. The subject matter of these works was intended to be socially meaningful and constraints were placed on artists on the content of their work. As most artists were deeply affected by the Depression, anything other than a socially conscious art in the 1930s seemed irrelevant. As Jacob Kainen, who joined the Graphic Arts Division of the New York City WPA/FAP in 1935, where he produced the lithograph *Rooming House* (cat. 80), later recalled: 'We were poor, foot-

loose, had never been anywhere, and had no prospects of going. The Depression had driven us to think of social change; in such an atmosphere a more than passing concern with aesthetics was tantamount to frivolity'.[67]

The Depression presented itself as a subject to artists in different ways. But urban and rural poverty, the plight of the African American and the working conditions in the Pennsylvania mines are themes that emerge most strongly in printmaking during the WPA period. The Philadelphia artist Julius Bloch became a national name when the First Lady, Eleanor Roosevelt, who championed social reform, chose his painting *The Young Worker* to be displayed in the White House.[68] His 1934 lithograph *The Prisoner* (cat. 75), showing a young manacled black prisoner appealing for deliverance, was based upon a painting he had produced while enrolled on the Public Works of Art Project; the British Museum's impression of this print is dedicated in gratitude to Mrs Roosevelt. At the age of twenty Blanche Grambs, who had trained with the leftist printmaker Harold Sternberg at the Art Students League, was one of the youngest artists to join the New York City WPA/FAP in 1936. That year she accompanied Sternberg to the mining town of Lanceford, Pennsylvania, which resulted in a group of gritty aquatints recording the grim, dangerous conditions of the mines and the physical hardships of the miners (cat. 79); these were printed and published by the New York City WPA/FAP. Prints such as these were intended as vehicles to effect social change by raising public consciousness.

In the stimulating environment of the New Deal patronage of printmaking, experimentation and the development of new print techniques were encouraged to further the aims of the WPA. In New York City colour lithography was introduced from 1937 at the workshop of the Federal Art Project at 39th Street under the guidance of Gustave von Groschwitz and with the technical assistance of the Cleveland lithographer Russell Limbach.[69] For the first time artists could readily make colour prints in lithography, a demanding and complex process which required multiple stones for each print, and one which was prohibitively expensive within the workshop of George Miller and other trade lithographers but now open to artists at the Federal Art Project through the support of the WPA. Leonard Pytlak, Jacob Kainen (fig. 7) and Stuart Davis were among the many WPA/FAP artists to make their first colour lithographs at the Federal Art Project workshop; Pytlak exploited the technique to express the realist theme of urban loneliness in New York in his print *Uptown* (cat. 86).

In Philadelphia the carborundum print was developed from late 1937 at the Fine Print Workshop run by the Philadelphia WPA/FAP, which opened its doors to African Americans. The three artists responsible for developing the carborundum print were Dox Thrash, the first African American to join the Philadelphia workshop, Hugh Mesibov and Michael J.

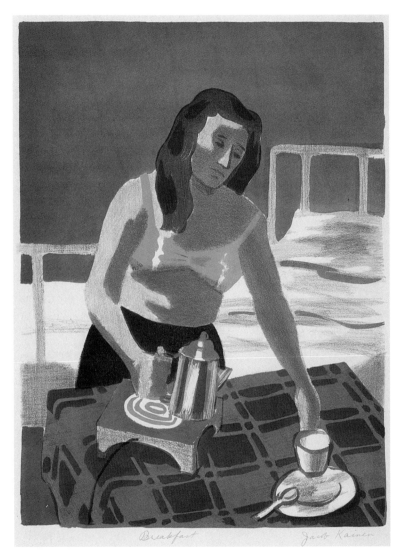

Fig. 7
Jacob Kainen, *Breakfast*, 1938, colour lithograph, printed under the auspices of the New York City WPA Federal Art Project, 350 x 261mm
(British Museum, P&D 1984,0331.8. Presented by the artist)

Gallagher.[70] Other artists to become involved included Gerardo Belfiore, and their subject matter focused on mining and urban themes (cat. 78). The technique involved grinding the metal plate with carborundum grains, the trade name for carbide silicon, to produce tonal prints that resembled mezzotints. Further developments of this intaglio technique went into colour (cat. 98). The Federal Art Project promoted the carborundum print through WPA/FAP exhibitions organized in Washington, DC in 1938 and in Philadelphia, where the first exhibition devoted entirely to this technique was held in 1940. But the carborundum print would always remain a short-

lived experiment, which was largely restricted to Philadelphia, and it never gained the appeal of either colour lithography or the colour screenprint, which first emerged as a fine art technique in the much larger workshops of the New York City WPA/FAP.

Of all the print techniques promoted by the WPA/FAP the screenprint was to have the most far-reaching consequences for American printmaking.[71] Until the 1930s this twentieth-century technique had been used for commercial work for advertising, showcards and posters. It was Anthony Velonis, an employee of the Poster Division of the New York City WPA/FAP, who pioneered its development as a fine art medium by persuading the Federal Art Project to establish a Silk Screen Unit under the auspices of the Graphic Arts Division of the New York City WPA/FAP in 1938. Among the artists to whom Velonis introduced the technique of screenprinting were Pytlak, Harry Gottlieb, Hananiah Harari and others, such as Edward Landon and Robert Gwathmey, who had contact with the Silk Screen Unit. Velonis wrote the first technical booklet for artists entitled *Technical Problems of the Artist – Technique of the Silk Screen Process*, which the WPA/FAP published in 1938. Unlike the carborundum print which never received more attention than a technical bulletin issued by the WPA/FAP in 1940, which went into a second printing, the screenprint quickly took on, and other artists such as Harry Sternberg, Max Arthur Cohn and Harry Shokler also published influential textbooks on the technique.[72]

In 1938 the first solo exhibition of screenprints was given to the pioneer Guy Maccoy, who had been making artistic screenprints since 1932. In March 1940 the art critic and writer Elizabeth McCausland, assisted by Landon, organized at the Springfield Museum of Fine Arts, Springfield, Massachusetts, the first group exhibition of screenprints, many of which had been made through Velonis's Silk Screen Unit. In the same month Carl Zigrosser held an exhibition at the Weyhe Gallery in New York billed as the 'First Exhibition of Silk Screen Stencil Prints'. It was Zigrosser who coined the term 'serigraph' (from the classical roots for 'silk' and 'drawing') to distinguish artistic screenprints from their commercial counterparts. In 1941, after taking up his appointment as Curator of Prints at the Philadelphia Museum of Art, he published the first historical account of the new technique in the pages of *The Print Collector's Quarterly*, signalling to collectors the importance of this new technique.[73] Zigrosser prophesied that

the serigraph will have for the twentieth century the significance and potentiality that the lithograph had for the nineteenth century … The new medium is barely three years old. With the active interest displayed in it by the artists, and the momentum it has gathered in

exhibitions and with the public, it seems hardly likely that serigraphy is a flash in the pan. It is an American contribution to the progress of the graphic arts.[74]

Many early practitioners of the screenprint used the glue-and-tusche method of making a stencil to produce painterly compositions of American Scene subject matter, such as Shokler's *Coney Island* (cat. 89), or Regionalist themes like Max Arthur Cohn's *Wheatfield Harvest* (fig. 8). But the use of hand-cut stencils was particularly well suited to artists such as Robert Gwathmey in *The Hitchhiker*, 1937 (cat. 83), made after an earlier painting, or Edward Landon in his 1942 abstraction *Counterpoint* (cat. 90), who both employed the technique to achieve flat planes of colour and hard edges in their simplified compositions. Gwathmey and Landon were among the founders of the National Serigraph Society in 1944, which had grown out of the Silk Screen Group established four years earlier. Writing in 1946, fellow member Shokler could claim that, under the auspices of the National Serigraph Society and its earlier Silk Screen Group, three hundred exhibitions of the screenprint had been sent out over the past six

years across the United States and beyond to Canada, Hawaii, Cuba, South America and even the Soviet Union.[75] The Society's dynamism under its director Doris Meltzer, who also ran the associated Serigraph Gallery from the Society's headquarters in New York from 1945, greatly contributed to the promotion of the screenprint as a fine art print technique.[76]

After the Second World War the US government, as part of its post-war reconstruction programme, sent exhibitions of screenprints as gestures of goodwill for display in US Information Centers in Germany, Austria and Japan; others were toured through various government agencies in Scandinavia, Czechoslovakia and other European countries, very often with the assistance of the National Serigraph Society.[77] Doubling as propaganda vehicles, these educational exhibitions promoted the screenprint abroad as an American technique well into the 1950s. While these government-sponsored initiatives were taking place overseas, the technique was largely ignored by the abstract expressionist pioneers in America, and although Pollock was to make a set of monochrome screenprints in 1951, it was not until the emergence of Pop Art in the early 1960s that screenprinting would once more claim the serious attention of artists.

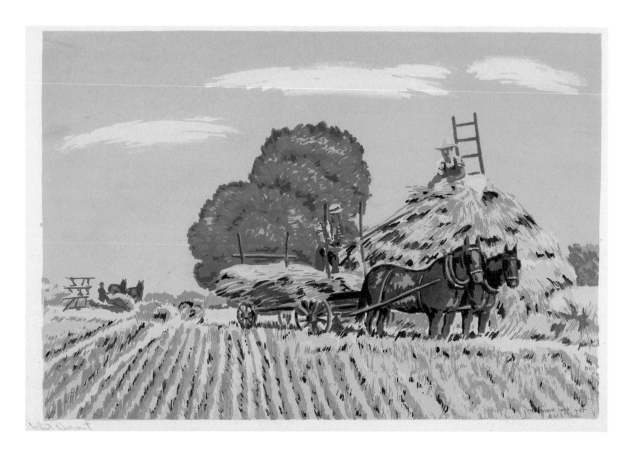

Fig. 8
Max Arthur Cohn, *Wheatfield Harvest*, 1935, colour screenprint, 304 x 450 mm (British Museum, P&D 2001,0930.2. Presented by Jane Waldbaum and Steve Morse through the American Friends of the British Museum)

8 ARTISTS OF THE LEFT AND THE SECOND WORLD WAR

The politics arising from the Depression often led to bitter divisions among artists; between those who argued for an isolationist agenda such as the Regionalists, those who were committed to a socially conscious art that could be an instrument for change, and those who continued to embrace European modernism.[78] Artists became politically organized during this period, with the Artists' Union attracting a growing membership from those involved on the WPA/FAP programme. When several of the New York City Projects, including the Federal Art Project, suffered budget cuts in November 1936, with the sacking of nearly four thousand employees, the Artists' Union protested by taking direct action and occupied the headquarters of the FAP, leading to violent clashes with the police and the arrest of some 219 artists, including Blanche Grambs.[79] Stuart Davis, who was a founding member of the American Artists' Congress, and its secretary (1936–8) and then chairman (1938–40), served as the polemical editor of its publication *Art Front* between 1935 and 1936, where he regularly sent up the Regionalists as reactionaries and the FAP administrators as self-seeking officials for their jibes at artists' self-importance. In 1936 Davis addressed the First American Artists' Congress, claiming that artists had become more politically assertive as a result of the Depression and that the members of the Artists' Union had been responsible for this change by 'their insistence on a democratic extension of government support to young and unknown artists [that] has brought a vast variety of talent completely ignored by private patronage and commercial galleries'.[80]

A further impetus to political change was prompted by the work of the Mexican muralists, notably by the three most important artists Diego Rivera, José Clemente Orozco and David Alfaro Siqueiros. The Mexicans are referred to here in the context of political printmaking in the United States but their work requires a separate story.[81] Their murals in Mexico City glorified the revolutionary struggle in Mexico and from the 1920s many artists from America came to see these works *in situ*. There was a constant interplay between Mexican artists going to the United States and American artists making visits to Mexico. Visiting American artists were enormously varied in their responses to Mexico: from Howard Cook with his Mexican woodcut scenes in the early 1930s to Josef Albers who made the first of fourteen visits in 1935, when he declared to Kandinsky: 'Mexico is truly the promised land of abstract art',[82] and the woodcut artist Misch Kohn who worked at the radical printmakers' collective *Taller de Grafica Popular* in Mexico City in 1944. From the late 1920s and early 1930s many of the Mexicans made lithographs as a means of disseminating the images from their murals to a wider audience in America. Orozco's early prints

Fig. 9
José Clemente Orozco, *The Masses*, also known as *Note I*, 1935, lithograph, produced in Mexico, 325 x 423 mm
(British Museum, P&D 1999,1031.2. Presented by Dave and Reba Williams through the American Friends of the British Museum)

were printed in New York by George Miller, and after his return to Mexico in 1934 Orozco continued to make political lithographs like *The Masses* (fig. 9) which were distributed by the Weyhe Gallery in New York. The circulation of such inflammatory images acted as a spur to printmakers in America.

The rise of Fascism in Europe during the 1930s provoked fierce debate among artists whether or not to become politically engaged. Artists with left-wing sympathies argued for involvement in European politics following the outbreak of the Spanish Civil War in 1936. This came to a critical point after the bombing of the Basque town of Guernica by Nazi warplanes acting on behalf of the Spanish dictator General Franco. This atrocity on 26 April 1937 provoked universal outrage and became a symbol of the political urgency to oppose Fascism. Picasso's political masterpiece *Guernica* and his caricatural etchings *The Dream and Lie of Franco* produced in reaction to this tragedy became a rallying call to politically engaged artists in America. Joseph Vogel, who had volunteered to fight in Spain for the Republican cause with the Abraham Lincoln Brigade in 1937, produced the lithographs *The Innocents*, *c*.1938–9 (cat. 95) and *Vision No. 2*, *c*.1939 (cat. 96); the political anguish of this period is expressed through their use of abstract and surrealist imagery. Other artists

concerned by the disturbing political events unfolding in Europe included Werner Drewes, whose 1934 linocut *It Can't Happen Here* (cat. 94) displaying a distorted swastika, served as a wake-up call to America from an artist who had left Germany even before the Nazis came to power.

Support by artists for the Communist Party in the United States became more pronounced during the 1930s as the threat of Fascism in Europe grew. Hugo Gellert had been involved with the Communist Party from the 1920s. A co-founder of the socialist radical magazine *New Masses* in 1926, he had later produced a series of lithographs at Desjobert's atelier in Paris entitled *Karl Marx Capital in Pictures.* As he later stated, 'to me, life and art are inseparable. Being an artist and being a communist are one and the same. One is as important as the other'.[83] With the outbreak of war in Europe in 1939 the situation became fraught between those artists who argued for America's involvement in the war and those who wanted to preserve the government's isolationist stance. This political view was also argued in terms of a polarity between socially engaged realist art and modernist abstraction shorn of any political content. Joseph Leboit, who had worked for the *New Masses* and *Art Front* magazines, satirized this dilemma in his 1940 WPA/FAP etching entitled *Tranquillity* (cat. 104) showing a gas-masked artist placidly painting an abstract composition while warplanes swarm over devastated buildings outside the studio window.

After the bombing of Pearl Harbor by the Japanese on 7 December 1941, America entered the war and the whole political landscape changed. One major consequence was the accelerated winding down of the WPA programme until its official demise in 1943, a process that had already begun in 1939 when funding was transferred from the federal to the state level, as resources were channelled into the war effort. The response from artists was to fall in with this. By January 1942 they had mobilized themselves into the central organization Artists for Victory, Inc., whose stated mission was 'to render effective the talents and abilities of artists in the prosecution of World War II and the protection of this country'.[84] Its membership by 1943 had reached over ten thousand artists, including painters, sculptors, designers and printmakers. As well as serving as a liaison organization between government agencies and artists, Artists for Victory organized a major open exhibition of more than 1,500 works of art of all types at the Metropolitan Museum of Art to mark the first anniversary of Pearl Harbor in December 1942.

The following year a more focused campaign was launched by Artists for Victory for a juried exhibition of patriotic prints entitled 'America in the War'. Organized by Joseph Leboit, head of the Graphics Committee, the exhibition was restricted to 100 prints by 100 artists adjudicated by two artists, William Gropper and the etcher Armin Landeck, and the

curator Carl Zigrosser. Leboit invited artists to contribute, stating in the prospectus: 'The theme, "America in the War", should be interpreted in its broadest sense, so that the exhibition when assembled becomes a picture of America in 1943, of a country and a people in their second year of war'.[85] On 20 October 1943 the exhibition opened simultaneously in twenty-six museums and galleries across the United States; these included the Cleveland Museum of Art and the Print Club of Philadelphia. The prints, produced in editions of 100, were available for purchase and a range of prizes were awarded within the four printmaking categories of intaglio, relief, lithography and the newcomer, screenprinting, of which fourteen examples were chosen. Almost a third of the contributors were women artists, including the Communist Jolán Gross Bettelheim, whose patriotic *Home Front* (cat. 100) extolled the women workers in the ammunition factories. The 'America in the War' exhibition proved a resounding patriotic success, with press coverage from fifty newspapers, nine magazines and three radio stations during its one-month exposure.[86] A complete set of the prints was subsequently presented by Artists for Victory, Inc., to the Library of Congress as a permanent record of this achievement.

The government-sponsored Artists for Victory initiative inspired artists all over America to take up the patriotic call. In 1943 Benton Spruance produced two complementary images of the war effort, both lithographs, one of civilians who have signed up for the home front as politically engaged citizens (cat. 107); the other, entitled *Riders of the Apocalypse* (cat. 106), depicting the overwhelming power of the American bombers.

A more politically committed left-wing organization than Artists for Victory, Inc. was the Victory Workshop, which had been set up by the Artists' League of America in 1942. The artist Charles Keller, a lifelong Communist of independent means, who had joined the Communist Party USA in 1940, was placed in charge of the Victory Workshop as its executive secretary and produced patriotic screenprints (cat. 102) at the Workshop until 1945, when at the end of the war its purpose had been fulfilled.[87] It reformed as the Graphic Workshop and in 1948 issued two print folios, *Yes, the People!* and *Negro USA*, before it broke up three years later under pressure from the FBI.

After the Second World War America emerged as a superpower in a new atomic age, and the Soviet Union, its former ally during the war, was now its deepest enemy. In the hardening climate of the Cold War artists of the left who had been ardent supporters of the national war effort found themselves blacklisted as a potential fifth column. Hananiah Harari, who had been an active member of the Artists' Union and the American Artists' Congress during the 1930s, found himself targeted by Senator Joseph McCarthy's House Un-American Activities Committee for his satirical

illustrations to the magazine *New Masses*. Gwathmey had won first prize in serigraphy for *Rural Home Front*, his depiction of the rural underclass, in the 'America in the War' exhibition sponsored by Artists for Victory. However, eight years later, in 1951, he was denounced as a 'concealed Communist' to the FBI and placed under open surveillance, as particular suspicion attached to his defense of 'the rights of Negroes' and his association with Paul Robeson, who had written an introduction to the catalogue of his 1946 exhibition.[88] While Gwathmey persevered with his social realist themes during the 1950s, Jacob Kainen, who had taken up a museum post in Washington, DC during the war, broke his ties with the political left in New York and began to adopt abstraction from 1949. Nevertheless, his earlier political involvement with the Left during the 1930s brought him under suspicion and three times he was called before McCarthy's Committee between 1948 and 1954. Ostracized for her known Communist affiliations, Jolán Gross Bettelheim felt no alternative but to return to her native Hungary in 1956, on the eve of the uprising.[89] Keller, who became art editor of *New Masses* from 1945 until it folded three years later, suffered under McCarthyism in the post-war period, and his confiscated passport was only returned to him in 1960.

9 JOSEF ALBERS AND GEOMETRIC ABSTRACTION

While the main themes of the 1930s were the Depression and the politics of the period leading up to the Second World War, other elements in American printmaking continued. One of these was geometric abstraction, which found its expression through émigré artists, the most influential of whom was Josef Albers. Abstraction had been a huge success as an avant-garde movement in Europe during the 1920s and 1930s. Its suppression as a 'degenerate art' in Germany by the Nazis after they came to power in 1933, and the persecution of those who were Jewish as well as those artists who subscribed to abstraction, made it impossible for some artists to remain.

Albers had trained and lectured at the Bauhaus from 1920. He had gone there as a student at the newly opened institution in Weimar, which had been established by Walter Gropius as a pioneering school for modern art and industrial design. At the Bauhaus, first in Weimar and then at Dessau where the school moved in 1925, and finally to Berlin in 1932, Albers proved to be an innovative teacher on the compulsory foundation course which introduced students to materials, techniques and design, including photography, graphic design and typography. He was also experimental in his use of unconventional materials such as sandblasted glass to create his abstract compositions. Although the Bauhaus taught print-

making and ran a print workshop, Albers made no prints during his thirteen years there. It was only after the Nazis forcibly shut down the Bauhaus in Berlin and dismissed all the staff in July 1933 that Albers again took up printmaking. Whereas his pre-Bauhaus prints in linocut and lithography followed a figurative expressionist tendency, the prints made immediately after his dismissal were uncompromisingly abstract and geometric. These works in linocut and woodcut were printed privately on the presses of his wife's family publishing establishment in Berlin.[90]

Shortly afterwards Albers was invited to the United States to set up an art department at Black Mountain College, near Asheville, North Carolina, a rural liberal arts college which had been established in the same year the Bauhaus was shut down. At Black Mountain he was asked to employ the same innovative and experimental approach that he had used at the Bauhaus. Albers and his wife Anni, a textile artist who had taught in the weaving workshop at the Bauhaus, where she had previously been a student, arrived at Black Mountain College at the end of 1933 and remained there until 1949. Through his teaching and example Albers transmitted Bauhaus principles and philosophy to America. His presence at Black Mountain made it a mecca for other artists to teach there at the summer schools from 1944; these included Robert Motherwell, Willem de Kooning, John Cage and Merce Cunningham. Even after Albers had resigned in 1949, following a bitter dispute over the future direction of the college, Black Mountain continued to maintain its reputation as a place for experimentation and unfettered creativity, attracting students such as Robert Rauschenberg and Kenneth Noland, until a lack of funds forced it to close in 1957.

True to his Bauhaus principles Albers advocated a rigorous geometric abstraction in his printmaking. In 1934, the year following his arrival at Black Mountain College, Albers produced the linocuts *i* (cat. 109) and *Segments* (cat. 110), which presented a seamless continuation from the 'degenerate' geometric abstract prints he had made in Germany before leaving. In the absence of any professional workshop in North Carolina, or indeed any access to WPA Federal Art Project facilities, Albers pulled his first prints in America on the small hand-presses used at Black Mountain College to crank out its flyers and leaflets. In the 1940s he turned to a local firm of commercial printers to pull his prints. These included the relief prints *Inscribed* (cat. 111) and *Involute* (cat. 112), made in 1944, which Albers had produced from the unconventional material of cork. His prints exploited the natural grain of the material, whether wood, linoleum or cork, as a pictorial element in his rigorously abstract designs. In the 1950s he was to make geometric inkless intaglio prints, but it was not until the early 1960s, when he was invited to the Tamarind Lithography Workshop

in Los Angeles, that he worked with a professional workshop for the first time. By then Albers was an emeritus professor at Yale University, where he had held the chair in the Department of Design from 1950, after leaving Black Mountain College. His teachings at Yale on colour and design inspired a generation of his own students and would lead to the publication of his highly influential book *The Interaction of Color* in 1963.

Besides Albers, other abstractionists made a career in the United States. Harry Bertoia arrived in Detroit via Canada with his father from his native Italy in 1930. As a student at the innovative Cranbrook Academy of Art in Bloomfield Hills, Michigan, his jewellery designs attracted the attention of Eliel Saarinen, the Finnish architect and school founder, who put him in charge of the school's metalwork workshop where he taught from 1937 to 1942. At the same time he began to make geometrically abstract monotypes and continued to do so while pursuing his career as a designer and sculptor. He worked with fellow Cranbrook student Charles Eames, the furniture designer, in Los Angeles on moulded plywood chairs, before taking up an appointment as the designer for Knoll Associates in Pennsylvania where he produced his famous wire-framed Bertoia chair in the early 1950s. His work attracted the attention of Albers, who recommended him to the post of visiting critic in sculpture at Yale in 1953–4.

Monotypes and metalwork designs were inseparable in Bertoia's thinking. As he wrote in 1961, 'Metals and graphics have held an equal interest for me … To do one, then the other, is refreshing and stimulating, and one medium can do what the other could not. Yet at times they merge into a single image'.[91] The importance of his abstract work in monotype was recognized in New York when the Museum of Non-Objective Painting, the forerunner of the Guggenheim Museum, showed examples from its collection of more than one hundred recently purchased Bertoia monotypes at its 1943 survey exhibition of non-objective art by American artists. The interest of Bertoia, Eames and Eero Saarinen, the son of Eliel Saarinen, in industrial design and architecture was in line with Bauhaus thinking. This had been consolidated with the setting up of the New Bauhaus in Chicago in 1937 and its successor, the School of Design, a year later under the former Bauhaus teacher László Moholy-Nagy, who remained the School's head until his death in 1946. Moholy-Nagy was joined in Chicago in 1938 by the former Bauhaus teacher Mies van der Rohe, who was appointed director of the architecture school at the Armour Institute of Technology, where he stayed for the next twenty years. Like Albers, Moholy-Nagy and Mies van der Rohe were very influential in advocating European geometric abstraction and the industrial machine aesthetic.

10 S.W. HAYTER AND ATELIER 17 IN NEW YORK

The next wave of European ideas to infiltrate American art came with the arrival in New York of the émigrés displaced by the outbreak of the Second World War. They brought with them a new language and vocabulary to express the most up-to-date forms of the Paris avant-garde. Abstract surrealism was its most significant manifestation, and the Englishman Stanley William Hayter was the catalyst for the transmission of these ideas to printmaking in America. Hayter, who had a scientific background in chemistry and geology before switching to art and printmaking, had run a successful collaborative print workshop in Paris known as Atelier 17 from its address at 17 rue Campagne-Première. From 1933 it had served as a vibrant centre for experimentation in engraving and other forms of intaglio printmaking where it attracted a cosmopolitan and international group of artists, many of whom were surrealists.

After the outbreak of war Hayter left Paris and arrived in the United States, via a short stay in England, in 1940. Following a brief period teaching at the California School of Fine Arts in San Francisco, Hayter re-established his Atelier 17 in New York at the New School for Social Research in the autumn of 1940. It subsequently moved to a larger, independent space at 41 East 8th Street in 1945. Hayter's magnetic personality, immense energy and cosmopolitan outlook immediately drew the émigré artists to the new Atelier 17; among them were the Paris surrealists Max Ernst, Yves Tanguy, André Masson, Miró and Jacques Lipchitz. Hayter was the ideal conduit for transmitting to America surrealist ideas of automatism and the exploration of the subconscious, which he championed through engraving. He knew the European émigrés personally from Paris and his Atelier 17 served as a social and intellectual centre for the displaced artists in which printmaking became the focus around which they gravitated. This stimulating atmosphere and the collaborative environment in which printmaking took place acted as a magnet to the emerging young American artists Jackson Pollock, Willem de Kooning and Robert Motherwell, who would shortly dominate the New York avant-garde.[92]

After seeing Hayter's automatist engravings (fig. 10) Pollock made eleven intaglio prints at Atelier 17 between 1944 and 1945. From Hayter he learnt how to use the burin to engrave on copper his automatist drawings inspired by Jungian psychoanalysis. His spontaneous, all-over, web-like compositions on the plate (cats 119–22) foreshadow the abstract expressionist paintings he would produce by the late 1940s. Pollock's prints made at Atelier 17 remained very much experiments, in some cases worked on both sides of the metal plate out of economic necessity. They were only pulled as trial proofs and it was not until after his death, when the plates

were rediscovered, that a posthumous edition of fifty was eventually published by the Museum of Modern Art in 1967.

Other American artists who experimented with intaglio printmaking at Atelier 17 included sculptors Alexander Calder and Louise Bourgeois. Calder had become close friends with Hayter in Paris during the 1930s, where he had made intaglio prints, and it was only natural that he should return to making prints at Atelier 17 in New York. There he produced his abstract surrealist soft-ground etching *The Big I* (cat. 123), one of his best-known prints. The Paris-born Louise Bourgeois came to the United States in 1938, shortly after marrying the American art historian Robert Goldwater, but only began to work at Atelier 17 from 1946 to 1948. There she made her most important suite of nine engravings, *He Disappeared into Complete Silence* (cats 124–32), which was accompanied by her own parables. These, like the prints themselves, expressed her feelings of loneliness, fear and isolation. In a period of intense activity Bourgeois reworked the plates in many states, using engraving as a means of ridding herself of personal anxieties and emotional turmoil. Although she intended to produce this suite as an artist's book, it was not until the 1980s that the publication was assembled from the engravings printed at Atelier 17 and the text sheets printed by the Gemor Press in the late 1940s. Despite her fraught working relationship with Hayter, whom she later described as 'a printer-perfectionist [whose] impatience came because very few people had the control of the hand' in the use of the burin, she did not continue with printmaking after his return to Paris in 1950.[93] Instead she concentrated on her sculpture and only resumed printmaking in the 1970s.

The experimentation and technical innovations at Atelier 17 were introduced to a wider public at the Museum of Modern Art's landmark exhibition entitled 'Hayter and Studio 17: New Directions in Gravure' which opened in 1944 and included Calder's *The Big I*. This exhibition was later shown in venues across the United States and Latin America over the following two years and helped to disseminate the new ideas of abstract surrealism in engraving. Hayter's thinking and practice were brought together in his highly influential book *New Ways of Gravure*, first published in 1949. His various techniques of engraving, the use of soft-ground textures and his innovative method of simultaneous colour printing from a single plate using both intaglio and surface inking, which he had first fully developed in his 1946 intaglio print *Cinq Personnages* (cat. 117), were lucidly addressed to the novice and the professional alike as 'a very valuable medium for original expression'.[94]

After Hayter returned to Paris in 1950 to set up Atelier 17 for the third time, the New York workshop continued to function under the direction of his follower Peter Grippe for the next few years. Among the artists

Fig. 10
S.W. Hayter, *Combat*, 1936, engraving, 400 x 500 mm
(British Museum, P&D 1973,0414.5)

who came to make prints there before its closure in 1955 was Dorothy Dehner (cat. 142). The most important project initiated under Peter Grippe was the portfolio *21 Etchings and Poems*, an ambitious collaboration between painters and poets begun in 1951, which was only published nine years later by the Morris Gallery in New York. Among the contributing artists were the abstract expressionists De Kooning (cat. 145) and Franz Kline (cat. 146), as well as Hayter and his former assistants Fred Becker, one of his first American students, and Peter Grippe.

One side of Hayter's legacy in the United States was the emergence of a new academicism in which an emphasis was placed on the 'cuisine' of printmaking, its technical procedures and accomplishments. A number of Hayter's followers at Atelier 17 in the 1940s were subsequently appointed to teaching positions as artist-instructors at newly opened printmaking facilities on university campuses: the Argentinian Mauricio Lasansky taught for decades at the State University of Iowa from 1945; the Hungarian émigré Gabor Peterdi at Hunter College, New York, during the 1950s and then at Yale University from 1960 to 1987; while Fred Becker, founder of the printmaking department at Washington University in St Louis in 1948, was based there for the next twenty years. Their teaching within an academic environment ensured the continuation of Hayter's precepts as the new orthodoxy; it came to dominate the practice

of printmaking in America during the 1950s before, in turn, being over-taken by the print workshop publishers a decade later.

11 THE POST-WAR WOODCUT

Another development in printmaking that took place in the immediate post-war years was the resurgence of the woodcut. As Carl Schniewind, Curator of Prints and Drawings at the Art Institute of Chicago, observed in 1949, 'In the United States the woodcut has not yet reached general popularity, but there is every indication that artists are becoming more and more interested in this important graphic medium'.[95] After the devastation of the Second World War and the horrors of the Holocaust it was perhaps not surprising that the woodcut and Expressionism should be considered the appropriate vehicles to express suffering and loss. This was particularly the case among artists like Misch Kohn and Leonard Baskin, who came from a humanistic Jewish background. They continued an expressive, figurative tradition in black and white which resisted the trend towards a predominantly abstract expressionistic mode among the post-war generation of the New York avant-garde. Both artists sought to respond to the terrible loss of human life during the Second World War by insisting on the human image. The threat of nuclear annihilation during the years of the Cold War gave an added urgency to their depiction of the human figure. To their minds the human figure was now also threatened with artistic extinction by abstraction.

Misch Kohn came from Chicago where his wife's family had been among the last Jews able to leave Germany. His large-scale woodcuts, such as *Death Rides a Dark Horse* (fig. 11), produced in 1949, were apocalyptic in theme. They drew upon a long-standing northern European tradition coupled with his own experience of working in the *Taller de Grafica Popular* print workshop in Mexico City in the mid-1940s, where the Day of the Dead popular prints were reprinted.[96]

Leonard Baskin, the son of a rabbi in Brooklyn, made his monumental woodcuts after seeing Gothic sculpture in Europe after the war. His life-size *Man of Peace* (cat. 136), produced in 1952, became one of the most famous images of the 1950s as it seemed to encapsulate the bitter mood of despair provoked by the ideological divisions of the Cold War. His horrific vision of mankind following a nuclear holocaust was expressed in the burnt and flayed human figure of *The Hydrogen Man* (cat. 137) made two years later. Baskin compared his series of twelve life-size figurative woodcuts, all of which were hand-printed, to 'a kind of ambulatory mural. They are insistently black, complexly cut, and reasonably successful in causing alarm, misgivings, and exaltation ... I should say that the mastodon wood-

Fig. 11
Misch Kohn, *Death Rides a Dark Horse*, 1949, wood-engraving, 555 x 400 mm
(British Museum, P&D 1998,1108.17. Presented by the artist)

cuts are the capital achievement of my printmaking activity. Imbedded in those twelve blocks are the traces of my tangled vision'.[97]

Baskin and Kohn represent the emphatically figurative strand in the post-war woodcut which depended on the sharp contrasts of black and white and a complex web of lines to express their heightened emotion. But there was a second, more influential strand to the woodcut dynamic which was abstract in form and which obtained its effect through rich and luminous colour. An early exponent was Louis Schanker, who from 1943 taught classes in woodcut at the small printmaking studio of the New School for

Social Research, where for a brief period Hayter's Atelier 17 shared the same facilities until it moved to its own premises in Greenwich Village in 1945. Schanker and Hayter both became involved with finding inventive ways of working the surface of the metal plate or the wood block to obtain expressive textured effects. As Schanker explained, 'Traditional tools are no longer sufficient … anything which can be used to "mar" the surface of the wood is legitimate as a tool. This offers endless possibilities. Ordinary wire screening forced into the wood will, of course, provide a particularly ingratiating texture, almost a patina …'.[98] Wire brushes and rasps, as well as the usual knives and gouges, were used to work the block to create his abstract woodcuts of the 1940s, such as *Hand Ball Players* (fig. 12). His prints were concerned with movement and the handling of space through simplified dynamic forms and the use of bold colour as an integral part of the composition.

Schanker's experimental attitude to the woodcut attracted the attention of other artists such as Anne Ryan. An American novelist and poet who had only come to art in 1938 when she was almost fifty, Ryan first began to make engravings at Hayter's Atelier 17 in the New School for Social Research, where she became a close friend of the European émigré artists. She learnt the colour woodcut from Schanker, whose classes at the New School for Social Research she joined in 1945 and very quickly demonstrated her mastery of the technique in her woodcuts of abstract form and colour (cat. 133). Unlike her teacher, who continued to use several blocks, Ryan made her colour prints by inking and overprinting the same block of cheap plywood to build up layers of rich colour. She used both opaque oil paints and thin glazes which gave her prints their striking effect; this was enhanced by the black paper on which they were printed and which came from recycled photographic wrapping sheets. Ryan made more than a hundred prints in four years before abandoning the woodcut altogether by the end of 1949, when, after seeing a Kurt Schwitters exhibition, small collages from fabric and paper became her primary means of expression.

Leonard Nelson had also worked at Hayter's Atelier 17 in the mid-1940s, making engravings before turning to the woodcut. He had been taken up by Peggy Guggenheim at her Art of This Century Gallery from the early 1940s, and then by Betty Parsons who was showing the emergent abstract expressionist painters at her gallery from 1946. But in 1948 Nelson cut all ties with Parsons and the avant-garde New York School and returned to Philadelphia, where he concentrated on painting and making woodcuts that explored the primitivistic and the collective unconscious. His hieroglyphic woodcuts (cat. 134) were inspired by the ancient cultures of Mexico which he first visited in the mid-1940s and later, Haiti.

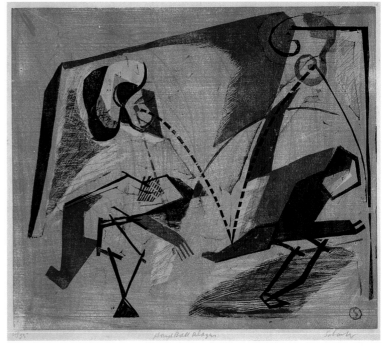

Fig. 12
Louis Schanker, *Hand Ball Players*, 1942, colour woodcut, 302 x 355 mm
(British Museum, P&D 1981,0725.17)

The artist who exerted the strongest influence on the colour woodcut in the post-war years came from outside America. Latvian-born Adja Yunkers had spent the years after the Bolshevik Revolution of 1917 wandering across Europe, to Cuba and Mexico, and most recently in Scandinavia, before a disastrous studio fire in Stockholm precipitated his departure for the United States in 1947. 'My history begins with my arrival in the U.S.A.', he declared. 'I have never before worked so constantly and strenuously as in this country. Why? Very simply because the enthusiasm, the freshness, and the openness of American art and the people intoxicate me.'[99] Upon his arrival Yunkers obtained a post at the New School for Social Research where he taught intermittently over the next nine years, and at the same time began to teach during the summers at the University of New Mexico in Albuquerque, where he helped to establish the Rio Grande Graphics Workshop in 1950. Under Yunkers's supervision three print portfolios were issued by Rio Grande Graphics in 1952; each portfolio by Yunkers (colour woodcuts), Gabor Peterdi (colour intaglio prints) and the Chinese American artist Seong Moy (colour woodcuts) contained five prints and was published by Ted Gotthelf in New York for $40 a portfolio or $108 for the set of three.

Fig. 13
Adja Yunkers, *The Shoemaker*, 1951, colour woodcut, 725 x 423 mm (British Museum, P&D 2004,0731.63. Presented by Patricia Hagan through the American Friends of the British Museum)

12 JACKSON POLLOCK AND ABSTRACT EXPRESSIONISM

By the late 1940s Abstract Expressionism had become the dominant avant-garde mode. Its international position had been assured with the inclusion of Pollock, De Kooning and Gorky among the artists represented in the American pavilion at the 1950 Venice Biennale. As a phenomenon Abstract Expressionism was vigorously promoted by its polemical spokesman, the influential critic Clement Greenberg. It was essentially a non-figurative painting style characterized by spontaneous gesture, improvisation and emotional expressiveness executed on a commanding, monumental scale. De Kooning and Pollock were the principal exponents of gestural spontaneity, famously called 'action painting' by the critic Harold Rosenberg, while the painters Mark Rothko and Clyfford Still conveyed a more contemplative effect through their colour-field work. Both strands were highly subjective, seeking inspiration in the individual psyche as a means to tap the universal inner workings of the subconscious mind. Also known as the New York School, Abstract Expressionism quickly dominated the international avant-garde and its triumphant success shifted the post-war art world from Paris to New York.[101]

The huge success of abstract expressionist painting had implications for printmaking. As a completely new style of painting there was no model or pattern for what an abstract expressionist print should look like. For painters working in a direct, improvisatory manner on a monumental scale there seemed little incentive to make small-scale prints which required the mediation of a press and printers. Furthermore, some artists like Franz Kline and De Kooning were resistant to the idea of making prints which they associated with the socially conscious works of the WPA and the Depression. Although many of the Abstract Expressionists had known each other since the 1930s when they were employed under the different divisions of the Federal Art Project in New York, by the 1940s they had completely dissociated themselves from WPA politics and social attitudes. The arrival of the European émigrés and the exchange of automatist surrealist ideas at Hayter's Atelier 17 helped them to find a new form of abstraction that was personal and ideologically neutral. In the 1940s, when the Abstract Expressionists were establishing their careers as painters, there was no market for their prints, and in the 1950s, when they had attained international recognition, it was their success as painters that claimed the attention of the dealers.

The printmaking that did take place was low-key and experimental.[102] As we have seen, Pollock's experiments with intaglio engraving at Atelier 17 in 1944–5 went no further than a few individual trial proofs, and there was never any intention of producing these plates as editions either then

Yunkers's woodcuts were widely exhibited and collected by museums. John Palmer Leeper, Director of the Pasadena Art Institute and an admirer of Yunkers, could write in 1952: 'Not only have his woodblock prints and monotypes been seen from Pacific to Atlantic, but virtually every print cabinet in America owns examples.'[100] Displaying strong colour and abstract forms, his woodcuts were expressionistic in style and often impressive by their size. They were repeatedly inked and overprinted by hand with opaque and semi-transparent colours from several blocks to create a painterly texture. His prints such as *Man Startled by Birds* (cat. 135) and *The Shoemaker* (fig. 13), made in 1951, were quite unlike any other woodcut that had been produced before in America. Their bold colour, painterly effects and large scale were in keeping with the spirit of Abstract Expressionism, to which Yunkers was introduced through the New York School critic and writer Dore Ashton, who had become his fifth wife in 1950.

or later in his career. Yet they were important in developing his ideas towards abstract expressionist painting and in this sense printmaking, however erratic and experimental, acted as a stimulus to painting as his primary means of expression. In 1951, when Pollock had become the undisputed leader of Abstract Expressionism, his dealer, the Betty Parsons Gallery, issued a portfolio of six black and white screenprints (cat. 144). These were photo-screenprinted translations of his new black 'drip' paintings which were on exhibition with Betty Parsons in New York. Pollock had employed his brother, Sanford McCoy, to photograph the paintings and make the screens for printing in his commercial studio.[103] Although Pollock had earlier worked as a 'squeegee man' for a silkscreen business in 1943, the year from which it is believed his first few colour screenprints date, in the case of the Betty Parsons portfolio he turned to screenprinting as a convenient way of reproducing his paintings. His adoption of commercial photo-screenprinting was an exception at this time, although it later became more widely practised as a creative medium by Andy Warhol and the Pop artists in the 1960s. Pollock's screenprint portfolio was priced at $200 and made few sales, most probably because his supporters were only interested in his paintings, while for most print collectors the portfolio was too avant-garde in style and too close to reproductions of his paintings.

An important context in which abstract expressionist printmaking took place came out of the close association between the painters and their poet friends. They would meet in Greenwich Village at their regular haunts, the Cedar Tavern and The Club, a boisterous discussion group which Kline and De Kooning helped to establish in 1949. The young poets included John Ashbery, Kenneth Koch and Frank O'Hara, who forged close friendships with the painters. Two important collaborative print projects emerged, one in screenprint and the other in intaglio. The screenprint project involved a younger generation of abstract expressionist painters who produced prints to accompany the work of young poets and writers. These first appeared in *Folder*, an avant-garde literary magazine established by the printer Floriano Vecchi of Tiber Press, a commercial screenprint workshop, the poet and actress Daisy Aldan, and Richard Miller, Vecchi's business partner, who had associations with the museum and dealer world.[104] In 1956 Tiber Press launched a more ambitious project of pairing a poet with a painter to produce a deluxe portfolio volume illustrated with colour screenprints. Four volumes finally appeared in 1960, in large editions of 225 copies: the four respective pairs of artists and poets were Joan Mitchell and John Ashbery; Alfred Leslie and Kenneth Koch; Grace Hartigan and James Schuyler; and Michael Goldberg and Frank O'Hara. Joan Mitchell, whose lifelong passion for poetry developed from her poet mother's background, made her first mature prints at the Tiber

Press; these included a few painterly screenprints of spontaneous gestural brushstokes, such as *Untitled (Green, Black, White)* (cat. 147), which were not ultimately used in the project and never published in editions. Despite the close collaboration of Vecchi with his artists, the four portfolios of abstract expressionist screenprints and poems failed to find a market, and the Tiber Press gave up the idea of branching out as a fine art print publisher and returned to the more profitable business of remaining a commercial screenprint workshop.

The intaglio project *21 Etchings and Poems* was initiated by Peter Grippe in 1951 after he had taken over the running of Atelier 17 following Hayter's departure for Paris. But it was almost a decade before the project was issued as a portfolio of artist-poet collaborations by the Morris Gallery in 1960.[105] Twenty-one painters and poets from America and Europe were invited to work together in pairs on a plate, with the poet's handwritten text fused with the painter's image to produce a pictured poem. Inspired by William Blake's illuminated books, the project had developed out of earlier investigations by Hayter, the poet Ruthven Todd and Joan Miró at Atelier 17 in 1947 into ways of uniting word and image on the single plate.[106] Although various styles, ranging from Surrealism to geometric abstraction, were among the contributions to *21 Etchings and Poems*, the project also included the work of the abstract expressionists De Kooning, Kline, Yunkers and the European Pierre Alechinsky. Kline supplied a collage drawing which was photo-etched to the plate with a poem by Frank O'Hara; the powerfully gestural work by Kline (cat. 146), made in 1957, was the artist's only mature print; while De Kooning's contribution (cat. 145), produced at the same time, was his first recorded print and was paired with a poem by his friend Harold Rosenberg. Many of the plates were made at Atelier 17, but after its closure in 1955 Peter Grippe used his own printmaking studio to complete them. The printing of the portfolios in editions of fifty was done by the firm Anderson and Lamb in Brooklyn in 1958 but not released until two years later when Morris Weisenthal, a contributing poet and a key ally in ensuring their success, distributed them through his New York gallery.

Despite its protracted and often fraught genesis, *21 Etchings and Poems* became a landmark in American printmaking as the first major collaborative project in the United States between artists and writers.[107] The inclusion of Kline and De Kooning, two stars of Abstract Expressionism whose aversion to printmaking was well known, was the first step towards breaking down the prejudices of the New York School against printmaking. However, it was only after the establishment of ULAE, Tatyana Grosman's lithographic workshop at West Islip, Long Island, in 1957, and its West Coast counterpart the Tamarind Lithography Workshop

Fig. 14
Philip Guston, *Untitled*, 1966, lithograph, 565 x 762 mm
(British Museum, P&D 2003,1231.18. Presented by the
American Friends of the British Museum)

Fig. 15
Willem de Kooning, *Minnie Mouse*, 1971, lithograph, 698 x 532 mm
(British Museum, P&D 1979,1006.14)

under June Wayne in 1960, that the leading abstract expressionist painters started to make prints in any serious way. Helen Frankenthaler and Grace Hartigan both made their first major gestural statements in lithography at ULAE in 1961 and Barnett Newman followed with his *18 Cantos* in 1963–4. At Tamarind Yunkers produced his painterly *Skies of Venice* suite of nine monochrome lithographs in 1960. Four years later Irwin Hollander, one of the first Tamarind-trained printers, established his own workshop on East 10th Street to provide a service for the New York School.[108] There Robert Motherwell and Philip Guston (fig. 14) created abstract expressionist lithographs in 1965–6, and De Kooning later made a series of twenty-four gestural lithographs in 1970–71 (fig. 15). Printmaking had now become an acceptable practice for the New York avant-garde and an integral part of their work.

By the 1960s the American Scene had long been a phenomenon of the past. America after the Second World War had emerged as a super-power. The old isolationism of the Depression era had gone and America found itself fulfilling a new role as a global power. Under this different political configuration the American Scene looked increasingly outmoded and irrelevant. Images of American city or rural life represented in small black-and-white etchings or lithographs now seemed completely inappropriate to the reconfigured world order. An internationalist political outlook demanded an internationalist avant-garde style, and American Abstract

Expressionism fulfilled this role. It bestrode the international art world and the style became synonymous with America – big, imposing and indomitable. A language without national boundaries, Abstract Expressionism was appropriated by the US government as representative of democratic freedom and used as a propaganda vehicle during the Cold War against the socialist realism of totalitarian Communism. New York was now the heart of the international art world, and with an unstoppable momentum America's contribution to the international avant-garde would continue with Pop Art, Minimalism and Conceptual art. If by then the American Scene seemed retrograde, provincial and inward looking, the years from 1900 to 1960 now seem an era of considerable artistic vibrancy in which the shifts of social and political change were most acutely observed by its printmakers. The prints of this period provide a compelling portrait of America at a critical stage of its development.

NOTES

1 For historical accounts of these workshops, see Pat Gilmour, *Ken Tyler Master Printer and the American Print Renaissance*, Canberra: Australian National Gallery, 1986; Ruth E. Fine, *Gemini GEL: Art and Collaboration*, Washington, DC: National Gallery of Art, 1984; Esther Sparks, *Universal Limited Art Editions: A History and Catalogue: The First Twenty-Five Years*, Chicago: The Art Institute of Chicago, 1989; Garo Z. Antreasian and Clinton Adams, *The Tamarind Book of Lithography: Art and Techniques*, New York: Harry N. Abrams, 1971; and Karin Breuer, Ruth E. Fine and Steven A. Nash, *Thirty-Five Years at Crown Point Press: Making Prints, Doing Art*, exh. cat., San Francisco: Fine Arts Museums of San Francisco and the University of California Press, 1997.

2 Letter cited in June and Norman Kraeft, *Armin Landeck, The Catalogue Raisonné of his Prints*, 2nd edn, Carbondale and Edwardsville: Southern Illinois University Press, 1994, pp. 11–12.

3 On the formation of these exhibition societies, see Richard Field's introductory essay in *American Prints 1900–1950*, exh. cat., New Haven: Yale University Art Gallery, 1983, pp. 17–21.

4 Una Johnson, *American Prints and Printmakers: A chronicle of over 400 artists and their prints from 1900 to the present*, New York: Doubleday & Company, 1980, p. 11.

5 James Watrous, *American Printmaking: A Century of American Printmaking 1880–1980*, Madison: University of Wisconsin Press, 1984, p. 152.

6 Barbara Stern Shapiro, *From Paris to Provincetown: Blanche Lazzell and the Color Woodcut*, exh. cat., Boston: Museum of Fine Arts, Boston, 2002, p. 15.

7 For an historical overview of the American print clubs and a list of them, see Lisa Peters, 'Print Clubs in America', *Print Collector's Newsletter*, vol. 13, no. 3 (July–August 1982), pp. 88–91.

8 See Janet A. Flint, *The Prints of Louis Lozowick, A Catalogue Raisonné*, New York: Hudson Hills, 1982, cat. 48.

9 See Paul McCarron, *The Prints of Martin Lewis, A Catalogue Raisonné*, Bronxville, New York: M. Hausberg, 1995, cats 77 and 85.

10 John Ittmann, *Dox Thrash: An African American Master Printmaker Rediscovered*, exh. cat., Philadelphia: Philadelphia Museum of Art, 2001, p. 20.

11 Ibid., pp. 35–6.

12 Ibid., note 170, p. 156. Ittmann cites these membership figures from the Print Club Archives, Historical Society of Pennsylvania, Philadelphia.

13 Clinton Adams, *American Lithographers 1900–1960: The Artists and Their Printers*, Albuquerque: University of New Mexico Press, 1983, pp. 150–3.

14 McCarron, op. cit. [note 9], cat. 83, p. 152.

15 Una Johnson, *Ambroise Vollard, Editeur: Prints, Books, Bronzes* (1944), 2nd edn, New York: Museum of Modern Art, 1977.

16 Johnson, op. cit. [note 4]

17 John Sloan, *Gist of Art* (1939), 2nd edn, New York: American Artists Group, 1944, p. 81.

18 A copy of the published prospectus for the Art Students League, Winter Catalogue, 29 September 1930–29 May 1931 (fig. 2), in the Department of Prints and Drawings, British Museum, outlines the constitution and administration of the School and gives a list of its current instructors, including Thomas Hart Benton, the etcher and lithographer Eugene Fitsch, and Jan Matulka.

19 For Miller's role as a lithographic printer, see Adams, op. cit. [note 13], pp. 25–8, 33–4, 51–2, 121–2 and 140–1. See also Janet A. Flint, *George Miller and American Lithography*, exh. cat., Washington, DC: Smithsonian Institution, 1976.

20 For Bolton Brown's biography and a study of his lithographs, see Clinton Adams, *Crayonstone: The Life and Work of Bolton Brown, with a Catalogue of his Lithographs*, Albuquerque: University of New Mexico Press, 1993. The British Museum holds some 353 lithographs by Brown which he donated to the Print Room at various points between 1915 and 1925.

21 For Kistler's role as a lithographic printer for artists in Los Angeles, see Adams, op. cit. [note 13], pp. 170–6.

22 For American printmakers in Paris at the Atelier Desjobert, see ibid., pp. 72–6.

23 For a detailed history of the Weyhe Gallery during Carl Zigrosser's directorship of the print business, see the doctoral dissertation of Reba White Williams, 'The Weyhe Gallery between the Wars, 1919–1940' (Ph.D, The City University of New York, 1996), a copy of which is held in the library of the Department of Prints and Drawings, British Museum.

24 Carl Zigrosser's essay 'Concerning Prints' accompanying the 1919 Weyhe portfolio; cited in ibid., pp. 50–1.

25 For Edith Halpert's role at the Downtown Gallery, see Sylvan Cole and Jane Myers, *Stuart Davis Graphic Work and Related Paintings with a Catalogue Raisonné of the Prints*, exh. cat., Fort Worth, Texas: Amon Carter Museum, 1986, pp. 25 and 51. See also Adams, op. cit. [note 13], p. 55.

26 'Left Wing of American Print Makers, 36 Strong, Hold Annual', *Art Digest*, vol. 5, no. 6 (15 December 1930), p. 23; cited in Cole and Myers, op. cit. [note 25], p. 51.

27 For an interesting historical synopsis of Kennedy & Company and the traditional print publishing world in New York, see McCarron, op. cit. [note 9], pp. 16–17.

28 For a full account of Robert Henri, see William Innes Homer, *Robert Henri and his Circle*, with the assistance of Violet Organ, Ithaca and London: Cornell University Press, 1969.

29 The phrase 'Ashcan School' is attributed by Van Wyck Brooks to the hard-line socialist Art Young at a contentious board meeting of the social radical magazine *The Masses* in 1916 as a jibe 'for a kind of picture in which ash-cans figured but without value for Socialist propaganda'; see Van Wyck Brooks, *John Sloan: A Painter's Life*, London: J.M. Dent, 1955, pp. 77–8.

30 John Sloan, 'Autobiographical Notes on Etching' in Peter Morse, *John Sloan's Prints: A Catalogue Raisonné of the Etchings, Lithographs, and Posters*, London and New Haven: Yale University Press, 1969, p. 385, where Sloan is quoting the National Academy's grounds for rejection.

31 Ibid., p. 17.

32 Ibid., pp. 384–5, note 16.

33 See Lauris Mason, *The Lithographs of George Bellows: A Catalogue Raisonné* (1977), assisted by Joan Ludman and with a foreword by Charles H. Morgan, rev. edn, San Francisco: Alan Wofsy Fine Arts, 1992, cat. 1A–C, pp. 33–4.

34 The collaborative relationship between Bellows and Brown is described by Adams, op. cit. [note 13], pp. 39–42.

35 Blanche Lazzell, 'The Provincetown Print', 2, undated manuscript; cited by Janet A. Flint, *Provincetown Printers: A Woodcut Tradition*, exh. cat., Washington, DC: Smithsonian Institution Press for the National Museum of American Art, 1983, p. 14.

36 Blanche Lazzell, 'The Color Wood Block Print', manuscript dated 2 November 1930; cited by Shapiro, op. cit. [note 6], p. 11.

37 For an account of the American *japoniste* woodcut artists, see David Acton, *A Spectrum of Innovation: Color in American Printmaking 1890–1960*, with contributions by Clinton Adams and Karen F. Beall, exh. cat., Worcester, Massachusetts and New York/London: Worcester Art Museum and W.W. Norton & Company, 1990, pp. 14–15.

38 Zorach's statement in the catalogue for the 1916 Forum Exhibition of Modern American Painters in New York; cited by Efram L. Burk, 'The Prints of William Zorach', *Print Quarterly*, vol. 19, no. 4 (December 2002), p. 360.

39 The organization of the Armory Show and its subsequent impact on Henri and the Eight is outlined in Homer, op. cit. [note 28], pp. 166–70. See also Milton W. Brown, *The Story of the Armory Show*, New York: The Joseph H. Hirshhorn Foundation, 1963, where a catalogue raisonné of the Armory exhibits is appended, pp. 217–302.

40 First used by the journalist Julian Street in the magazine *Everybody's*, this description became the most popular catchphrase to ridicule Duchamp's painting; see Brown, op. cit., p. 110.

41 Sloan, 'Autobiographical Notes on Etching' in Morse, op. cit. [note 30], p. 386.

42 At the Armory Sloan showed two oils and five etchings: *Anshutz on Anatomy* (Morse 155); *Girl and Beggar* (M.150); *Mother* (M.139); *Night Windows* (M.152); and *The Picture Buyer* (M.153); see Brown, op. cit. [note 39], p. 291.

43 Marin's proclamation for his 1913 exhibition at the 291 Gallery cited by Carl Zigrosser, *The Complete Etchings of John Marin, Catalogue Raisonné*, exh. cat., Philadelphia: Philadelphia Museum of Art, 1969, p. 16.

44 Stuart Davis, *Stuart Davis*, New York: American Artists Group, 1945; cited by Diane Kelder in her essay 'Stuart Davis: Methodology and Imagery' in Cole and Myers, op. cit. [note 25], p. 3.

45 Frank Getlein attempts to repudiate the charge of Avery as an American Matisse; see his introduction to Harry H. Lunn Jr, *Milton Avery: Prints 1933–1955*, Washington, DC: Graphics International Ltd, 1973, unpag.

46 Louis Lozowick, 'The Americanization of Art', in *Machine Age Exposition*, exh. cat., New York City: Steinway Hall, 6–26 May 1927; text reprinted in Flint, op. cit. [note 8], p. 18.

47 Ibid., p. 19.

48 Janet Flint makes this point in her essay 'Matulka as printmaker: a checklist of known prints' in Patterson Sims and Merry A. Foresta, *Jan Matulka 1890–1972*, exh. cat., New York: Whitney Museum of American Art and Washington, DC: National Collection of Fine Arts, Smithsonian Institution, 1980, p. 83.

49 Sloan, op. cit. [note 17], p. 3.

50 Edward Hopper, 'John Sloan and the Philadelphians', *The Arts*, vol. 11, no. 4 (April 1927), p. 172; cited by Gail Levin, *Edward Hopper: The Complete Prints*, exh. cat., New York: Whitney Museum of American Art, 1979, p. 25.

51 Levin cites these remarks of Hopper from an unpublished letter of 10 February 1956 to Marian Ragan; ibid., p. 30.

52 Hopper quoted in Suzanne Burrey, 'Edward Hopper. The Emptying Spaces', *Arts Digest*, 1 April 1955, p. 10; cited by Levin, ibid., p. 25.

53 One was by Malcolm C. Salaman, the British spokesman on contemporary prints, in his series of *Modern Masters of Etching* published by the Studio, London; the other was volume 11 in the series of *American Etchers* published by Crafton Collection, New York, the deluxe edition of which included the drypoint *Little Penthouse* (cat. 43); on the relationship of Lewis and the Kennedy & Company gallery, see the essay by Paul McCarron, op. cit. [note 9], esp. pp. 16–21.

54 Cited by Lloyd Goodrich in his introduction to Norman Sasowsky, *The Prints of Reginald Marsh*, New York: Clarkson N. Potter, Inc., 1976, p. 8.

55 Cited by Ben Bassham, *The Lithographs of Robert Riggs, with a Catalogue Raisonné*, London, Philadelphia and Toronto: The Art Alliance Press and Associated University Presses, 1986, p. 38.

56 A photograph of Riggs posing with one of his thirty-nine pet snakes is reproduced in ibid., p. 16.

57 See Alfred H. Barr, Jr (ed.), *Fantastic Art, Dada, Surrealism*, exh. cat., New York: Museum of Modern Art, 1936, p. 278, where Fred Becker's wood-engravings *John Henry's Hand*, 1936

(no. 524) and *The Monster*, 1936 (no. 525) were lent by the New York City WPA/FAP to the exhibition.

58 Thomas Hart Benton, *An Artist in America* (1937), 4th rev. edn, Columbia and London: University of Missouri Press,1983, p. 314. In 1951, for the 2nd edition of his book and in subsequent editions Benton added the chapter 'After', in which he also referred to his fellow Regionalists Grant Wood and John Steuart Curry, from which this quotation comes.

59 For a detailed discussion of Regionalism, see Joseph S. Czestochowski, *John Steuart Curry and Grant Wood: A Portrait of America*, Columbia and London: University of Missouri Press, with the Cedar Rapids Art Association, 1981, and Wanda M. Corn, *Grant Wood: The Regionalist Vision*, exh. cat., New Haven and London: Yale University Press for the Minneapolis Institute of Arts, 1983.

60 Cited by Adams, op. cit. [note 13], p. 140.

61 For a breakdown of AAA's rate of print publishing during this period, see the marginal note in Adams, op. cit. [note 13], p. 141.

62 See Sylvan Cole with Susan Teller, *Grant Wood: The Lithographs. A Catalogue Raisonné*, New York: Associated American Artists, 1984, p. 6.

63 These statistics come from Olin Dows, 'The New Deal's Treasury Art Program: A Memoir', in Francis V. O'Connor (ed.), *The New Deal Art Projects: An Anthology of Memoirs*, Washington, DC: Smithsonian Institution Press, 1972, p. 12; cited in Adams, op. cit. [note 13], p. 122.

64 Audrey McMahon, 'A General View of the WPA Federal Art Project in New York City and State', in O'Connor (ed.), op. cit., p. 54; cited in Adams, op. cit. [note 13], p. 123.

65 Adams, op. cit. [note 13], p. 128, marginal note.

66 This was the weekly sum which the New York City WPA printmakers Blanche Grambs and her partner Hugh 'Lefty' Miller each received in 1936; see James Weschler, 'The Great Depression and the Prints of Blanche Grambs', *Print Quarterly*, vol. 13, no. 4 (December 1996), p. 385.

67 Jacob Kainen, 'Memories of Arshile Gorky', *Arts* (May 1976), p. 97; cited by Janet A. Flint, *Jacob Kainen: Prints, a Retrospective*, exh. cat., Washington, DC: National Collection of Fine Arts, Smithsonian Institution, 1976, p. 10.

68 See Patricia Likos, 'Julius Bloch: Portrait of the Artist', *Philadelphia Museum of Art Bulletin*, vol. 79, no. 339 (summer 1983), pp. 16–17.

69 For the setting up of colour lithography at the Federal Art Project, see Adams, op. cit. [note 13], pp. 123–6.

70 For the development of the carborundum print in Philadelphia, see Cindy Medley-Buckner, 'The Fine Print Workshop of the Philadelphia Federal Art Project', in John Ittmann, op. cit. [note 10], pp. 43–51, and her article 'Carborundum Mezzotint and Carborundum Etching', *Print Quarterly*, vol. 16, no. 1 (March 1999), pp. 34–49.

71 For a history of the screenprint, see Reba and Dave Williams, 'The Early History of the Screen-print', *Print Quarterly*, vol. 3, no. 4 (December 1986), pp. 287–321 and 'The Later History of the Screenprint', *Print Quarterly*, vol. 4, no. 4 (December 1987), pp. 379–403. See also Reba and Dave Williams, *American Screenprints*, exh. cat., New York: National Academy of Design,1987.

72 In addition to Anthony Velonis, *Technical Problems of the Artist – Technique of Silk Screen Process*, Works Progress Administration/ Federal Art Project, New York, 1938, early treatises on the technique include Harry Sternberg, *Silk Screen Color Printing*, New York and London: McGraw-Hill Book Company, Inc., 1942; J.I. Biegeleisen and Max Arthur Cohn, *Silk Screen Stencilling as a Fine Art*, New York and London: McGraw-Hill Book Company, Inc., 1942 (2nd edn as *Silk Screen Techniques*, New York: Dover Publications, Inc., 1958); and Harry Shokler, *Artists Manual for Silk Screen Print Making*, New York: American Artists Group, 1946.

73 Carl Zigrosser, 'The Serigraph, A New Medium', *The Print Collector's Quarterly*, vol. 28, no. 4 (December 1941), pp. 443–77.

74 Ibid., p. 477.

75 Harry Shokler, op. cit. [note 72], p. vii.

76 For the role of Doris Meltzer in the National Serigraph Society, see James Wechsler's essay in *Edward Landon (1911–1984): Silkscreens*, exh. cat., New York: Mary Ryan Gallery, 1994, p. 11.

77 See Reba and Dave Williams, 'The Later History of the Screenprint', op. cit. [note 71], pp. 385–7.

78 For a detailed historical analysis of the left movement in American art during this period, see Andrew Hemingway, *Artists on the Left: American Artists and the Communist Movement 1926–1956*, New Haven and London: Yale University Press, 2002.

79 See Weschler, op. cit. [note 66], pp. 385–6.

80 Stuart Davis, 'Why an Artists' Congress?', *First American Artists' Congress*, New York, 1936; cited by Diane Kelder in her essay 'Stuart Davis: Methodology and Imagery', in Cole and Myers, op. cit. [note 25], p. 11.

81 The two pioneering studies of Mexican printmaking of this period are both by Reba and Dave Williams, *The Mexican Muralists and Prints*, exh. cat., New York: The Spanish Institute, 1990; and *Mexican Prints from the Collection of Reba and Dave Williams*, with contributions by Starr Figura and James Wechsler, [New York], c.1998. For a full scholarly appraisal of the Mexican printmakers, see John Ittmann (ed.), *Mexico and Modern Printmaking: A Revolution in the Graphic Arts, 1920 to 1950*, exh. cat., with contributions by Innis Howe Shoemaker, James Wechsler and Lyle Williams, Philadelphia: Philadelphia Museum of Art and San Antonio: McNay Art Museum, in association with Yale University Press, 2006.

82 Josef Albers, in a letter of 1936 to Kandinsky; cited in Brenda Danilowitz, *The Prints of Josef Albers: A Catalogue Raisonné 1915–1976*, New York: Hudson Hills Press, 2001, p. 17.

83 Cited by Jeff Kisseloff in his essay in Mary Ryan, *Hugo Gellert: A Catalogue of Prints and Drawings*, exh. cat., New York: Mary Ryan Gallery, 1986.

84 Ellen G. Landau, *Artists for Victory*, exh. cat., Washington, DC: Library of Congress, 1983, p. 2.

85 Ibid., p. 3.

86 These figures come from a publicity committee report of 31 January 1944 to Artists for Victory; cited by Landau, op. cit. [note 84], p. 7.

87 For the Artists' League of America and Victory Workshop, see Hemingway, op. cit. [note 78], pp. 192–5.

88 See Michael Kammen, *Robert Gwathmey: The Life and Art of a Passionate Observer*, Chapel Hill and London: University of North Carolina Press, 1999, pp. 52–5 and 106–9.

89 See Reba and Dave Williams, 'Jolán Gross-Bettelheim: A Hidden Life', *Print Quarterly*, vol. 7, no. 3 (September 1990), pp. 303–7.

90 For a detailed account of Albers's career as a printmaker, see Brenda Danilowitz's essay 'Josef Albers: The Graphic Work' in her monograph, op. cit. [note 82], pp. 11–34.

91 Bertoia's notes for an address to the Collectors Circle at the Virginia Museum of Fine Arts, Richmond, 14 October 1961; cited by June Kompass Nelson, *Harry Bertoia, Printmaker: Monotypes and other Monographics*, exh. cat., Detroit: Wayne State University Press, 1988, p. 37.

92 For a detailed analysis of Hayter's influence in America, see Joann Moser, 'The Impact of Stanley William Hayter on Post-War American Art', *Archives of American Art Journal*, vol. 18, no. 1 (1978), pp. 2–11.

93 Louise Bourgeois, as quoted by Deborah Wye in her essay 'A Drama of the Self: Louise Bourgeois as printmaker', in Deborah Wye and Carol Smith, *The Prints of Louise Bourgeois*, New York: The Museum of Modern Art, 1994, p. 27.

94 S.W. Hayter, *New Ways of Gravure*, London: Routledge & Kegan Paul, 1949, p. 19.

95 Carl O. Schniewind in a press release for the Art Institute of Chicago's 1949 exhibition 'The Woodcut Through Six Centuries'; cited by Watrous, op. cit. [note 5], p. 173.

96 See the entry on Misch Kohn in Frances Carey (ed.), *The Apocalypse and the Shape of Things to Come*, exh. cat., London: The British Museum, 1999, pp. 318–19.

97 Leonard Baskin, cited by Alan Fern in his foreword to Alan Fern and Judith O'Sullivan, *The Complete Prints of Leonard Baskin: A Catalogue Raisonné 1948–1983*, Boston: Little, Brown and Company, 1984, p. 8.

98 Louis Schanker, quoted by William S. Lieberman, 'Printmaking and the American Woodcut Today', *Perspectives U.S.A.* no. 12 (summer 1950), p. 50; cited by Watrous, op. cit. [note 5], p. 178.

99 Adja Yunkers, quoted by John Palmer Leeper in his essay accompanying the *Adja Yunkers* portfolio of five colour woodcuts issued by Rio Grande Graphics and published by Ted Gotthelf, New York, 1952.

100 John Palmer Leeper's essay in ibid., unpag.

101 For an overview of Abstract Expressionism by one of its pioneering critics, see Dore Ashton, *The New York School. A Cultural Reckoning*, Harmondsworth: Penguin Books, 1979.

102 For a detailed and masterly survey of the abstract expressionist print in America, see David Acton, *The Stamp of Impulse: Abstract Expressionist Prints*, with essays by David Amram and David Lehman, exh. cat., Worcester, Massachusetts: Worcester Art Museum, in association with Snoeck-Ducaju & Zoon, 2001. A more general account of the abstract expressionist print in America and its European variations is given in Lanier Graham, *The Spontaneous Gesture: Prints and Books of the Abstract Expressionist Era*, exh. cat., Canberra: Australian National Gallery, 1987.

103 For a discussion of Pollock's screenprints, see Reba and Dave Williams, 'The Prints of Jackson Pollock', *Print Quarterly*, vol. 5, no. 4 (December 1988), pp. 347–73, esp. pp. 361–71.

104 The role of Floriano Vecchi and the Tiber Press in the abstract expressionist screenprint is discussed in Acton, op. cit. [note 102], pp. 13–14 and under his entries for Alfred Leslie, p. 142; Elaine de Kooning, p. 148, and Joan Mitchell, p. 168.

105 The *21 Etchings and Poems* project is discussed by Graham, op. cit. [note 102], pp. 20–1; Acton, op. cit. [note 102], pp. 14–16; and Riva Castleman, *A Century of Artists Books*, exh. cat., New York: Museum of Modern Art, 1994, p. 40.

106 Hayter described the intaglio experiments with word and image inspired by Blake's books which were conducted at Atelier 17 in 1947 in *New Ways of Gravure*, op. cit. [note 94], pp. 85 and 143–4.

107 This point is made by Eleanor M. Garvey, *The Artist and the Book 1860–1960 in Western Europe and the United States* (1961), exh. cat., with an introduction by Philip Hofer, 2nd rev. edn, Boston: Museum of Fine Arts and Harvard College Library, 1972, p. 101.

108 See Acton, op. cit. [note 102], p. 17. For the collaborative projects of the printer Fred Genis, business partner of Irwin Hollander at Hollanders Workshop between 1969 and 1972, when the De Kooning suite was produced, see Sonia Dean, *The Artist and The Printer. Lithographs 1966–1981: A Collection of Printer's Proofs*, exh. cat., Melbourne: National Gallery of Victoria, 1982.

CATALOGUE

1 THE ASHCAN SCHOOL TO GEORGE BELLOWS

John Sloan

1871–1951

John Sloan, painter, printmaker and teacher, first took up etching as a self-taught adolescent when he made prints after Turner and Rembrandt. After attending the Academy of Fine Art in Philadelphia from 1892 to 1894, he started work as a commercial illustrator. In 1904 he moved to New York and became part of a group of artists known as 'The Eight' around the teacher Robert Henri. Sloan and his fellow artists abandoned the academic style, which had dominated American art, in favour of an 'art for life', focusing upon images of urban realism. The term 'Ashcan School' was later used to describe them. Initially Sloan's work met with a mixed response but by the 1930s he was an established figure. By that point, though, his interests had shifted away from urban realism towards other subject matter, such as nudes and landscapes.

He taught at the Art Students League from 1916, becoming its president in 1931. Recognition for his printmaking came with the award of a bronze medal for the 1915 San Francisco Pan-Pacific Exposition and a gold medal from the Academy of Fine Art, Philadelphia, in 1931. Sloan was also politically committed, and in 1910 he became a socialist. From about 1911 to about 1916 he was an art editor for the left-wing magazine *The Masses*, producing many cover illustrations for the magazine as well as commissioning other artists of the Ashcan School, such as Henri, George Bellows and Stuart Davis.

Sloan was a prolific printmaker: between 1891 and 1940 he produced some three hundred etchings. He also tried lithography, but etching remained his true medium. He wrote about printmaking, focusing upon his personal experiences of the medium. He also produced more technical notes, giving a systematic guide to etching from how to ground the plate to the choice of paper used. His influence as one of the first chroniclers of the American scene and his technical abilities as an etcher would have a profound influence upon later American artists. The Whitney Museum held a solo show of his etchings in 1936 followed by a retrospective in 1956. In 1939 he published his autobiography, entitled *Gist of Art*. Sloan continued making etchings until his late seventies; his final etchings date to 1949. The British Museum owns twenty-nine etchings and one lithograph by Sloan, which were presented as a group by his widow, Helen Farr Sloan, through the Wilmington Society of the Fine Arts, in 1965.

BIBLIOGRAPHY
Peter Morse, *John Sloan's Prints: A Catalogue Raisonné of the Etchings, Lithographs, and Posters*, London and New Haven: Yale University Press, 1969

1 Turning out the Light

1905
Etching
Signed and dated on plate; signed, titled and inscribed in pencil '100 proofs' and '#70/ Platt imp'. 125 x 175 mm
Morse 134. III
1965,1211.8. Presented by Helen Farr Sloan

This and the following three etchings (cats 2–4) come from the series of ten prints entitled *New York City Life*, which Sloan produced between 1905 and 1906. This series recorded the lives of the ordinary inhabitants of Manhattan whom Sloan encountered in its less affluent areas, such as the Bowery. The prints had a mixed reception from a public unused to frank depictions of urban life and sales were poor. Sloan was forced to sell the prints individually at $5 each, although he had always intended that they be kept together in sets priced at $25. In 1906 Sloan was invited to send in a set of *New York City Life* to an exhibition of the American Watercolor Society, but when some of the etchings were rejected as being 'vulgar' and 'indecent', he was outraged and sought to withdraw the entire series.

Sloan heightens this intimate scene through the use of strong chiaroscuro. The densely worked areas of cross-hatching, in the deeper shadows, are contrasted with the unetched blank areas of the plate that show the light. The mood is one of anticipation and intimacy: the woman, whose shift is about to slip loose from her shoulder, glances down at the man who lies stretched out on their unmade bed, while her discarded stockings are draped over the bed frame.

As well as pulling prints himself, Sloan used different printers to print his plates, even within the same edition. Morse records that four printers were responsible for this plate at different times. Peter J. Platt (1859–1934), who printed this impression, was one of the leading intaglio printers in America; Sloan used his services from 1927 until 1933.

2 The Women's Page

1905

Etching

Signed and dated on plate; signed and inscribed
in pencil 'First state' and '#68 / JS imp The Women's
Page'. 123 x 175 mm

Morse 132. I

1965,1211.7. Presented by Helen Farr Sloan

Many of Sloan's etchings of this period were
inspired by everyday life in furnished rooms
observed from the back of his studio on 23rd
Street. Sloan was particularly proud of this
etching, declaring that of all his prints it was
'perhaps the best all-round example, both in
subject matter and treatment' (cited by Morse,
p. 141). Here a barefoot, slatternly woman in a
rocking chair is engrossed in reading the women's
page of an illustrated magazine for tips on fashion
and housekeeping. The fashionable woman
depicted in the magazine underscores the irony
of the scene. Instead of densely worked cross-
hatching, Sloan uses here a more fluid etched
line, creating a looser feeling of form to evoke the
untidiness of the cramped interior.

This impression comes from the first state and was
printed by Sloan himself; touches of additional
shading, such as on the cupboard door at left,
were made in the subsequent state printed in an
edition of 100.

3 Connoisseurs of Prints

1905

Etching

Signed and dated on plate; signed, titled and inscribed
in pencil '100 proofs' and '#63 / Platt imp'. 127 x 176 mm

Morse 127

1965,1211.4. Presented by Helen Farr Sloan

Sloan mocks the snobbery of the print connois-
seurs for whom the appropriate subject of an etch-
ing was still life or a landscape view and not the
urban realism of the Ashcan School. A short and
corpulent man removes his pince-nez, his top hat
resting on his expansive stomach, as he loudly
passes comment to his companion. He is unaware
of the thrust-out posterior of the woman bending
before him to examine a print. The subject of the
print connoisseur is not uncommon in art, and
Sloan's etching recalls several lithographs on this
theme by the French artist Honoré Daumier
(1808–79), in particular his lithograph of 1865,
Eh! bien en regardant ce tableau.…

This impression has tack holes around the edges of
the sheet. Sloan's printer, Peter J. Platt, habitually
stretched the proofs by tacking them at the edges;
the paper was rarely trimmed after drying, and
consequently the tack holes on the rough edges of
the sheet remain.

4 Roofs, Summer Night

1906

Etching

Signed and dated on plate; signed, titled and inscribed in
pencil '100 proofs' and '#72 – Peters imp'. 135 x 176 mm

Morse 137. II

1965,1211.9. Presented by Helen Farr Sloan

Before the invention of air conditioning, sleeping
on the roof was the only escape from the heat for
many of New York's poorer inhabitants. Although
Sloan would usually leave New York at the start of
June, he enjoyed observing the city in summer,
capturing the specific activities of its residents; he
described it as 'more human' during that season.

From a high viewpoint, Sloan captures the airless,
oppressive atmosphere on a sweltering night.
Exhaustion is evoked through the motionless
figures and such telling details as the redundant
fan which has slipped from the woman's grasp. The
communal nature of tenement life, with its lack of
privacy, is conveyed by the crowded families lying
next to each other. The subject of city life at night
was one that Sloan often returned to in his etch-
ings and became a familiar subject among those
artists he influenced, such as Martin Lewis,
Edward Hopper and Reginald Marsh.

This impression is noted as being pulled by Peters.
Richard W. and Gustav A. Peters were brothers
who ran a print workshop in Philadelphia, where
Sloan first learnt to etch; they printed all of Sloan's
editions until their deaths in 1925. Careful wiping
of the plate to leave a tone of ink was character-
istic of their printing, and to an extent Sloan
depended on this to obtain some of his chiaroscuro
effects.

5 Anshutz on Anatomy

1912

Etching

Signed and dated on plate; signed and inscribed in pencil '#83 / JS imp 6th state – final'. 191 x 226 mm

Morse 155. VI

1965,1211.15. Presented by Helen Farr Sloan

In 1905, Sloan's teacher, Robert Henri, invited their old teacher from Philadelphia, Thomas P. Anshutz, to the New York School of Art to give a series of lectures on anatomy. Anshutz holds a lump of clay which he will model onto the skeleton in order to demonstrate musculature; the live model stands by for comparison. All faces are turned towards the teacher, only the empty sockets of the skull look directly towards the viewer. Amongst those identified are: John Sloan with glasses, top, right; Robert Henri with moustache, third in from right; and George Bellows, top, third in from right. The latter is also shown as a caricature in profile inscribed 'G.B.' pinned to the classroom wall.

Sloan's etching is more than a record of the anatomy class given by Anshutz; it is also a memorial to him, as Anshutz died in the year it was made. The prominent skeleton stands as a memento mori. The subject looks back to Rembrandt's painting *The Anatomy Lesson of Dr Nicolaes Tulp*, 1632 (Mauritshuis, The Hague), and to the tenebrism of his etchings.

Rich in anecdotal detail, Sloan's etching proved to be problematic to work on as the acid over-bit and under-bit the plate, and it required much scraping and burnishing through eight states. This proof is printed by Sloan himself on a sheet of fine oriental paper; he described it as the final state, although he went on to work on it further. The British Museum also has proofs of the first and third states.

6 Hell Hole

1917

Etching and aquatint

Signed and dated on plate; signed, titled and inscribed in pencil '100 proofs' and '#109 / Ernest Roth imp / Gold Medal Sesqui-Centennial International Exposition 1926'. 200 x 250 mm

Morse 186.II

1965,1211.16. Presented by Helen Farr Sloan

Sloan has depicted the densely packed back room of Wallace's, located at Sixth Avenue and West 4th Street, in Greenwich Village. Known colloquially as 'The Hell Hole', the bar was a hang-out for theatrical types, writers, artists and other bohemians. Sloan was a regular, and among the identifiable characters in this scene are the playwright Eugene O'Neill, seated top right, and the actor Charles Ellis by the table in the left foreground.

The subject of a packed and rumbustious bar and the energetic handling of the form and line recall Hogarth, an artist whom Sloan much admired and one whom he encouraged his students to follow. Here Sloan quotes from Hogarth's *A Rake's Progress*, his series of etchings and engravings of 1735; in particular, the outstretched woman's leg on the right is lifted directly from the pose of Hogarth's rake in plate 3 of the series, where the protagonist is surrounded by prostitutes inside the Rose Tavern, Drury Lane. Sloan has added aquatint to unify the multi-figured composition and to describe the smoky atmosphere of the bar.

The etching proved successful: it was awarded a gold medal at the 1926 Sesqui-Centennial International Exposition in Philadelphia. Although the published edition was 100 and Sloan pulled the early impressions himself, the later impressions were printed by Ernest Roth to whom Sloan entrusted his plates from 1945 until his death in 1951.

7 Nude Reading

1928
Etching
Signed and dated on plate; signed, titled and inscribed
in pencil '100 proofs' and 'Old paper. #150 – Ernest Roth
imp'. 125 x 175 mm
Morse 234. IV
1965,1211.23. Presented by Helen Farr Sloan

The interior of Sloan's studio is shown in this etch-
ing. Behind the resting model is the artist's etching
press, over the spokes of which are hung the
model's clothes; a bottle of etching acid and an
aquatint box sit on the bed of the press, with
further bottles arrayed on the bureau at right.

This etching marks a new direction in his work
away from anecdotal compositions towards more
traditional subjects such as the nude, in which
Sloan could explore what he called a 'sculptural
approach' in his etchings. Between 1930 and 1933
he made thirty-one etchings of nude subjects,
where the figure is often depicted like a piece of
metallic sculpture. Sloan's method of working also
changed at this time. Instead of transferring a pre-
liminary drawing on tissue to the plate, which had
been his practice, he worked directly on the plate
without the aid of a tissue transfer. The British
Museum also owns a first state of this print,
inscribed with the date 20 May 1928, when it was
pulled by Sloan, in which the subject and the press
are sketchily described but the back wall is blank.

8 A Thirst for Art

1939
Etching
Signed and dated on plate; signed, titled and inscribed
in pencil '#216/ Chas.White imp'. 100 x 152 mm
Morse 306. IV
1965,1211.27. Presented by Helen Farr Sloan

Although nudes and etched illustrations domin-
ated his work in the 1930s, Sloan continued to
make wry observations of contemporary American
life. The Prohibition on the sale and consumption
of alcohol in public, which had been in force since
1920, was lifted in 1933. Here Sloan casts a sar-
donic eye on a fashionable art opening in Manhat-
tan: the guests, with their backs to the wall, knock
the pictures out of kilter in their frenzy to reach
the waiter with the cocktail shaker. As the artist
put it, 'One of those exhibition opening cocktail
parties [where the] enthusiasm resulting from the
lifting of Prohibition prevails over interest in art'
(cited by Morse, p. 339).

Sloan made two editions of 100 of this print, both
of which were printed by Charles White, who
pulled editions of some sixty-one plates for the
artist, mostly in the late 1930s and early 1940s.
This, the fourth and final state, differed from the
previous edition of 100 in minor details; notably,
the hair of the woman holding her cocktail fourth
from the left was changed from brunette to blonde
by burnishing. Sloan gave the entire edition to the
benefit of the Society of Independent Artists, of
which he was then president.

9 Sunbathers on the Roof

1941
Etching
Signed and dated on plate; signed, titled and inscribed
in pencil '#219 – Chas. White imp'. 150 x 175 mm
Morse 307
1965,1211.28. Presented by Helen Farr Sloan

In 1941 Sloan produced this etching on commis-
sion for the American College Society of Print
Collectors, a little-known group of print amateurs
based at the San Jose State College, California,
which was disbanded two years later. It was done
many years after his *New York City Life* series
to which it is thematically related. Yet a different
atmosphere prevails in this plate from the earlier
night scene of rooftop tenements crowded with
people desperate to escape the oppressive heat
(cat. 4). The two figures share a private moment
enjoying the sun's heat. A relaxed, sensual note
is struck by their state of undress and by the
romantic novel and discarded stiletto shoe.

For Sloan, the rooftops of New York came to life in
the spring and summer months. As he described it:
'More washes are hung out – gay colored under-
things flap in the breezes, and on Saturdays and
Sundays girls and men in bathing togs stretch
themselves on newspapers, blankets or sheets in
the sun, turning over at intervals like hotcakes'
(cited by Morse, p. 340).

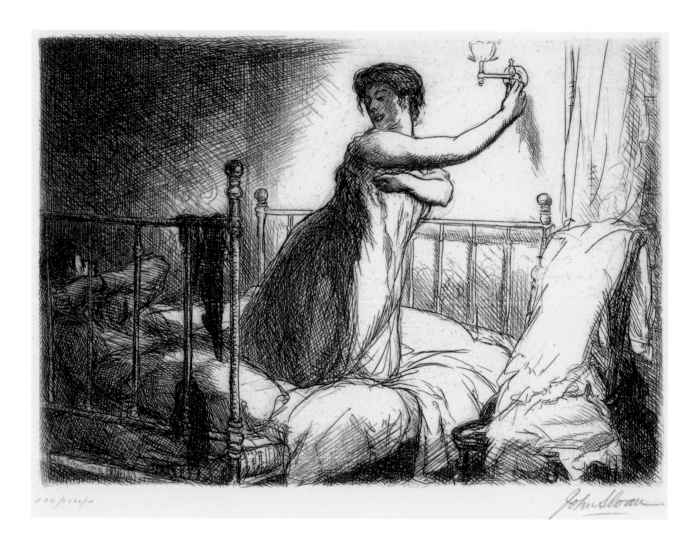

2
Sloan
The Women's Page

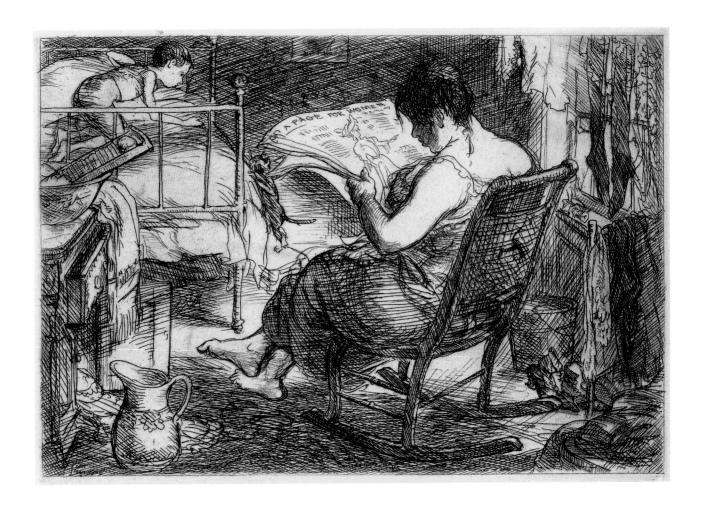

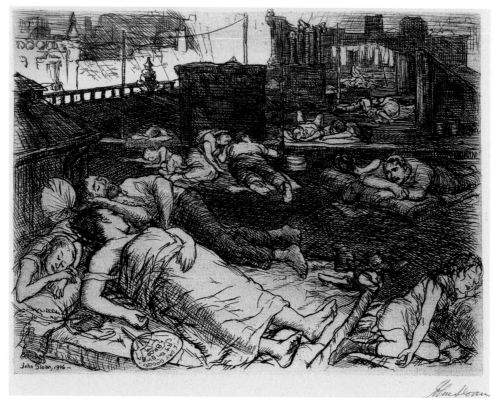

5
Sloan
Anshutz on Anatomy

6
Sloan
Hell Hole

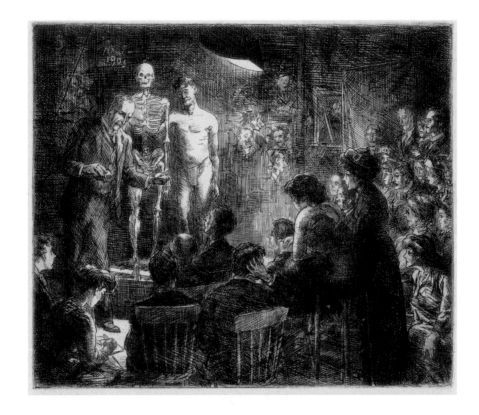

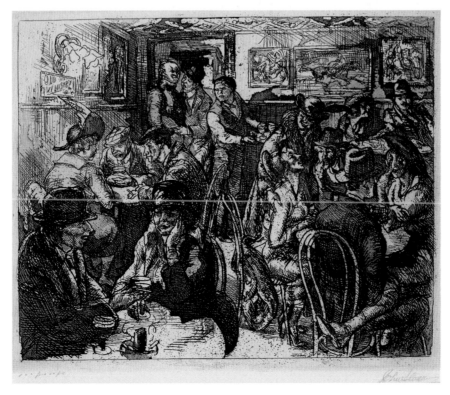

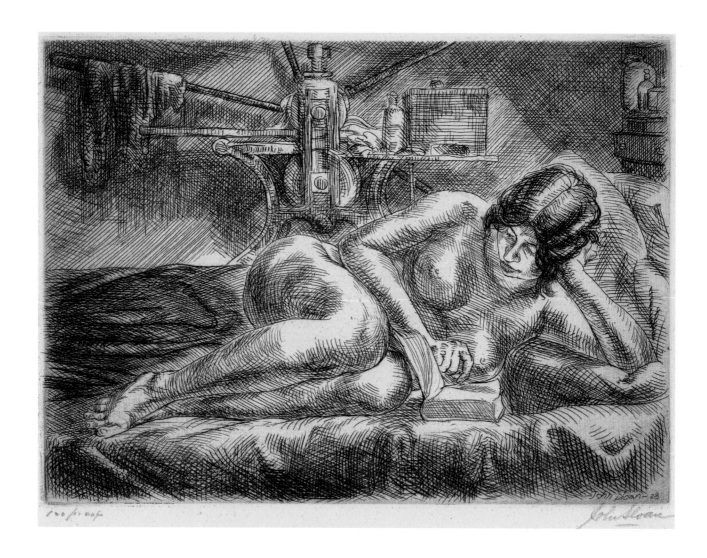

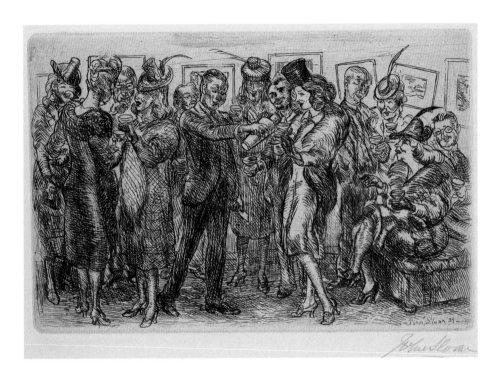

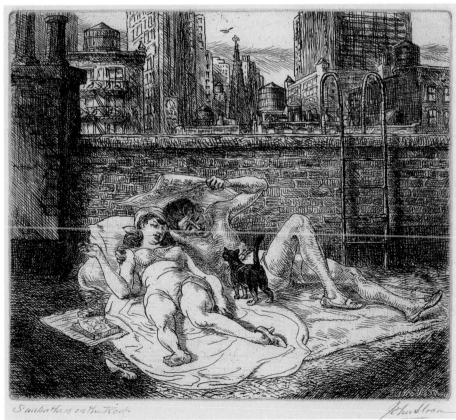

Peggy Bacon

1895–1987

Peggy Bacon was born into an artistic family from Connecticut: her mother was a painter of miniatures and her father a landscape artist who had studied in Paris and painted at Giverny, where he was a friend of the American Impressionist Theodore Robinson. After the suicide of her father in 1913, Bacon enrolled at the School for Applied Arts for Women in New York and then at the Art Students League from 1915 to 1920. Her teachers at the League, including John Sloan and George Bellows, were all former students of Robert Henri, who had been a friend of her father. In 1920 she met and married Alexander Brook, also a painter.

Although Sloan gave classes in life drawing and composition, printmaking was absent from the curriculum at the League. Bacon taught herself drypoint at this time, and although she would take up etching and lithography in the late 1920s, it would remain her preferred printmaking technique. Sloan was her favourite teacher at the League and his classes provided the subject for some of her first drypoints. His influence can be seen in her compositions and her interest in the anecdotal and the humorous. In 1919 her drypoints were shown for the first time at the Society of Independent Artists and at the Painter-Gravers of America in New York. In the same year her first book appeared, *The True Philosopher and Other Cat Tales*, which she also illustrated; she subsequently published a further nineteen books.

In 1927 she began a series of caricatures in chalk pastel that would prove highly successful, and pastel became her principal medium over the next twenty years. During this period she produced many caricatures of artists and friends, as well as light-hearted genre scenes, including the Lower East Side of Manhattan where she lived. From the mid-1930s she also taught widely in a variety of art schools, including initially at the Art Students League in 1935 and again from 1949 to 1951, as well as at the Corcoran Gallery of Art, Washington, DC, from 1942 to 1944. Her final teaching post was at Moore College of Art, Temple University from 1963–4, which awarded her an honorary doctorate.

With her eyesight failing, Bacon stopped making drypoints in the mid-1950s and returned to painting. She received many awards for her work, including a Guggenheim Fellowship in 1934 for her book of caricatures, *Off with Their Heads!*; in 1953 she was given the Edgar Allen Poe Mystery Award for her novel *The Inward Eye*. She was made a member of the National Institute of Arts and Letters, being twice elected its vice-president, in 1960 and 1962. Retrospectives of her work were held by Associated American Artists, New York, in 1942 and by the Smithsonian, Washington, DC, in 1975.

BIBLIOGRAPHY

Roberta K. Tarbell, *Peggy Bacon: Personalities and Places*, with a checklist of the prints by Janet Flint, exh. cat., Washington, DC: National Collection of Fine Arts, 1975

10 Lunch Room at the League

1918
Drypoint
Signed and titled in pencil. 151 x 202 mm
Flint 8
1980,0223.17

Peggy Bacon's first drypoint shows a scene of lunchtime at the Art Students League, which provided the subject matter for many of her early prints and where she often worked on the plates *in situ*. Bacon has portrayed herself, second row left, in striped jumper, looking out to the viewer; her fellow women students include Dorothy Varian, beside her; Doris Rosenthal, first row, in profile; and Isabel Howland, with glasses and hat in centre. Among the men who have been identified is Edmund Duffy, later a newspaper caricaturist, upper right, in jacket and tie, turned to the left.

As with Sloan, Bacon's technique was based upon observation and is anecdotal in nature. Although Sloan never taught her etching or drypoint but only gave her tuition in quick charcoal sketching, life class drawing and composition, Bacon was certainly aware of his etchings. Yet, in her early prints, Bacon's stylistic handling of the figures is more schematized and flattened than in the etchings of her mentor. The figures are first outlined and then filled in with shading, with particular emphasis given to the description of texture and pattern. Careful examination reveals that Bacon reworked certain areas of this initial plate, notably the 'ghost' figures of a woman in glasses with a bob haircut, centre left, and a spectacled man in a trilby hat beside the upper left figure in profile.

11 A Frenzied Effort

1925

Drypoint

Signed, dated and titled in pencil. 150 x 228 mm

Flint 57

1980,0223.18

In this drypoint Bacon returns to the theme of art student life first explored in her early prints. The print shows a life class at the Whitney Studio Club, where Bacon's husband, Alexander Brook, was then assistant director. In depicting the students' sketches of the model, as well as the actual figure of the nude, Bacon plays upon the notion of representation. She includes a discreet self-portrait in the figure of the woman in glasses in the back row, top left. Other artists have been identified: Mabel Dwight, who became well-known for her satirizing genre lithographs, seated lower left wearing a hat; and the lithographer George Overbury 'Pop' Hart, with spectacles and pipe, back row towards the centre. The spider descending on its thread top centre often appeared in Bacon's works and can be regarded as the artist's visual signature.

A Frenzied Effort illustrates a change in Bacon's working method from her earlier period at the Art Students League in 1919. Composition is more open and the outline of the figures more lightly drawn, with less shading. The greater emphasis on linearity is characteristic of Bacon's mature works in the period from 1920 to 1950.

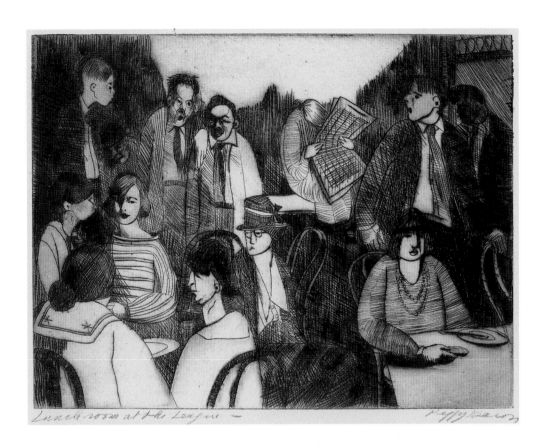

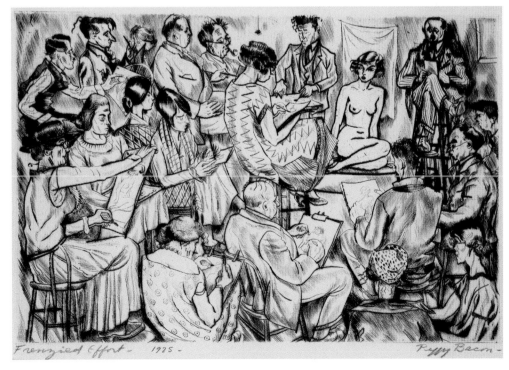

George Bellows

1882–1925

Born of a Methodist family, Bellows was the son of a building contractor in Columbus, Ohio. As a young man he excelled at sports and nearly became a professional baseball player, but was drawn to art which became his main interest. In 1901 he registered at Ohio State University, Columbus, but left without graduating in 1904, when he moved to New York and joined the New York School of Art. His teachers were Robert Henri and also, briefly, John Sloan, with whom he was associated as one of 'The Eight', known more colloquially as the Ashcan School. In 1913, under the direction of Sloan, he joined the art board of the left-wing periodical *The Masses*, producing some twenty-five illustrations for the magazine by 1917.

Bellows's career rose rapidly when measured against that of his contemporaries. His early paintings of street children, such as *River Rats*, 1906 (private collection) and *Forty-two Kids*, 1907 (Corcoran Gallery of Art, Washington, DC), which were composed in a broad, loose style, with strong contrasts of light and dark, attracted critical attention; *River Rats* was shown in the 1906 spring exhibition of the National Academy of Design. In 1909 he became the youngest ever Associate of the National Academy. He was involved in the hanging of New York's 'International Exhibition of Modern Art' at the Armory, in which his work was also included. From 1910 until 1919 Bellows taught in the life and composition classes at the Art Students League and in 1919 at the Art Institute of Chicago.

Bellows was introduced to lithography by the printer George Miller in 1916 when he had a press installed in the studio of his house on East 19th Street. From 1918–19 he began to collaborate with Bolton Brown as his printer. By the time of his early death from a burst appendix in 1925, he had produced some 193 prints; his most intense period was between 1923 and 1924, when he made sixty-four lithographs alone. The subjects of his lithographs ranged from sporting themes to images of New York street life, as well as political concerns, while studies of the nude and many portraits dominated the latter years. Bellows worked directly on the lithographic stone for immediacy and speed, and soon showed a mastery of crayon and wash techniques. Although his career was cut short, his reputation as one of America's most significant lithographers and painters has continued to grow.

BIBLIOGRAPHY

Lauris Mason, *The Lithographs of George Bellows: A Catalogue Raisonné* (1977), assisted by Joan Ludman and with a foreword by Charles H. Morgan, rev. edn, San Francisco: Alan Wofsy Fine Arts, 1992

12 A Stag at Sharkey's

1917
Lithograph
Signed on the stone; signed, titled and numbered '58' in pencil. 475 x 610 mm
Mason 46
1979,1006.91

By virtue of its large scale and powerful handling, this is Bellows's best-known lithograph and one of the most iconic images of twentieth-century American printmaking. Bellows based the lithograph on the composition of his earlier painting, *Stag at Sharkey's, August 1909*, 1909, now in the Cleveland Museum of Art. As prize fights in public were illegal in New York at the time the painting was done, the way round the prohibition was to hold them in private clubs, such as Tom Sharkey's Athletic Club. These events were called 'stags' and the fighter had to be a 'member' of the club, tickets for which were called 'dues'. Sharkey's Club was located close to Bellows's first studio in the Lincoln Arcade Building on 1947 Broadway, to which he moved in 1906 with his friends Ed Keefe and Fred Cornell and where many artists had their studios.

By 1917, when this print was made, prize fighting had become legal and popular. While Bellows made sixteen lithographs of boxing subjects in all, *A Stag at Sharkey's* was his most ambitious and monumental work. It was printed in an edition of ninety-nine, the largest edition of all his lithographs. The boxers are arranged in a strong, pyramidal composition that recalls classical sculpture; the force of their action is evoked by interlocking forms and bold diagonal lines. Whereas in the 1909 painting the boxers were enclosed behind ropes, these were largely removed from the foreground of the lithograph, thus pitching the viewer into the roaring crowd. Bellows delineates musculature through careful shading with the lithographic crayon, reserving a broader technique for the rest of the composition. Whereas the fighters' features remain anonymous, Bellows differentiates the faces of the spectators, showing a range of social types from the office clerk in tie to the worker in shirtsleeves.

13 Dance in a Madhouse

1917
Lithograph
Signed on stone; signed by the artist's daughter 'Geo Bellows. JBB' and inscribed 'No.9' in pencil. 470 x 625 mm
Mason 49
1979,0623.1

As a young man Bellows was a friend of the family of the superintendent of the State Hospital in his home town of Columbus, Ohio. This large, Goyaesque lithograph was inspired by memories of visits there when dances for the inmates would be held. Bellows gave an extended commentary on this print:

> For years the amusement hall was a gloomy old brown vault where on Thursday nights the patients indulged in 'Round Dances' interspersed with two-steps and waltzes by the visitors. Each of the characters in this print represents a definite individual. Happy Jack boasted of being able to crack hickory nuts with his gums. Joe Peachmyer was a constant borrower of a nickel or a chew. The gentleman in the center had succeeded with a number of perpetual motion machines. The lady in the middle center assured the artist by looking at his palms that he was a direct descendant of Christ. This is the happier side of a vast world which a more considerate and wiser society would reduce to a not inconsiderable degree. (cited by Mason, p. 104)

The lithograph follows a drawing of the same size in black crayon, charcoal and ink (now in the Art Institute of Chicago) which Bellows made ten years earlier. The cold black ink in which the lithograph is printed heightens the terrible power and drama of the subject and its overt reference to Goya's oil painting, *The Madhouse*, 1794 (Royal Academy of San Fernando, Madrid). The initials on this impression are those of his daughter Jean Bellows Booth; after his death, his widow Emma Story Bellows, and then her daughter, signed impressions as they were sold from the estate.

14 Electrocution

1917
Lithograph on oriental paper
Signed on stone; signed, titled and inscribed in pencil 'No 10'. 208 x 300 mm
Mason 42. II
1980,0510.10

Bellows described this print 'a study of one of the most horrible phenomenon [*sic*] of modern society' (cited by Mason, p. 88). Although Bellows did not elaborate further on its making, it has been suggested that it was prompted by the death sentence passed down on Thomas J. Mooney, a labour activist convicted of being involved in anarchist bombings during a patriotic parade in San Francisco in 1916. The US Government was seeking at the time to persuade the American people of the need to intervene in the First World War, and Mooney's cause became a rallying point for both anarchists and socialists. *The Masses* periodical, with which Bellows was closely involved, was strongly opposed to the death sentence.

Bellows's horrific subject recalls Goya's etching, *The Garrotted Man* (late 1770s), where the victim is also tied to an upright rectangular block. Bellows equates the fate of those executed by the State with secular martyrdom. Certain devices from religious art are used, such as the signifying of the condemned man by lighter tones, in contrast to the darker tones of his executioners. After a few minor changes were made in the third state, the print was cut down on either side in two versions, progressively giving more prominence to the victim.

15 Solitude

1917
Lithograph on oriental paper
Signed on stone; signed, titled and numbered 'No.1'
in purplish ink. 438 x 394 mm
Mason 37. I
1979,0512.5

Bellows identified the scene as New York's Central
Park on a spring night. The title contains an
element of ironic humour – a lonely man on a park
bench surrounded by amorous couples who can
find no solitude. Bellows's night scene speaks
of the isolation of the individual in the modern
metropolis.

A certain awkwardness in the handling of the litho-
graphic technique betrays this as one of Bellows's
early prints. The man's form is roughly blocked
in with lithographic crayon, the arms and hands
reduced to a few basic shapes. The soft, deep
shadows are achieved with tusche over crayon
work. Certain contours and areas of shadow that
required lightening are scratched through the
drawn stone with the needle. An edition of sixty
was printed of this print. Bellows subsequently
worked over the stone, plunging the scene into
almost complete darkness, but only a few proofs
of the unsuccessful second state were printed.

16 Business Men's Bath

1923
Lithograph on simili-japan paper
Signed on stone; signed and titled in pencil and
countersigned by the printer 'Bolton Brown – imp' in
pencil. 300 x 432 mm
Mason 145
1979,0512.4

When Bellows first arrived in New York in 1904 he
stayed at the YMCA, and this print is a recollection
of his initial experiences of the city almost twenty
years earlier. The subject is a humorous reworking
in reverse of the composition of an earlier litho-
graph, *The Shower-Bath* (Mason 45) of 1917.

The pose of the young man in the foreground,
with hand on hip and one leg raised, is taken
from Eakins's painting *The Swimming Hole*,
1885 (Amon Carter Museum, Fort Worth). Unlike
Eakins's static treatment, Bellows imbues his
figures with a naturalistic dynamism, from the
young man poised to dive into the crowded pool
to the surfacing figure, bottom right, gasping for
breath. In perhaps a comment on his ageing body,
Bellows contrasts the younger athletic bodies with
the bulkier frame of the older men. The figure
of the heavy-set man, foreground left, is posed
to ironically evoke the *Farnese Hercules* (Museo
Archeologico Nazionale, Naples), the famous
classical image of masculine strength. Through
glance and gesture, Bellows sets up a relationship
between this figure and the boy whispering to the
older man in the background, who both turn to-
wards him.

This impression is countersigned by Bolton Brown,
the highly skilled printer of artistic lithography
with whom Bellows collaborated closely from
1919.

Bellows
A Stag at Sharkey's

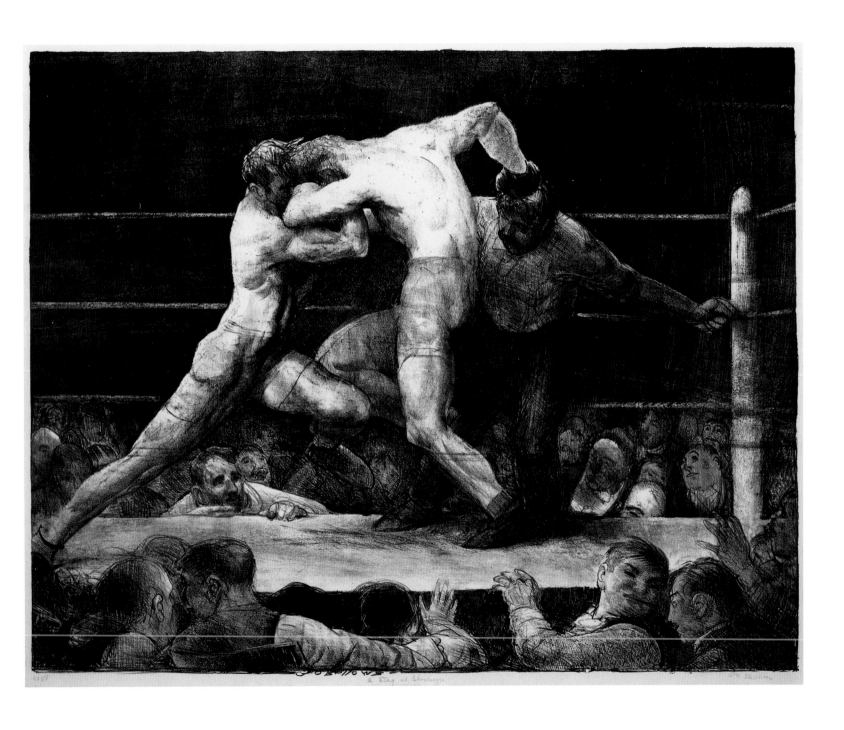

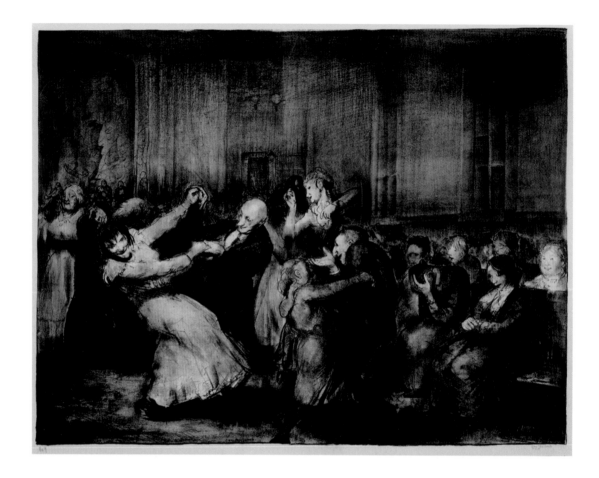

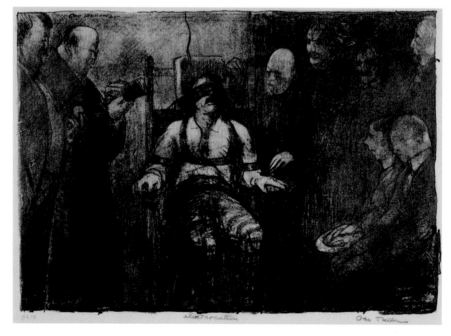

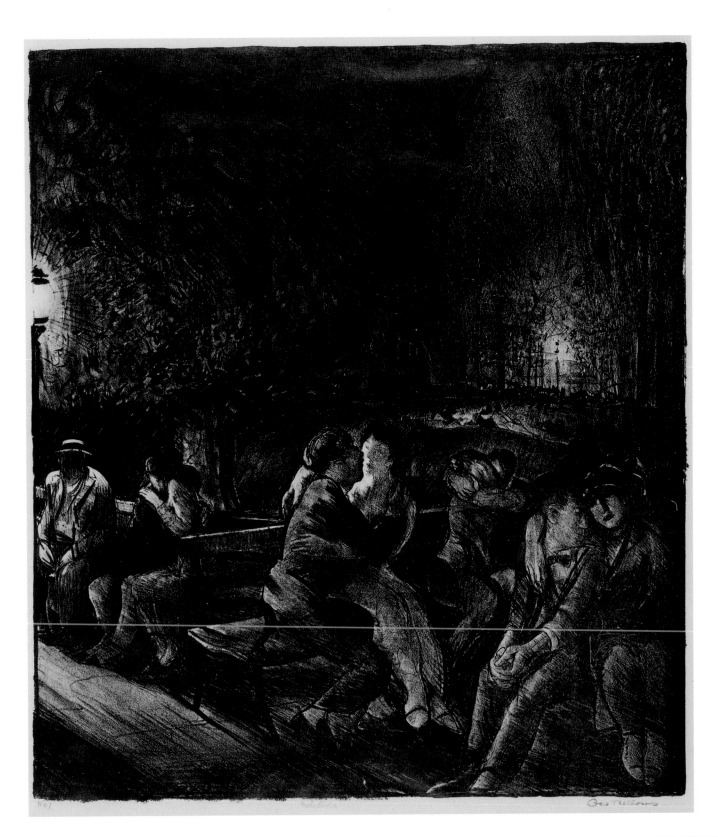

16

Bellows
Business Men's Bath

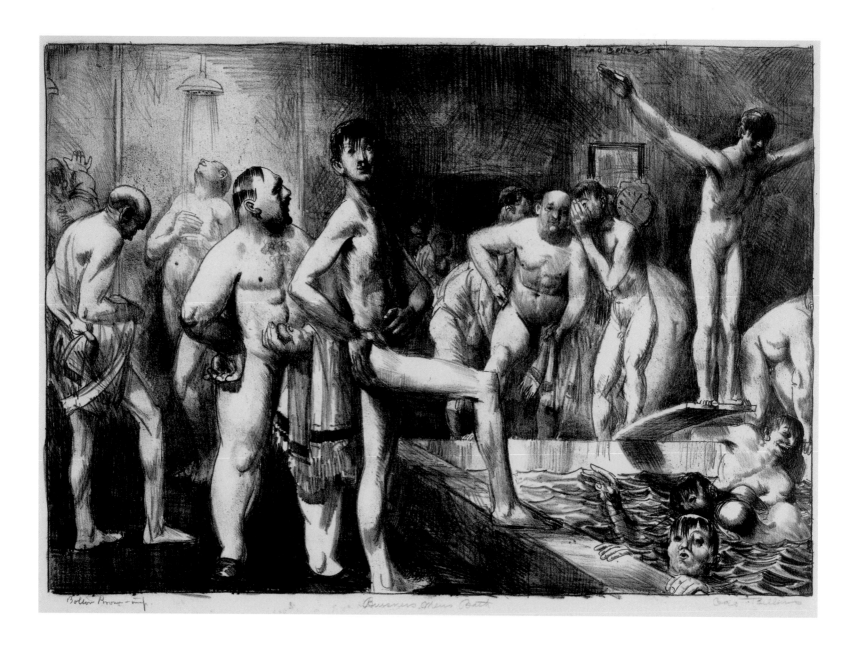

2 THE PROVINCETOWN WOODCUT

William Zorach

1887/9-1966

Born in Lithuania in either 1887 or 1889 (authorities give conflicting dates), Zorach emigrated to America with his family in 1893; they settled in Cleveland, Ohio, and adopted the surname 'Finkelstein'. Upon finishing an apprenticeship with the Morgan Lithography Company, commercial printers, during which period he also took evening classes at the Cleveland School of Art, William Finkelstein moved to New York in 1908 to study at the National Academy of Design for two years. In 1910 he travelled to Paris where he studied at La Palette, a progressive art school, and there met his future wife Marguerite, also an artist. In Paris he was exposed to the work of Matisse and the Fauves as well as of the post-Impressionists, which would influence his future direction.

After their return to the United States and marriage in 1912 (where they assumed William's given name 'Zorach' as their surname), the Zorachs settled in New York where they became hosts of a 'salon' of writers and artists, including Marsden Hartley and Max Weber. Zorach himself wrote poetry, and this he published in several avant-garde periodicals, together with reproductions of his linocuts. Zorach was closely associated with *Others*, an experimental poetry magazine launched in 1916, to which he contributed linocuts as covers and end-pieces and on which he served as its art editor in 1918. In 1916 the Zorachs spent their first summer at Provincetown, Massachusetts, where they designed sets for the Provincetown Playhouse and contributed to the artistic life of the community; they spent subsequent summers there from 1921 until 1923, when they purchased a rural retreat in Maine. William Zorach also began to teach, initially from the Zorachs' studio and apartment in New York, where joint exhibitions of their work were held, and then from 1929 until 1959 at the Art Students League. From 1946 until his death in 1966 he was also visiting artist during the summer at the Skowhegan School of Painting and Sculpture in Skowhegan, Maine.

Although William Zorach began his career as a painter and from 1923 concentrated on direct-carving sculpture, he also made a small group of some twenty-four prints, nearly all linocuts, during his formative years between 1915 and 1922. Although he shortly abandoned printmaking in favour of sculpture, the process of cutting straight into the lino foreshadowed his subsequent technique of direct carving. His first wood reliefs are based on the motifs and compositions of his graphic work. His autobiography, *Art is My Life* (Cleveland and New York: The World Publishing Company, 1967), was published posthumously. In 1967, a year after his death, the Smithsonian American Art Museum, Washington, DC, gave him a retrospective; the same institution holds more than seven hundred of his works.

BIBLIOGRAPHY

Efram L. Burk, 'The Prints of William Zorach', *Print Quarterly*, vol. 19, no. 4 (December 2002), pp. 353–73 (with 3 appendices of Zorach's prints)

Jessica Nicoll and Roberta K. Tarbell, *Marguerite and William Zorach: Harmonies and Contrasts*, with annotated chronology by Margaret MacDougal, exh. cat., Portland Museum of Art, Maine, 2001

17 The Weirs

1916
Linocut on thickish oriental laid paper
Signed, titled 'The Wiers' (*sic*) and dated in pencil.
294 x 216 mm
2002,0929.159. Bequeathed by Jacob Kainen

This linocut comes from the period when the Zorachs spent the summers in Provincetown. Located on the peninsula of Cape Cod, this fishing village was famous for the cod caught off the banks from boats using fishing nets called 'seiners'. These hung vertically in the sea with floats on the top and weights on the bottom, their ends drawn together to encircle the fish in 'weirs'.

Zorach sought a transcendentalist view of man and nature. As he explained of an earlier painted version of *Seiners* upon which this print is based, 'In this picture there is not the ordinary realism, but there are other truths – of the sea-lines, triangles, of the strange boat, reflections, and encircling weirs, and the mysterious relations of men and boat and sea' (cited by Burk, p. 360). By echoing the shape of the boat, with the shape of the rising sun, sea, the mountains and the teeming shoal of fish, Zorach placed his human figures and their unceasing toil in harmony with the rhythms of nature.

Zorach gave variant titles to his prints in different impressions and some are dated 1915. Although this impression is titled 'The Weirs', this linocut is usually called 'Seiners' in the literature. There was also a coloured version made by applying oil paint to selected areas of the block. The block itself is in the Smithsonian American Art Museum.

18 Mountain Stream

1916
Linocut on yellow laid paper
Signed in pencil. 274 x 355 mm
1992, 1008.53

William and Marguerite Zorach's experiences during their summer retreats inspired Zorach's depictions of man in harmony with nature. In his autobiography, *Art is My Life*, he recalled their summer of 1914 at Chappaqua with its forests and mountain pools: 'The country was a new world to me – every flower and every weed was a revelation of color and design.... Flowers bloomed, wild life carried on, clouds floated, trees designed themselves in the landscapes. Nude figures lay around pools, played with children, made love, dreamed' (cited by Burk, p. 358). *Mountain Stream* evokes this forest idyll through the integration of the bathing figures within the overall design of luxuriant natural growth. The rhythms and curvilinear movement owe a debt to Art Nouveau, particularly German Jugendstil, as well as to Fauve painting, which the Zorachs had admired during their stay in Paris a few years earlier. Zorach's linocuts were printed by hand without a press; in this example the block has been printed in a heavy black ink on a yellow oriental paper for contrast.

17
Zorach
The Weirs

18
Zorach
Mountain Stream

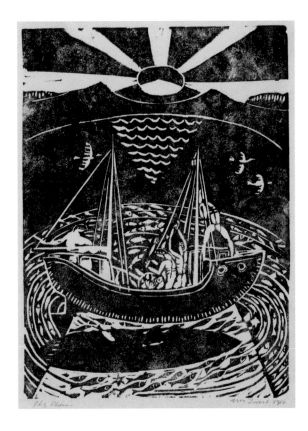

Blanche Lazzell

1878–1956

Born in Maidsville, West Virginia, on the family farm, Lazzell graduated from West Virginia University in drawing, painting and art history in 1905. When almost thirty she moved to New York to study at the Art Students League from 1907 to 1908. From 1912 to 1913 she lived in Paris, where she enrolled at the Académie Julian, and discovered the work of Matisse, Picasso and Braque. In 1913 she returned to West Virginia, founding her own art school at Morgantown, and began to exhibit there the following year. In 1915 she joined the artists' colony of Province-town, Massachusetts, where she was reunited with many of her artist friends from Paris, including Ethel Mars and Maud Squire.

Lazzell became a prominent member of the newly founded Provincetown Printers, who advocated the white-line woodcut technique introduced to the group by the Swedish-born Bror Julius Olsson Nordfeldt in 1916; she learnt the technique from fellow-member Oliver Chaffee. Her first woodcuts were shown at the Province-town Art Association in 1917, and she was included with other Provincetown Printers in 'Wood Block Prints in Color by American Artists' at the Detroit Institute of Arts in 1919.

In 1923, at the age of forty-five, Lazzell made a second trip to France to study Cubism at first hand from Fernand Léger, André Lhote and Albert Gleizes. The private tuition she received from Gleizes was particularly important to her. While in Paris she exhibited at the Salon d'Automne in 1923 and 1924; she also took part in the major exhibition of abstract painting, 'L'Art d'aujourd'hui Exposition inter-nationale', in 1925. Returning to Provincetown in 1926 she built a new studio, and henceforth divided her time between Provincetown and Morgantown. In the late 1920s she was invited by Katherine Dreier to join the Société Anonyme, estab-lished by Dreier, Marcel Duchamp and Man Ray in 1920 for the promotion of modernism in America. In 1934, at the height of the Depression, Lazzell was hired under the WPA/FAP programme to make woodcuts of historical buildings around Morgantown and a civic mural for the local court room. By her own calculation she had made seventy-seven prints and ten oils under the WPA/FAP by 1938. In 1937, being always open to fresh ideas, she joined Hans Hofmann's summer classes in Provincetown, where his interests and experience of Paris abstraction coincided with hers. She continued to attend Hofmann's classes during the 1940s. In 1949 Lazzell was recognized as a pioneer of American abstraction when her work, with three other Provincetown artists, was included in 'Forum 49', Provincetown, alongside fifty painters of the emerging Abstract Expressionist School.

Although Lazzell also painted, worked in ceramics and made hooked rugs, she is recognized as the leading exponent of the modernist Provincetown woodcut. In all she produced some 138 woodcuts up to the early 1950s; but her most active period was between the wars, when she made ninety prints.

BIBLIOGRAPHY

Barbara Stern Shapiro, *From Paris to Provincetown: Blanche Lazzell and the Color Woodcut*, exh. cat., Boston: Museum of Fine Arts, 2002

19 The Blue Vase

1927

Colour woodcut on thickish on oriental laid paper
Signed with artist's initials on block; signed, titled 'The Blue Vase' and dated in pencil. Verso inscribed by the artist 'Wood Block Print / "The Blue Vase" / Blanche Lazzell/ Provincetown Mass / Nov 7 1927' and numbered '191 / 2'. 354 x 309 mm

2003-12-31-14. Presented by Leslie and Johanna Garfield through the American Friends of the British Museum in honour of Stephen Coppel

The white-line woodcut technique used by Blanche Lazzell and the Provincetown Printers was distinctive. Instead of making a colour print by the laborious process of cutting a separate block for each colour, which would then need to be carefully registered for printing, a single block was used. The block was cut with a gouge, with each segment of the design differentiated by a deep groove. Each segment could then be inked in a different colour and printed in one operation, with the incised grooves printing as white lines.

In this major example Lazzell demonstrates the cubist teachings of Albert Gleizes, with whom she studied in Paris from 1923 to 1925. As Lazzell asserted, 'Cubism is to express volume and strength by the use of geometric forms' (cited by Shapiro, p. 21). Taking the still life, a favourite motif of the Cubists, Lazzell has analysed the com-position as a series of interlocking planes of colour. The grain of the woodblock is exploited by hand-printing to give texture to the print.

A variant title for this print is *The Blue Jug*; an impression so titled was acquired by the Philadelphia Museum through the WPA/FAP in 1937. Colour variants also exist. Lazzell's system of numbering her prints requires explanation: the artist gave the total of impressions she had printed to date, followed by the number of impressions taken from the particular block in question; in this case, Lazzell had produced a total of 191 impressions from all her blocks by 7 November 1927, but only two impressions from this one.

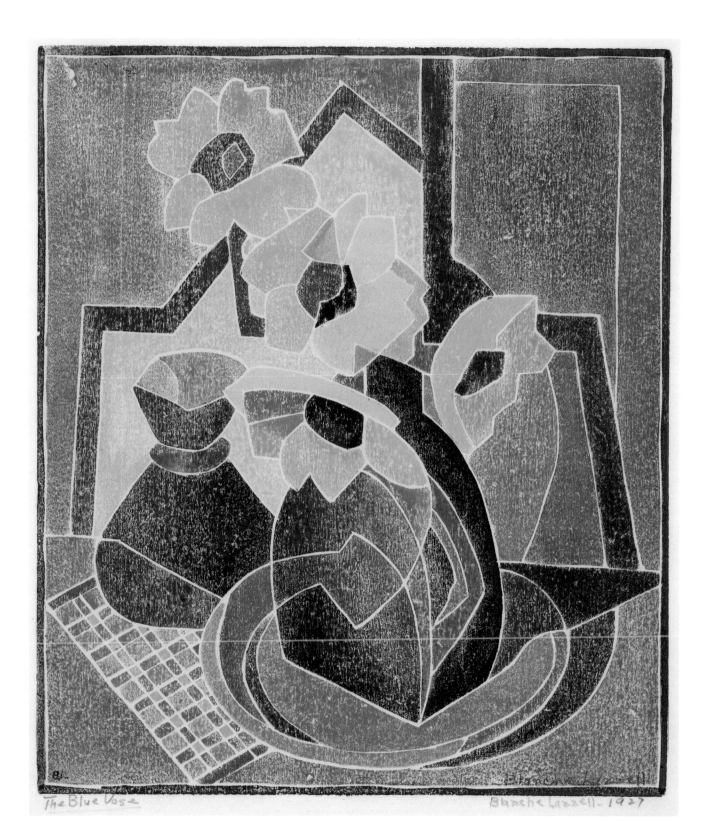

The Blue Vase

Blanche Lazzell – 1927

Grace Martin Taylor

1903–1995

Born in Morgantown, West Virginia, Grace Martin Taylor was a younger cousin of Blanche Lazzell, who encouraged her artistic talent. In 1921 she enrolled at West Virginia University, Morgantown, which Lazzell had first attended some twenty years earlier. Not finding instruction in the studio arts at West Virginia University sufficiently rigorous, in 1922 Grace Taylor supplemented her studies at the Pennsylvania Academy of Fine Arts, Philadelphia, where her teachers Arthur B. Carles and Henry McCarter introduced her to abstraction.

After graduating from West Virginia University in 1929, she took up Lazzell's invitation to come to Provincetown, where she learned the technique of white-line colour woodblock printing and soon assumed proficiency. Taylor joined the American Color Print Society as one of its founders, as well as the Woodcut Society based in Kansas City, Missouri. In 1933, one of her woodcuts, *Studio Window*, was nominated by the Printmakers Society of California for the Fifty Best Prints of the Year.

Although she made periodic visits to Provincetown, where, like Lazzell, she attended Hans Hofmann's summer classes in the 1940s, Taylor largely spent her career in West Virginia, where she was committed to art education. For more than forty years she taught at Mason College of Music and Fine Art in Charleston, eventually becoming its president. In 1931 she set up the Allied Artists of West Virginia, helping with its exhibitions; she also established the Creative Arts Festival of West Virginia and sat on various state educational and historical bodies. Her commitment to art education in West Virginia brought her several official honours. In 1998 the National Museum of Women in the Arts, Washington, recognized her role as a woman pioneer of American abstraction with a special display of her 1938 painting *Still Life with Ukulele*.

BIBLIOGRAPHY
Grace Martin Taylor (1903–1995): An American Modernist, exh. cat., New York: The Orange Chicken, 7 September–7 October 2001

20 Composition No. 1

1930 or 1939
Colour woodcut on thickish oriental laid paper
Signed with partial signature and date 'Grace Martin [Frame erased] 193 [0 or 9]', titled and numbered '3/35' in pencil. 305 x 356 mm
2003,1231.16. Presented by Leslie and Johanna Garfield through the American Friends of the British Museum in honour of Stephen Coppel

Grace Taylor was a committed advocate of abstraction. She explained the rigour of her work in abstraction by making the analogy with musical composition:

> There is excitement planning a movement around a pivot, in, out, and across a picture plane to plot a design which is vibrant with harmonic life. That brings up music. A melody in music can flow up and down the scale. A harmony in painting flows in and through the field by virtue of relationships of color, space, and plane. Making all these elements behave is similar to conducting a symphony orchestra – trying to have all the parts working together and in harmony to express a unified composition (cited in *Grace Martin Taylor*, Orange Chicken exh. cat., n.p.).

Several of Taylor's woodcuts, watercolours and paintings from the 1930s to the early 1950s take up the cubist motif of the musical instrument. In this white-line woodcut she achieves the effect of cubist passage through the subtle blending of tones and by allowing the grain of the woodblock to assert itself. The artist later preferred to use her maiden name, Martin, which explains why several early impressions of her prints, like this one, have the surname of her first husband, Frame, erased, and in this case regrettably also the date. Taylor was the name of her second husband.

Taylor

Composition No. 1

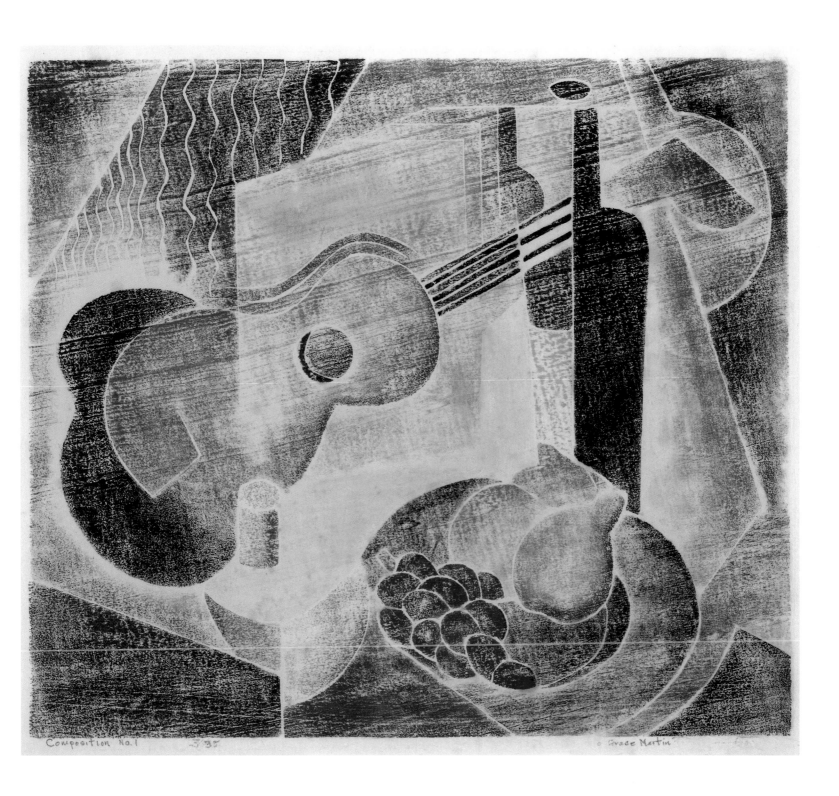

Composition No. 1 '35 © Grace Martin

3 AMERICAN MODERNISM AND PRECISIONISM

John Marin

1870–1953

John Marin was born in Rutherford, New Jersey. His mother died very shortly after his birth and his father, a successful public accountant, entrusted Marin's up-bringing to maternal grandparents. His father sought a business career for his son but nothing came of it, and for several years he worked in an architectural office. In 1899 Marin enrolled at the Pennsylvania Academy of Fine Arts, where he stud-ied under Thomas P. Anshutz, but he cut short his studies after two years and then briefly tried at the Art Students League, New York. As Marin found art school uncongenial, his father sent him on an extended trip to Paris in 1905. Marin trav-elled widely in Europe, largely supported by his father, until 1911. He produced his first etching in Paris in 1905, at the age of thirty-five, where his step-brother, the painter Charles Bittinger, gave him his unwanted etching materials. Though self-taught, Marin became technically accomplished in etching and produced architectural views of European cities (Paris, Amsterdam, Venice, Rouen) in an impressionistic manner influenced by Whistler. During his six years in Europe he produced more than 100 etchings, which began to find an outlet with the dealers Albert Roullier in Chicago and Louis Katz in New York.

In 1911 Marin returned permanently to the United States where the photographer Alfred Stieglitz, who ran the avant-garde 291 Gallery in New York and who had first met the artist in Paris, became his patron. Steiglitz's offer of an annual stipend gave Marin freedom to paint and make watercolours of New York and of the rural landscape of Maine, where he often spent his summers from 1914. Marin showed an important group of watercolours inspired by the bridges and sky-scrapers of New York at 291 in 1913, the same year as the Armory Show in which he also participated. His etchings of the Brooklyn Bridge (Zigrosser 107–12) and the Woolworth Building (Z. 113–16), both produced in 1913, were the most expressionistic of his career. The etchings following his return to America were entirely of urban themes and remained so until 1932, although as a painter during this period Marin's principal preoccupations were with mountain landscapes and the sea. From 1920 he spent nearly all his summers in Maine but his press and etching tools remained at his house in New York at Cliffside, New Jersey. By con-trast to those of his European years, his American etchings were less prolific; just over fifty were produced between 1911 and 1931. Throughout his career Marin mostly printed his own etchings. He resumed etching in 1941, producing a few nude studies and figural studies inspired by the coastal life of Maine.

Marin's achievements as a painter and etcher were recognized with his first, major retrospective at the Museum of Modern Art, New York in 1936. The Philadelphia Museum of Art, which owns the most comprehensive collection of his etchings and some sixty-six of his plates, organized an exhibition of his complete etchings in 1969.

BIBLIOGRAPHY

Carl Zigrosser, *The Complete Etchings of John Marin, Catalogue Raisonné*, exh.cat., Philadelphia: Philadelphia Museum of Art, 1969

21 Brooklyn Bridge, No. 6 (Swaying)

1913
Etching
Signed, titled: 'B.B. 6' and dated on plate; signed in pencil. 272 x 222 mm
Zigrosser 112
1980,0510.69

Brooklyn Bridge was one of Marin's most signifi-cant urban subjects. Over the course of his career he produced some eighteen etchings showing this iconic modern structure from various viewpoints, but this is his best known. Shortly after his return to America in 1911 he adopted a modernist idiom to express the rising New York of skyscrapers and bridges that confronted him. In 1913, when this etching was made, Marin explained in a catalogue of his modernist watercolours at the 291 Gallery his emotional reaction to the cityscape:

> … if these buildings move me, they too must have life. Thus the whole city is alive; build-ings, people all are alive; and the more they move me the more I feel them to be alive … And so I try to express graphically what a great city is doing. Within the frames there must be a balance, a controlling of these warring, pushing, pulling forces (cited by Zigrosser, pp. 16–17).

Using brisk, broad lines, Marin conveys the way-ward sway of Brooklyn Bridge with an expression-istic urgency in this etching.

Marin often drew directly onto the copper plate in front of the motif; in this case there are two pre-liminary etched studies of this viewpoint. Marin nearly always did his own printing. *Brooklyn Bridge, No. 6 (Swaying)* was published by Stieglitz at 291 Gallery, New York in an edition of probably no more than twelve impressions. As in this print, Marin would etch his name, the date and sometimes the title on the plate itself, a prac-tice he adopted shortly after he began to etch. Zigrosser surmises that Marin only signed in pencil those prints which were released for publication, although the artist only numbered his editions sporadically.

22 Downtown, the El

1921
Etching
Signed and dated on plate. Collector's stamp
'JK' (Jacob Kainen) on verso. 173 x 222 mm
Zigrosser 134
2002,0929.137. Bequeathed by Jacob Kainen

The etching was produced for a mixed portfolio
of prints entitled *Six American Etchings
(Series I)* published by the left-wing periodical
New Republic in 1924 in an edition of between
five and six hundred. The portfolio was offered for
$8.00 to readers taking out a year's subscription
of the magazine. As well as Marin, the portfolio
included etchings by Sloan (*Bandits Cave*, 1920,
Morse 195) and Edward Hopper (*Night Shadows*,
1921, Levin 82).

An alternative etching, *Brooklyn Bridge and
Lower New York* (Zigrosser 106), was also in-
cluded by Marin in the *New Republic* portfolio. He
made two preliminary etched studies before mak-
ing the final plate; after about thirty proofs had
been taken, the plate was steel-faced for the large
New Republic edition.

Unlike Sloan or Hopper, Marin's images of the
cityscape are devoid of anecdotal content. Figures
are only indicated as indistinct marks to suggest
the urban rush through the canyons of Manhattan.
Marin has arranged the composition by a careful
counterbalance of dynamic tensions; the vertical
thrust of the skyscraper is opposed by the pro-
nounced diagonal cut of the elevated railway line.

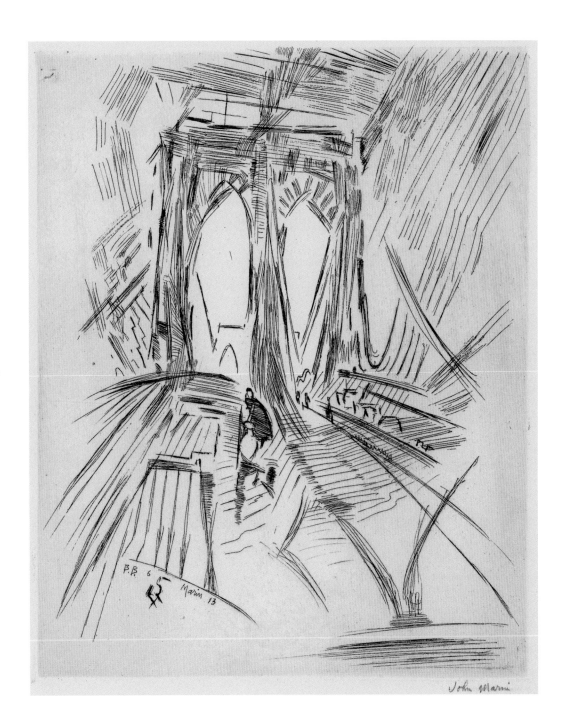

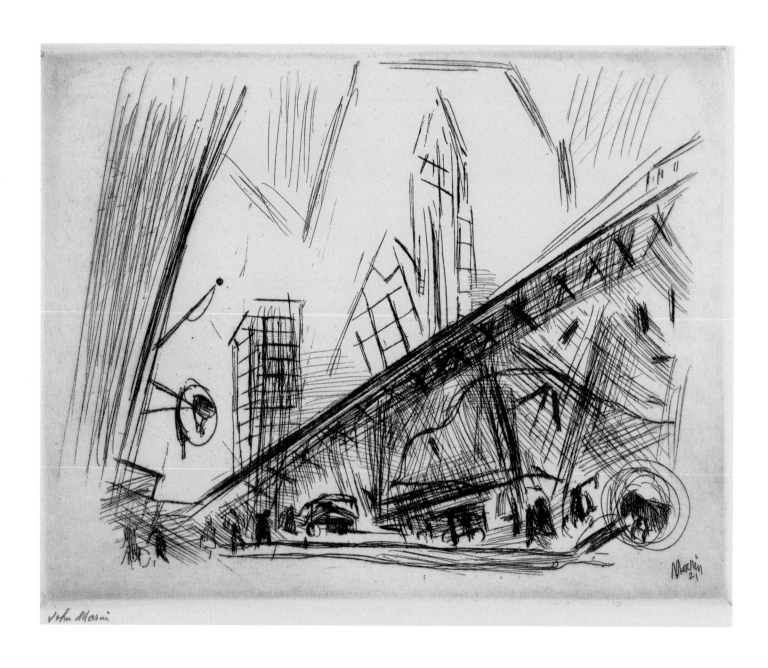

Jan Matulka

1890–1972

Born in Vlachovo Brezi, in Austro-Hungarian Bohemia, Matulka emigrated to America with his family in 1907, having spent two years studying art in Prague. Although principally known as a painter, he also made prints during the 1920s. From 1908 until 1917 he was a student at the National Academy of Design, New York, where he was introduced to printmaking. He seems to have first taken up etching seriously in 1923, when he dedicated several prints to his friend Eugene Fitsch. Fitsch gave him access to the workshop facilities at the Art Students League, where Matulka formally enrolled in etching classes in 1925. It was also Fitsch, in all likelihood, who introduced Matulka to lithography in about 1925, and the two worked closely as printmakers over the next couple of years.

Between 1919 and 1924 Matulka made a series of trips to Paris where he gained first-hand experience of the European avant-garde. He also spent his summers in Czechoslovakia, and in 1921 he made a linocut of a Czech hill town, which is stylistically indebted to André Derain. In 1923 he exhibited several drawings in Prague with the Czech modernists Josef Capek, Josef Síma and Václav Spála. His mature graphic art, as well as his paintings, are characterized by a cubist and fauvist vocabulary derived from the School of Paris and Czech Cubism, which he aligned with American Precisionism.

During the 1920s Matulka showed regularly; in 1926 his second solo show of paintings and lithographs at the Art Center, New York was organized by Katharine Dreier, founder of the Société Anonyme. In 1929 Matulka began to teach at the Art Students League, and although this came to an end in 1931, his classes on life drawing, painting and composition had a profound impact on his students, including the sculptors David Smith and Dorothy Dehner, who later acknowledged his importance to them. During the Depression Matulka joined the various relief projects, initially with the Public Works of Project in 1933 and then with the WPA/FAP from 1935 to 1939, during which period he painted murals for the Williamsburg Federal Housing Project, Brooklyn. His last solo show of current work was held in 1944. Interest in Matulka revived following the David Smith retrospective at the Guggenheim in 1969.

Some forty-one prints are recorded by Janet Flint and of those nearly half are believed to have been produced between 1925 and 1928. Matulka's career as a printmaker effectively stopped around 1930. The reason for this lay in the changing taste in printmaking. Due to the Depression there was a move away by artists from the type of European experimentation which characterized Matulka's work towards prints of the American Scene.

BIBLIOGRAPHY

Patterson Sims and Merry A. Foresta, *Jan Matulka 1890–1972*, with a memoir by Dorothy Dehner and a checklist of the prints by Janet Flint, exh. cat., Whitney Museum of American Art and the National Collection of Fine Arts: Smithsonian Institution, Washington, DC, 1980

23 Boat Scene in Central Park

1923
Drypoint with etching and heavy plate tone
Initialled on plate. 275 x 345 mm
Flint 20
2007,7001.4. Presented by Dave and Reba Williams

This drypoint shows a nocturnal boating party on the Lake in New York's Central Park. A barefoot sailor pushes off a courting couple in a rowing boat from a rickety wooden landing stage along the Lake's undulating shoreline. Central Park had been laid out in 1858 to give the residents of densely packed lower Manhattan a public recreational area and green space.

Matulka, in the manner of Cézanne, has simplified the figurative forms. A few years later his compositions became more cubist in their arrangement (see cat. 24). The motif of the boating party was one to which Matulka returned in his 1925 lithograph *Boat Scene in Central Park* (Flint 23) and his watercolour *Sailors and Boats*, around the same year. Although these boating scenes are rendered using a modernist idiom, Matulka here also evokes the tradition of the *fête champêtre*, such as Watteau's *Departure for the Island of Cythera*, 1717 (Louvre, Paris).

The soft and velvety black tones of this night-piece have been achieved with drypoint. Three states of this print are recorded by Flint, and this proof is possibly between the first and second states. The paper is watermarked 'J. Whatman 1923' and the inky margins give every indication of a print pulled by Matulka himself. Traces of newsprint on the left edge of the sheet suggest that the proof was laid on newspaper to dry.

24 Untitled (Dancing Woman with Parasol)

c.1929
Lithograph
Not signed or dated. 298 x 187 mm
Flint 16
1989,0304.1

This print is identical to a gouache and watercolour of the same subject from 1929, whose forms echo the syncopated rhythms of jazz. Matulka also made a companion lithograph at the same time, *Untitled (Man at Table with Banjo)* (Flint 17). Matulka was more interested in the experimental possibilities of printmaking than in the making of marketable images. He rarely dated or signed his prints and almost never produced formal editions. His lithographs are also characterized by a lack of technical 'polish'. Matulka often worked on chipped or irregular stones; the improvisatory manner of his printmaking is clearly visible in this lithograph by the inking to the edges of the stone.

Printed in purple-black ink, this lithograph has analogies with Matulka's paintings in the use of various textures. As well as scratching directly into the lithographic tusche, he has also pressed fabric to reproduce texture.

23
Matulka
Boat Scene in Central Park

24
Matulka
Untitled (Dancing Woman with Parasol)

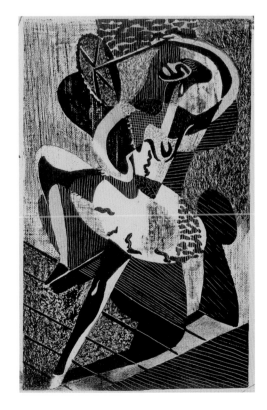

Louis Lozowick

1892–1973

Lozowick was born into an impoverished family of orthodox Jews in a Ukraine village. He moved to Kiev in 1903 where he enrolled at the Kiev School of Art. With the outbreak of the 1905 Revolution he left Russia and joined his brother in America in 1906. From 1912 to1915 he studied at the National Academy of Design, New York, followed by further studies at Ohio State University, where he graduated in 1918.

Lozowick's most formative years were spent in Europe from 1920 until 1924. In 1920 he lived in Paris, mixing freely with the international artistic community, and in 1922 he briefly visited Moscow, where he met Kasimir Malevich and Vladimir Tatlin. But it was Berlin, where he lived between 1922 and 1924, which had the most profound impact in developing his machine aesthetic, initiated through his friendship with the Russian Constructivist El Lissitsky and other émigré artists. Inspired by their machine-age aesthetic, Lozowick began a series of paintings of American cities recalled from a journey he had made across America in the year prior to his departure. In Berlin he also produced his first lithographs, *Cleveland* and *Chicago*. During these years he also contributed articles and translations to the avant-garde periodical, *Broom*. He exhibited with Lissitsky and his circle in Düsseldorf in 1922, and had his first solo exhibitions in Berlin in 1922 and 1923.

Lozowick returned to America in 1924. Encouraged by Carl Zigrosser, director of the Weyhe Gallery, New York, he focused on making lithographs, and in 1929 Zigrosser organized his first exhibition of lithographs. Lozowick also began to attract attention as a writer. His book *Modern Russian Art* was published by the Société Anonyme in 1925 from a series of lectures he had given in New York to the Société. During the 1920s he became increasingly engaged with political issues, joining the editorial board of the left-wing periodical *New Masses* in 1926. In 1927 Lozowick exhibited in 'The Machine Age Exposition' in New York, which he helped to organize, and contributed a key essay to the catalogue entitled 'The American-ization of Art'. During the Depression years Lozowick was registered with the Graphic Arts Division of the WPA/FAP in New York from 1935 to 1940, apart from a secondment to the Treasury Relief Art Project, where he produced two murals of Manhattan for the New York City Post Office in 1936–7.

Lozowick continued to make prints throughout his career. In all he made some 301 prints, nearly all in lithography, but from the 1930s social realist themes dominate his oeuvre and the prints vary widely in quality. In 1972, a year before his death, the Whitney Museum of American Art, New York, held a retrospective of his lithographs. His widow Adele Lozowick gave an almost complete collection of his lithographs to the Smithsonian American Art Museum.

BIBLIOGRAPHY

Janet Flint, *The Prints of Louis Lozowick, A Catalogue Raisonné*, New York: Hudson Hills Press, 1982

Virginia Carol Hagelstein Marquardt, *Survivor from a Dead Age: The Memoirs of Louis Lozowick*, Washington, DC: Smithsonian Institution Press, 1997

25 New York

c.1925
Lithograph
Signed and titled in pencil. 292 x 229 mm
Flint 6
1993,0725.58. Bequeathed by Mrs K. M. Gray

One of the iconic images of Manhattan, this litho-graph is Lozowick's most important print. *New York* expresses his utopian vision of New York as the ultimate symbol of the modern American city. Using a vocabulary derived from Cubo-futurism and Constructivism, he evokes the architectural landscape of Manhattan. The lithograph was made in New York shortly after his return from Berlin where he had painted from memory a series of paintings of American cities, including New York. Writing to Martin Friedman, Director of the Walker Arts Center, Minneapolis, in 1961, Lozowick re-called the New York painting as '... a memory impression of Brooklyn Bridge and several sky-scrapers. About a year later I did the same subject with quite a number of modifications: I changed the directional lines of the buildings, lowered the bridge and treated the right hand side in a futurist technique' (cited by Flint, p. 54). This lithograph is based upon this second reworking of the com-position. Lozowick here shows the highest section of the Elevated railway on West 109th Street, just west of Central Park.

New York was probably printed at the workshop of George Miller, with whom Lozowick worked from the mid-1920s. It was listed in a Weyhe Gallery catalogue for 1928 which gave an edition of 100, although it is now believed the edition was much smaller, perhaps no more than fifteen.

26 Tanks No. 1

1929
Lithograph
Signed with initials on stone; signed in pencil. 355 x 203 mm
Flint 39
1979,1110.4

Lozowick saw the modern industrial landscape as being particularly characteristic of contemporary America. In his important 1927 text 'The Ameri-canization of Art', he called for an art of America evident '... in the verticals of its smoke stacks, in the parallels of its car tracks, the squares of its streets, the cubes of its factories, the arc of its bridges, the cylinders of its gas tanks' (Lozowick, in Flint, pp. 18–19). In keeping with the 'machine aesthetic' of the period, Lozowick used geometri-cal order to give structure to his compositions. In this image of industrial progress he contrasts the outmoded form of horsepower represented by the two horses with the modern aeroplane flying overhead.

This print was made in the workshop of George Miller in an edition of fifty. In the bottom left corner Lozowick has included his distinctive monogram of two letter L's, one of which is inverted.

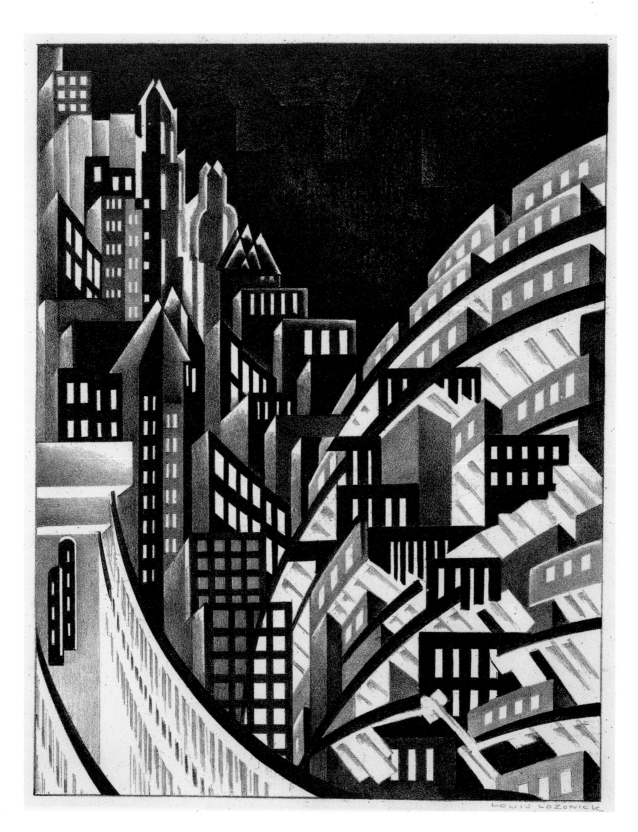

26
Lozowick
Tanks No. 1

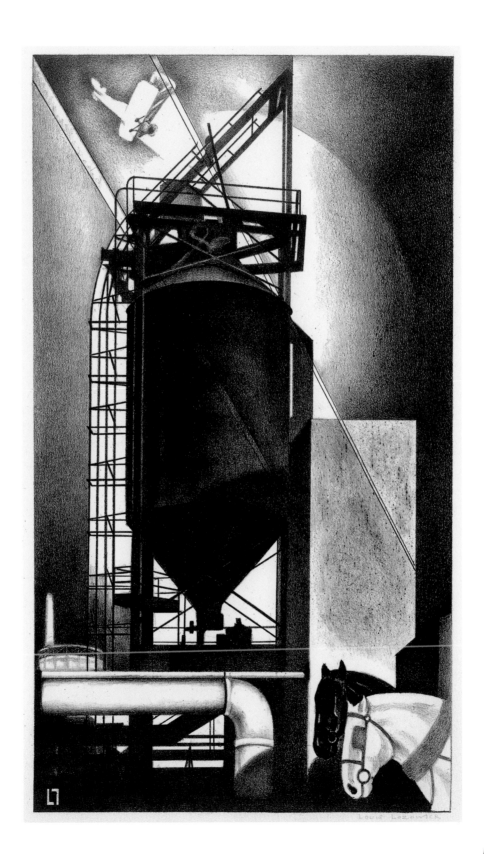

Charles Sheeler

1883–1965

Born in Philadelphia, Sheeler encompassed painting, photography and drawing in the course of his career, as well as the design of flatware, fabric and glassware. In 1900 he enrolled at the School of Industrial Art in Philadelphia, where the emphasis on industrial design would later have some bearing on his precisionist work. In 1903 he entered the Pennsylvania Academy of Fine Arts and studied painting under the American impressionist William Merritt Chase. Although Sheeler started exhibiting from 1908, his work did not sell and in 1910 he took up commercial architectural photography. He exhibited his paintings at the 1913 Armory Show, where the work of Cézanne, in its use of form and structure, influenced his own painting. In 1917 Sheeler took part in the 'Independents' exhibition organized by John Sloan in New York. There he became a friend of the collectors Walter and Louise Arensberg, who exhibited their works by Picasso, Matisse and Marcel Duchamp, alongside early examples of American furniture and folk art, in their New York apartment, which functioned as an artistic salon.

In 1919 Sheeler moved permanently to New York and through the Arensbergs participated in the New York avant-garde. His work became a hybrid of the modern and the traditionally American, in which his precisionist depiction of the modern American urban and industrial landscape also owed a debt to the 'minimal' purity of Shaker furniture.

Sheeler was never a prolific printmaker: only five lithographs over a ten-year period from 1918 to 1928 are known to have been made, all but one printed at George Miller's workshop in New York. The five lithographs vary widely in subject matter and treatment, from still lifes to yachting scenes. His interest in lithography can be seen as an extension of his work in photography and drawing.

Although he stopped making prints in 1928, he continued painting, and in the 1950s returned to the theme of New York in a series of canvases. He produced his final major painting in 1959, just before he suffered a stroke which left him incapacitated.

BIBLIOGRAPHY

Carol Troyen and Erica E. Hirshler, *Charles Sheeler: Paintings and Drawings*, exh. cat., Boston: New York Graphic Society and Little, Brown and Co., 1987

27 Delmonico Building

1926
Lithograph
Signed, titled and numbered '#2' in pencil. 248 x 171 mm
1979,1006.90

This print is one of Sheeler's best-known works and an iconic image of Manhattan's soaring architecture. The Delmonico Building, on Park Avenue and 59th Street, had been built in the early years of the twentieth century. Sheeler shows the side and corner of the building, adopting a low viewpoint in order to exaggerate the verticality of the architecture. These compositional devices are also found in his experimental film *Manhatta*, produced in collaboration with the photographer Paul Strand in 1920. The film was a dynamic portrait of the city composed of high-angle shots from the skyscrapers and dramatic perspectives of the canyons between them.

Sheeler's precisionist lithograph, like those of Lozowick, has a highly finished quality similar to a technical drawing. This lithograph is very close in style and draughtsmanship to his conté crayon drawings of architectural and industrial subjects. Sheeler also took many independent photographs of skyscrapers, but none appears to relate directly to the Delmonico Building, which was situated opposite George Miller's lithographic workshop.

27
Sheeler
Delmonico Building

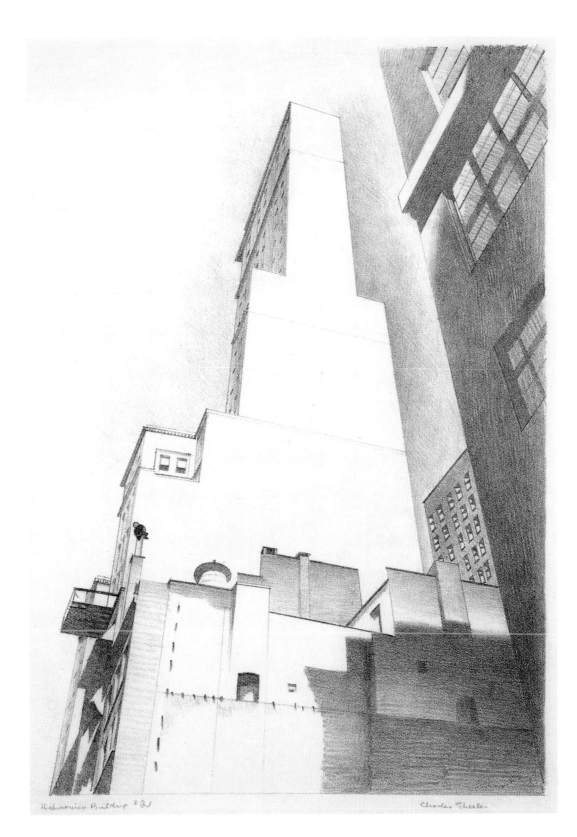

Howard Cook

1901–1980

Born in Springfield, Massachusetts, Cook won a scholarship to the Art Students League, New York, in 1919. After a year's break to see Europe, he returned to the League in 1923 where Joseph Pennell briefly taught him to etch. But it was during a trip to Paris in 1925, when he stayed with the American printmakers James Allen and Thomas Handforth, that Cook took up etching seriously in Handforth's studio. Back in the United States in 1926 he made his first significant woodcuts in Maine and then in New Mexico, where he responded to the Spanish and Indian cultural heritage of the Southwest, making Taos his long-term base. In 1929 Cook returned to Paris to make lithographs at Atelier Desjobert, following the recommendation of Carl Zigrosser, then Director of the Weyhe Gallery, New York.

During the 1920s Cook supported himself on his extensive travels by providing illustrations of the places he visited for the magazines *Harpers*, *The Atlantic Monthly* and *Forum*, which also reproduced his woodcuts. His first solo exhibition in New York was at the Weyhe Gallery in 1929 and consisted entirely of his prints. By the early 1930s Cook was widely recognized for his prints of New York, particularly its skyscrapers and bridges. His lithographs of New York were made with George Miller in 1930, the start of a long collaboration with the printer. Cook insisted on printing his woodcuts and etchings himself. From a total oeuvre of some 223 prints in his catalogue raisonné, nearly 100 works were produced between 1928 and 1931.

In 1932, thanks to a Guggenheim Fellowship, the first of two he was awarded, Cook visited Mexico where his exposure to the work of the Mexican muralists led by Diego Rivera proved a turning point. Although he made a few prints of his Mexican experiences, he largely abandoned printmaking thereafter to concentrate on monumental public murals in fresco. He was commissioned by the Public Works of Art Project to produce murals for courthouses in Springfield and Pittsburgh in 1933 and 1935 respectively; his most ambitious murals were for the San Antonio Post Office in Texas, a commission won by national competition in 1937. Cook was appointed an Artist War Correspondent in the South Pacific in 1943 and saw combat in the Solomon Islands. In 1949 he was elected to the National Academy of Design in recognition of his achievements in printmaking. In the early 1960s Cook was diagnosed with multiple sclerosis, which severely curtailed his career; the disease progressively worsened until his death in Santa Fe, New Mexico. The Smithsonian American Art Museum holds a virtually complete collection of his prints.

BIBLIOGRAPHY

Betty and Douglas Duffy, *The Graphic Work of Howard Cook*, with an essay by Janet A. Flint, Bethesda, Maryland: Bethesda Art Gallery, 1984

28 Times Square Sector

1930
Etching
Signed and dated 'imp 1930', numbered '4/75', titled 'Times Square Section' and inscribed 'Etching' in pencil.
304 x 250 mm
Duffy 146
1979,0623.25

For much of his life Cook lived in New Mexico, but it is his urban views of New York, particularly those made between 1928 and 1931, for which he is now best known. New York offered what Cook described as 'the endearing serrated skyline of the most exciting modern city in the world' (cited by Flint, p. 35). This panoramic view of the Manhattan skyline, with its bold contrasts of light and dark and cubistic forms, expresses the spirit of urban progress and optimism he shared with his contemporaries John Marin, Louis Lozowick, and Charles Sheeler. Cook lived in New York for varying periods between 1930 and 1938, but unlike other artists during these years the onset of the Depression did not diminish his enthusiasm for the city. Whereas he entrusted George Miller with the printing of his lithographs, Cook always printed his own etchings. For this print he planned an edition of 75, although only 35 impressions were in fact pulled.

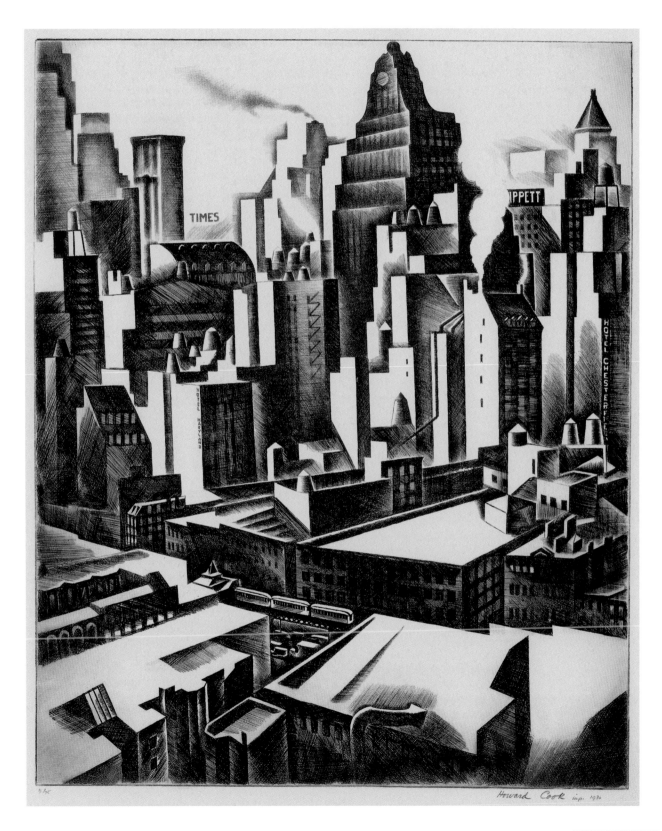

Werner Drewes

1899–1985

Born in Canig, Niederlausitz, Germany, the son of a Lutheran minister, Drewes enlisted in the German army during the First World War and served in France. In 1919 he enrolled in the Technische Hochschule in Berlin-Charlottenburg, where he studied architecture and design. In Berlin he was exposed to the work of Wassily Kandinsky and the Blaue Reiter group at Der Sturm Gallery. After a brief stint at the Stuttgart School of Arts and Crafts, he studied at the Bauhaus in Weimar from 1921 to 1922 and later at the Bauhaus in Dessau from 1927 to 1928. His teachers at the Bauhaus included Paul Klee, Oskar Schlemmer and Johannes Itten; he also had painting classes with Kandinsky, and worked with László Moholy-Nagy and Lyonel Feininger. Drewes later kept a lengthy correspondence with Kandinsky.

With the worsening political climate in Germany, Drewes moved to America in 1930. His arrival coincided with the Depression and from 1934 to 1936 he became a teacher under the WPA/FAP at the Brooklyn Museum, where he incorporated some of the teaching methods he had learnt from the Bauhaus. From 1940 to 1941 Drewes took over the directorship of the Graphic Arts Division of the Federal Art Project in New York. In 1945 he was invited by Moholy-Nagy to teach at the School of Design in Chicago, formerly instituted as the New Bauhaus. At the instigation of Kandinsky he also became closely involved with the avant-garde scene in New York, exhibiting regularly at Duchamp's Société Anonyme from 1931. In 1936 he helped to establish the group American Abstract Artists, which became a major force in the development of American abstraction.

Drewes first started printmaking as a student. His first published prints were a suite of ten woodcuts entitled *Ecce Homo* (1921; Rose III 24–33). He soon mastered an impressive range of graphic techniques, although he always considered himself a painter foremost, and over the course of his career he produced etchings, woodcuts, drypoints, aquatints and lithographs but only one screenprint. After his arrival in America he produced several ambitious print series, including a suite of ten semi-abstract woodcuts entitled *Ten Views of Manhattan* (1930–32; R.III 47–56) and *It Can't Happen Here* (1934; R.III 87–96), a portfolio of ten woodcuts which presented a totally abstract response to the rhythms of the modern metropolis. In 1944 he worked at S.W. Hayter's Atelier 17, where he met Alexander Calder, Yves Tanguy and Roberto Matta, amongst others. By the late 1940s and early 1950s Drewes had begun to move away from abstraction, citing the dominance of Abstract Expressionism as the cause. It was only towards the end of his life that he returned once more to abstraction. In 1984 the National Museum of American Art at the Smithsonian held a retrospective of his prints.

BIBLIOGRAPHY

Martina Roudabush Norelli, *Werner Drewes: Sixty-five Years of Printmaking*, exh. cat., Washington, DC: Smithsonian Institution Press for the National Museum of American Art, 1984

Ingrid Rose, *Werner Drewes: A Catalogue Raisonné of his Prints*, Munich and New York: Verlag Kunstgalerie Esslingen, 1984

29 Broadway Canyon

1930
Woodcut on oriental paper
Signed, dated, titled and numbered 'N. 3-X' in pencil and inscribed in ink 'No.32'. 405 x 297 mm
Rose III 45
1985,1109.6

This is one of Drewes' first woodcuts of New York, produced shortly after he had emigrated there. Although initially life was difficult, New York proved to be full of new sensations, as Drewes recorded in a series of interviews just before his death:

> At this time I also began to do woodcuts of city scenes … I was fascinated by the brilliant light on skyscrapers, bridges, and boats on the East River where we lived. In 1933 I started to do abstractions in wood as well as abstract etchings. I made quite a number of prints then. Since I could not sell woodcuts – nobody was interested in my style of woodcuts – I began to concentrate on etchings (cited in Norelli, pp. 20–21).

In order to create a forum for abstract work he helped to found the American Abstract Artists group, which also hosted talks by such important figures as Mondrian and the former Bauhaus teacher Josef Albers.

In the early years Drewes always printed his own woodcuts, specifying the edition size in roman numerals, in this case an edition of ten. However, when he was working for the Federal Art Project he used Isaac Sanger as his printer. Throughout his printmaking career he always used oriental paper as his preferred support, irrespective of the print technique used. This woodcut was further developed in a second state, where Drewes lightened the composition through additional cutting of the block.

30 Hell Gate Bridge

1931
Woodcut on oriental laid paper
Signed, dated, titled and numbered in pencil '1-XX'.
Collector's stamp 'JK' (Jacob Kainen) on verso.
405 x 293 mm
Rose III 56
1984,1215.5. Presented by Jacob and Ruth Kainen

The woodcut comes from a portfolio of prints entitled *Ten Views of Manhattan*, which was cut during 1930–31 and printed between 1930 and 1932. Other views of New York in the series include the corner of Fifth Avenue and 57th Street, George Washington Bridge, Times Square, the front of the New York Public Library, and Radio City under construction. Hell Gate Bridge, the subject of this print, was built to span a dangerous channel of water at the confluence of the Harlem and East Rivers, near where Drewes lived on East 55th Street. Built in 1917, the bridge was then the world's longest steel-arch span and carried four railway tracks. Drewes has underscored the monumentality of the structure by including two diminutive figures standing beneath the bridge as a train rumbles overhead.

In common with his early woodcuts, Drewes has treated the subject expressionistically, drawing upon the type of work produced by his Bauhaus teacher Lyonel Feininger. Drewes inked and printed the block unevenly to exploit the grain of the wood and the fibrous texture of the oriental paper support. He pulled twenty impressions of this print; a few of them are also dated 1932. The back of this impression bears the monogram of the artist and print scholar Jacob Kainen (see cat. 80), who also collected prints.

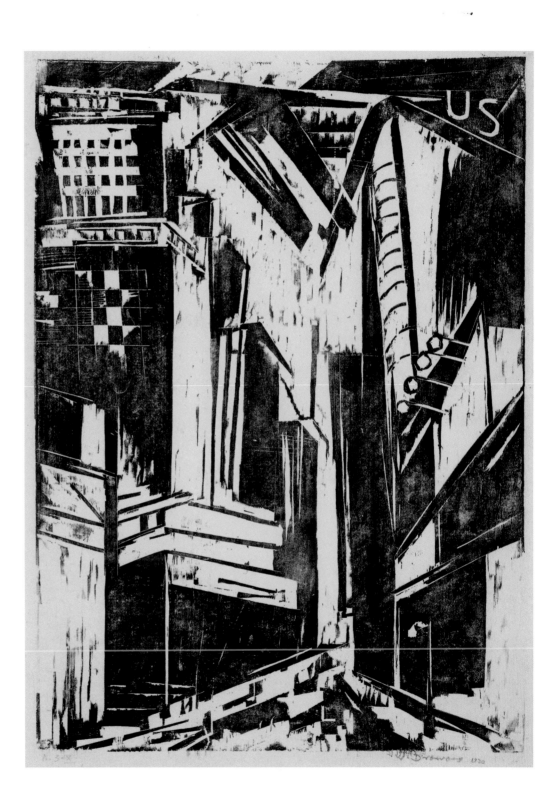

30
Drewes
Hell Gate Bridge

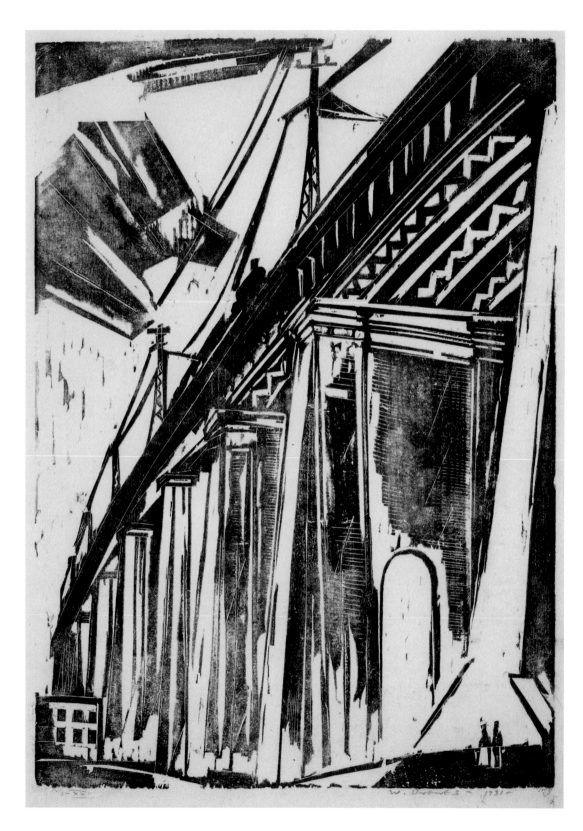

Stuart Davis

1892–1964

Stuart Davis was born in Philadelphia to an artistic family; his mother, Helen Stuart Foulke, was a sculptor; his father, Edward Wyatt Davis, was art editor of the *Philadelphia Press* and a friend of Robert Henri, John Sloan and other members of The Eight. In 1909 Davis enrolled at Henri's art school in New York, where his work developed in the manner of the Ashcan School. He became a good friend of Sloan who, as one of the art editors of the socialist periodical *The Masses*, employed Davis as an illustrator from 1913 to 1916. At this time Davis made a few cursory prints in etching and monotype under Sloan's tutelage. He exhibited five watercolours in the 1913 Armory Show. Over the next four years his art moved away from Realism; by the 1920s he was exploring Synthetic Cubism in his paintings and collages.

In 1928 Davis made his only trip abroad, to Paris, where he stayed for over a year and produced paintings of Paris street scenes. He took up lithography for the first time and continued the theme of his paintings into his printmaking. It is most probable that he worked at the Atelier Desjobert, where other American artists including Lozowick, Cook and Spruance made lithographs in the 1920s. Of his twenty-two lithographs, eleven were produced in Paris in 1928–9 and six following his return to New York between 1929 and 1931.

The return to New York in 1929 proved to be a culture shock. Davis later declared that he was 'appalled and depressed by its giantism', but also stimulated by New York's 'impersonal dynamism' (Stuart Davis, *Stuart Davis*, New York: American Artists Group, 1945; cited by Diane Kelder in Cole and Myers, p. 8). During the 1930s he combined modernism with American subject matter and became one of the most prominent artists of the avant-garde in America. The five lithographs he produced in 1931 are his most significant achievement in American printmaking. His return to America coincided with the Wall Street Crash and the onset of the Depression. Davis was among the first artists to register with the Public Works of Art Project in 1933 and then with the WPA/FAP from 1935 to 1939, working on murals for the World's Fair in New York.

During these years he was politically outspoken and became the first secretary and then chairman of the left-wing American Artists' Congress from 1936 to 1940. He was a skilful advocate and polemicist for abstract art. His introduction to the 1935 Whitney Museum exhibition 'Abstract Painting in America' became a much-quoted text on modernism, in which he defined his notion of painting 'as a reality which is parallel to nature' (cited by Diane Kelder in Cole and Myers, p. 11). In 1946 the Museum of Modern Art, New York, held a retrospective of his work.

BIBLIOGRAPHY

Sylvan Cole and Jane Myers, *Stuart Davis Graphic Work and Related Paintings with a Catalogue Raisonné of the Prints*, with an essay by Diane Kelder, exh. cat., Fort Worth, Texas: Amon Carter Museum, 1986

31 Sixth Avenue El

1931

Lithograph

Signed on the zinc plate; signed, titled, dated and numbered '17/25' in pencil. 302 x 456 mm

Cole and Myers 15

1983,0625.42

This and cat. 32 come from the important suite of five figurative abstract lithographs which Davis produced two years after his return from Paris. Both are New York scenes which use motifs from drawings he had earlier made in his sketchbooks in 1926. Two other lithographs in the suite, *Barber Shop Chord* (Cole and Myers 14) and *Theatre on the Beach* (C&M 16) are based on coastal motifs from New England where he spent his summers at Gloucester, Massachusetts. The fifth, *Composition* (C&M 18), is the most abstract of the suite. All were produced on zinc plates and printed in an edition of twenty-five, with five artist's proofs. Although there is no conclusive evidence, the high technical quality of the lithographs strongly suggests that the printer George Miller was involved. This print and *Barber Shop Chord* were first exhibited at the Downtown Gallery's annual exhibition of 'American Print Makers' in 1931; *Two Figures and El* and *Theatre on the Beach* were included in the same show in 1933. From the late 1920s until the 1940s the Downtown Gallery represented his paintings and prints.

Davis often recycled his own imagery. Several motifs in this lithograph, such as the Jewish delicatessen sign, the street light and the barbershop pole, were taken from his 1926 New York sketchbook, while the head was appropriated from a gouache, *Buildings and Figure*, 1926 (Collection of Mr and Mrs S. Roger Horchow). However, the interior of the tailor's shop, lower left, is a new motif, and appears for the first time in a preparatory study for the lithograph made about 1931. The final outcome is a harmoniously balanced composition of abstract and figurative forms and of black and white contrasts. The radical changes of scale and style within the one composition and the overlapping planes, with their different textures, create the effect of a cubist collage.

32 Two Figures and El

1931

Lithograph

Signed on the zinc plate; signed and inscribed 'artists proof' in pencil. 279 x 381 mm

Cole and Myers 17

1979,1110.2

Davis did not see any conflict between his adoption of abstraction and his incorporation of motifs drawn from the American Scene. Writing in 1940, in an unpublished essay entitled 'Abstract Painting Today' commissioned by *Art for the Millions*, Davis declared: 'The quality called "art" has always been abstract and has had its material existence in a series of unique and real orders in the materials of art … The best work of the last seventy-five years is great because it is real contemporary art, which expresses in the materials of art the new lights, speeds and spaces of our epoch' (cited by Diane Kelder in Cole and Myers, p. 12).

This lithograph is based upon a preparatory study in graphite, in which only the linear aspects of the composition are articulated, without any indication of the rich tonal effects of the final print. Through the contrast of black tusche, greyish lithographic crayon work and the white support of the paper, Davis creates an image in which illusionistic depth is reduced to a minimum and spatial relationships depend upon interlocking planes. The two biomorphic, abstracted figures on either side of the barbershop pole show an awareness of Surrealism, to which Davis must have been exposed in Paris. His use of surrealist motifs pre-dated the December 1931 Wadsworth Athenaeum exhibition of European Surrealism, which was shown two months later at the Julian Levy Gallery in New York. This makes Davis one of the earliest exponents of American Surrealism.

31
Davis
Sixth Avenue El

32
Davis
Two Figures and El

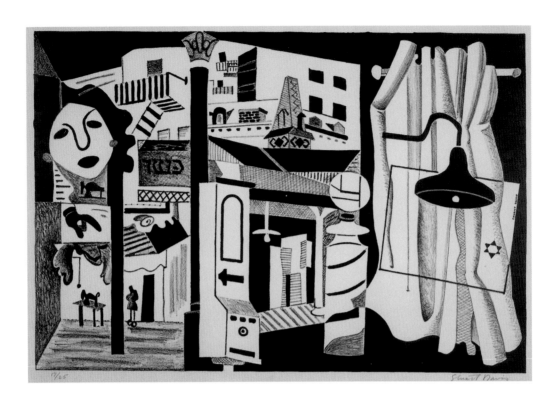

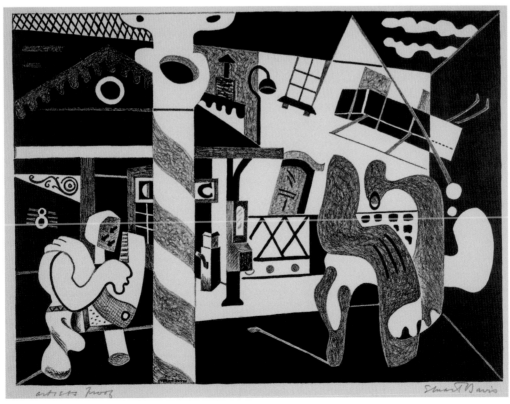

Milton Avery

1893–1965

Best-known as a painter, Avery was born in Altmar, New York State, the son of a tanner. In 1898 the family moved to an area outside Hartford, Connecticut. Milton's training in art began while he worked in a factory: from 1905 to 1918 he took evening life-drawing classes at the Connecticut League of Art Students; in 1918 he transferred to the School of the Art Society of Hartford and a year later came top in portraiture and life-drawing. In 1925 he moved to New York and married Sally Michel, a freelance illustrator, taking an apartment in Lincoln Arcade, a network of studios which was home to many artists. From the late 1920s he became a friend of the young Mark Rothko, Adolph Gottlieb and Barnett Newman, and began to develop his own abstract painting style. Although demand for his work remained low, Avery was taken up by prestigious New York galleries; he was represented initially by Valentine Gallery, who gave him his first solo show in 1935, and then by Paul Rosenberg from 1943, who showed the work of Matisse and Picasso. Avery's work shared superficial similarities with Matisse, and to his chagrin he was sometimes called the American Matisse.

Avery's first prints were a series of drypoint studies of his wife and infant daughter made in 1933. It is not known who introduced him to printmaking, but from 1933 to 1948 he produced some thirty drypoints. These include portraits of his artist friends in the mid-1930s, notably one of Rothko with pipe, as well as nudes, landscapes and beach scenes in the 1940s. Avery took proofs from his plates but did not have the patience to produce editions. In 1948 the Laurel Gallery, New York, published five of his drypoints, including two from the 1930s, in a portfolio edition of 100; the plates were printed by S.W. Hayter at Atelier 17 in New York. In 1964 many of his drypoint plates were steel-faced by Anderson and Lamb in Brooklyn, and these were printed in editions of 60 to 100.

In 1949 Avery suffered a major heart attack which left him unable to paint and without the physical strength to produce drypoints. Recuperating in Maitland, Florida, he took up monotype, which was less physically demanding, and produced more than 200 prints, mostly in 1950 and 1951. He delighted in the spontaneity and unpredictability of monotype and the scope it gave him for experimentation. In 1952 Avery turned to making woodcuts and he produced twenty-one woodcuts and a single linocut over the next three years. But in 1955 his health again broke down and, as the effort of cutting and printing the blocks became too onerous, he was forced to give up printmaking.

Avery had a major influence on the younger American colour-field painters of the 1950s and early 1960s, particularly through his use of thinly applied, luminous colour. Rothko delivered the memorial address at Avery's funeral in New York in January 1965.

BIBLIOGRAPHY

Harry H. Lunn Jr, *Milton Avery: Prints 1933–1955*, with introduction by Frank Getlein and a technical note by Alan Fern, Washington, DC: Graphics International Ltd, 1973

33 Drawbridge

1936
Drypoint
Signed, dated and numbered '48/60' in pencil.
162 x 327 mm
Lunn 10
1986,0621.35

Set in a marginal area of the city, the subject of this drypoint is the Harlem River Bridge, New York, and it is Avery's only known print of an industrial subject. Unlike the Regionalists, or those artists interested in the American Scene, Avery was not interested in content but used the subject in order to explore shape.

Principally a painter, Avery first took up drypoint in 1933. He used discarded scraps of copper and zinc from a photo-engraver's studio as his plates, and this accounts for the irregular shape often found in his prints. Avery enjoyed the direct scratching of the plate entailed by drypoint. He took proofs but left the editioning to others, sometimes many years later.

34 Standing Nude

1941
Drypoint
Signed on plate; signed, dated and numbered '18/60' in pencil, and inscribed '#19 Standing Nude' lower right corner. 362 x 194 mm
Lunn 21
2002,1130.4. Presented by the Friends of Prints and Drawings

The female nude was a prominent motif in Avery's work and features in his most significant drypoints of the 1940s. He also made two woodcut nudes in 1953. This monumental nude is one of his finest prints, and reveals his assured and economical handling of line in deliberate, broad strokes. Avery's simplified forms are derived from Matisse, with whom his American contemporaries often compared him, despite his avowed dislike of Matisse's work.

35 Night Nude

1953

Woodcut on oriental paper

Initialled on block; signed, dated and inscribed 'artist's proof' in pencil. 245 x 610 mm

Lunn 48

1981,0725.13

Avery first took up the woodcut in 1952 in response to an approach from the Collectors of American Art who wanted an edition for its members. After he was shown the technique by Steve Pace, who pulled the first edition, Avery produced twenty-one woodcuts in three years. He printed the blocks himself, rubbing the back of the paper against the inked block by hand, rather than using a press. He obtained different effects by varying the degree of rubbing and pressure, and consequently no two impressions from an edition are identical. Avery also experimented with colour, sometimes printing an uncut area of the block in colour together with the black, or by adding a tone block. He exploited roughly grained plank wood for its expressive textures; this is apparent in *Night Nude*, where a sawn-off section of plank has been used. Additional textures were created by hammering the slotted head of a screw into the wood; this is clearly visible among the stars in the strip of night sky at the top of the white-line woodcut.

Night Nude was printed in black in an edition of twenty-five; a second version, in blue and black, was also pulled in twenty examples.

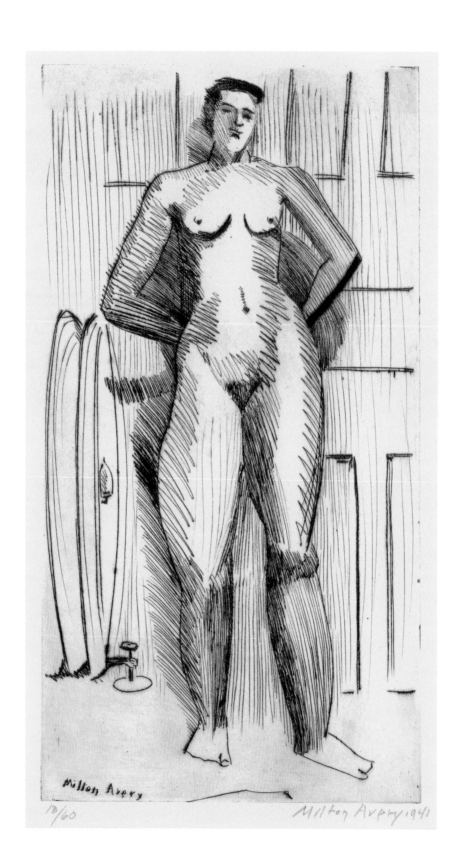

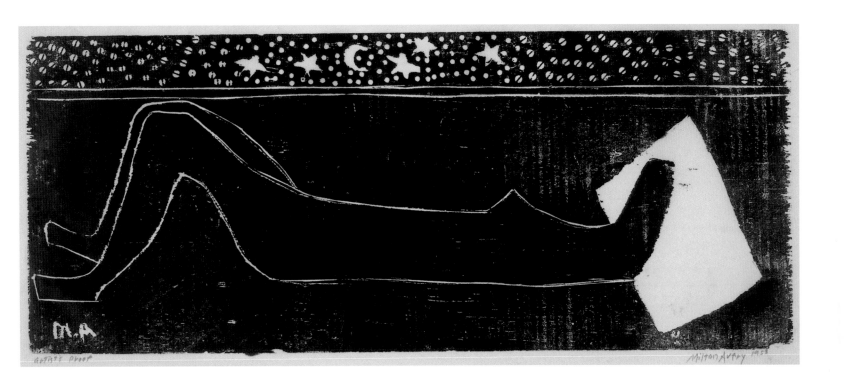

Benton Spruance

1904–1967

Born and raised in Philadelphia, Spruance trained at the Pennsylvania Academy of Fine Arts from 1925 to 1929. In 1928 he was awarded a Cresson Travelling Scholarship, which took him to Paris where he learnt lithography at the Atelier Desjobert. On his return to Philadelphia he began making lithographs with the printer Theodore Cuno, a collaboration that would continue until the early 1950s. In 1930 he returned to Paris on a second Cresson Travelling Scholarship with the artist Robert Gwathmey, where he worked at Desjobert's and studied painting at André Lhote's Académie Montparnasse. In 1933 he had his first solo show at the Weyhe Gallery, where Carl Zigrosser promoted contemporary American print-making and became a lifelong friend of the artist. From 1932 Spruance had regular exhibitions with the Print Club of Philadelphia, to which he was elected to its board of directors in 1944, and his work was shown in many printmaking exhibitions across the United States.

Spruance was seen as a 'citizen-artist' by his contemporaries, who was as engaged with teaching and with improving the conditions of artists as he was with his own printmaking. From 1934 he taught at the Philadelphia Museum School of Industrial Arts where he developed the graphic workshop. As well as teaching studio practice he also taught art history, focusing on the development of the print both in Philadelphia and at Beaver College (now called Arcadia University), where he was appointed to the chair of the Department of Fine Art in 1933, a post he held for the rest of his life. Closely involved with the artistic politics of Philadelphia, in 1949 he became a founding member of Artists Equity, a union dedicated to artists' rights. From the early 1950s Spruance participated in the urban regeneration of Philadelphia, and in 1953 he was appointed to the Philadelphia Art Commission, where, with his strong support, the ordinance of 'One Percent for Art' became law in 1959 – henceforth one percent of the budget for every new building in Philadelphia had to be spent upon public art.

Lithography was Spruance's principal printmaking technique. He made 536 lithographs out of a total oeuvre of 555 recorded prints; between 1928 and 1939 alone he produced some 177 lithographs. During this period his style varied from naturalistic portraits to a precisionist approach of flattened and layered forms. A deliberate socially conscious agenda informs his lithographs from 1935 to the 1940s, when he began to work in a more highly charged expressionistic style and turned to wartime subjects. From the early 1950s, prompted by a need for greater technical freedom and experimentation, Spruance began to print for himself. During the 1950s and 1960s he produced colour lithographs, mostly literary or symbolic in theme, which showed a complexity in composition and colour printing technique. The Philadelphia Museum of Art holds over seventy works by Spruance in its permanent collections.

BIBLIOGRAPHY

Ruth E. Fine and Robert F. Looney, *The Prints of Benton Murdoch Spruance: A Catalogue Raisonné*, with an introduction by Ruth E. Fine, Philadelphia: University of Pennsylvania Press, 1986

36 The People Work – Night

1937
Lithograph
Initialled on stone; signed, dated, titled and numbered '4/40' in pencil. 347 x 480 mm.
Fine and Looney 144
1986,0125.1

This print is from a set of four issued within a portfolio entitled *The People Work*, which took American working life as its subject. The other prints in the quartet refer to morning, noon, and evening. The lithographs were printed by Theodore Cuno in an edition of forty and the portfolio was accompanied by a foreword by Henri Marceau, a curator at the Pennsylvania Museum of Art (later renamed the Philadelphia Museum of Art), who wrote: 'The measure of an artist's success is largely to be found in his ability to live within his own times and to find in his daily surroundings the pictorial material through which he will speak to his audience' (cited by Fine in her introduction, p. 5).

The People Work expresses Spruance's commitment to humanist ideals and his articulation of a socially conscious art. The format of a traditional narrative series in which motifs could be contrasted and compared was one which appealed to Spruance, and *The People Work* was the first of several such sequences he was to produce. This print shows the influence of Bellows both in the handling of the lithographic crayon directly on the stone and in the tendency towards caricature in some of the figures, such as the man laughing, bottom right. But there are other influences at work too: the cut-away, grid-like view of the Subway, with the exposed geometrical girders, recalls Precisionism, while the embracing couple in the Subway car appears to quote Edward Hopper and the American Scene (see cat. 37).

36

Spruance

The People Work - Night

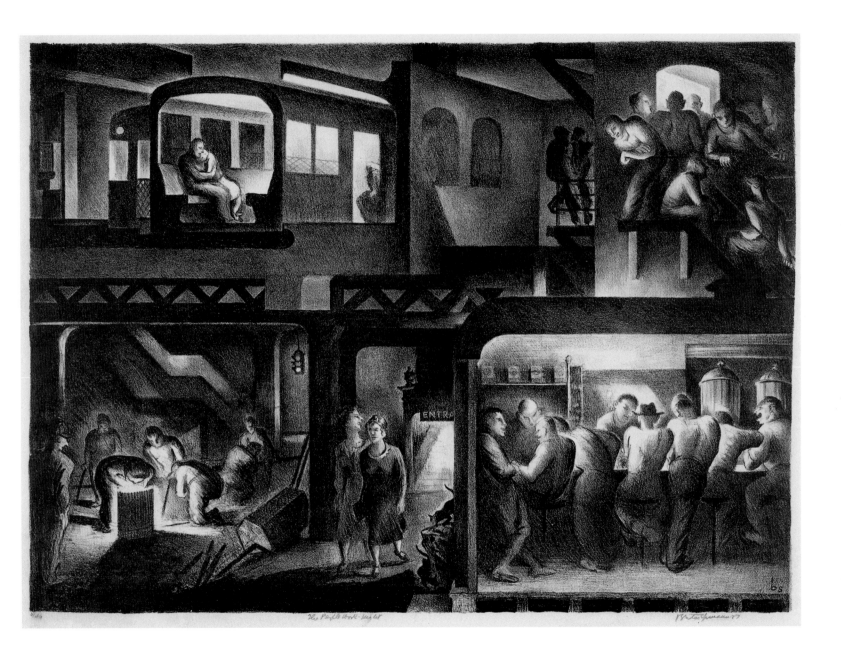

Edward Hopper

1882–1967

Born in Nyack, New York, where his father owned a dry-goods store, Hopper registered with the Correspondence School of Illustrating in 1899. He attended the New York School of Art from 1900 to 1906, where he studied under William Merritt Chase and Robert Henri; George Bellows was a fellow classmate. In 1906–7 he made a trip to Europe, living mostly in Paris and visiting other cities, including London where he stayed near the British Museum; a second trip to Paris followed in 1909. In 1913 he moved permanently to New York to live in a studio at Washington Square North in Greenwich Village, where he remained for the next fifty-four years until his death. From 1907 to 1923 Hopper worked as a freelance commercial artist, a role he detested.

In 1915 the Australian-born printmaker Martin Lewis (see cats 41–6) taught Hopper how to make etchings and drypoints. Although he sold a canvas, *Sailing*, 1911 (Carnegie Museum of Art, Pittsburgh), at the Armory Show in 1913, it was the exhibition of his prints and his illustrations rather than his paintings that brought him attention. His first financial and critical success came in 1924, at the age of forty-two, with an exhibition of watercolours at the Frank K.M. Rehn Gallery, which remained his dealer for the rest of his life. The success of this exhibition enabled Hopper to give up commercial illustration and printmaking, and to focus on painting.

Between 1915 and 1923 Hopper made nearly seventy etchings and drypoints, but he abandoned printmaking completely thereafter, with the exception of two drypoints, *The Balcony* (Levin 108) and *Portrait of Jo* (L. 109), in 1928. His early etchings were executed directly on to the copper plate; preparatory sketches exist for his later prints. His etchings went through many changes of state as minor adjustments were made to the plate. With one exception, he printed all his own plates, using an old money-printing press. He did not number the impressions of his editions, which were limited to about a hundred, but usually pulled proofs when required.

The four Hopper etchings owned by the British Museum were donated in 1926 by Campbell Dodgson, Keeper of Prints and Drawings from 1912 until 1932. The Whitney Museum of American Art, New York, holds the world's largest collection of Hopper's paintings and etchings, as well as study drawings and correspondence, a bequest from the artist and his wife, Jo Nivison Hopper.

BIBLIOGRAPHY

Gail Levin, *Edward Hopper: The Complete Prints*, exh. cat., New York: Whitney Museum of American Art, 1979

Gail Levin, *Edward Hopper: The Art and the Artist*, exh. cat., New York and London: W.W. Norton & Co. in association with the Whitney Museum of American Art, 1980

Sheena Wagstaff et al., *Edward Hopper*, exh. cat., London: Tate Modern, 2004

37 Night on the El Train

1918
Etching
Signed on plate; signed and annotated with price '$18' in pencil. Titled 'On the L-Train' on verso in ink.
183 x 201 mm
Levin 56
1926,0624.15. Presented by Campbell Dodgson

Hopper, like his fellow etcher and teacher Martin Lewis, was fascinated by the theme of the railroad. Unlike the Ashcan School artists, Hopper did not base his etchings upon direct observation of everyday New York, but rather upon his recalled experiences. He nearly always chose landscape format for his prints. This allowed him to deploy his favourite compositional device of the oblique viewpoint, emphasized here by the row of seats. Through partial wiping of the deeply etched plate, Hopper achieves the eerie illumination of the train compartment. The motion of the train is indicated by the billowing blinds and the swaying straps.

A preparatory sketch in charcoal exists which is compositionally very close to the print. This etching, one of eight prints Hopper showed at the MacDowell Club, New York, in 1918, was originally priced at $18.

38 Evening Wind

1921

Etching

Signed in pencil and annotated with price '$22'.
Titled on verso and annotated with price 'Etching $22'
and 'Edward Hopper, 3 Washington Square N New York'
in pencil. 175 x 210 mm

Levin 77

1926,0624.14. Presented by Campbell Dodgson

The subject of the open window was one that was
particularly significant to Hopper. His teacher,
Robert Henri, described windows as 'symbols'. The
billowing curtain in *Evening Wind* gives move-
ment to the composition and mediates between
the exterior world and the privacy of the girl's
room. The contrast between the intense black ink
of the etched lines and the brilliant white of the
untouched paper is most evident in the window.
Although the window area remained unaltered,
details of the etching underwent minor modifica-
tions through eight states. A preparatory sketch,
in conté crayon and charcoal, shows that the back-
ground details of the picture frames were initially
more visible. In the final etching these are
obscured by shadow.

Hopper often altered the titles of his etchings; this
work is sometimes also called *Night Wind*.

39 Night in the Park

1921

Etching

Signed and annotated with price '$18' in pencil.
Titled on verso in ink. 173 x 210 mm

Levin 80

1926,0624.13. Presented by Campbell Dodgson

This etching may be compared to Bellows's litho-
graph, *Solitude*, 1917 (cat. 15), in showing a
nocturnal park scene. Both are similar composi-
tionally through the use of an oblique view into
space – a device learnt from the Impressionists,
notably Degas, and ultimately derived from
Japanese art. However, unlike Bellows's sardonic
reflection on the isolation of the individual in
modern society, Hopper's work deals with
distinctly different emotions from the Ashcan
School. The image of the man, with his back
towards the viewer, is reminiscent of a film still,
yet a sense of unease arises as there is no 'before'
or 'after' to the narrative that is evoked.

Nocturnes were particularly suited to Hopper's
use of a deeply bitten line, with heavy hatching
and cross-hatching. To unify the composition and
to evoke the tonal quality of the night scene,
Hopper left a light film of ink on the plate surface
before printing the plate. A preparatory study in
charcoal for this etching exists. In the etching
Hopper darkened the foliage of the trees with
additional hatching. He also introduced foreground
shadows, with the effect of isolating the figure
within a pool of light.

40 East Side Interior – New York

1922

Etching

Signed in pencil. Titled on verso in ink. 198 x 251 mm

Levin 85

1926,0624.12. Presented by Campbell Dodgson

The composition of this etching is notably close
to Hopper's painting *Girl at Sewing Machine*,
c.1921 (Museo Thyssen-Bornemisza, Madrid). It
also recalls images of feminine domesticity by
seventeenth-century Dutch and Flemish artists
such as Vermeer, whom Hopper admired. As with
Evening Wind (cat. 38), the open window acts
as a metaphor.

Hopper produced a preparatory sketch for this
etching. The final print differs from the drawing
in several key respects, notably in the use of deep
shadow on the left and right sides of the plate
to frame the young woman and to create a more
dramatic chiaroscuro effect. Adjustments to the
composition were made through several states as
Hopper built up shade in certain areas of the plate
and lightened other areas with burnishing. This
is most evident in the cross-hatching on the back
wall, which is not present in the earlier states.

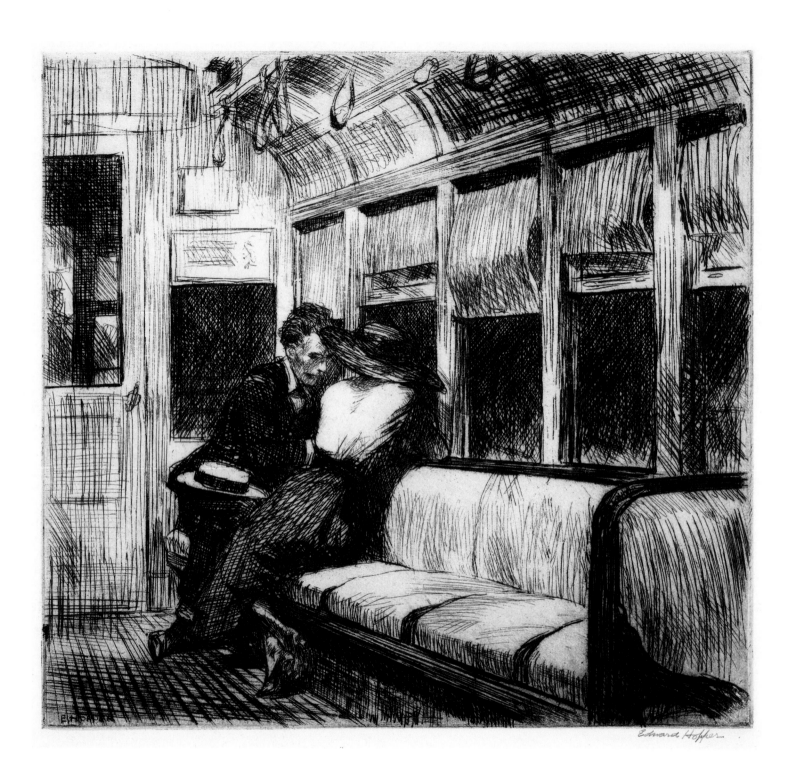

38
Hopper
Evening Wind

39
Hopper
Night in the Park

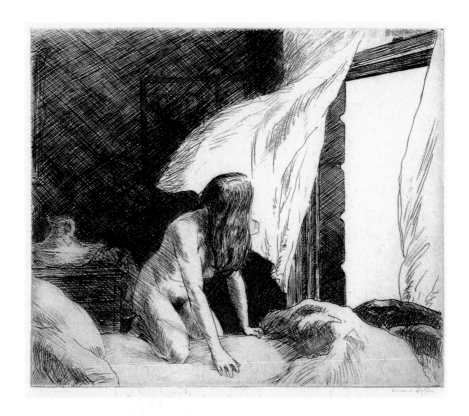

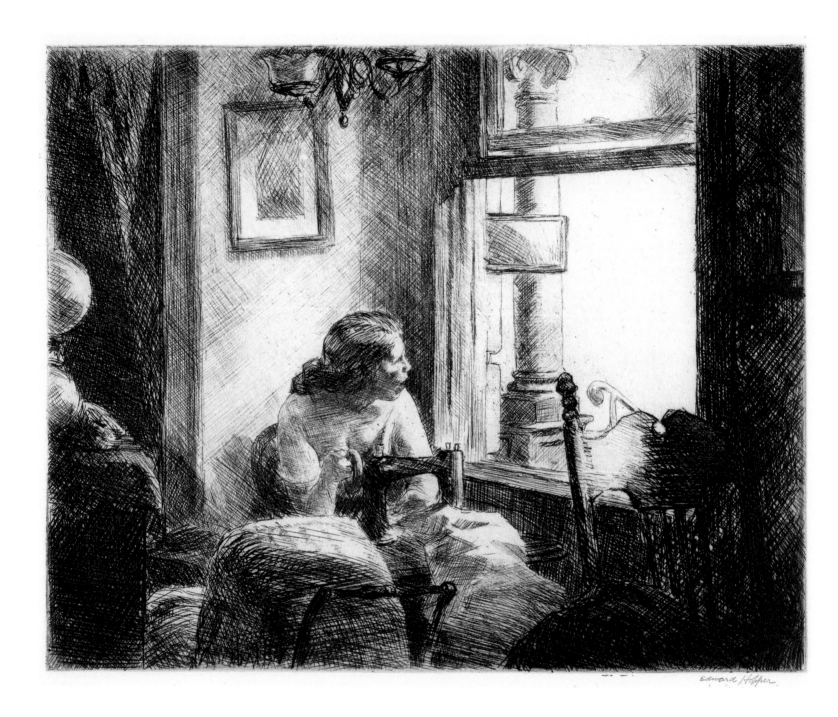

Martin Lewis

1880–1962

Born and raised in Castlemaine, Australia, a former gold-mining town in Victoria, Lewis received his initial art training at the Castlemaine School of Mines in 1895–6. After the early death of his father, he found life in his rural hometown too restrictive, spent a year roaming rural Victoria and New South Wales, and by 1899 was in Sydney, where he supported himself through illustration work. After a brief spell at Julian Ashton's Sydney Art School, he emigrated to America in 1900, disembarking at San Francisco and making his way to New York, where he gained work in commercial illustration. The first ten years of his life in New York are still unclear, but in 1910 he made a brief trip to Britain where he formed a liaison with the concert singer and pianist Esta Verez, with whom he returned to New York.

From 1915 Lewis started to make etchings and taught the technique to his friend Edward Hopper, whom he had met through their commercial work. Technically rigorous, Lewis insisted that all the effects of the plate were to be obtained from work on the plate itself and not through the manipulation of the inking. Although his formal education was limited, he was admired for his astuteness and became part of a circle of intellectuals and writers around the radical poet Lola Ridge. After the break-up of his relationship with Verez, Lewis left to live in Japan from 1920 to 1921, producing on his return to New York a series of drypoints inspired by Japanese *ukiyo-e*. From 1928 he began to concentrate on drypoints of New York City observed under different weather conditions and at different times, particularly at night.

On the strength of the critical and financial success of his first solo exhibition at Kennedy & Company, New York, in 1929, Lewis gave up commercial work to focus on his printmaking. Prints in editions of 100 sold out within the year, and between 1929 and 1931 Kennedy & Company published seventeen new prints. But when the full effects of the Depression struck, Lewis was forced to leave New York in 1932 and live in rural Connecticut. He returned to New York in 1936, and although he continued to make prints, his career had stalled following the collapse of the etching market. In 1944 he obtained a position as an instructor of graphics at the Art Students League, but in 1952 he had to give it up due to ill health. By this time interest in his prints had long ceased and around 1960 he gave away his etching press and equipment. He died forgotten in 1962.

The master set of Lewis's prints, together with his record book, is now held by the Detroit Institute of Arts. Other major holdings include those of the Print Room of the New York Public Library and the Brooklyn Museum, New York.

BIBLIOGRAPHY

Paul McCarron, *The Prints of Martin Lewis, A Catalogue Raisonné*, Bronxville, New York: M. Hausberg, 1995

Kirsten McKay, *Martin Lewis: Stepping into the Light*, exh. cat., Castlemaine, Victoria: Castlemaine Art Gallery and Historical Museum, 2002

41 Quarter of Nine, Saturday's Children

1929

Drypoint printed in brown ink

Signed on plate; signed in pencil. Titled on verso and inscribed 'ML-57' in pencil and stamped 'Collection Patricia Lewis'. 250 x 325 mm

McCarron 78

1979,1006.2

The title refers to the nursery rhyme that starts 'Monday's child is fair of face' and continues 'Saturday's child works hard for a living'. In this scene, young women in fashionable cloche hats and fur-collared coats hurry to their Saturday jobs in department stores. The location is Manhattan's 34th Street at Park Avenue, not far from Lewis's studio at 145 East 34th Street. On the right are the crenellated towers of the 71st Regiment Armory (since demolished).

Lewis has depicted with drypoint the indirect, slanting light of the morning sun, casting its long shadows across the pavement. He printed the plate in a brown ink to evoke the warmth and bright light of the morning sun. The drypoint was published in an edition of 100 by Kennedy & Company, who sold 89 impressions at $42 each between 1930 and 1949. A preparatory sketch for this print exists, which was inscribed by Lewis 'East Thirty-Fourth Street N.Y.C., about 1927'.

Patricia Lewis, widow of the artist's son, Martin Deming Lewis, and former owner of the British Museum's impression, assembled a collection of Martin Lewis prints.

42 Spring Night, Greenwich Village

1930

Drypoint with sandpaper-ground

Signed on plate; signed in pencil. 251 x 313 mm

McCarron 85

1979,0407.11

A note in Lewis's record book suggests that the location of this scene is Bedford Street in Greenwich Village, New York. Lewis includes many anecdotal vignettes such as the lovers embracing in the dark doorway and the illuminated shop interior with a cobbler at work. Typical for Lewis is the use of a hidden light source. A rough preparatory sketch shows that he was particularly concerned with the positioning of the shadows cast on the pavement.

Lewis used drypoint and sandpaper-ground to create specific tonal effects. Disliking bare copper plates, he pressed sandpaper, or emery paper, face-down onto the wax-covered plate and ran it several times through the press. The pitted marks through the ground were then bitten in acid, creating an even, grainy texture akin to what he called a 'simulated mezzotint' effect. He then incised with drypoint into the textured plate, the burr thrown up by the drawn line producing a 'velvety' softness in the deepest areas of shade when printed. He also 'sanded' over areas of hatched and cross-hatched lines to produce softly graduated shadows.

This drypoint, known in some ninety-two impressions, proved to be a critical success, for in 1931 Lewis received the Charles M. Lea Prize from the Philadelphia Print Club, the second year in a row that he was awarded this distinction.

43 Little Penthouse

1931

Drypoint

Signed 'Martin Lewis – imp' and inscribed 'To Warren Hutty with best regards from his friend – M L – May – '31'. 253 x 175 mm

McCarron 91

1979,0512.8

This drypoint was included in the deluxe edition of *American Etchers*, a series of twelve volumes devoted to contemporary American printmakers published in New York either by T. Spencer Hutson or the Crafton Collection. The series was aimed at both the bibliophile and the print collector, and the deluxe editions presented within portfolios included original prints by John Taylor Arms, Childe Hassam and other artists less well known today. The deluxe edition of volume XI, devoted to Martin Lewis, was published by the Crafton Collection in an edition of seventy-five and the British distributor was P. & D. Colnaghi of London. Each of the Lewis portfolios contained a statement signed by the notary public, Winifred Hutty, certifying the edition size and print number. This particularly fine impression, printed by Lewis himself as indicated by the annotation 'imp' beside his signature, was dedicated to his friend, Warren Hutty.

Little Penthouse evinces parallels with film noir in its depiction of the nocturnal cityscape and the use of exaggerated lighting effects. Lewis had direct contact with this genre. He was a friend of the screenwriter Dudley Nichols, who owned a collection of his work, and who wrote the script for the film noir *Scarlet Street*, 1945.

44 Ha'nted

1932
Drypoint with sandpaper-ground
Signed on plate; signed in pencil. 333 x 226 mm
McCarron 100
1979,0512.7

According to an annotated impression of this print belonging to the artist's wife, Lucile Lewis, this drypoint shows Walnut Tree Hill Road, in Sandy Hook, Connecticut, where the couple lived in the early 1930s. Lewis depicts a still and clear winter's night, the sky punctuated by three pinpoint stars, as two workers make their way home. The title is a colloquialism for the 'haunting' effect of the dramatic shadow which, cast by the kerosene lamp and magnified on the side of the house, looms over the walking men. The use of crossed lines of shadow and the device of exaggerated human shadows emanating from a single light source was often employed by Lewis in his prints. It first occurs in his earlier drypoint *The Great Shadow*, 1925 (McCarron 44).

Ha'nted was published by Kennedy & Company in an edition of 107 impressions, including two trial proofs, and retailed for $36 each. Lewis noted in his day book that sixty-seven impressions were sold between 1933 and 1936.

45 The Passing Freight, Danbury

1934
Drypoint with sandpaper-ground
Signed on plate; signed and titled 'Passing Freight' and annotated with the price '24⁰⁰' in pencil. Stamped 'Lucile Deming Lewis Collection' on verso. 226 x 365 mm
McCarron 108
1979,0512.9

Danbury was a small town not far from Sandy Hook, Connecticut, to which Lewis and his wife moved from New York in 1932 when the Depression took full effect. Lewis produced some seventeen prints depicting scenes of the locality. This drypoint records the familiar sight of the steam train passing Danbury on the New York to New Haven line. Drypoint and sandpaper-ground are deployed to evoke the atmospheric effect of a rainy early evening, with reflections on the pavement. This is punctuated by the terse use of highlighting for the beam of the train's headlight and for the glow of its tail-light.

When he did not print his own impressions, Lewis turned to the services of the printer Charles S. White, who also worked for John Sloan. Lewis's record book notes that forty-seven impressions were pulled between October 1934 and December 1935, but that Kennedy & Company only succeeded in selling fourteen prints between 1935 and 1948, an indication of how deeply the Depression affected Lewis's sales.

46 Shadow Magic

1939
Drypoint
Initialled on plate; signed in pencil. Titled on verso in pencil and stamped 'Collection Patricia Lewis'.
342 x 240 mm
McCarron 126
1979,0512.10

The dramatic lines of shadow cast on the gas tank are the main subject of this drypoint – a motif that Lewis had used in earlier prints, such as his etching *The Boyfriends*, 1927 (McCarron 61). A note in his record book reveals that Lewis initially considered calling this print 'Black Magic, Gashouse District' before settling on the present title. The print won the John Taylor Arms Prize at the 24th National Arts Club Exhibition in December 1939.

Three preparatory studies were produced for this work, the most abstract composition that Lewis tackled. At the bottom of one of the drawings he wrote 'Euclid alone has looked on beauty bare', a quotation from a poem by Edna St Vincent Millay and a reference to the geometrical lines of shadow in this work.

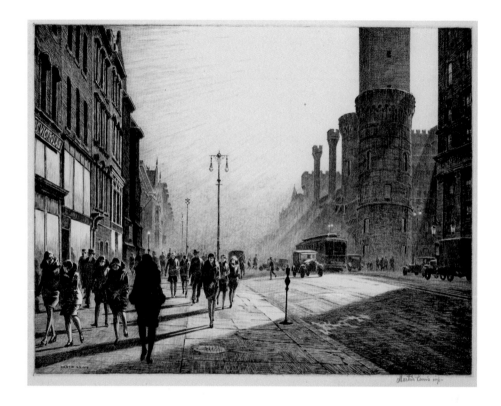

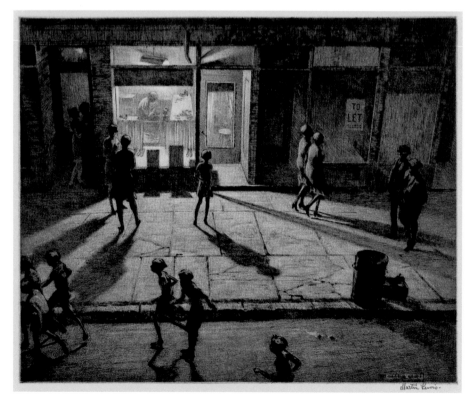

43
Lewis
Little Penthouse

44
Lewis
Ha'nted

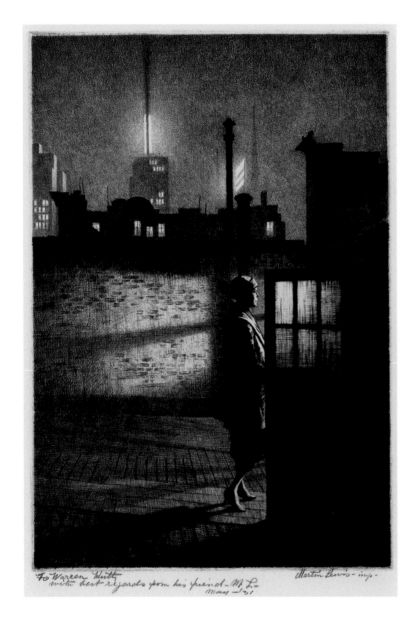

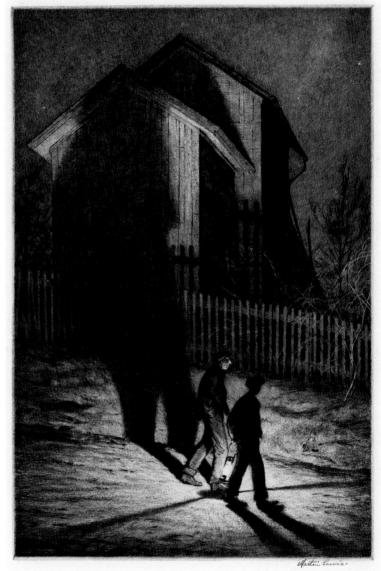

45

Lewis

The Passing Freight, Danbury

Armin Landeck

1905–1984

Born in Crandon, Wisconsin, Landeck first moved with his family to Oshkosh, Wisconsin, and then, after his parent's divorce, to Toledo, Ohio. In 1923 he enrolled at the University of Michigan, Ann Arbor, where he studied architecture. He transferred to Columbia University, New York, in 1925 and graduated with a bachelor's degree in architecture in 1927. As a student in New York he also visited many galleries and museums and this sparked his initial interest in graphic art. On the strength of his first etching, *The Armenian*, 1927 (Kraeft 1), he was taken up by the Kennedy Galleries, New York.

In 1928 Landeck left New York for an extended honeymoon in Europe to absorb its art and architecture, enrolling briefly in Nuremberg's Kunstgewerbeschule, where he made a group of etchings and drypoints. The Wall Street Crash of 1929 forced the Landecks to return to New York, where he failed to find work as an architect and concentrated instead upon printmaking. In 1930 Landeck moved to East Cornwall, Connecticut, where he converted an old granary into a studio and regularly commuted to New York.

The deserted city streets of early-morning New York became a favourite motif of his etchings and drypoints in the 1930s and 1940s, and they show the influence of his training as an architect. In 1932, with George Miller's help, he produced his first lithographs. Together with Miller and Martin Lewis, Landeck opened the School for Printmakers at Miller's studio in 1934, but the Depression soon forced its closure. Landeck also began to give classes in printmaking and the history of the print at the Brooklyn Academy of Music. During the 1930s and 1940s Landeck was most closely involved with the Society of American Etchers, where he was admired for his etchings and drypoints.

A chance meeting in 1941 with Stanley William Hayter (see cat. 117) prompted Landeck to take up engraving at Atelier 17 in New York. During the 1940s engraving began to assume importance in his printmaking, sometimes in combination with drypoint, but after 1951 nearly all his prints were engravings.

During the 1950s Landeck began to user large plates as he moved towards more abstract treatments. He returned to Europe on a Guggenheim Fellowship from 1954 to 1955, where he worked again with Hayter in Paris. Although his printmaking slowed during the 1960s and 1970s, in a late burst of work just before his death in 1984 Landeck produced thirteen new prints. Kraeft, his cataloguers, record a total oeuvre of 141 prints. The Whitney Museum of American Art, New York, holds some ninety-three prints by Landeck in its collection.

BIBLIOGRAPHY

June and Norman Kraeft, *Armin Landeck, The Catalogue Raisonné of his Prints*, 2nd edn, Carbondale and Edwardsville: Southern Illinois University Press, 1994

47 Manhattan Nocturne

1938

Drypoint and etching

Signed, dated and initialled on plate; signed in pencil. 180 x 303 mm

Kraeft 70

1998,1213.2. Presented by Catherine E. Burns through the American Friends of the British Museum

The view is from Landeck's apartment window at the corner of University Place and 8th Street, New York. The print was commissioned by the Society of American Etchers as the annual presentation print for its associate members and was printed in an edition of 100. The subject matter, which shows a deposit bank abutting a slum area of Manhattan, drew protests from recipients of the print (see introduction, p. 10).

Landeck has used densely hatched drypoint lines to create the soft, dark tones, and then selectively burnished the plate to indicate the glow of lights on the night sky. The parapet in the foreground is etched. In 1974 he reworked the plate, adding engraved lines in the sky area and in the shadow below the parapet; an edition of 100 of this second state was printed (Kraeft 127).

47
Landeck
Manhattan Nocturne

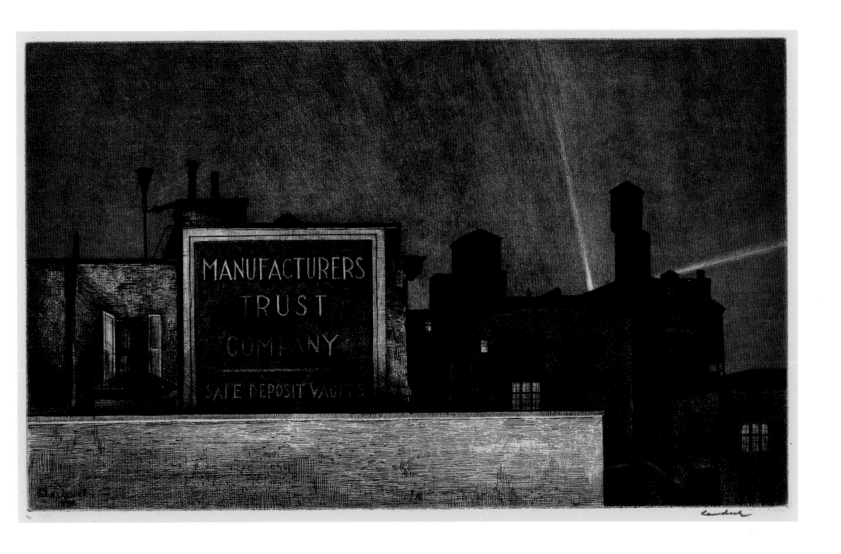

Lawrence Kupferman

1909–1982

Born and raised in Boston, Kupferman first made drypoints and etchings of Boston street scenes in a Whistlerian manner in 1930. Following a period at the School of the Museum of Fine Arts, Boston, he enrolled in 1931 at the Massachusetts College of Art. After graduation he worked as a guard at the Boston Museum of Fine Arts by day and painted at night.

In 1937 Kupferman signed up with the WPA/FAP, where he produced his drypoints of empty Victorian houses and tenement blocks for which he is now best known. Examples include *Abandoned House*, 1939, and *Victorian Mansion*, 1938, which depict Victorian villas in a highly objective manner reminiscent of Hopper. He is recorded as having made some forty-eight prints with the WPA/FAP but after he left in 1940 his work took on a more expressive style. An emphasis on the alienation and loneliness of the individual in the modern metropolis emerged in his prints, in which line and shape were exaggerated. His expressive style was also allied to political themes during this period.

From the late 1940s his prints were informed by surrealist imagery, first expressed in his 1940 drypoint *Fantasia Americana*, depicting a nineteenth-century steam locomotive emerging from a fantastical, architectural capriccio of Victoriana. During the 1950s, following a summer spent in Provincetown, Massachusetts, where he was captivated by the marine life he encountered there, Kupferman developed an abstract surrealist style. He was encouraged in this new direction by his friends Mark Rothko and Adolph Gottlieb. His 1950 screenprint *Microscopic Creatures from the Ocean Deep*, showing free-floating biomorphic forms against a black background, is an example.

Kupferman was associated with the second generation of Boston printmakers, who included Leonard Baskin (see cats 136 and 137). As well as being a practitioner, he also taught printmaking at the Massachusetts School of Art from 1941 to 1969, and was chairman of the painting department. In the late 1970s, in response to the renewed interest in American printmaking of the 1930s, he returned to making prints of urban buildings in the style of his early work.

Kupferman's prints are held in several museum collections in New York, including the Metropolitan Museum of Art, the Museum of Modern Art, the Whitney Museum of American Art, as well as the Fogg Art Museum, Cambridge, Massachusetts.

BIBLIOGRAPHY

Roger T. Dunn, *Lawrence Kupferman: A Retrospective Exhibition*, exh. cat., Brockton, Massachusetts: Brockton Art Center (Fuller Museum of Art), 1974

C. N. Ruby and V. W. Julius, *The Federal Art Project: American Prints from the 1930s*, exh. cat., Ann Arbor: University of Michigan Museum of Art, 1985 (for Kupferman, see p. 92)

48 Boston Street

1938
Drypoint
Signed, titled, dated and inscribed twice 'May 19, 1938' in pencil. 340 x 244 mm
1989,0128.101

Kupferman stated that his interest in the Victorian buildings of Boston came from their expression as documents of human use. The buildings are shown devoid of human activity: human presence is only indicated indirectly, by the car parked at the kerbside or by the advertisement sign for a car wash. Kupferman based his prints of Boston streets and buildings on preliminary photographic studies made while wandering through the districts of the city. The objectivity and clarity of the photograph seems to be replicated in this drypoint, although Kupferman adapted Boston's architecture to suit his compositional requirements rather than creating an accurate rendition of an actual city street. This is evident in the change of scale between the tenements on the right and the building with the 'Garage Washing' sign opposite.

Kupferman's use of line in this drypoint is very precise. In particular, he has carefully delineated, with very fine hatching, the ashlars on the ground floor of the tenements, to the right, and the brick used for the storeys above. Like Hopper, he has left the whiteness of the paper to describe the sky and the light reflecting off the windows of the buildings.

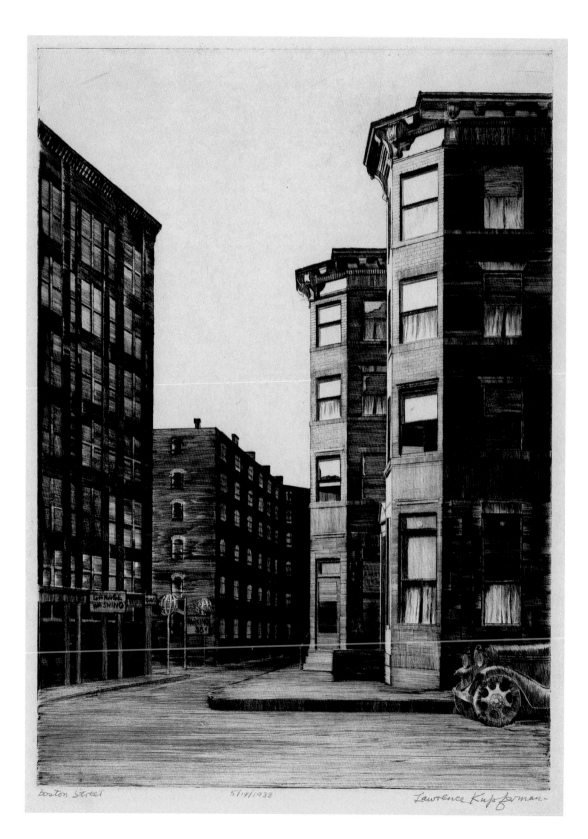

Boston Street 5/17/1938 Lawrence Kupferman

Reginald Marsh

1898–1954

Reginald Marsh was born in Montparnasse, the heart of bohemian Paris. Both his parents were artists: his mother, Alice Randall, painted miniatures and his father, Fred Dana Marsh, was a painter who specialized in images of industry. Returning to America in 1900, the family settled in the New York suburb of Nutley, New Jersey. It was through observing his father that Marsh developed his initial training as an artist. He attended Yale University, where he began to draw for the student journal *The Yale Record*. After graduating from Yale in 1920, he moved to New York where he continued to work in illustration, initially for the New York *Daily News*, and then for the newly launched *New Yorker* magazine in 1925. He also attended classes given by John Sloan and Kenneth Hayes Miller at the Art Students League. Between 1935 and 1953 Marsh also taught life-drawing classes at the League. His knowledge of human anatomy, gained through study of actual dissections at the various medical colleges in New York, led him to publish a book on the subject, *Anatomy for Artists*, in 1945.

Marsh was largely self-taught as a printmaker, beginning in 1921 with a series of thirty-three woodcuts. The main body of his oeuvre consists of 204 etchings and engravings on copper. In all, he produced some 269 prints, including thirty-one lithographs, between 1921 and 1950. He kept careful records of his etchings and noted such details as the temperature of his studio, as well as the length of time the plate was immersed in the acid bath. He often experimented with various types of grounds, the way they were applied to the plate and the types of mordant used. In 1930 Marsh began to introduce engraving to his etchings and through this he intuitively developed his 'pure' copper engravings. He worked with Stanley William Hayter (see cat. 117) in 1940 and, while he did not share Hayter's interest in the subconscious, his line became looser and more fluid.

Marsh travelled to Paris twice, in 1928 and in 1932, where he produced a series of lithographs. He was more inspired by the old masters at the Louvre than by the by the avant-garde School of Paris. Like Sloan, Bellows and Hopper, to whom his work was compared following an exhibition at the Frank K.M. Rehn Gallery, New York, in 1931, Marsh looked to the life of New York for his subjects. In particular he focused upon strip shows and burlesques, the beaches and board walks of Coney Island and the Bowery in Manhattan. Although not explicitly political, his breadline images echoed the concerns of the social realists.

His final etching, *Striptease in New Jersey*, was made in 1951, three years before he succumbed to a fatal heart attack in 1954, at the age of fifty-six. In 1969 the Whitney Museum of Art, New York, made posthumous restrikes of thirty of his prints from the original plates in its possession.

BIBLIOGRAPHY

Norman Sasowsky, *The Prints of Reginald Marsh*, New York: Clarkson N. Potter, 1976

49 Tank Car

1929

Etching

Signed and dated on plate; signed in pencil. Collector's stamp 'JK' (Jacob Kainen) on verso and numbered '20#1961' in pencil. 150 x 225 mm

Sasowsky 86.V

2002,0929.139. Bequeathed by Jacob Kainen

Marsh's interest in the locomotive was a theme he shared with Hopper and Lewis. Like Hopper, Marsh has here used the device of an oblique view, down the rail tracks, in order to organize the composition of his etching.

Over his career Marsh produced some eighteen prints of locomotives, including four lithographs, the rest being etchings or engravings or a combination of the two techniques. This etching is the fifth and final state of the work. Marsh described how he 'scraped, snaked, and charcoaled this plate for hours' (cited by Sasowsky, p. 137). A comparison of the final state with the preceding four shows that he had trouble with extensive foul biting, which created unwanted vertical lines, traces of which are still visible.

50 Tattoo-Shave-Haircut

1932; restrike 1969
Etching
Signed and dated on plate; numbered '93/100' in pencil.
Blind-stamp 'WM' of the Whitney Museum. 251 x 248 mm
Sasowsky 140
1979,1006.44

Marsh's best-known print presents an iconic
image of the more sordid side of life in Manhattan's
Bowery. The packed composition captures the
crowded street life beneath the girders and beams
of the El with its signs advertising cheap haircuts
and tattooing. The figures are caricatures rather
than individuals. Marsh has exaggerated the stoop
and pensive expression of the man on crutches
and the wide-eyed, grinning faces of the African
Americans to the left. The 'All Night Mission' sign
makes reference to the many flop-houses in the
Bowery.

Marsh based the composition on his painting
Tattoo and Haircut, 1932 (Art Institute of
Chicago). This and the following two etchings
(cats 51 and 52) come from the restrike edition
of 100 published by the Whitney Museum in 1969.

51 Star Burlesque

1933, restrike 1969
Etching
Numbered '93/100' in pencil. Blind-stamp 'WM' of the
Whitney Museum. 301 x 223 mm
Sasowsky 142
1979,1006.45

Burlesque and striptease shows were of particular
interest to Marsh, who produced some twenty
prints on the subject. He often visited the bur-
lesque shows, in the down-market theatres of
Manhattan's Lower East Side, with his friend and
contemporary at Yale, Senator William Benton.
Working from direct observation, Marsh has set
the scene within an opulent neo-baroque theatre,
with the semi-nude dancer performing for her
male audience.

The etching is based on the composition of his
painting of the same year, *Star Burlesque*, now
in the William Benton Museum of Art, University
of Connecticut.

52 Breadline – No One Has Starved

1932, restrike 1969
Etching
Initialled and dated on plate; numbered '93/100' in pencil.
Blind-stamp 'WM' of the Whitney Museum. 160 x 302 mm
Sasowsky 139
1979,1006.43

By 1932 unemployment had reached an unprec-
ented level in America as the Depression deep-
ened. Marsh shows a line of unemployed men
forming at one of the many food distribution
points that had been set up in New York. Using a
frieze-like format, he has cropped the composition
so that the line seems endless. The focus is on the
men themselves, and the only anecdotal detail is
the litter lying in the gutter at their feet.

A preparatory drawing for this print is in the
Benton Collection.

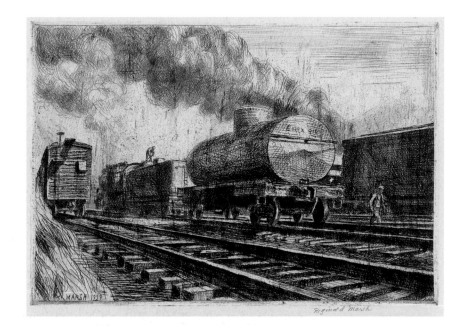

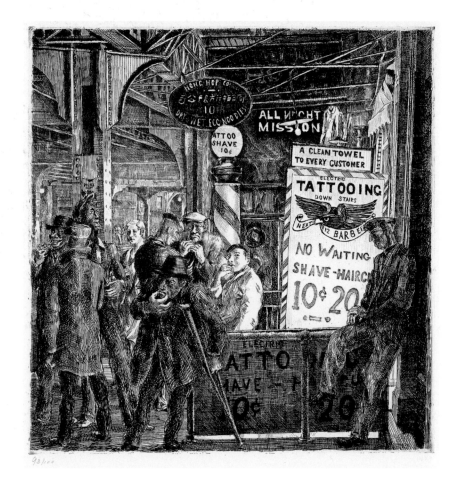

51
Marsh
Star Burlesque

52
Marsh
Breadline – No One Has Starved

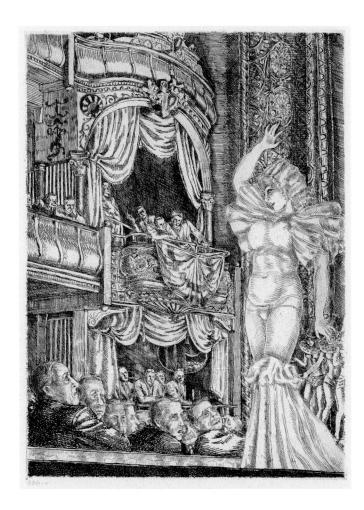

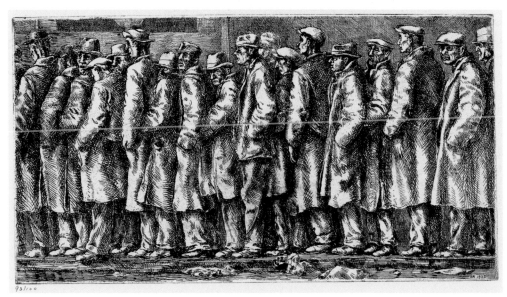

James E. Allen

1894–1964

Allen was born in Louisiana, Missouri, but raised in Montana. In 1911, at the age of seventeen, he enrolled at the Art Institute of Chicago, where he studied painting. He then went to New York, where he attended various art classes, including those at the Art Students League, where he studied etching with Joseph Pennell and William Auerbach-Levy. He worked as a commercial illustrator for periodicals, including the *Saturday Evening Post*, before enlisting as a pilot in the First World War.

In 1925 Allen travelled to Paris where he shared a studio with Howard Cook (cat. 28). There he produced his first etching, *Dragon Court*, 1925, a naturalistic depiction of a Parisian courtyard. On his return to New York in 1930, he continued to work as a commercial illustrator, producing, amongst other commissions during the 1930s, a series of six lithographs of dinosaurs for the Sinclair Refining Company. But it is for his images of industrial workers from the 1930s that he is best known. Though commissioned for commercial purposes, these etchings won a series of printmaking awards. As one reviewer of his 1938 print exhibition at the US National Museum in the Smithsonian remarked: 'avoiding the present-day epidemic of social protest … these are graphic depictions of men at work, healthy, satisfied to build for tomorrow, proud in their strength and manual skill' (cited by Elisa M. Rothstein in Ryan, p. 4).

In 1943 Allen abandoned printmaking in order to study abstract painting with Hans Hofmann. Tragically, he later developed a degenerative brain disease and one of the consequences of his illness was that he destroyed many of the preparatory sketches for the prints. The Smithsonian American Art Museum, Washington, DC, holds some fifty-six of his prints, including twenty-two etchings and twenty-five lithographs, as well as some archival material relating to the artist.

BIBLIOGRAPHY

Mary Ryan, *James E. Allen*, with brief texts by Elisa M. Rothstein and David W. Kiehl, exh. cat., New York: Mary Ryan Gallery, 1984

53 The Connectors

1934
Etching
Signed in pencil; inscribed with title 'B-120/ Cover' in pencil. Inscribed with title on verso in pencil.
327 x 250 mm
Ryan 66
2005,0331.10. Presented by Mary Ryan through the American Friends of the British Museum

The construction workers who built the skyscrapers of Manhattan fascinated Allen and he produced some six etchings on the subject during the 1930s. In spite of the Depression, many skyscraper building projects continued, such as the Chrysler Building (completed in 1930) and the Empire State Building (built 1930–31). Allen depicts the men who worked on such construction sites, high above the streets of Manhattan, without the aid of safety harnesses. The vertiginous effect of this etching is emphasized by the stepped form of the lower high-rise buildings in the background. The cropped close-up of the workmen is contrasted with the distant view.

The Connectors is one of Allen's most important prints and was recognized with a honourable mention by the Society of American Etchers in 1942.

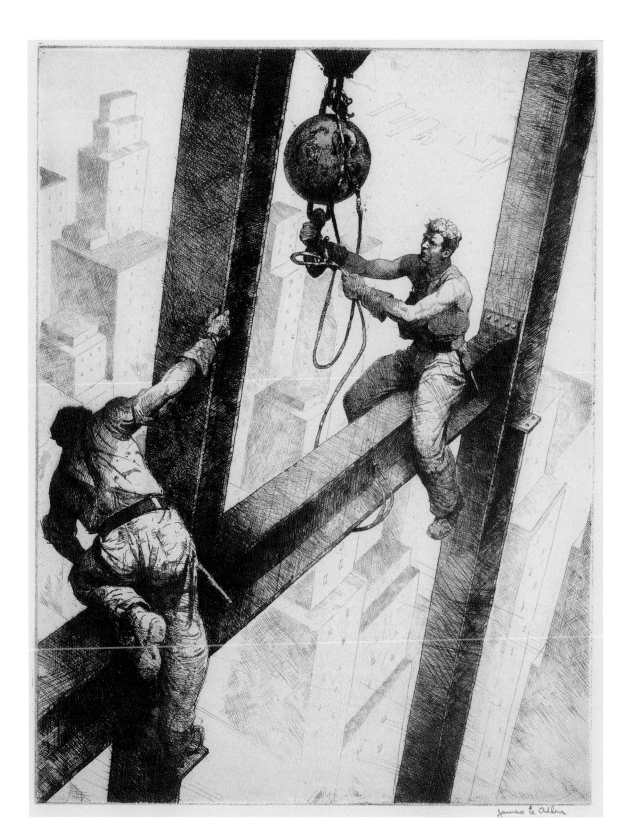

5 SATIRICAL REALISM

Robert Riggs

1896–1970

Born in Decatur, Illinois, Riggs entered Decatur College and Industrial School Academy in 1911, where he studied fine and applied art. In 1915 he won a scholarship to the Art Students League, New York, where he was influenced by the humanist ideas of Robert Henri and the Ashcan School. Following his first one-man show at Decatur Art Institute in 1917, Riggs moved to Philadelphia, the centre of American magazine publishing, and began to work for an advertising agency. When America entered the First World War, he served with the Red Cross in France. He remained in France after the war and studied at the Académie Julian in Paris from 1918 to 1919.

He returned to Philadelphia in 1919 and continued to work in advertising. His images of athletic, clean-cut American types became familiar in *Life* magazine and *The Saturday Evening Post*. Riggs never felt that his commercial work, for which he was well paid, compromised his career as a fine artist. By 1940 his commercial drawings commanded large fees, from $750 to $1,500 each. A bachelor with a good income, he collected American Indian objects as well as ethnographic pieces from Asia and Africa, beginning on a world trip he made in 1924–5. These he kept on one floor of his Philadelphia apartment; the floor below housed his menagerie of snakes, alligators, turtles and lizards, some kept behind glass and others let to slither at will.

Riggs began to make lithographs in 1932, possibly inspired by an exhibition of Bellows's work held in Philadelphia the previous year. Of the eighty-four lithographs in Riggs's oeuvre, the great majority, some fifty-five, were produced between 1932 and 1934. His first printer was Theodore Cuno in Philadelphia, but his unconventional methods of working on the stone meant that he soon sought the services of George Miller in New York. In 1933 Riggs had his successful first one-man exhibition of his lithographs at the Frank K.M. Rehn Gallery, New York. The principal themes of his lithographs from this period were prize-fighting and the circus. Around 1940 he made a group of equally graphic depictions of hospital wards, from the accident and emergency room to the children's orthopaedic ward and the psychiatric ward.

During the 1950s, with changes in advertising and magazine illustration, Riggs received fewer commissions, and by 1961 he was forced to take up teaching illustration for two years at the Philadelphia College of Art, where Benton Spruance was a colleague. In 1968, two years before his death, the Capricorn Galleries, Bethesda, Maryland, held a retrospective of his lithographs. His prints are held in numerous museum collections in America.

BIBLIOGRAPHY

Ben Bassham, *The Lithographs of Robert Riggs, with a Catalogue Raisonné*, London, Philadelphia and Toronto: The Art Alliance Press and Associated University Presses, 1986

54 On the Ropes

*c.*1932–3
Lithograph
Signed on the stone; signed, titled and numbered '24' in pencil. 376 x 496 mm
Bassham 27
1979,1110.5

Riggs made boxing the subject of twenty-six of his lithographs between 1932 and 1934. When these were shown at his first solo exhibition at the Rehn Gallery in 1933, comparisons were made with his predecessor, George Bellows. A reviewer for the *New York Times* remarked: 'To the artist's praise be it said that he is not a little George Bellows. Mr. Riggs's work is individual, strong, sometimes brutal, despite its finish' (*New York Times*, 26 March 1933, cited by Bassham, p. 38). Unlike the timeless, classical composition of Bellows's *A Stag at Sharkey's* (cat. 12), Riggs focuses here on the brutality of the sport, with his depiction of the fighters' broken noses and heavy jaws. This is the only print where Riggs shows a fight in progress; the others focus on boxers before the fight or knocked out afterwards. He made many studies from his ringside vantage point, which he then incorporated in his lithographs.

This lithograph illustrates Riggs's idiosyncratic, subtractive method of working from the darkest to the lightest tones. He applied tusche to the stone and then painstakingly scraped or rubbed away the grease to create the image. Although he soon gave up this laborious manner of working in favour of tint stones, the *manière noire* technique was particularly well suited for showing the subtle gradations of tone in the boxers' muscles.

On the Ropes proved to be the most popular print in Riggs's exhibition at the Rehn Gallery in 1933, with half the edition of fifty sold.

55 Psychopathic Ward

*c.*1940

Lithograph

Signed on stone; signed, titled, numbered '5'
in pencil. 362 x 478 mm

Bassham 78

1979,0512.13

Riggs's best-known print is based on his observations within the secure wards of the Philadelphia State Hospital for the Mentally Ill, where he made at least nine sketches. It is one of four lithographs on contemporary medical practice commissioned from Riggs around 1940 by the American pharmaceutical company Smith, Kline and French as part of its advertising campaign. The other prints in the set were *Accident Ward* (Bassham 75), *Children's Ward* (B.76), and *Ward Rounds* (B.79). Produced in editions of about fifty, sets of these prints were sold to physicians for display in their waiting rooms – although given Riggs's treatment of these subjects, it is questionable how efficacious they were in illustrating modern medical progress.

Riggs here repeats a theme which Bellows had dealt with earlier in *Dance in a Madhouse* (cat. 13). Through the inmates' agitated gestures, Riggs explicitly expresses the fragility of human mental health rather than the triumphs of modern psychiatric care. This lithograph was achieved by printing the drawn stone in black over a tint stone in yellowish-grey, which gives the print its lurid effect.

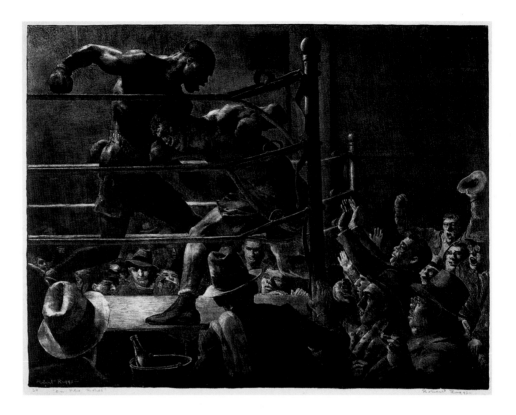

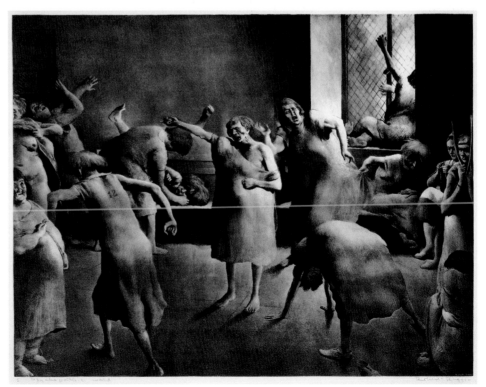

John Ward McClellan

1908–1986

McClellan was born in London to American parents and spent the first ten years of his life in England. After periods of study at Yale University and the Boston Museum Art School, he went to Paris in 1932 and took classes at the Académie Julian, where he developed his interest in sculpture.

In 1938 he returned to France and travelled to Spain, before making a further trip in the same year to Mexico. There he met the journalist and author Manuel Komroff, who urged him to visit the Byrdcliffe artists' colony based at Woodstock, in the Catskills Mountains, New York State. On his return to America later that same year McClellan moved to Woodstock, where he lived until his death in 1986.

At Woodstock McClellan began making lithographs with the printer Grant Arnold, although he must have had prior experience of the technique, possibly from Charles Locke at the Art Students League, as some of his prints are earlier than 1938. McClellan joined an established group of printmakers at Woodstock, including Adolf Dehn, Milton Avery and Peggy Bacon, all of whom had been drawn to the locality. McClellan used George Miller's workshop in New York to print his lithographs, and his prints from this period, such as *Fantasy of Cataclysm* or *Fantasy of Drought*, both dating to 1937, share an ominous surrealist imagery. He also made reference to current political events in his 1940 lithograph *Winter in Poland*.

From 1942 until 1946 McClellan served in Europe with the US forces, where his unit was among the first to reach the liberated concentration camps. His first-hand experience of witnessing the survivors had a powerful effect on him personally and upon his subsequent imagery. He contributed a lithograph, *The Imprisoned Outcasts*, to the exhibition 'America in the War' organized by Artists for Victory in 1943. After demobilization McClellan returned to Woodstock and continued to produce lithographs, which after 1960 began to reflect his long-standing fascination with mathematics and also inspired a return to his original interest in sculpture.

Although little has been published on his career or on his printmaking, McClellan produced some of the most unsettling images in twentieth-century American lithography. His prints are represented in several museum collections in New York, including the Metropolitan Museum of Art, as well as in the Smithsonian American Art Museum and the Library of Congress collection in Washington, DC.

BIBLIOGRAPHY

Robert Conway, *John McClellan Prints and Drawings 1927–1970*, exh. brochure, New York, Associated American Artists, 1988

56 Entrapped

1936
Lithograph
Signed, dated and numbered '12'
in pencil. 235 x 302 mm
Conway 13
1987,0307.4

McClellan's lithographs of the 1930s are characterized by surreal imagery presented in a naturalistic manner, in which an atmosphere of menace often pervades the scene. In this disturbing image human figures are caught in giant mousetraps within a strange, cavernous undercroft. Some of the figures have had their necks snapped by the traps; others, caught by their limbs, are struggling to free themselves. The horror of this scene awaits the discovery of anonymous figures descending a monumental staircase to the lower level. The device of the staircase and the surreal architectural setting are reminiscent of the work of M.C. Escher, the Dutch graphic artist, whom McClellan admired.

McClellan built the composition using short strokes of the lithographic crayon, creating an overall soft and even tone which contrasts with the brutal imagery. With light scratching into the stone, certain details have been brought out, such as the hands of the prone figures and the springs of the traps.

57 Panic

1937
Lithograph
Signed and dated on stone; signed, dated and numbered '/40' in pencil. 376 x 496 mm
Conway 25
1987,0307.5

Panic-stricken figures flee from an unknown danger in this unsettling lithograph. The atmosphere of inexplicable fear is heightened by the figure restraining two terrified horses in the background, while the anthropomorphic trees resemble upraised human hands. The mask and the chequerboard in the foreground are both common motifs in surrealist imagery. McClellan is not illustrating a particular narrative but evoking an emotional state.

58 Dissension at the Club

1937
Lithograph
Initialled and dated on stone; signed
in pencil. 348 x 256 mm
Conway 20
1987,0307.6

The circumstances behind the making of this print are obscure. Although this is by no means certain, McClellan appears to be targeting the Daughters of the American Revolution, the patriotic women's organization for the descendants of those who had taken part in the American War of Independence. The Daughters of the American Revolution stood for the promotion of American patriotism and the preservation of American values of freedom and democracy. These cherished values have been violently turned upside down in McClellan's print as the women openly brawl. One woman shouts and points to the American flag, vainly reminding her fellow members of the values held by those who had signed the American Declaration of Independence.

The lithograph was produced in 1937, and although McClellan makes no direct comment on these events, the year was marked by the Japanese invasion of China and by the Nazi bombing of the Basque town of Guernica on behalf of Franco's Nationalists.

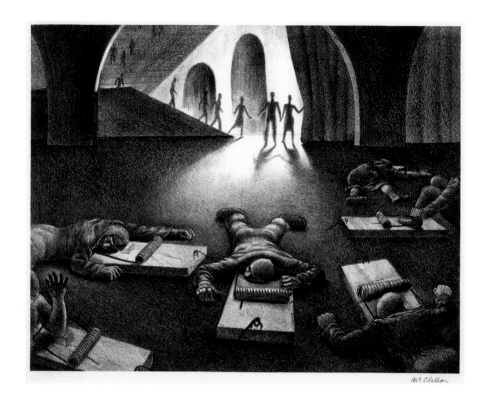

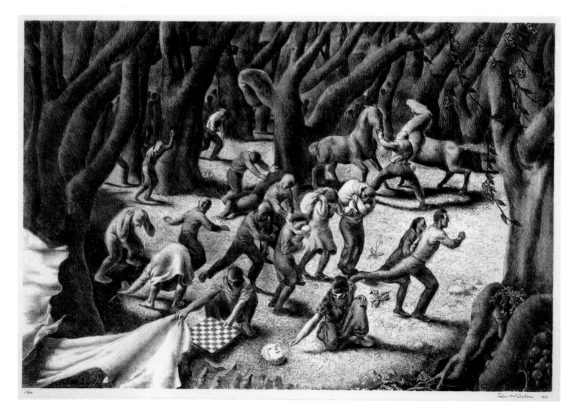

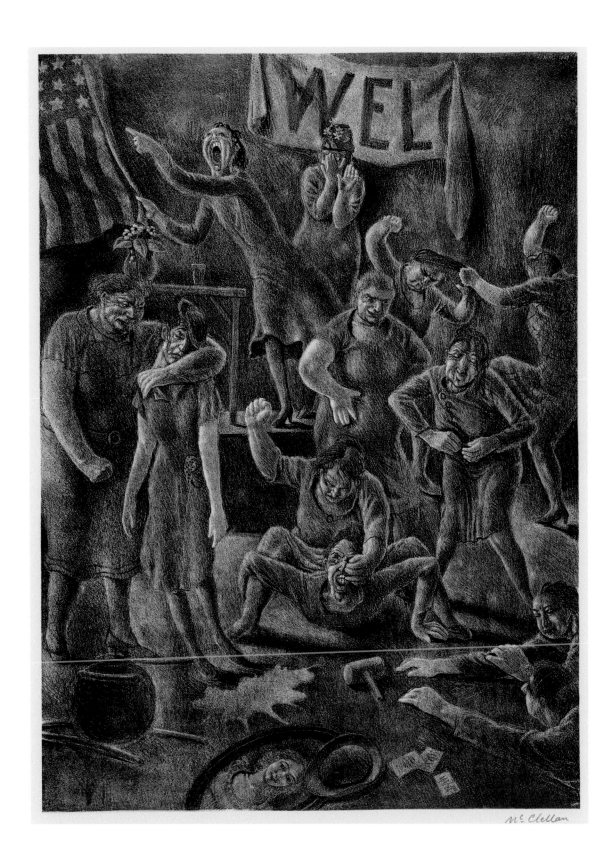

Adolf Dehn

1895-1968

Born in Waterville, Minnesota, to second-generation German-American parents, Dehn entered the Minneapolis School of Art in 1914, where he focused on caricature and illustration. There he became a close friend of his contemporary, Wanda Gág, and the two went to New York to study at the Art Students League in 1917. After America joined the First World War that same year, Dehn declared himself a conscientious objector.

Dehn was first introduced to lithography by the printer George Miller in 1920, encouraged by Carl Zigrosser of the Weyhe Gallery. Between 1922 and 1926 he lived principally in Berlin, where he became a friend of George Grosz and produced satirical lithographs of Weimar Germany. In 1926 he moved to Paris and began to work with the lithographic printer Edmond Desjobert at Atelier Desjobert, where he produced more than seventy lithographs in 1928, including the portfolio of ten prints, *Paris Lithographs*. At Atelier Desjobert his satirical lithographs became freer and more unconventional in their working.

In 1929 Dehn returned to New York where he held a successful exhibition of his work at the Weyhe Gallery, which included thirty-four of his lithographs. He soon returned to Europe, bringing with him sketches of Manhattan nightlife and New York themes as subjects for lithographs at the workshop of Meister Schulz in Berlin. With the political situation in Germany becoming increasingly ominous, Dehn left for Paris to work for a second stint at Desjobert's from 1931 to 1932, returning to America in the following year.

With the onset of the Depression Dehn designed murals with the New York Public Works of Art Project in 1933, but this came to an end the following year. With George Grosz, who had emigrated to New York in 1933, Dehn became a founder member of the print programme of the Associated American Artists. He also set up a print marketing business, the Adolf Dehn Print Club, in an attempt to distribute his prints, but this ran at a loss from 1934 to 1937. Dehn and the lithographic printer Lawrence Barrett collaborated in writing and illustrating a technical treatise, *How to Draw and Print Lithographs*, which was published by the American Artists Group in 1950. Although he continued to produce lithographs, by 1945 Dehn had largely moved away from satire and from 1952 he began to print in colour. A prolific printmaker, he produced some 665 prints, almost all of which were lithographs. The Minnesota Historical Society in St Paul, Minnesota, holds the largest collection of prints by Dehn.

BIBLIOGRAPHY

Lawrence Barrett and Adolf Dehn, *How to Draw and Print Lithographs*, New York: American Artists Group, 1950

Joycelyn Pang Lumsdaine and Thomas O'Sullivan, *The Prints of Adolf Dehn: A Catalogue Raisonné*, with essays by Richard W. Cox and Clinton Adams, St Paul, Minnesota: Minnesota Historical Society Press, 1987

59 Swinging at the Savoy

1941
Lithograph
Signed, titled, dated, inscribed 'Ed. 30' in pencil. 315 x 452 mm
Lumsdaine and O'Sullivan 333
1986,0301.51

The Savoy Ballroom, on Manhattan's Lenox Avenue between 140th and 141st Street, became the most popular dance palace in Harlem after opening its doors in 1926. Dubbed 'the home of happy feet', the Savoy launched many black dance and jazz styles, including the swing dance bands of the 1930s made popular by Duke Ellington. Dehn was a keen jazz fan and frequented Harlem's clubs and dance houses. His Harlem nightclub lithographs are among his most frenzied compositions, provoking his friend and fellow artist, Guy Pène du Bois, to remark: 'The carnal sensation of the orgy on closer examination seemed more like a swirling mass of beef than like anything human' (Guy Pène du Bois, 'Adolf Dehn', *Creative Art*, no. 9 [July 1931], p. 35; cited by Richard C. Cox in Lumsdaine and O'Sullivan, p. 12).

Dehn here captures the hot, syncopated rhythms of the jazz beat through the angular postures of the dancing figures. To convey the energy of the jazz scene, he freely mixes various techniques, including rubbing, scraping and washes, as well as crayon work. This lithograph was printed in an edition of thirty by the Colorado printer Lawrence Barrett, whom Dehn got to know at the Colorado Springs Fine Arts Center, where he taught during the summers from 1939 until 1942.

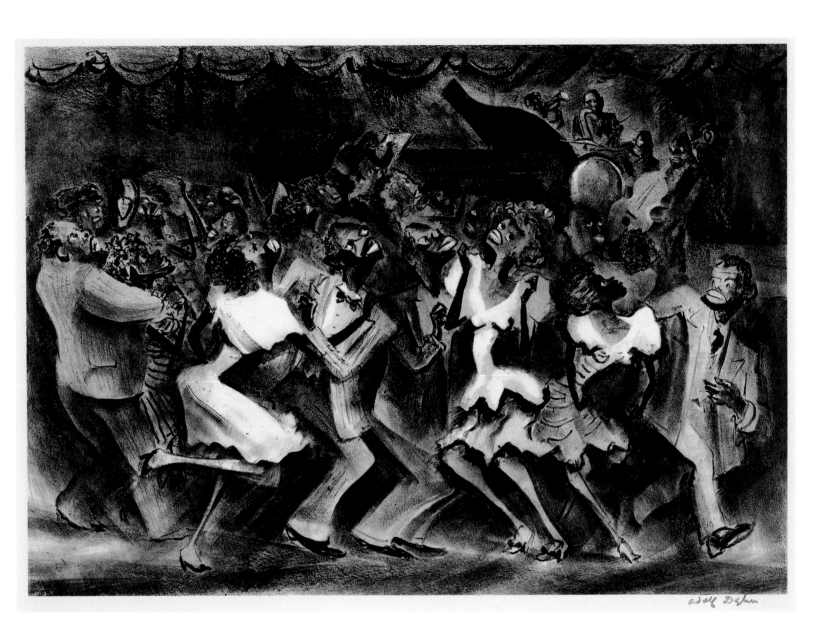

Fred Becker

1913–2004

Born in Oakland, California, the son of a silent film actor, Becker was brought up in Hollywood. After studying at the Otis Art Institute, Los Angeles, from 1931 to 1933, he left the West Coast to study architecture at New York University in 1933, but finding architectural study too restrictive he turned to drawing and print-making instead. In 1935 Becker joined the Graphic Arts Division of the Works Project Administration, on the selection of Louis Lozowick, where he worked under Gustave von Groschwitz and then Lynd Ward. Becker was the only WPA/FAP printmaker included by Alfred Barr in his seminal exhibition 'Fantastic Art, Dada, Surrealism' at the Museum of Modern Art, New York, in 1936. The prints selected were the wood-engravings *Monster* and *John Henry's Hand*, both made in 1936. Following this exposure Becker was given his first one-man exhibition at the Marion Willard Gallery, New York, in 1938. His prints of this period were mostly white-line wood-engravings of Manhattan jazz 'dives' and nightclubs.

Becker's printmaking underwent a radical shift when he met S.W. Hayter in 1940 and began to work at Atelier 17, now re-established in New York, following Hayter's move from Paris shortly after the outbreak of the Second World War (see cat. 117). Becker was amongst Hayter's first American students and he later helped to print Hayter's work, such as *Falling Figure* (Black and Moorhead 178), 1947, a colour engraving with soft ground and scorper. Becker experimented with various intaglio techniques, including relief etching, open-bite aquatint and engraving at Atelier 17, where his fellow printmakers included the émigré artists André Masson, Roberto Matta and Yves Tanguy.

By the late 1940s and early 1950s Becker's style had become fully abstract, being composed of linear webs and filaments that were interwoven to suggest spatial depth. He also took up Hayter's innovations in simultaneous colour printing and placed increased emphasis upon surface textures, achieved either with the scorper or through different textiles pressed into soft ground.

From 1948 Becker taught at Washington University, St Louis, where he founded the printmaking department. He remained there for the next twenty years before taking up his final academic post at the University of Massachusetts in Amherst from 1968 to 1986. A retrospective of his work was held by the Herter Gallery of the University of Massachusetts in 1999. He died in Amherst at the age of ninety in 2004.

The principal museum collections in New York all have prints by Becker, as does the Smithsonian American Art Museum in Washington, DC, which owns some thirty-one of his works.

BIBLIOGRAPHY

Fred Becker: Prints 1939–99, exh. cat., Amherst: Herter Gallery, University of Massachusetts, 1999

60 Clambake

*c.*1937
Wood-engraving
Signed on block; signed and titled in pencil. Stamped on verso 'Federal Art Project NYC WPA'. 194 x 247 mm
1986,0301.49

'Clambake' is jazz slang for an impromptu jazz session, in this case taking place in the furnished room of one of the musicians. This print, made when Becker was employed on the Federal Art Project from 1935, belongs to a group of white-line wood-engravings that reflect his fascination with contemporary jazz, an interest he shared with Adolf Dehn (cat. 59) and other artists.

The use of a white line against the black background evokes a smoky jam session at night and gives the composition great clarity; even small details, such as the book of matches discarded on the rug in the lower left, are clearly discernible. Becker used a multiple tool, an engraving instrument with evenly spaced teeth, to achieve the fine hatching and crosshatching in the face of the double-bass player and on the jacket of the trumpet player.

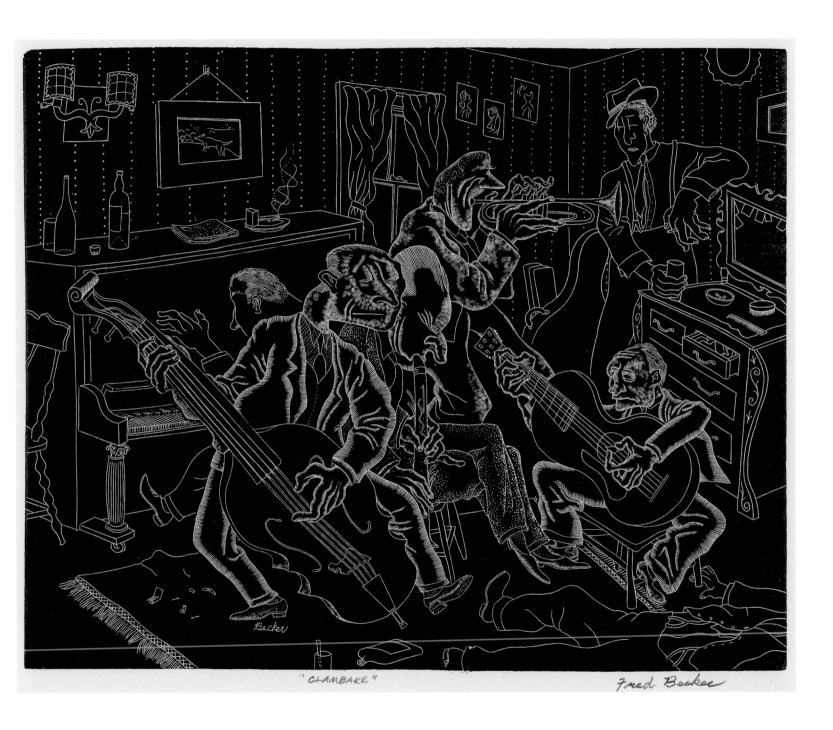

"CLAMBAKE" Fred Becker

6 THE REGIONALISTS

Thomas Hart Benton

1889–1975

Born in Neosho, Missouri, to a political family, with his father serving as a Congressman in Washington from 1896 to 1905, Benton first studied at the Art Institute of Chicago in 1907. The following year he enrolled at the Académie Julian in Paris, where he was exposed to different artistic styles. Returning to America in 1912, he spent the next few years in New York experimenting with various avant-garde styles, including synchromist 'form through colour' paintings pioneered by the American artist Stanton McDonald Wright. But after his experience as a US Navy draughtsman in 1918–19, he decided that his future would lie in portraying the American Scene, particularly of its rural heartlands and its folkloric stories.

From the late 1920s Benton taught at the Art Students League, where Jackson Pollock (see cat. 64) was one of his pupils in the early 1930s. During this period Benton continued to live in New York, although his subject matter came from rural America. From the early 1920s he had begun making extensive trips across the States to sketch rural life as well as to lecture; in 1928 alone he was reported to have covered more than 8,000 miles. In 1935 he left New York permanently and returned to his roots in Missouri; here he embarked on a major mural commission for the Missouri State Capitol in Jefferson City, which he completed the following year. He was also appointed head of painting at the Kansas City Art Institute at this time, but, after disagreements, was fired in the early 1940s.

Benton began a lifelong collaboration with the printer George Miller when he took up lithography in 1929. His first lithograph, *The Station* (Fath 1), was printed by Miller, as were all eighty prints in his oeuvre bar two, which were printed by his son, Burr Miller, in 1967. In theme and composition most of his lithographs are related to his paintings and drawings, some being studies for paintings and others based upon them. They invariably illustrate his Regionalist preoccupations with aspects of rural America, from its people and landscape to its folk stories and legends. His lithographs were mainly published by Associated American Artists, who represented him from 1934 until 1949.

Benton's most prolific period of printmaking occurred between 1939 and 1941 when he made twenty-nine lithographs, including a set of six illustrating John Steinbeck's *The Grapes of Wrath*, which was commissioned in 1939 by the film corporation Twentieth-Century Fox to advertise its film of the novel. He also made lithographic illustrations for books commissioned by the Limited Editions Club, including Mark Twain's *Adventures of Tom Sawyer* and *Huckleberry Finn*, as well as Steinbeck's *The Grapes of Wrath*.

In 1975 Benton bequeathed forty-five works to the Nelson-Atkins Museum of Art, Missouri, which holds the largest collection of his works.

BIBLIOGRAPHY

Thomas Hart Benton, *An Artist in America* (1937), 4th rev. edn, Columbia and London: University of Missouri Press, 1983

Creekmore Fath, *The Lithographs of Thomas Hart Benton*, Austin and London: University of Texas Press, 1969

61 Frankie and Johnnie

1936

Lithograph

Signed on zinc plate; signed in pencil. 420 x 560 mm

Fath 11

2005,0331.13. Presented by Patricia Hagan through the American Friends of the British Museum

Benton drew upon the rich folklore of America as source material for many of his compositions. The subject of this print is the well-known American folk ballad *Frankie and Johnnie*, about a lover's murder in St Louis, which became part of the Missouri legend:

> Frankie went back to the bar-room,
> As she rang the bar-room bell,
> She said, 'Clear out all you people.
> I'm gonna blow this man to hell.
> He was my man,
> But he done me wrong.'

> Johnnie he grabbed off his Stetson,
> 'Oh-my-God, Frankie, don't shoot.'
> But Frankie put her finger on the trigger,
> And her gun went root-a-toot-toot,
> She shot her man,
> 'Cause he done her wrong.

The lithograph is one of his largest prints, and it comes from a series of four based on mural paintings that Benton had recently completed for the Missouri State Capitol, Jefferson City, in 1936. The other three prints are *Missouri Farmyard* (Fath 10), *Huck Finn* (F. 12) and *Jesse James* (F. 13). Although Benton's preference was to work on the stone, the size of these lithographs required that they were drawn on zinc plates, prepared by his printer, George Miller. They were published in an edition of 100 by Associated American Artists.

62 Nebraska Evening

1941

Lithograph

Signed on stone; signed in pencil. 255 x 333 mm

Fath 45

2002,1130.2. Presented by the Nate S. and Ruth B. Shapero Foundation

The lithograph, which has the alternative title of *Arkansas Evening*, is based on a drawing made in 1939 when, according to his notes, Benton was 'on [a] horse buying trip'. While some of his lithographs are studies for paintings, in others, such as this, they are based on painted compositions; in this case of an oil painted the year before entitled *Nebraska Evening*, 1940 (William I. Koch Collection).

Benton often captured the special qualities of light in his depictions of rural America. The dramatic effect of the cloud silhouetted against the setting sun was a particular motif. Benton has prominently inscribed his name on the tail of the wooden-framed windmill, a distinctive feature of the American Midwest. The lithograph was published by Associated American Artists in an edition of 250.

63 The Race

1942

Lithograph

Signed on stone; signed in pencil. 227 x 334 mm

Fath 56

1979,1110.6

For Benton, the steam train evoked childhood memories and defined the open spaces of the American plains. As he explained in his 1937 autobiography, *An American Artist*:

> For the nomadic urges of our western people, the prime symbol of adventurous life has for years been the railroad train … All during my boyhood it was the prime space cutter and therefore the great symbol of change. Above all other things it had the power to break down the barriers of locality. Its steam pushed promises, shook up the roots of generations, and moved the hearts of men and women … the steam train … was a thing replete with suggestive motion
> (Benton, *An Artist in America*, pp. 70–71)

The lithograph was made as a study for a painting, *Homeward Bound*, executed in the early 1940s. Benton presents a romanticized image of the prairie lands. He later noted to his cataloguer, Creekmore Fath: 'Common enough scene in the days of the steam engine. Why did horses so often run with the steam trains while they now pay no attention to the diesels?' (Fath, p. 132).

The lithograph was published by Associated American Artists in an edition of 250.

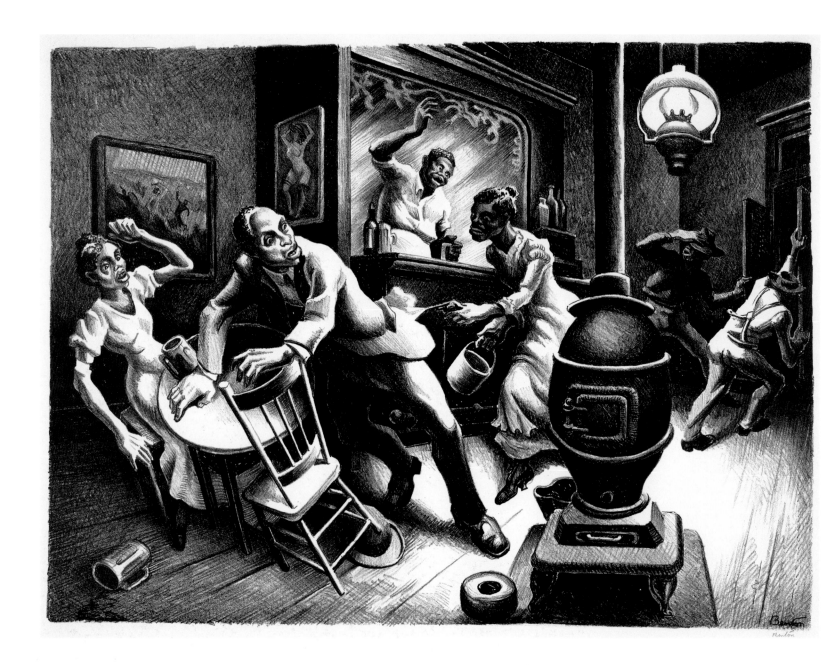

Benton
Nebraska Evening

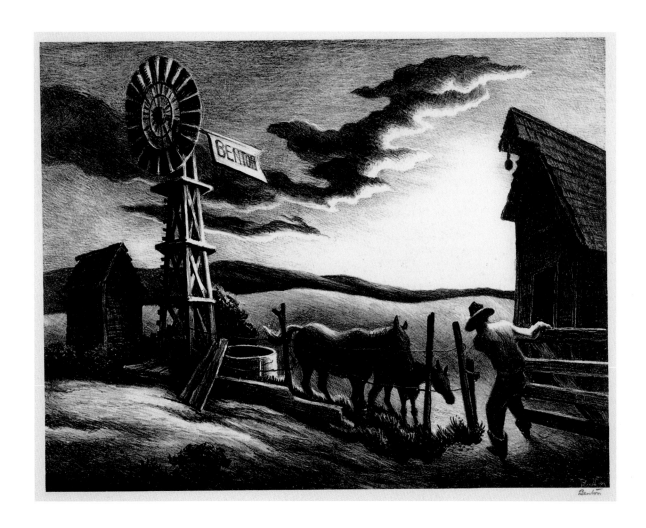

Benton

The Race

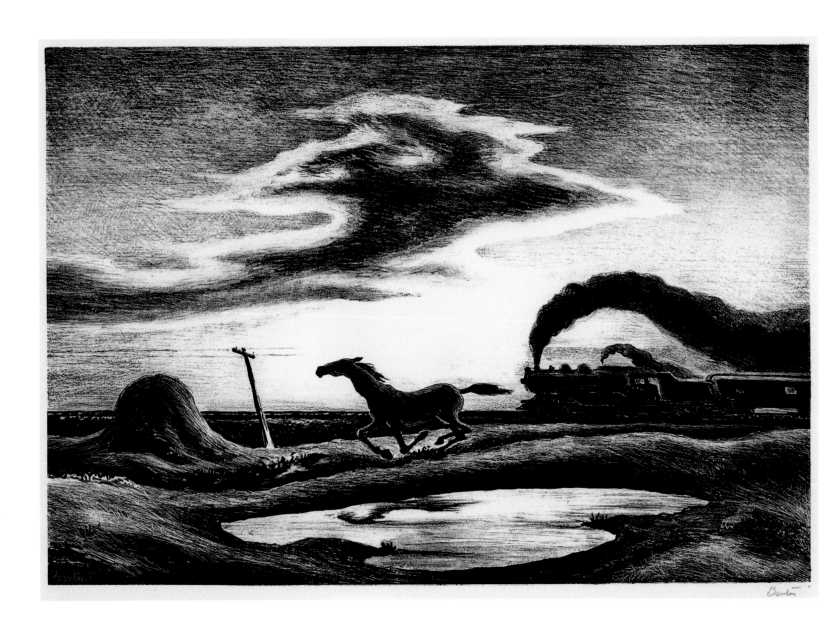

Jackson Pollock

1912–1956 (for biography see p. 256)

64 Stacking Hay

*c.*1935–6

Lithograph

Signed on stone; inscribed by the printer in pencil 'Print from original plate – Theodore Wahl'. With earlier state printed on verso, also signed on stone. 233 x 326 mm

O'Connor and Thaw P.5

2002,1130.3. Presented by the Friends of Prints and Drawings

When Pollock made this lithograph in the mid-1930s he was still very much under the influence of his Regionalist teacher Thomas Hart Benton, who had taught him painting at the Art Students League for three years from 1930. Benton was himself deeply involved in making lithographs from 1929, and his example must have inspired Pollock to experiment with the technique. In all, Pollock made twelve recorded lithographs of Regionalist subjects between 1934 and 1937. They were printed by Theodore Wahl, a lithographic printer for the Federal Art Project in New York, who also printed for artists at his own studio. Pollock would visit, often late in the evening, and declare that he wanted to work on the stone. The prints were pulled in only two or three impressions, but *Stacking Hay* was an exception in that Wahl produced an edition of sixty. It was published by the Colorado Springs artist Archie Musick in a portfolio of prints by various artists, including Bernard Steffen, but the commercial venture proved a financial loss.

This particular impression is a printer's proof retained by Wahl. The verso of the sheet is printed with an earlier state of the image, which is more faintly inked.

Grant Wood

1891–1942

Wood was born on a farm near Anamosa, Iowa, but after his father's death in 1901 his family moved to the city of Cedar Rapids, Iowa. After attending the Minneapolis School of Design and Handicraft in 1910, he took night classes at the Art Institute of Chicago while working in a silversmith's shop from 1914 until 1916. After serving as a camouflage painter in the US Army, Wood taught art at public schools in Cedar Rapids from 1919.

Between 1920 and 1928 he made four trips to Europe, where he briefly attended the Académie Julian in Paris. In 1928 Wood travelled to Munich to supervise the making of a large stained-glass window he had designed for the Cedar Rapids Veterans Memorial Building. At the Alte Pinakothek in Munich he responded strongly to the paintings of Dürer, and especially Hans Memling, with their sharp outlines, luminous colour and smooth finish. These stylistic features entered Wood's own paintings of rural Iowa subjects, culminating in his most famous work, *American Gothic*, 1930 (Art Institute of Chicago), which was immediately acclaimed as an icon of American art and launched his career.

In 1932 Wood and fellow artists established the Stone City Art Colony near Anamosa, Iowa, with the ambition of making art expressive of the Midwest, but the colony only lasted two years. In 1934 he was appointed director of the Public Works of Art Project in Iowa and began making murals for the Iowa State University Library, Ames. In 1934, when his reputation was at its height, he was appointed associate professor of fine art at the University of Iowa, but his prescriptive teaching methods and his perceived anti-liberalism were criticized by both students and faculty staff. From 1940–41 he took leave of absence and ceased printmaking; soon afterwards he was diagnosed with cancer and died in 1942, aged fifty-one.

In all he made nineteen lithographs between 1937 and 1940, printed by George Miller in New York from stones which the artist had worked on and sent to him from Iowa. The prints were published and distributed by AAA, with the exception of *Family Doctor*, 1940 (Cole 18), which was distributed by Abbott Laboratories, a Chicago pharmaceutical company. A set of four flower-piece lithographs was hand-coloured by Wood's sister (C. 7–10).

Complete collections of Wood's lithographs are held by the Amon Carter Museum, Fort Worth, Texas, the Des Moines Art Center, Iowa, and by the Davenport Municipal Art Gallery, Iowa.

BIBLIOGRAPHY

Sylvan Cole with Susan Teller, *Grant Wood: The Lithographs. A Catalogue Raisonné*, New York: Associated American Artists, 1984

Wanda M. Corn, *Grant Wood: The Regionalist Vision*, exh. cat., New Haven and London: Yale University Press for the Minneapolis Institute of Arts, 1983

Joseph S. Czestochowski, *John Steuart Curry and Grant Wood: A Portrait of America*, Columbia and London: University of Missouri Press, with the Cedar Rapids Art Association, 1981

65 Sultry Night

1939
Lithograph
Signed in pencil. 245 x 315 mm
Cole 6
2004,0331.10. Presented by the British Museum Friends

This lithograph of a naked farmer cooling off after a long day's work reflects Wood's vision of the Midwest pioneers bound to the prairies. Wood described how their character had been formed by the land:

> Finding no woodlands or deep valleys to shelter them, they had to learn a special intimacy with the soil. They had to adapt themselves to the vast openness of the prairie and the ubiquitous light of an unbroken sky. And they … developed a character … akin to that of the land itself… I saw it in the eyes of my father and mother – a quality bleak, far-away, timeless – the severe but generous vision of the midwest pioneer (Grant Wood's unfinished memoir 'Return from Bohemia, A Painter's Life'; cited in Corn, p. 3)

To evoke the sultry heat of the night, Wood carefully stroked the lithographic crayon on to the stone, creating a soft, silvery tone. By showing the male figure naked, Wood also imbued the farmer with a primal quality akin to the first man. However, in the eyes of the US Post Office authorities the subject was obscene, and Associated American Artists, whose print distribution depended on the mail, was forced to remove this print from sale. Only 100 of the planned edition of 250 were ever printed as a result.

66 Shrine Quartet

1939
Lithograph
Signed in pencil. 202 x 302 mm
Cole 11
1979,1006.64

The 'Ancient Arabic Order of the Nobles of the
Mystic Shrine', founded in New York in 1872, is a
Freemasonry society, with affiliated Temples in
other parts of America, including the Midwest. It
claims that some of its ritual originated in seventh-
century Egypt. This explains why in Wood's litho-
graph each of the four Shriners wears a fez,
despite their suits and ties, and each is placed
before a painted backdrop depicting pyramids
and camels. Within the shallow, cropped space,
Wood has focused on the facial expressions of the
singing Shriners, whose features are illuminated
by the stage lighting.

67 March

1939
Lithograph
Signed in pencil. 226 x 301 mm
Cole 14
2002,1130.5. Presented by the British Museum Friends

In his unfinished memoir, 'Return from Bohemia,
A Painter's Life', written with his friend and secre-
tary Park Rinnard, Wood described his attachment
to the Iowa landscape: 'The rhythms of the low
hills, the patterns of crops upon them, the mystery
of the seasons, and above all, a feeling for the
integrity of the ground itself – these are my deep-
rooted heritage' (cited by Corn, p. 90).

This lithograph was to have formed part of a series
on the changing seasons of the rural calendar, but
Wood only managed to produce *January*, 1938
(C. 3) and *February*, 1940 (C. 17). He has
depicted the rolling farmland of Iowa in a sensual
way: the rounded hills and the furrows of the
newly turned earth evoke the fertility of the
Midwest.

John Steuart Curry

1897–1946

Born on a farm near Dunavant, Kansas, to parents of Scotch Presbyterian descent, Curry studied at the Art Institute of Chicago from 1916 to 1918 under Edward J. Timmons and John Norton, and then at Geneva College, Beaver Falls, Pennsylvania, in 1918–19.

Curry's first job was as a freelance illustrator of cowboy western stories in the popular magazines *Boy's Life* and the *Saturday Evening Post.* His work was successful, but in 1925 he decided to turn towards fine art. After spending a year, 1926–7, in Paris studying with the Russian academician Basil Schoukhaieff, Curry returned to his studio at Westport, Connecticut. His first one-man show was held in 1930 at the Whitney Studio Club, New York, to critical acclaim. The Whitney Museum of American Art purchased his first major Regionalist painting, *Baptism in Kansas* (1928). With Thomas Hart Benton and Grant Wood (whom he had first met at Wood's Stone City Art Colony in 1933), Curry showed at the Ferargil Gallery, New York, in 1934, where the artists were proclaimed 'the Regionalist triumvirate' by the press.

In 1936 Curry was appointed America's first artist-in-residence by the Agricultural College of the University of Wisconsin, Madison, where he also produced murals in 1940–42. Other important mural commissions were *The Tragic Prelude* (John Brown) and *Kansas Pastoral* for the Kansas State Capitol, Topeka, in 1938–40. He died in Madison, Wisconsin, from a heart attack in 1946, aged forty-eight.

Curry was taught lithography by Charles Locke at the Art Students League in 1927. Most of his lithographs were printed at George Miller's studio in New York, although occasionally he would print from the stone himself. In 1934, with Thomas Hart Benton, Reginald Marsh, George Grosz, Adolf Dehn and Charles Locke, he became one of the founding members of Associated American Artists, and remained with them for the rest of his career. He produced some forty-one lithographs, many of which were based on his paintings or murals. Curry's subject matter included the recent pioneering past of western America, as well as scenes of contemporary rural life. The tornados, storms and floods of the Great Plains were favourite subjects, which he endowed with an epic and often biblical quality.

Curry's prints can be found in many American museum collections including the Philadelphia Museum of Art, the Metropolitan Museum of Art, New York, and the Smithsonian American Art Museum. His sketchbooks and drawings were donated by his widow, Kathleen Curry, to the Worcester Art Museum, Massachusetts, in 1999.

BIBLIOGRAPHY

Sylvan Cole, *The Lithographs of John Steuart Curry*, with an introduction by Laurence Schmeckebier, New York: Associated American Artists, 1976

Joseph S. Czestochowski, *John Steuart Curry and Grant Wood: A Portrait of America*, Columbia and London: University of Missouri Press, with the Cedar Rapids Art Association, 1981

68 Manhunt

1934

Lithograph

Signed on stone; signed, titled, dated and numbered
'10/50' in pencil. 250 x 330 mm

Cole 22

2003,1231.5. Presented by Martha J. Fleischman through
the American Friends of the British Museum

A fugitive from the law, with county sheriff and
armed posse in hot pursuit, was a potent image in
America. It evoked the lawlessness of the old Wild
West and became a popular subject of films in the
1930s. But Curry may also be referring to a darker
side of life in the Southern states – the practice
of lynching. Curry tackled this theme in *The Fugitive*, 1935 (Cole 26), depicting a black man hiding
in a tree from a lynching party, in a composition
similar to *Manhunt*.

The lithograph was published by the Contemporary Print Group, New York, in a portfolio entitled
The American Scene, Series 2, which included
six lithographs by Curry, Thomas Hart Benton,
William Gropper, Russell Limbach, Charles Locke
and Raphael Soyer. The project proved commercially unsuccessful, and it is believed that, in all,
fewer than 100 impressions were ever printed,
despite a planned edition of 300 portfolios.

69 John Brown

1939

Lithograph

Initialled and dated on stone; signed and titled
in pencil and inscribed 'Merry Xmas for Chris and
Cara –1941 J.& K–'. 374 x 276 mm

Cole 34

2007, 7048.1 Presented by the James A. and Laura M.
Duncan Charitable Gift Fund

John Brown (1800–59) was a vociferous slavery
abolitionist who led a raid on the Federal Arsenal
at Harpers Ferry, Virginia, in 1859. He hoped to
precipitate an uprising by arming the slaves, but
he was captured by the local militia, found guilty
of treason and hanged on 2 December 1859.

The lithograph is after Curry's painting *John
Brown*, 1939 (Metropolitan Museum of Art, New
York). Both the print and the painting are based on
his large mural *The Tragic Prelude* for the Kansas
State Capitol, Topeka, on which he worked from
1938 to 1940. In the lithograph, as in the painting,
Curry has cut down the composition to focus
directly upon the Moses-like John Brown, who is
presented as a fiery preacher of the Bible belt. The
fanatical intensity of Brown's beliefs is matched by
the fury of the tornado and the prairie fire rising
behind him. The lithograph was published by
Associated American Artists in 1940 in an edition
of 250.

This particular impression was dedicated as
a Christmas present from Curry and his wife
Kathleen to his close friend Chris Christensen,
then Dean of the Agricultural College at the
University of Wisconsin, Madison, who had
appointed Curry as the nation's first artist-in-
residence there in 1936.

70 Stallion and Jack Fighting

1943

Lithograph

Initialled and dated on stone; signed
in pencil. 300 x 392 mm

Cole 37

1979,1110.1

The fight between the two horses is presented
as the struggle of animal forces. Curry first
explored this theme in one of his earliest lithographs, *Coyotes Stealing a Pig*, 1927, which he
made in two versions (Cole 2 and 3), and again, in
1931, with *Hounds and Coyote* (C. 12). He was
particularly drawn to horse subjects; examples
include *Horses Running before the Storm*, 1930
(C. 10) and *Prize Stallions*, 1938 (C. 31), showing
a struggling horse being led into an arena.

68
Curry
Manhunt

70
Curry
Stallion and Jack Fighting

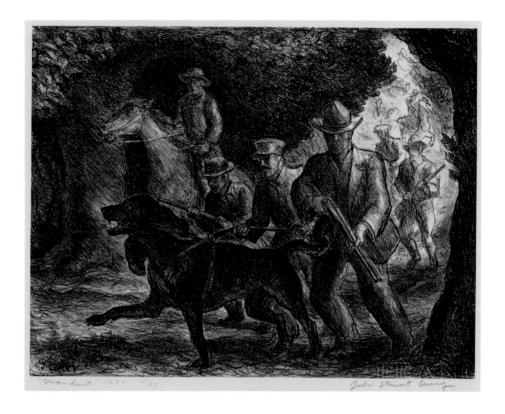

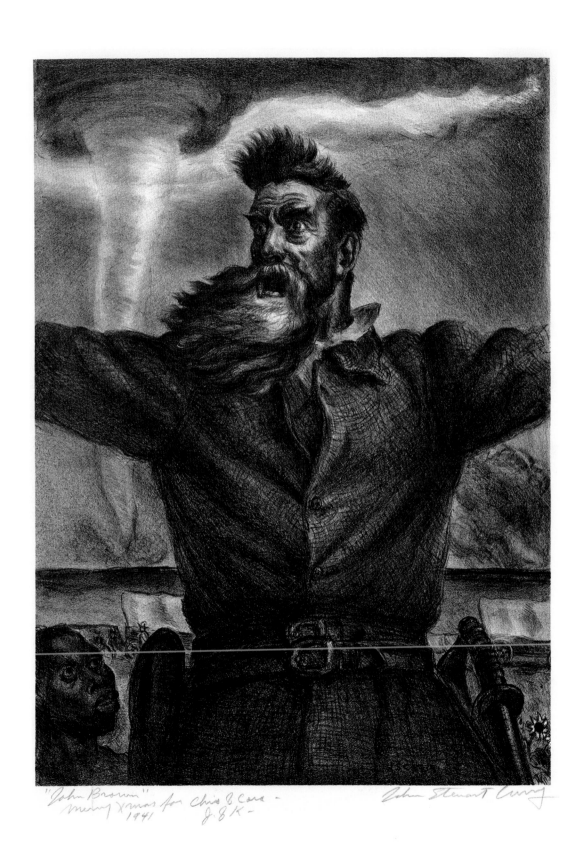

Paul Weller
b.1912

Paul Weller was born in Boston and trained at the National Academy of Design, New York. During the Depression he was involved in various public art projects. He was with the New York City WPA/FAP for various periods between 1937 and 1940. In 1938 he was among thirty-three artists invited to submit designs for the Museum of Modern Art's exhibition 'Subway Art', organized by the Public Use of Arts Committee. Weller's designs were singled out by the *New York Times* art critic Edward Alden Jewell as being among the few good proposals for a decorative scheme for the New York Subway system. In 1941 Weller painted a mural entitled *Gateway to the West*, commissioned by the WPA/FAP for the post office in Baldwinsville, Onondaga, New York State. Weller is known to have produced nine prints for the New York City WPA/FAP, including the lithographs *Flood Waters*, *c.*1935, and *Sleeper* (cat. 71), and at least one woodcut, *Shampoo*, *c.*1936. During the early 1930s Weller travelled widely through the American West as an itinerant on the freight trains and working on the ranches. This experience fed into his work. He was introduced to lithography by Jacob Freelander and his figurative prints of this period show his empathy with the hobos and migrant families. After 1940 Weller took up photography, for which he became well known.

BIBLIOGRAPHY

Karen F. Beall and David W. Kiehl, *Graphic Excursions: American Prints in Black and White 1900–1950*, Boston: Godine, 1991 (for Weller, see p. 153)

C.N. Ruby and V.W. Julius, *The Federal Art Project: American Prints from the 1930s*, exh. cat., Ann Arbor: University of Michigan Museum of Art, 1985 (for Weller, see p. 214)

71 Sleeper

1935
Lithograph
Signed on stone; signed and titled in pencil. Inscribed 'PW1 (3)' on verso in pencil and numbered '12' in ink.
199 x 305 mm
1992,1107.4

Riding the rails in search of work was a familiar sight during the Depression. Weller's hobo is shown in this night scene exposed to the elements, lying on a flatcar, his head resting on a rolled-up bundle of his possessions, as the goods train rounds a bluff. The title of the lithograph makes ironic comment on the notion of a deluxe railway sleeper car.

Weller used the lithographic crayon to progressively build up the softly graduated tones of the sleeping figure, while the darkest passages of the composition were worked with tusche.

Wanda Gág

1893–1946

Wanda Gág was born in New Ulm, Minnesota, the daughter of the painter Anton Gág, an émigré from Austro-Hungarian Bohemia. She studied at the Minneapolis School of Art from 1914 to 1917, where she met Adolf Dehn (cat. 59) and together they moved to New York in 1917 on an Art Students League scholarship. Her teachers included Frank Vincent DuMond, Kenneth Hayes Miller and Robert Henri, who gave her composition classes. She was taught etching by Mahonri Young and attended lectures by John Sloan. Her first prints were drypoints and date from 1918.

Gág first took up lithography with Dehn in 1920, when George Miller pulled her first print; he remained her lithographic printer for the rest of her career. Although she also made linocuts, wood-engravings and drypoints, lithography became her principal medium, and some sixty-five of her 122 prints are lithographs. Between 1923 and 1926 she experimented with a technique she had discovered of using sandpaper as a matrix, which gave her lithographs a soft and grainy tone. Her work was sold through the Weyhe Gallery, New York, where its director, Carl Zigrosser, became a close friend. Throughout the 1930s her prints were well received, and a number of her lithographs, including *Grandma's Kitchen*, 1931 (Winnan 82), were selected among the Fifty Prints of the Year by the American Institute of Graphic Arts.

Drawn to nature and to country life, Gág rented a rickety old house in Glen Gardner, New Jersey, which she named 'Tumble Timbers'. Here she spent her most productive period during the summers and autumns from 1925 to 1930. In 1928 Gág's children's book, *Millions of Cats*, which she had written and illustrated, was published. Its huge success brought her financial security for the first time, and royalties from this and her other children's books saw her through the Depression. Gág was a consummate draughtsman, and her deft line was readily translated into her prints. Her last lithographs date from 1944; her health failing, she was diagnosed with lung cancer, and died in 1945.

The British Museum owns twelve prints and a drawing by Gág, presented by Carl Zigrosser in 1967. A comprehensive collection of her prints, together with many of her zinc plates, is in the Philadelphia Museum of Art. Her letters and dairies are held by the Van Pelt Library, University of Pennsylvannia, Philadelphia.

BIBLIOGRAPHY

Audur H. Winnan, *Wanda Gág: A Catalogue Raisonné of the Prints*, Washington and London: Smithsonian Institution Press, 1993

72 Whodunit

1944
Lithograph
Stamped in ink 'Lithograph by Wanda Gág', inscribed 'Whodunit Cat. 105' in pencil. Blind-stamped 'Cuno. Phila., PA. Impression'. 300 x 398 mm
Winnan 122
1967,1219.9. Presented by Carl Zigrosser

The title invites the viewer to solve a bizarre mystery. Gág depicts a murder scene on a farm, with the corpse's feet protruding from the chicken coop, the carcass of a hen floating in the water trough, and a fish stabbed ritualistically by a dagger. The upraised arm brandishing a kerosene lamp makes reference to Gág's private sexual symbolism.

This lithograph was printed a year after Gág's death by Theodore Cuno in Philadelphia, in an edition of thirty-five; no lifetime impressions are known. Ordinarily Gág used zinc plates, as she found the weight of the lithographic stones difficult to handle, but in this case she worked on the stone. Several preparatory studies and a related gouache exist in the Philadelphia Museum of Art.

Doris Lee

1905–1983

Doris Lee was born in Aledo, Illinois, close to the Mississippi River; her father was a banker, though most of her large family came from farming stock. She gained a liberal arts degree from Rockford College, Illinois, in 1927, and after a trip to Italy and Paris she attended classes at the Kansas City Art Institute in 1928. The following year she returned to Paris, where she began to paint abstract works under André Lhote. She then took further classes at the California School of Fine Arts, San Francisco, in 1930, where her teacher Arnold Blanch, whom she later married, advised her to give up abstraction and to paint instead subjects that appealed to her.

Characterized by a naïve, folk-art style, her works often took traditional American themes as their subject. Her painting *Thanksgiving*, 1935 (Art Institute of Chicago), became a huge success after winning the Art Institute's prestigious Logan prize. The patron, Mrs Frank G. Logan, protested against the award, arguing, somewhat implausibly, that Lee's naïve style was too avant-garde.

From 1931 Lee made her home in Woodstock, New York, in the Catskills. She retained a studio in New York at 30 East 14th Street, where she worked, from 1935–7, on a large mural entitled *Rural Postal Delivery* for the Federal Post Office in Washington, which had been commissioned by the Treasury Department. She also produced illustrations for magazines such as *Life*, which supported Regionalism.

Her lithographs were published by Associated American Artists, which promoted the Regionalist printmakers, but details of her printmaking are sketchy. Several of her prints, such as the lithograph *Thanksgiving*, 1942, are based on earlier compositions of her paintings. The distribution of her prints through AAA ensured the commercial popularity of her images. She also produced genre lithographs for Abbott Laboratories, the Chicago pharmaceutical company, for whom Grant Wood also made a print. Although Regionalism had fallen from favour by the mid-1940s, Lee retained her popularity well into the 1950s.

Her prints are represented in the collections of the Palmer Museum of Art, Penn State University, Pennsylvania; the Smithsonian American Art Museum, Washington, DC; and the Library of Congress, Washington, DC.

BIBLIOGRAPHY

Doris Lee, *Doris Lee*, New York: American Artists Group, 1946

Todd D. Smith, 'Painting for the Middlebrow: Doris Lee and the Making of a Popular Artist', in *American Art from the Dicke Collection*, exh. cat., Dayton: The Dayton Art Institute, 1997, pp. 34–65

73 Afternoon Tea

*c.*1945
Lithograph
Signed in pencil. 230 x 285 mm
1992,0404.56

The folksy, whimsical scene is set near the coast; in the distance, yachts are visible on the horizon. The flattened perspective of the composition, most apparent in the tilted-up floor of the veranda and the table laid for tea, recalls the naïve style of the American folk artist Anna Mary Robertson (1860–1961), better known as 'Grandma Moses', whose work was popular in America during the 1940s.

The lithograph was published by Associated American Artists in an edition of 250. The printer was probably George Miller, who printed the work of the other AAA printmakers, including Thomas Hart Benton and Grant Wood. Lee used the lithographic crayon in a precise manner, delineating even such small details as the speckled plumage of the hens in the foreground.

74 Helicopter

1948
Lithograph
Signed in pencil. 225 x 303 mm
2007,7001.2. Presented by Dave and Reba Williams

An unexpected sign of modernity intrudes upon this Regionalist scene in the form of a helicopter hovering over the neat rows of corn and cabbages. The rural scene is depicted in Lee's typical naïve style. The incongruous appearance of the helicopter, which in 1948 was still a relatively new phenomenon, recalls the naïve paintings of Henri Rousseau with his similar treatment of dirigibles and biplanes in the skies above Paris. Rousseau's work was widely reproduced, but Lee may also have seen a travelling exhibition of his pictures from American collections, which went to several venues, including the Metropolitan Museum of Art, New York, in 1945.

The lithograph, published by AAA in 1948, reproduces a painting of the same title.

7 THE DEPRESSION AND THE WPA

Julius Bloch
1888–1966

Julius Bloch was born in Kehl, near Strasbourg, Germany, to German-Jewish parents who emigrated to America in 1893 and settled in Philadelphia. Although the family were poor, Bloch studied at the Pennsylvania Academy of Fine Arts from 1908 to 1912, where he was taught life drawing and portraiture under Thomas P. Anshutz. After serving in France during the First World War, Bloch returned to Philadelphia and attended the Barnes Foundation in Merion. But, uneasy with the tendency towards modernism that had begun to influence painters in Philadelphia, Bloch began to focus instead on the actualities of American life for his subject matter. He drew inspiration from the nineteenth-century French realist painters, such as Millet. His genre paintings also shared an affinity with the Ashcan School artists who preceded him, and with Thomas Eakins.

Bloch was taught lithography by Theodore Cuno in Philadelphia during the late 1920s. His most prolific period was during the 1930s, when he used lithography to reproduce his painted compositions, as well as for its own sake. In 1934 he gained nationwide attention when Eleanor Roosevelt, herself an advocate of social reform, selected his painting *The Young Worker*, *c*.1934, for the White House collection. The painting had been included in the first Public Works Art Project exhibition at the Corcoran Gallery of Art, Washington. In 1936 Bloch was made project director of the Easel Painting Division of the Philadelphia WPA/FAP, but he resigned from the post a year later, frustrated by the restraints the Federal Art Project imposed upon its artists. From 1948 until his retirement in 1962, Bloch taught at the Pennsylvania Academy of Fine Arts. By then he had moved away from his earlier social realist style in favour of an expressionist idiom that referred to Byzantine art, which he had studied during his travels in Sicily, Greece and Istanbul in the mid-1950s.

BIBLIOGRAPHY

Patricia Likos, 'Julius Bloch: Portrait of the Artist', *Philadelphia Museum of Art Bulletin*, vol. 79, no. 339 (summer 1983), pp. 3–24

75 The Prisoner

1934

Lithograph

Initialled on the stone; signed, titled, numbered '24/50' and inscribed in pencil 'To Mrs. Franklin D. Roosevelt, from Julius Bloch. Philadelphia, December 12. 1934'.
340 x 253 mm
2001,0930.19

The lithograph is based upon Bloch's painting, *The Prisoner*, 1933 (Public Works of Art Project, on deposit with the Philadelphia Museum of Art). The model was Alonzo Jennings, who had sat for an earlier portrait. In his journal Bloch described the placing of handcuffs on Jennings: 'I had a horror of putting them on him, but he only laughed, and said, "I'll trust you to take them off again"' (Bloch, Journals, no. 3, 25 November 1933; cited by Likos, p. 13). Bloch heightens the emotional tension of the subject by focusing upon the black youth's expression of suffering and upon his large, manacled hands. The black prisoner looks upwards, like a martyr in a religious image, towards deliverance from his plight.

Bloch dedicated this impression to the First Lady, Eleanor Roosevelt, who was a strong supporter of civil rights.

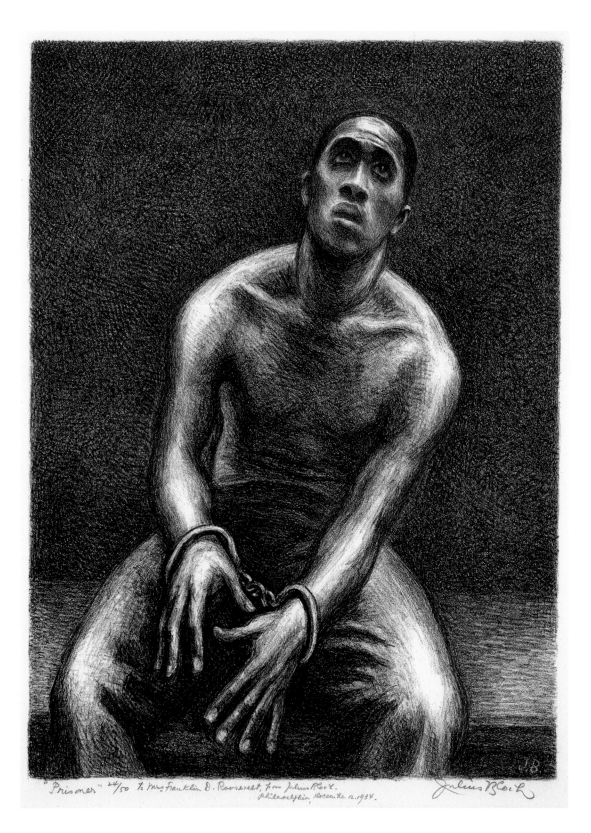

Benton Spruance

1904–1967 (for biography see p. 92)

76 Young Colored Girl

1932
Lithograph
Initialled on stone; signed, titled and numbered '2/23'
in pencil. 337 x 273 mm
Fine and Looney 58
1997,1102.18. Presented by Mike Godbee

Throughout his career Spruance produced a series
of naturalistic lithographic portraits. The sitter of
this study is anonymous, but she is depicted with
great sensitivity and simplicity. Broad strokes of
the lithographic crayon are used to describe the
warmth of the sitter's skin, while her hands are
sensitively rendered by a particularly animated
use of line.

Spruance's portraits received critical acclaim, as
did his other work. In 1929, his *Portrait of Betty
Schnabel* (Fine and Looney 12) won first prize
in the Philadelphia Printmakers Annual exhibition
held at the Print Club of Philadelphia. *Young
Colored Girl* was probably printed by Theodore
Cuno, the Philadelphia printer whom Spruance
used for many years.

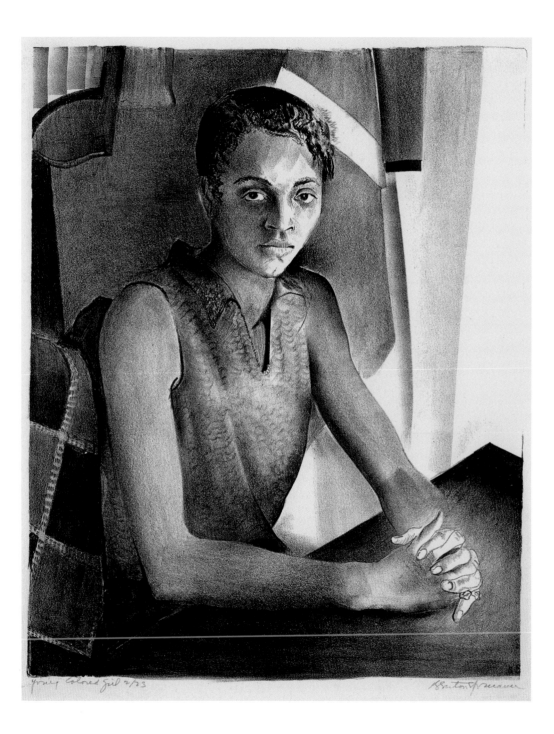

Dox Thrash

1893–1965

Born to an African American family in Griffin, Georgia, Thrash enrolled in evening classes at the Art Institute of Chicago. During the First World War he served with the famous all-black 92nd Division of the American Expeditionary Force, later known as the 'Buffaloes'. After resuming night classes at the Art Institute, which he completed in 1923, Thrash moved to Philadelphia around 1924–5.

In 1930 he began to take classes at the Graphic Sketch Club in Philadelphia, where he studied printmaking with Earl Horter and made his first etchings and aquatints. From the mid-1930s to the early 1940s he became best known for his sensitive portrayals of black models, the rural and urban poor, and the working class. His treatment of black subjects responded to the call by African American writers such as Alain Locke for a new visual culture representing African American life. Over the course of his career as a printmaker, from the early 1930s to the early 1950s, Thrash produced some 188 prints.

In 1937 Thrash joined the Fine Print Workshop of the Philadelphia Federal Art Project, where he worked with fellow printmakers Michael J. Gallagher and Hugh Mesibov. He was the first African American to join the workshop, and the WPA/FAP prided itself upon its anti-discrimination policies. With his colleagues Thrash played a central role at the WPA/FAP in developing the innovative carborundum print, which relied on carborundum (carbide silicon) powder to produce a mezzotint-like effect. In 1938 some thirty carborundum prints by Thrash and his associates were shown in the exhibition 'New Techniques in WPA Graphic Arts' at the National Museum of Natural History, Washington, DC, up to then the most extensive display of new work produced by WPA printmakers.

As an African American artist Thrash was also closely involved with the Pyramid Club, which he joined in 1937. The club was set up to advance the social, cultural and civic standing of Philadelphia's African American community; it was also the pre-eminent venue for exhibiting the work of African American artists in Philadelphia. Thrash exhibited there from 1941 to 1957, but by the early 1950s he had stopped making prints and focused on painting. His last prints were made around 1952.

The Free Library of Philadelphia holds the largest public collection of Thrash's prints, comprising some sixty-two works.

BIBLIOGRAPHY

John Ittmann, *Dox Thrash: An African American Master Printmaker Rediscovered*, exh. cat., Philadelphia: Philadelphia Museum of Art, 2001

77 Surface Mining

*c.*1939
Aquatint
Sticker with no.'52 A' lower right-hand corner.
176 x 251 mm
Ittmann 59
1998,0712.9

The heavily industrialized areas of Pennsylvania were a common theme in Thrash's prints. This aquatint shows two African American figures mining coal from an open seam. Thrash created texture in the sky by using spit-bite, while the tonal modulations of the coal-dust-covered figures were achieved by stopping out. Lighter linear accents, such as the taut rope pulling the coal trolley, were created by scratching into the aquatint.

Thrash made this print at the Fine Print Workshop for the Philadelphia WPA/FAP. It is listed in the WPA/FAP inventories as *Surface Miners*. Although the size of the edition is not recorded, his other WPA/FAP prints suggest that it was probably between thirty and thirty-five impressions.

77
Thrash
Surface Mining

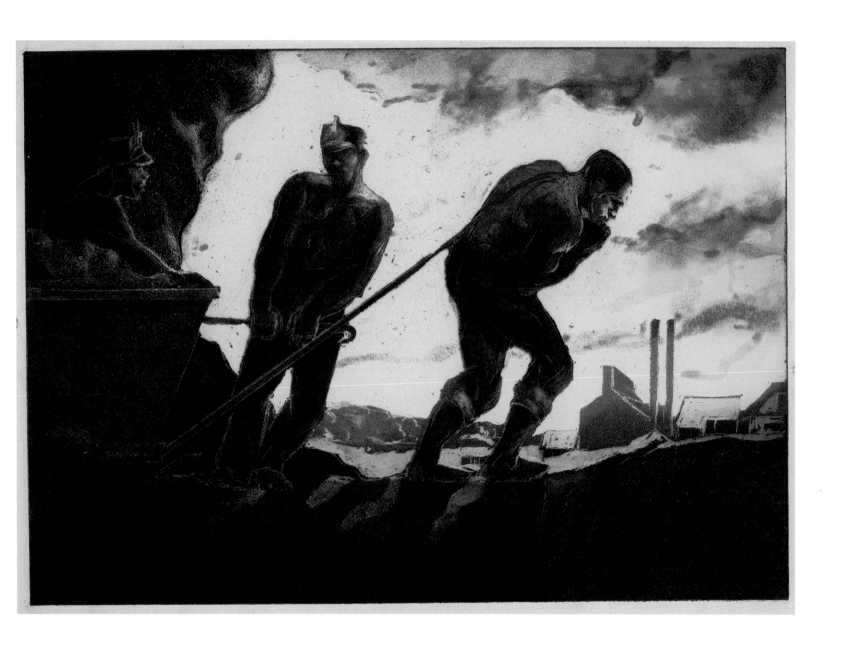

Gerardo Belfiore

1914–2002

Belfiore was born in Agropoli, Italy, but emigrated to the United States in 1930 and settled in Philadelphia. During the Depression he worked for the Philadelphia WPA/FAP. He was largely self-taught, and although he made a number of lithographs, he was better known for his carborundum prints, and in particular for his role in developing colour carborundum etching. An early example of the latter is *In Old Philadelphia*, *c*.1938–40. In 1940 he took part in an exhibition billed as the world's first carborundum exhibition, organized by the Philadelphia Federal Art Project. The *Philadelphia Inquirer*, reviewing the exhibition, described Belfiore as one of Dox Thrash's 'disciples' (see cat. 77), together with other Philadelphia carborundum printmakers, including Claude Clark and Raymond Seth. Little else is known about Belfiore's subsequent career.

78 Mid-city

1937
Carborundum print
Signed, titled 'Midcity' and numbered '6/35' in pencil.
226 x 175 mm
2003,0531.31. Presented by the British Museum Friends

Belfiore has chosen the entrance to Market St Station in Philadelphia to capture the anonymous bustle of the city. The highly defined architecture is contrasted with the shadowy figures of the commuters.

Belfiore used the carborundum mezzotint technique to make this print. The copper plate was ground with carborundum grains, the commercial name for carbide silicon, in order to evenly texture the plate with small pits. Experiments by Thrash, Mesibov and Gallagher at the Fine Print Workshop of Philadelphia revealed that the most suitable grade of carborundum grain had a hardness approaching that of diamonds. This produced a grainy effect similar in appearance to aquatint. The grained plate was then scraped and burnished to obtain subtle effects, such as the silhouetted figures and shadows in the foreground. The linear elements of the architecture were also achieved through careful burnishing.

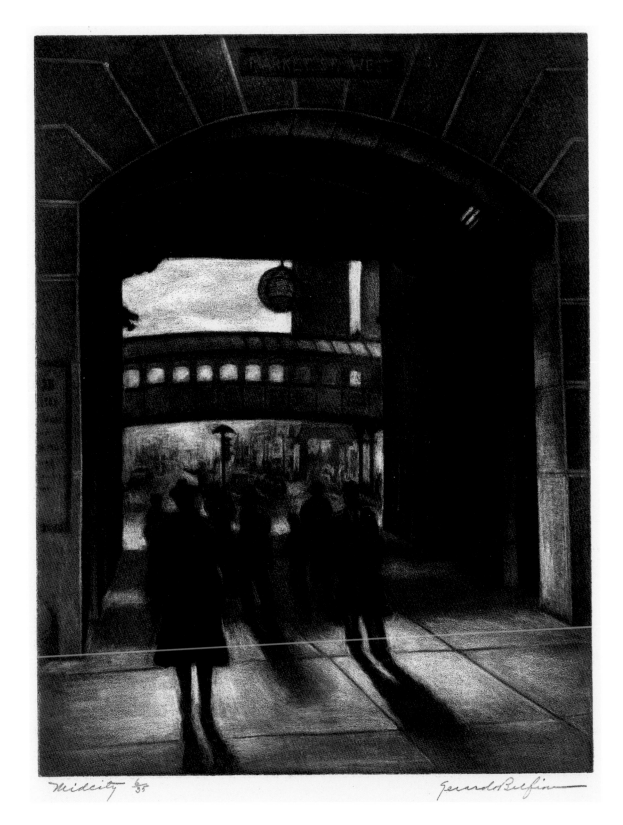

midcity 6/35 Gerardo Belfiore

Blanche Grambs

born 1916

Born in Beijing, China, to American parents, Grambs was raised in one of the foreign concessions in the city of Tian-Jing. In 1934, at the age of seventeen, she left China to study at the Art Students League in New York, where she joined the left-wing art politics of the League. She also attended classes in Marxist theory at the New Workers School, New York, and took part in Communist rallies. Grambs was a member of the Artists' Union, serving on its membership committee and, in December 1936, when members of the Union staged a sit-down protest at cuts to the New York City WPA/FAP budget, she was one of the 219 members arrested.

Grambs learnt printmaking at the League from Harry Sternberg, who advocated experiment and an art of social commitment. His classes attracted many politically radical artists inspired by his call to depict the harsh reality of the Depression. They included Riva Helfond (cat. 103), Ida Abelman, Will Barnet and Hugh 'Lefty' Miller, whom Grambs later married.

Grambs's first prints, dating to 1934, were produced at the League with the help of the printer Will Barnet and reflect her commitment to political and social reform. After leaving the League in 1935, she briefly made lithographs at George Miller's studio. In 1936 she signed up for the New York City WPA/FAP, at the age of twenty one of its youngest members. She made forty-nine prints during her brief printmaking career from 1934 to 1939, and thirty of these were published by the WPA/FAP. They are concerned with the plight of dock-workers, miners and the unemployed, and reveal a debt in their emotional intensity and social content to the prints of Käthe Kollwitz, whose work she admired. She made her most powerful prints in aquatint and etching when she accompanied Sternberg and several of her former classmates, including Helfond and 'Lefty' Miller, to the bleak coal mining area of Lanceford, Pennsylvania, in 1936.

After her marriage to 'Lefty' Miller, the couple moved to France in the spring of 1939 and arrived in Paris just as war broke out. They managed to return to New York but found a changed world. Funding for the Federal Art Project had diminished when it was transferred from Federal to State level in 1939. Grambs's printmaking activity came to an end, and she supported herself by working as an illustrator for *Woman's Day*; her husband served in the US Army but after he returned from the war the couple divorced. Grambs continued to work as an artist, producing illustrations for more than thirty children's books.

The Metropolitan Museum of Art, New York, the Newark Museum, New Jersey, the Philadelphia Museum of Art and the Smithsonian American Art Museum all hold prints by Blanche Grambs in their collections.

BIBLIOGRAPHY

James Wechsler, 'The Great Depression and the Prints of Blanche Grambs', *Print Quarterly*, vol. 13, no. 4 (December 1996), pp. 376–96

79 Miner's Head

1937
Aquatint
Signed and titled in pencil. Stamped in ink on verso 'Federal Art Project NYC WPA'. 377 x 299 mm
Wechsler 38
1991,1109.13

In 1936 Grambs made a study trip with her former teacher Harry Sternberg to the coalfields of Lanceford, Pennsylvania. She stayed with a mining family and was given permission to enter the mineshafts. In direct response to this experience, in 1937 she produced a group of ten prints in aquatint and etching which were published by the New York City WPA/FAP in editions of about twenty-five.

Miner's Head is her only print produced by aquatint alone, which she more commonly used with etching. The coarse aquatint grain in this print evokes the gritty coal dust and the dark and dangerous conditions of working deep inside the mines. The black depths are barely illuminated by the lamp on the miner's hard hat, and his gaunt face and blank stare express his physical exhaustion. Through the use of a crusty aquatint Grambs creates an effect of choking dust, the cause of the debilitating illnesses from which many miners suffered.

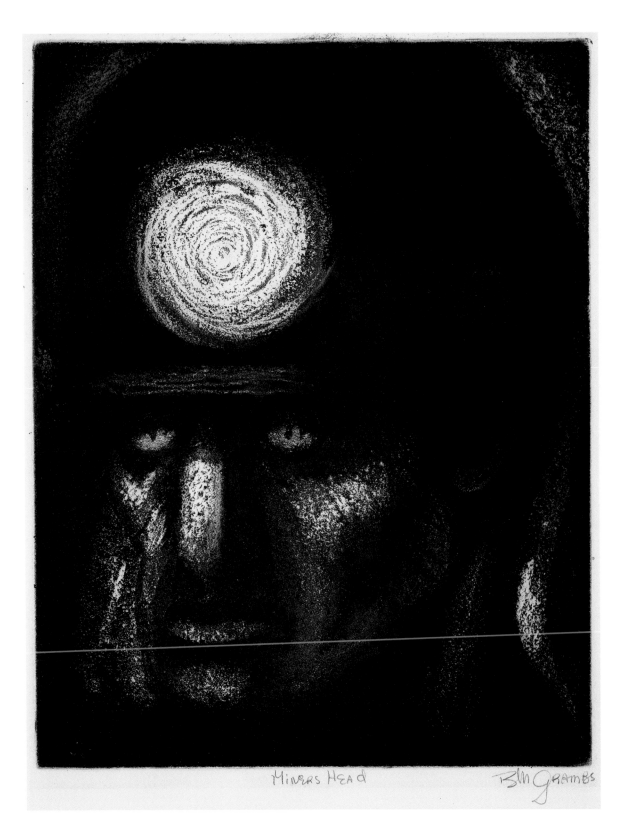

Miners Head BM Grambs

Jacob Kainen

1909–2001

A painter, printmaker, print curator and historian, Kainen was born in Waterbury, Connecticut, to Russian immigrant parents. Around 1919 his family moved to New York, and in 1927 he enrolled at the Pratt Institute. During the 1930s Kainen befriended Stuart Davis, John Graham and Arshile Gorky, whose emphasis on 'shapemaking' was a formative influence on him. He became involved with left-wing art politics, joining the Artists' Union in 1935 and contributing reviews to *Art Front*. From 1937 he was associated with the ACA Gallery, which held his first solo show of paintings in 1940.

He joined the Graphic Arts Division of the New York City WPA/FAP in 1935, on the advice of Stuart Davis. He remained there until 1942, concentrating on lithography: some forty of the forty-five prints he produced with the WPA/FAP were lithographs, mostly printed in editions of twenty-five. He worked with Russell Limbach who had set up a colour lithography section within the WPA/FAP programme. His prints at this time are largely concerned with the political and social issues of the Depression era.

In 1942 Kainen left New York permanently to take up a position in Washington, DC, with the Division of Graphic Arts at the Smithsonian Institution's US National Museum (later the National Museum of American History). In 1946 he was promoted to Curator of the Division of Graphic Arts, a position he held until 1966. He organized exhibitions of contemporary and old master prints, and expanded the Smithsonian's permanent print collection dramatically. He published on contemporary printmakers such as Raphael Soyer, as well as on the eighteenth-century woodcuts of John Baptist Jackson. In 1966, when he took up the post of Curator of Prints and Drawings at the Smithsonian's National Collection of Fine Arts (now the Smithsonian American Art Museum), he built up a collection of American works until his retirement in 1970.

Despite these curatorial demands, Kainen continued to work as a painter and printmaker. His first fully abstract paintings date from 1949, and in the same year he produced his aquatint *Marine Apparition*, one of the earliest abstract expressionist prints. From 1957 the figure returned to his work in an expressionistic manner, which also informs his woodcuts of the early 1960s. Kainen later turned to non-objective geometric shapes and vibrant colour. In 1976 the Smithsonian's National Collection of Fine Arts held a print retrospective and published a catalogue of his 147 prints. A retrospective of his paintings was given by the National Museum of American Art in 1993.

He left his collection of more than four hundred prints and drawings to the National Gallery of Art, Washington, DC. The Smithsonian American Art Museum holds some 136 works by him.

BIBLIOGRAPHY

Janet A. Flint, *Jacob Kainen: Prints, a Retrospective*, exh. cat., Washington, DC: National Collection of Fine Arts, Smithsonian Institution, 1976

80 Rooming House

1937
Lithograph
Initialled with artist's monogram 'JK' on the stone; signed and titled in pencil. Stamped in ink on verso 'Federal Art Project NYC WPA'. 268 x 340 mm
Flint 19
1984,0331.7. Presented by the artist

Kainen made this lithograph while he was employed by the New York City WPA/FAP. The subject of a dingy boarding house on the Lower East Side accorded with his strongly held political beliefs and social concerns provoked by the Depression. The two black men, probably working day and night shifts respectively, share the single iron-frame bed. The room is sparsely furnished – just the bed, a chair, an upturned wooden crate and a standard lamp, with a scroll-like arm, which is the only decorative detail in this bleak image. Kainen worked with tusche and crayon on the stone, scratching into it to underscore the gritty poverty of the scene depicted. The seated figure hunched over his darning, with one foot partially raised in concentration, is keenly observed.

Kainen donated fifteen of his prints to the British Museum. He later bequeathed twenty-five prints by other artists, including William Zorach (cat. 17) and Reginald Marsh (cat. 49).

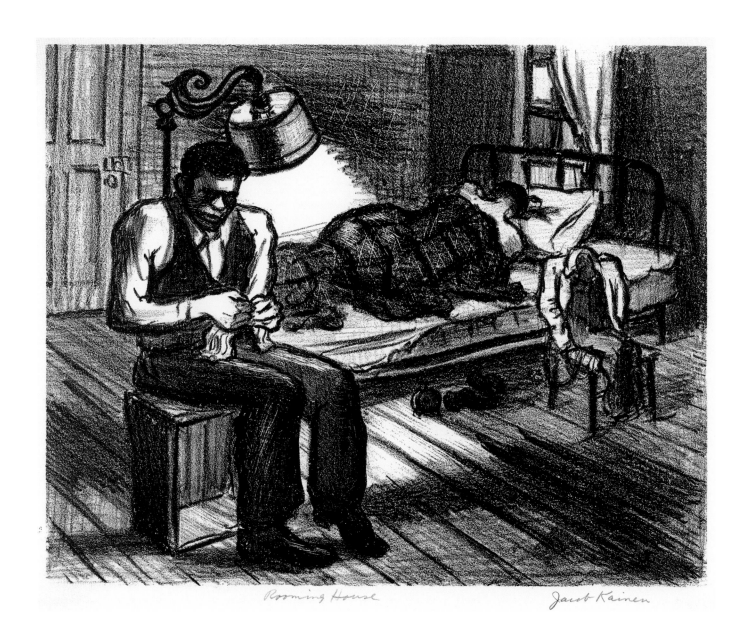

Rooming House Jacob Kainen

Shelby Shackelford

1899–1987

Little is recorded of Shackelford's life and work. She was born in Fredericksburg, Virginia, and trained at the Maryland Institute College of Art, Baltimore, where she received a traditional art education. Frustrated by academic teaching, she spent a summer in Provincetown with Marguerite Zorach, the wife of William Zorach, where she was introduced to modernism and possibly also to printmaking. She then travelled to Paris and worked in the studios of Othon Friesz, the former Fauve painter, and Fernand Léger.

Shackelford returned to America to paint in New York and Provincetown, and in 1943 she settled in Baltimore with her husband, Richard Cox, a physicist at the John Hopkins University. A leading figure in the artistic life of Baltimore, she gave art classes at a Marine Hospital for the Red Cross and taught painting at the Baltimore Museum of Art. In 1941 she published a book entitled *Electric Eel Calling*, an illustrated account of a scientific expedition she had made to study this marine creature at Santa Maria de Belem do Para in Brazil.

She used unconventional techniques in her printmaking, such as the wax print and the paraffin print. An example of the latter is *Mother and Child*, made in 1929. Unusual media were also evident in her drawings: as well as working in graphite, she also produced a series of 'soot drawings' later in her career.

The Provincetown Art Association and Museum, Provincetown, Massachusetts, holds a number of her prints and drawings in its collection.

81 Rust Cotton Picker Comes to the South

1936
'Wax' relief print
Signed, dated, titled and inscribed 'For Jules with appreciation' in pencil. 322 x 248 mm
1988,1001.40

The 'Rust Cotton Picker', a type of mechanized cotton harvester, had been developed in the late 1920s by the Rust Brothers of Memphis, Tennessee, and by 1936 was being introduced in the Southern States to a furore of opposition (see Ralph C. Hon, 'The Rust Cotton Picker', *Southern Economic Journal*, vol. 3, no. 4 [April 1937], pp. 381–92). Designed to make cotton picking more efficient and profitable for the plantation owners, the Rust Cotton Picker threatened to make redundant a large part of the rural labour force, which was poor and black. Shackelford shows a Rust Cotton Picker being operated by two faceless workers, while a redundant black man looks on, ineffectually cradling a handful of cotton.

Shackelford used her idiosyncratic 'wax' relief technique to make this print. This involved pouring wax into a baking tin and then scoring it with a tool after it had hardened. The wax matrix would be refrigerated in its tin to prevent it from becoming soft. The print, with its reserved white lines, shows an affinity with the work of the Provincetown printmakers, particularly Marguerite Zorach and Blanche Lazzell.

Rust Cotton Picker Comes To The South

For Jules with appreciation—

Shelby Shackelford—36

Bernard Schardt

1904–1979

Schardt was born in Milwaukee, Wisconsin, and after briefly attending the University of Wisconsin he studied at the school of the Art Institute of Chicago in 1924, and at the Art Students League in New York under Boardman Robinson and Max Weber in 1928. He joined the New York City WPA/FAP in 1935, where he was put in charge of the allocations division and supervised the WPA demonstraton exhibits at the New York World's Fair. He then assumed responsibility for the poster division, which produced screenprinted posters for government agencies. He also worked with Anthony Velonis at the Creative Printmakers Group in New York.

Schardt and his wife Nene Vibber, also a WPA/FAP artist, whom he had met in New York, shared a loft with Jackson Pollock (see cats. 64, 119–22, 144). In 1937 Pollock invited Schardt, together with several members of the Art Students League and friends from Los Angeles, to join a group exhibition for the Temporary Galleries of the Municipal Art Committee, New York; however, Pollock's exhibition plans fell through. In 1947 Schardt and his wife began to spend summers in Truro, near Provincetown, where they initially stayed with the artist Ben Shahn. They subsequently purchased a block of land in Truro and settled there permanently.

Schardt mostly made woodcuts for the WPA/FAP, although a few of his lithographs are also known. He is recorded as having made twenty-three prints with the WPA/FAP. The Smithsonian American Art Museum, Washington, DC, and the University of Michigan Museum of Art, Ann Arbor, both hold prints by him.

BIBLIOGRAPHY

C.N. Ruby and V.W. Julius, *The Federal Art Project: American Prints from the 1930s*, exh. cat., Ann Arbor: University of Michigan Museum of Art, 1985 (for Schardt, see p. 164)

82 Woman in Kitchen

*c.*1938
Colour woodcut on pliant oriental paper
Signed twice and titled and inscribed '22'
in pencil. Stamped in ink 'Federal Art Project NYC WPA'.
398 x 355 mm
2006,1030.3. Presented by Patricia Hagan through the American Friends of the British Museum

Schardt's woodcuts for the WPA/FAP focused on intimate domestic scenes, usually of African Americans. Other examples are *Farm Kitchen*, *c.*1937, and *Girl Sewing*, *c.*1943. In this respect Schardt was different from other WPA/FAP artists such as Blanche Grambs or Dox Thrash, who concentrated upon images of industrial workers or the urban poor. In *Woman in Kitchen* the black figure is depicted quietly engrossed in her task of peeling potatoes.

The woodcut is printed on a thin oriental paper. Three blocks were used: a tone block in brown, a block for the green, and finally the drawing block in black. The pronounced grain of the wooden plank is clearly visible in the finished print: it has been exploited to particular effect to describe the texture of the woman's hair and her wrinkled forehead.

Robert Gwathmey

1903–1988

Gwathmey was born in Richmond, an eighth-generation Virginian. He trained at the Maryland Institute of Art, Baltimore, from 1925 to 1926 and then at the Pennsylvania Academy of Fine Arts, Philadelphia, from 1926 to 1930. In 1929 and 1930 he travelled to Europe on Cresson scholarships to study art during the summers. From 1931 to 1937 he taught at Beaver College, Jenkintown, Pennsylvania, and made regular trips to New York. From 1938 to 1942 he taught at the Carnegie Institute, Pittsburgh, and from 1942 to 1968 at the Cooper Union, New York.

His experience of living and teaching in the North exposed him to more liberal attitudes towards African Americans, whom he first met as equals, he claimed, on the Philadelphia WPA/FAP project and through the Artists' Union. He was angered and shocked at the treatment they received in his native Virginia and in the Southern states. The poverty and oppression of the rural black poor informed the social content of his paintings and screenprints of the 1930s and 1940s. Characteristic of his paintings and screenprints are the flat, high-key colour and the use of a wiry, taut black outline to describe the figures.

From 1939 to 1941 Gwathmey painted the WPA/FAP mural *The Countryside* for the post office of Eutaw, Alabama. In 1946 he had a solo exhibition at the ACA Gallery, New York, for which Paul Robeson, the black spiritual singer and actor, wrote the catalogue introduction, describing him as 'a white Southerner [who] expresses his region in the democratic tradition and in the best fusion of esthetic and social principles' (Paul Robeson, introduction to *Robert Gwathmey*, exh. cat., New York: ACA Gallery, 21 January–9 February 1946).

Gwathmey's career as a printmaker was intermittent: he made only twenty-six prints, of which the first twelve were screenprints produced between 1937 and 1954, the key period of his career. It is not known who introduced him to screenprinting but his first work, *The Hitchhiker* (cat. 83) dates from 1937 and was probably made in New York, where artists were already experimenting with the technique prior to Anthony Velonis establishing the Silk Screen Unit of the New York City WPA/FAP in 1938. In 1945 Gwathmey published an article on how to make screenprints, entitled 'Serigraphy', for the magazine *American Artist* (December 1945). From the 1960s he also produced nine lithographs with the aid of Burr Miller, the son of George Miller, in New York.

BIBLIOGRAPHY

Robert Gwathmey, 'Serigraphy', *American Artist* (December 1945), pp. 8–11

Michael Kammen, *Robert Gwathmey: The Life and Art of a Passionate Observer*, Chapel Hill and London: The University of North Carolina Press, 1999

Reba White Williams, 'The Prints of Robert Gwathmey', *Hot off the Press: Prints and Politics*, eds Linda Tyler and Barry Walker (vol. 15 of *The Tamarind Papers*), 1994

83 The Hitchhiker

1937

Colour screenprint

Signed in ink in image; signed and titled in pencil below image. Inscribed on verso 'Robert Gwathmey/ "Hitchhiker"/ ACA Gallery 63 E. 57 ST.' in pencil. 428 x 332 mm

Williams 1

1981,0725.14

This screenprint is based upon Gwathmey's earliest surviving painting, also entitled *The Hitchhiker*, of 1936 (Brooklyn Museum, New York), which he later described as his first mature painting. In 1938 he destroyed all his previous work with the exception of this picture, the related screenprint and a couple of watercolours. The screenprint is a cropped version of the painting, with slight alterations to compositional details, such as the removal of a telegraph pole and a third hitchhiker. Gwathmey later disclosed to an interviewer that the subject was autobiographical: 'The shirt-sleeved figure in the foreground, with thumb to the sky, could well be the painter, heading back home to Richmond' (Gwathmey, in an interview of 1985 to Judd Tully; cited by Williams, p. 43). During the Depression he would often hitchhike home from Philadelphia and this experience highlighted the great social divide between the affluent and the unemployed. The roadside billboard advertisements, displaying attractive girls with 'Pepsodent' smiles and appetizing lobsters, stand in mocking contrast to the two unemployed men hitching rides in search of work.

The screenprint, with its ability to print flat, unmodulated colour, was the ideal medium for Gwathmey for translating the effects of the flat, even brushwork of his paintings. An inscription on this impression indicates that it was sold through the ACA Gallery which represented Gwathmey and specialized in Social Realism. The ACA gave Gwathmey his first solo exhibition in 1941, and another in 1946.

84 Share Croppers

1944

Colour screenprint

Signed in ink in image. 369 x 302 mm

Williams 3

2003,0930.6. Presented by Patricia Hagan through the American Friends of the British Museum

The plight of the rural, black poor was the consistent theme of the six screenprints which Gwathmey produced between 1944 and 1947. They developed from his experience of spending three months working with sharecroppers on a tobacco farm in North Carolina in 1944. He had received a Rosenwald Fellowship to enable him to do this, claiming that he could not portray the rural poor if he had not picked tobacco himself. The labourers are tied to the land, eking a meagre living from the soil, their movements stiff and deliberate.

The screenprint is based on an earlier painting of the same title from 1939 which was included in his 1946 exhibition at the ACA Gallery. Gwathmey discussed and reproduced this screenprint in his 1945 article on how to make a serigraph. He explained his approach: 'In arranging the sequence [of colours], I prefer to print in the largest areas first, as is illustrated in the earth and sky (of my print *Share Croppers*), which allows bold relief of the images and facilitates relating the color. The remaining colors are added … with the line coming last' (Gwathmey, 'Serigraphy', *American Artist* (December 1945), p. 8; cited by Williams, p. 35). In 1944 Gwathmey joined the National Serigraph Society, which promoted the screenprint as a fine-art medium, and published four of his screenprints in the late 1940s in large editions of between two and three hundred.

This print was included in the fourth annual exhibition of the National Serigraph Society in May 1944, although the edition size and publisher remain unknown.

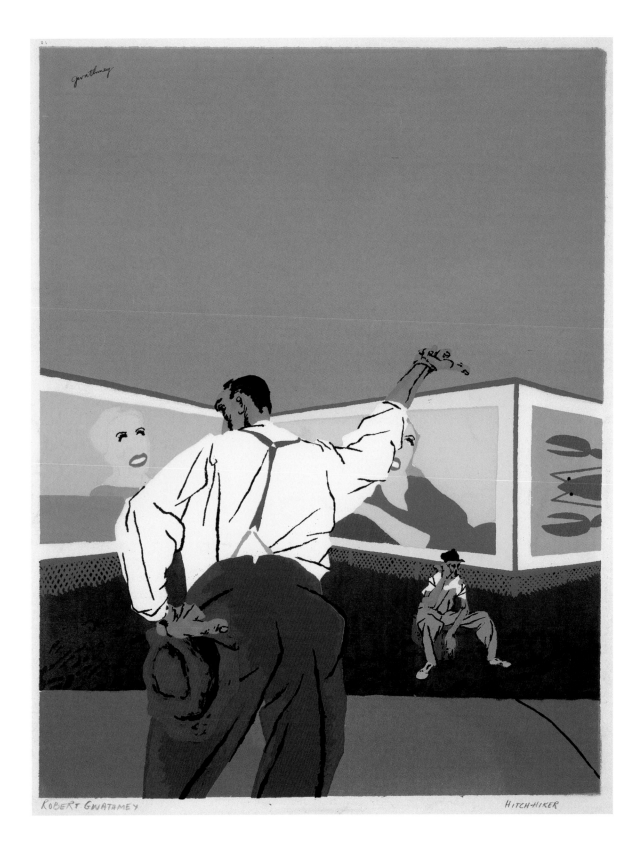

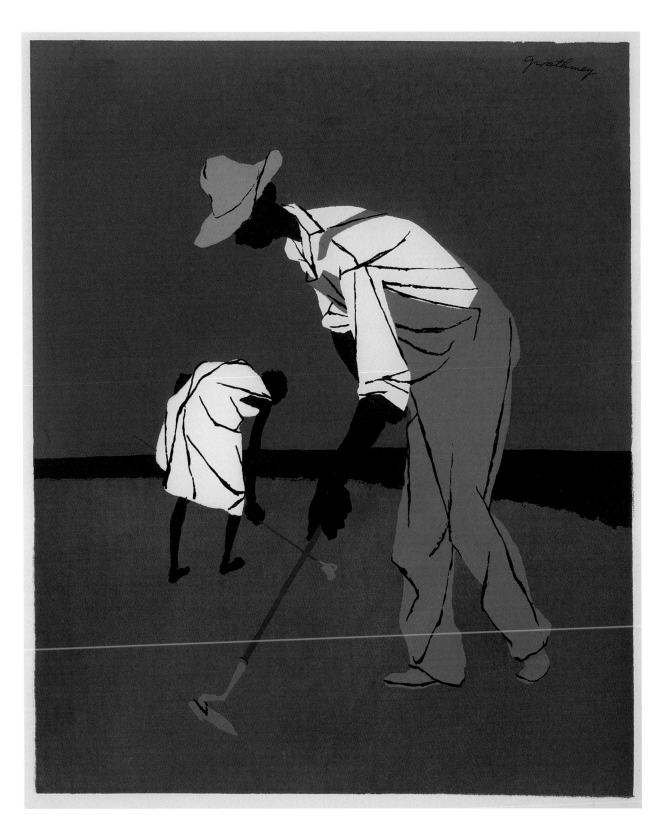

Leon Bibel

1913–1995

Bibel was born in Szczebrzeszyn, Poland, to a poor Jewish family which emigrated to America in 1926 and settled in San Francisco. He enrolled at the California School of Fine Arts, San Francisco, where he was taught by the German Impressionist Maria Riedelstein. In about 1933 Bibel signed on to the San Francisco WPA/FAP, where he collaborated with Bernard Zackheim, a pupil of Diego Rivera, on a set of murals of Jewish life for the San Francisco Jewish Community Center. He produced a second set of WPA/FAP murals with Zackheim on the history of medicine for the University of California Medical School.

In 1936 Bibel moved to New York and joined the New York City WPA/FAP under his brother's name, Philip Bibel, the Yiddish playwright, as he did not meet the Federal Art Project's residency requirements. He taught at Public School 94 and the Bronx House School of Performing Arts, and then joined the WPA/FAP Easel Painting Project and the Graphic Arts Division at the Harlem Art Center. When his work for the WPA/FAP came to an end in 1941, Bibel left New York and moved to South Brunswick, New Jersey. Now married with a family to support, he stopped work as an artist and became a chicken farmer for the next twenty years. In the early 1960s he returned to painting and sculpture, which he continued until his death in 1995.

While he was with the New York City WPA/FAP, Bibel made monochrome lithographs and colour screenprints. His earliest WPA/FAP prints are signed 'P.L. Bibel', the initials of his brother Philip, whose name he had assumed. Reba and Dave Williams record a dozen screenprints by Bibel, dated between 1938 and 1943, on page 297 of their article 'The Early History of the Screenprint', *Print Quarterly*, vol. 3, no. 4 (December 1986), pp. 287–321. His prints reflect a humanist outlook and are usually concerned with issues of social justice.

Bibel's work can be found in the collections of the Metropolitan Museum of Art, New York, the Museum of Fine Arts, Boston, and the Amon Carter Museum, Forth Worth, Texas. His brother Philip described their early childhood in Poland in his book, *Tales of the Shtetl* (2004).

BIBLIOGRAPHY
For Leon Bibel's career, see the website www.leonbibel.com

85 Red Hot Franks

1938
Colour screenprint on buff textured paper
Signed, dated, titled, and numbered '/25'
in pencil. 346 x 255 mm
1986,0301.42

Bibel often expressed the social condition of the working class in his prints. Here a downtrodden street vendor wearily pushes his handcart through the streets of an anonymous city. The screenprint is dated 1938 and was probably produced in the Silk Screen Unit set up that year by Anthony Velonis as part of the Graphic Arts Division of the New York City WPA/FAP, with the aim of encouraging artists to take up the technique.

Using hand-cut stencils Bibel took advantage of the screenprint's ability to produce planes of flat colour and hard edges in his composition of simplified, geometrical forms. The muted tonal range belies the fact that up to twelve colours were used. The textured, painterly effects in the areas of the sky and the pavement were achieved using tusche and glue stencils.

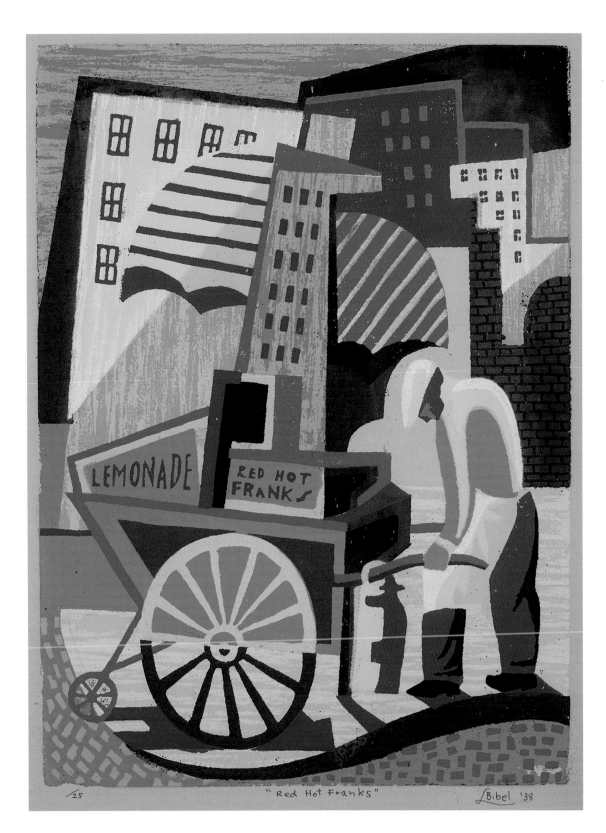

Leonard Pytlak

1910–1998

Born in Newark, New Jersey, Pytlak studied at the Newark School of Fine and Industrial Art before enrolling at the Art Students League, New York. It was probably here that he was introduced to printmaking. Under the WPA/FAP he produced a mural for the Greenpoint Hospital in Brooklyn. He was a member of the Graphic Arts Division of the New York City WPA/FAP from 1935 to 1941. His lithographs date from the mid-1930s to the early 1940s and showed New York scenes, such as the Bowery and Central Park.

In 1938 Pytlak became involved with Anthony Velonis's Silk Screen Unit of the Graphic Arts Division of WPA/FAP, and he played a pioneering role in developing and promoting the screenprint as a fine-art technique. In 1941 he was awarded a Guggenheim Fellowship to investigate new techniques in colour lithography and screenprinting. He was a founding member of the National Serigraph Society and was twice elected its president. Some ninety-six screenprints by Pytlak, dated between 1941 and 1949, are listed by Reba and Dave Williams on pages 315–17 of their article 'The Early History of the Screenprint', *Print Quarterly*, vol. 3, no. 4 (December 1986), pp. 287–21. He contributed a screenprint, *They Serve on All Fronts*, to the exhibition 'America in the War' organized by Artists for Victory in 1943; his print depicted a medical surgery unit working on the front line and won second prize after Robert Gwathmey in the serigraphy section. During the 1940s Pytlak had several solo shows, including the ACA Gallery in 1942, the Weyhe Gallery in 1944, the US National Museum, Smithsonian Institution, in 1948, and the Serigraph Gallery in 1949. He shared an exhibition of his screenprints with Harry Shokler at Kennedy & Company in 1943.

For many years he taught drawing, painting and screenprinting. He ran a private class for disabled students from the New York State Rehabilitation Department during the 1960s. In 1982 the Craft Students League Gallery in New York gave him a retrospective of his printmaking over the past fifty years.

The Smithsonian American Art Museum, Washington, DC, holds eight prints by Pytlak in its collection.

BIBLIOGRAPHY

Ellen G. Landau, *Artists for Victory*, exh. cat., Washington, DC: Library of Congress, 1983, (for biography of Pytlak, see pp. 92–3)

86 Uptown

1939

Colour lithograph

Signed and titled in pencil. Stamped in ink 'Federal Art Project NYC WPA'. 331 x 248 mm

2003,0131.73. Presented by the British Museum Friends and the Friends of Prints and Drawings

Pytlak's colour lithograph of the El in Uptown Manhattan recalls in diluted form the earlier precisionist prints on the same theme made by Louis Lozowick (cat. 25), notably in the patterns of the girders and the curve of the train carriages. An electric spark caused by the train crossing the points illuminates Pytlak's night scene with a spectral flash. The lone figure hurrying beneath the El adds to the sense of urban desolation.

Drawing with both lithographic crayon and tusche on up to eight stones, one for each colour, Pytlak demonstrates his considerable skill in colour lithography. The white stripes on the upright girder were created by using a razor to heavily shave away the tusche, while the electric flash of light has been achieved by spattering tusche on to the stone. The British Museum's impression has its original WPA/FAP label, which states that the lithograph was completed on 4 March 1939.

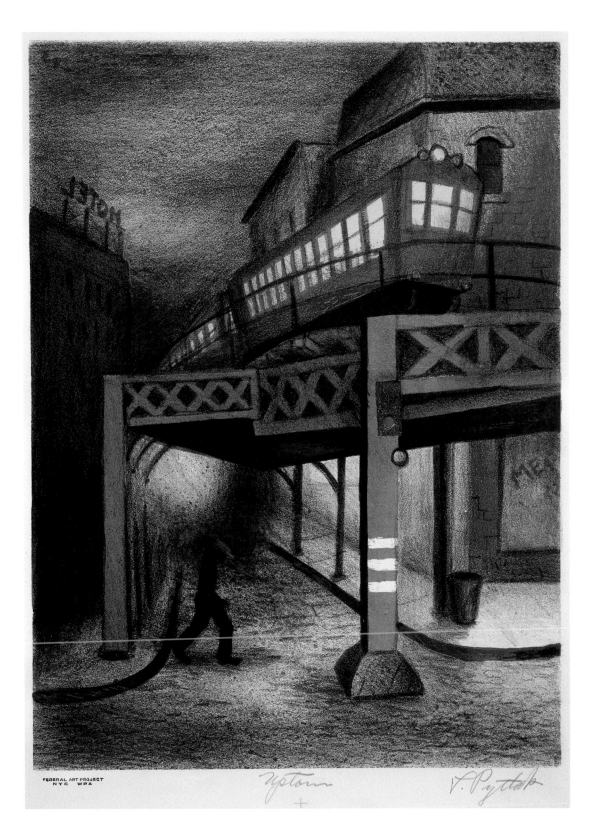

Hananiah Harari

1912–2000

Born in Rochester, New York, Harari studied at the Memorial Art Gallery of the University of Rochester, and from 1930 to 1932 at the School of Fine Arts, Syracuse University, where he was exposed to modernism. In 1932 he left for Paris and worked with André Lhote and Fernand Léger. He held his first solo show at the American Club in Paris in 1933. In 1934 Harari moved to Cagnes-sur-Mer, the artists' colony on the French Riviera, where he stayed in Chaim Soutine's former studio, before travelling to Palestine with his friend, the sculptor Herzl Emanuel. Following his return to America in 1935, he married Herzl's sister and settled in New York.

In 1936 he joined the Mural Project of the New York City WPA/FAP, working under Burgoyne Diller and remaining with the WPA/FAP until 1942. He also joined the Artists' Union and the American Artists' Congress, led by Stuart Davis. He was a founding member of the group American Abstract Artists from 1936 until 1943. Harari learnt how to make screenprints with Anthony Velonis, head of the Silk Screen Unit of the New York City WPA/FAP, from 1938.

From the mid-1930s Harari used an abstract style which also incorporated recognizable elements. He was unwilling to subscribe to total geometric abstraction advocated by some members of the American Abstract Artists. From the late 1930s his paintings expressed his fear of the disturbing political situation in Germany. In 1939 he also began to make *trompe l'œil* paintings, inspired by the illusionistic still lifes of the nineteenth-century American painter William Harnett. Drafted into the US Army in 1943, he returned to New York after the war and applied his illusionistic technique to commercial work for Coca-Cola. In 1948 he had a solo show at the Laurel Gallery, New York. In 1950 he was blacklisted by McCarthy's House Un-American Activities Committee for his work as a satirical illustrator on the left-wing periodical *New Masses* and its successor *Masses and Mainstream*. At the same time he was criticized by the Left for his commercial work for the big corporations. Deeply unsettled by this experience and unsympathetic to the rise of Abstract Expressionism, Harari turned his energies towards commercial work.

Several of Harari's paintings, drawings and prints are held by the Smithsonian American Art Museum in Washington, DC.

BIBLIOGRAPHY

Smithsonian Archives of American Art, oral history interview with Hananiah Harari, 24 September 1992, interviewer Gail Stavitsky

Gail Stavitsky, *Hananiah Harari: A Personal Synthesis*, exh. cat., New Jersey: Montclair Art Museum, 1997

87 Weather Contraptions

c. 1937–9
Colour screenprint
Signed and titled in pencil. Inscribed on verso
in pencil 'Printed in 1937 H.H.'. 315 x 246 mm
1988,1001.33

It is only with difficulty that an anemometer and a
windsock can be discerned, in the top section of
the composition, amongst the carefully balanced
geometrical planes and biomorphic forms. The
darkened colours and the use of yellow and black
elicit a sense of foreboding and danger, in keeping
with the dark political mood of the late 1930s. A
collage drawing by Harari with ink and gouache,
entitled *Weathervanes*, 1937 (Smithsonian Ameri-
can Art Museum, Washington, DC), has composi-
tional similarities to this print.

Cut stencils were used for the main geometrical
shapes, while the more painterly effects were
achieved with tusche and glue stencils. Thin inks
were used, most clearly seen in the large green
circle, bottom left, where the imprint of the
silkscreen mesh is visible. The transparent layers
and textured areas of the composition, such as the
white triangular strip towards the right-hand edge,
evoke the mutable light conditions and electrically
charged atmosphere of stormy weather.

Harari noted on the back of this impression that it
was printed in 1937, although it is usually stated
that he first learnt the technique of screenprinting
from Anthony Velonis at the Silk Screen Unit of
the New York City WPA/FAP in 1938. Another
impression of this print is given the date of 1939
by Reba and Dave Williams ('The Early History of
the Screenprint', *Print Quarterly*, vol. 3, no. 4
[December 1986], p. 306).

88 City Signs

1938
Colour screenprint
Signed and titled in pencil. Inscribed on verso 'Harari/
City Signs/ $10.50'. 459 x 304 mm
1991,0406.4

The composition is based upon one of his paint-
ings, dating from the same period (present
location unknown). Harari had been exposed to
cubist and surrealist work in Paris during the early
1930s, and these influences are apparent in the
juxtaposition of free-floating abstract elements.
His patchwork of motifs shares an affinity with
Stuart Davis's lithographs (cats 31, 32), although
the individual elements are less well integrated
and the composition not as sophisticated. Harari
and Davis were both employed by the Mural
Project of the New York City WPA/FAP.

Harari exploited the screenprint's suitability for
achieving flat planes of colour. He allowed the non-
printed areas of the paper support to form an
integral part of the composition. *City Signs* was
included in the exhibition 'Artists for Victory'
at the Metropolitan Museum of Art, New York,
in December 1942.

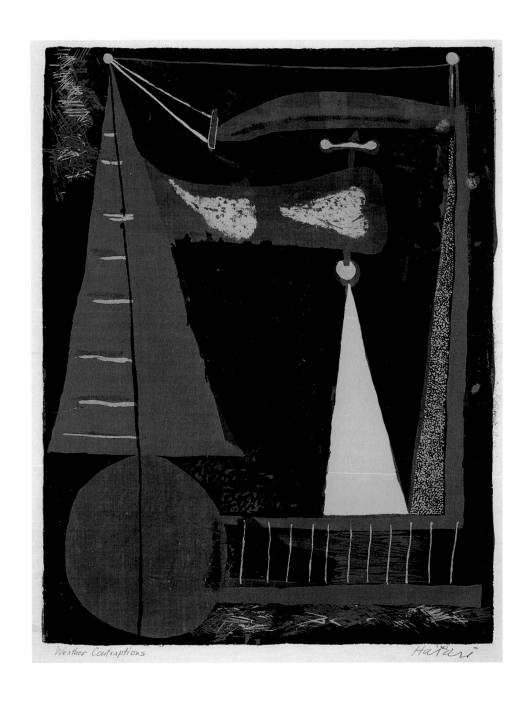

Weather Contraptions Harari

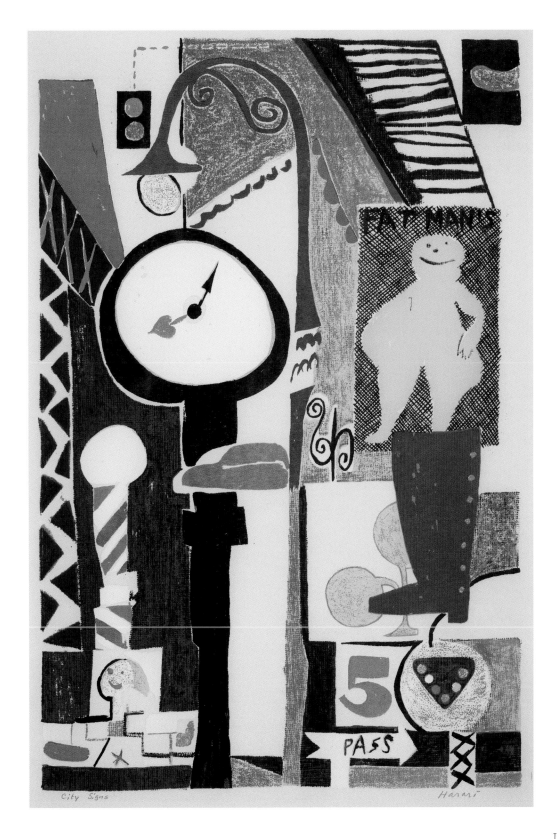

Harry Shokler

1896–1978

Harry Shokler was born in Cincinnati, Ohio, where his father ran a fur business. He first studied at the Cincinnati Art Academy, then at the Chester Springs Academy, Pennsylvania, and finally at the New York School of Fine and Applied Arts. During the First World War he joined the American Expeditionary Forces. In 1929 he won a travelling fellowship which enabled him to to study at the Académie Colarossi in Paris and to spend a few years painting in Europe and Tunisia, where he met his American wife. On his return to Paris he had a solo exhibition at the Galerie de Marsan and was included in the Salon des Beaux Arts.

In about 1937 Shokler joined the New York City WPA/FAP, and under its auspices produced wood-engravings of New England fishing villages as well as a few etchings. Shokler became part of Anthony Velonis's Silk Screen Unit of the Graphic Arts Division of the New York City WPA/FAP. He quickly established himself as a leading practitioner and teacher of screenprinting. Between 1941 and 1949 he produced forty-nine screenprints of American genre subjects (listed by Reba and Dave Williams on pages 318–19 of their article 'The Early History of the Screenprint', *Print Quarterly*, vol. 3, no. 4 [December 1986], pp. 287–321). His screenprints are characterized by their naturalistic observation and painterly handling. At least two of his prints were commissioned by the Princeton Print Club which Elmer Adler, the founder and former head of the WPA/FAP Graphic Arts Division, had established in 1940.

In 1943 Shokler held a joint exhibition with fellow screenprint pioneer Leonard Pytlak at Kennedy & Company in New York. In the same year he participated in the exhibition 'America in the War' organized by Artists for Victory, contributing the screenprint *Air Raid Drill*. Shokler served as president of the National Serigraph Society, and in 1946 he published his influential *Artists Manual for Silk Screen Print Making*, which reproduced examples by fellow members. He lectured widely on screenprinting and gave classes at Princeton University and at the Brooklyn Museum of Art School. He showed regularly at the Serigraph Gallery in New York and at the Southern Vermont Art Center in Manchester, Vermont, which gave him a retrospective of his paintings and screenprints in 1972.

Prints by Shokler are held by the Metropolitan Museum of Art, the Philadelphia Museum of Art and Princeton Library, Princeton University.

BIBLIOGRAPHY

Ellen G. Landau, *Artists for Victory*, exh. cat., Washington, DC: Library of Congress, 1983, (for biography of Shokler, see p. 101)

Harry Shokler, *Artists Manual for Silk Screen Print Making*, New York: American Artists Group, 1946

89 Coney Island

1942
Colour screenprint
Signed in ink on image. 318 x 407 mm
1992,1107.3

Coney Island is a resort on the southern shore of Brooklyn, off the Lower New York Bay. It was initially developed as an upper-class tourist resort in the nineteenth century but quickly degenerated into a popular destination full of amusement arcades and funfair rides. Although the Depression affected many of the concessions, Coney Island retained its popular escapist appeal. Here Shokler captures its tawdry atmosphere by juxtaposing garish candy-coloured inks of lime-green, lilac and orange. He evokes the cheap excitement of the rollercoaster and the thrill of the big wheel. Among those waiting for rides is a sailor on leave with his girlfriend. Although his observation of the scene is naturalistic, Shokler has used the screenprint technique in a painterly, almost impressionistic manner, which accorded well with the ephemeral nature of the subject matter.

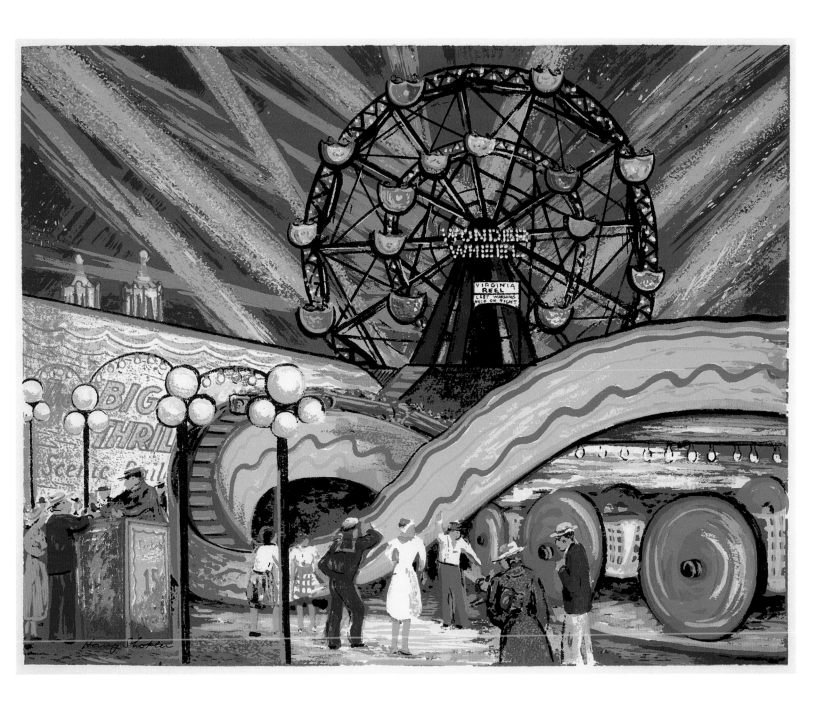

Edward Landon

1911–1984

Born in Hartford, Connecticut, to Swedish immigrant parents, Landon moved to New York in the late 1920s where he settled in Greenwich Village and attended the Art Students League. The Wall Street Crash of 1929 forced him to leave New York and in 1930 he moved to Springfield, Massachusetts. Landon painted murals in Springfield for the Public Works of Art Project, including a precisionist mural, *Allied Trades*, 1934 (now destroyed), for the Springfield Trade School. In Springfield he founded the Western Massachusetts branch of the Artists' Union, which put him in close touch with the New York art world, in particular with Stuart Davis, Blanche Grambs, Hugo Gellert, Thomas Hart Benton and Louis Lozowick, all of whom were activists in the Union.

In Massachusetts Landon was befriended by Elizabeth McCausland, a writer on contemporary art for the *Springfield Republican* and an influential supporter of young American modernists. She introduced Landon to a circle of artists, including Gertrude Stein, Georgia O'Keefe in New Mexico, and Arthur Dove. In 1938 Landon learnt the technical aspects of screenprinting from Harry Gottlieb at the New York City WPA/FAP. Landon quickly saw the potential of the screen-print, with its low-cost materials and equipment, and soon introduced it to his fellow Artists' Union members in Western Massachusetts. In 1940 he helped McCausland to organize the milestone 'Exhibition of Silk Screen Prints' at the Springfield Museum of Fine Arts, the first show to be devoted to the technique, which included his own prints.

By the early 1940s Landon had given up painting in favour of screenprinting. Although his compositions of the 1930s were characterized by a recognizable figuration, by the 1940s he had begun to move towards complete abstraction. In 1941 he joined the Silk Screen Group (founded by Gottlieb and Harry Shokler, among others, in 1940), which became the National Serigraph Society in 1944. During the 1940s, as the National Serigraph Society's exhibition secretary, he organized travelling exhibitions and demonstrations, and in 1950, on being awarded a Fulbright Grant to study art in Norway, he introduced screenprinting as a fine-art technique to artists in Scandinavia and France.

In 1958, shortly after moving to Vermont, Landon became paralysed from the waist down as a result of complications following back surgery. Despite this disability, he continued to work and exhibit until his death in 1984. Over the course of his career he produced some 235 screenprints.

During Landon's lifetime examples of his screenprints were exhibited and purchased by many American museums, including the Metropolitan Museum of Art, New York, and the Smithsonian American Art Museum in Washington DC.

BIBLIOGRAPHY

James Wechsler, *Edward Landon (1911–1984): Silkscreens*, exh. cat., New York: Mary Ryan Gallery, 1994

90 Counterpoint

1942
Colour screenprint
Signed and dated in pencil. 313 x 320 mm
Wechsler 45
1985,1109.4

From the early 1940s Landon's screenprints became reduced in their imagery to the interplay of abstract shapes, colour and line. A number of his prints make deliberate analogies between abstract art and music. Music inspired the titles of several of his screenprint compositions, including this one – *Counterpoint*. Here the sharp-edged linear shapes are placed at oblique angles to each other to suggest rhythm and counterpoint, while the emphatic red and yellow circles perform a visual counterbalance to the lively composition.

Landon exploited the screenprint's ability to produce flat areas of pure colour. This suited his simplified abstract compositions, with their hard edges and absence of illusionistic depth. His abstract screenprint *Arrangement with Blue Major*, 1941, was included in the 'Artists for Victory' exhibition at the Metropolitan Museum of Art in 1942.

Max Arthur Cohn

1903–1998

Cohn was born in London and emigrated with his family to America in 1905, settling in New York. In 1920 he worked at a commercial art studio, where he was introduced to the screenprint process. In 1922 he enrolled at the Art Students League where his teacher John Sloan was a formative influence and his classmates included Alexander Calder, Adolph Gottlieb and John Graham. To broaden his knowledge of art and painting, Cohn left for Paris in 1927 and enrolled at the Académie Colarossi, which had a large number of American students. He claimed that he was influenced by Matisse and Picasso in his use of colour, and his paintings of this period were shown in his first solo show at the New York Civic Club in 1929.

Following a second stay in France in the early 1930s, Cohn joined the Easel Project of the New York City WPA/FAP from the mid-1930s. His paintings were largely industrial scenes of power plants, factories and waterfronts. He also began to make screenprints; the earliest date from the mid-1930s and show rural activities, such as *Wheatfield Harvest*, 1935 (fig. 8). From the late 1930s Cohn focused primarily on the colour screenprint, extending his themes to the industrial waterfronts of New York. Many of his screenprints imitated the transparency of a watercolour in their effect; others, like *Red Abstraction* (cat. 91), were printed with opaque colours. Between 1941 and 1949 he produced at least fifteen screenprints, several of which were abstract, and as a founding member in 1944 of the National Serigraph Society became a leading advocate of the screenprint as a fine-art technique. In 1942 he co-authored with J.I. Biegeleisen, Chairman of the Silk Screen Department in the School of Industrial Art, New York, the widely used technical guide, *Silk Screen Stencilling as a Fine Art* (enlarged and republished in 1958 as *Silk Screen Techniques*). During the 1950s Cohn ran a commercial graphics studio in New York where he helped the young Andy Warhol make his first screenprints. He died in 1998 in New York, aged ninety-five.

Cohn is represented in the British Museum by nineteen screenprints made between 1934 and 1950; seventeen of these were presented by his daughter Jane Waldbaum and son-in-law Steve Morse in 2001.

BIBLIOGRAPHY

J.I. Biegeleisen and Max Arthur Cohn, *Silk Screen Techniques*, New York: Dover Publications, 1958

91 Red Abstraction

1945
Colour screenprint on buff textured paper
Initialled in ballpoint pen on the image. Signed and dated in pencil. 240 x 302 mm
1994,0515.28

Cohn's abstract still life recalls the cubist compositions of Picasso and Braque from 1911 to 1915. But by 1945, when Cohn made this screenprint, his composition would have seemed somewhat retrograde in the face of emerging Abstract Expressionism. Although the work is highly abstract, the shape of a guitar is discernible and the instrument's strings and tuning keys are indicated. Cohn used a simple block-out stencil for this print and only two colours, red and black. The non-printed areas of the buff-coloured textured paper were incorporated as an integral part of the composition.

91
Cohn
Red Abstraction

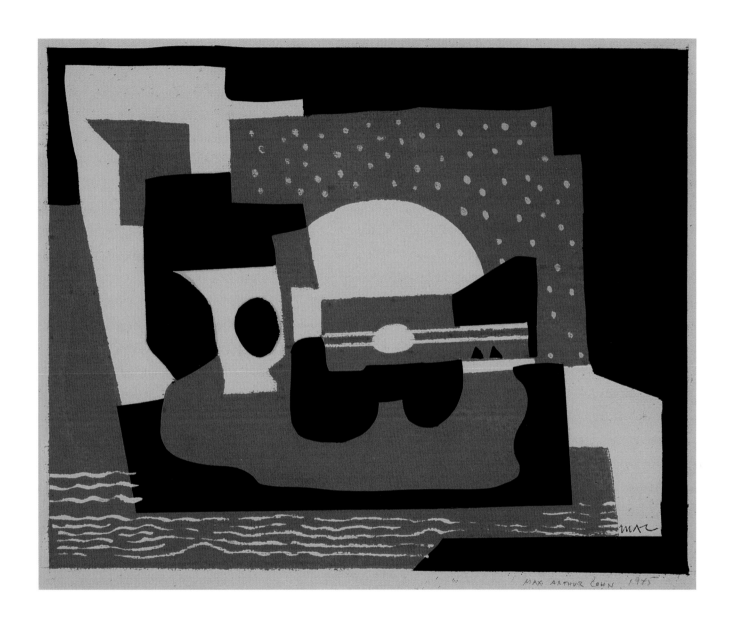

James McConnell

1914–1988

Few biographical details for James McConnell are known. He was born in Chicago and studied at Denison University in Granville, Ohio, and then at the State University of Iowa, Iowa City. For a while he appears to have lived in Laingsburg, Michigan. His known activity as a printmaker spans the years from 1940 to 1951, when he was making highly stylized abstract screenprints, and several of blues and jazz motifs. Reba and Dave Williams list forty-six screenprints, many dated between 1946 and 1949, on page 314 of their article 'The Early History of the Screenprint', *Print Quarterly*, vol. 3, no. 4 (December 1986), pp. 287–321. He was represented by the Meltzer Gallery, New York, at 38 West 57th Street. The Cleveland Museum of Art, Ohio, owns an impression of his colour screenprint *About Face*, 1948.

92 Combo

*c.*1950
Colour screenprint
Signed and titled in pencil. Stamped in ink on verso 'Meltzer Gallery/ 38 West 57 St., N.Y. 19' and inscribed 'Combo/ McConnell/ Ed 20/ Pr 25-' in pencil. 230 x 277 mm
2005,0331.11. Presented by the British Museum Friends

The frenetic rhythm and complex counterpoint of jazz find their visual form in this screenprint of a trio jamming. Shrill contrasts of colour and angular geometric shapes convey the excitement of the jazz session, as the saxophone player bends down low, carried along by the flow of the beat. Cut stencils were used for the sharp, geometrical shapes of the jazz players, while the more painterly areas of the composition, such as the floor and back wall, were achieved with tusche and glue stencils.

A stamp on the verso of this print indicates that it was retailed by the Meltzer Gallery in New York for the price of $25. Doris Meltzer was the energetic director of the National Serigraph Society, which was located at 38 West 57th Street from October 1945. From this address she also ran the Serigraph Gallery; its first exhibition was entitled 'Members' Prints in Permanent Collections' and opened in November of the same year with 100 screenprints.

Combo

Joseph Vogel
1911–1995

Born in Poland, Vogel emigrated with his family to America in 1927 and settled in New York. He enrolled at the National Academy of Design, where he was taught by the painter and lithographer Leon Kroll, a former pupil of Robert Henri. Vogel was equally influenced by the modern works in New York's galleries and museums, in particular Picasso's *Guernica*, 1937, on display at the Museum of Modern Art in 1939, and the work of Fernand Léger.

During the 1930s Vogel was active in the Marxist John Reed Club and was a member of the Artists' Union and American Artists' Congress. He assisted Ben Shahn on a mural project when he first joined the Federal Art Project and later the Graphic Arts Division of the New York City WPA/FAP, where he was involved in lithography and etching. Through the WPA/FAP he became a friend of Adolf Dehn, Stuart Davis, Arshile Gorky and Willem de Kooning, and a member of the 'New York Group' which showed at the ACA Gallery, New York. In 1937 he volunteered to go to Spain with the Abraham Lincoln Brigade to fight Franco's fascist forces, and served on the Córdoba front. His drawings made in Spain were published in the *Volunteer for Liberty*. He re-enrolled with the WPA/FAP on his return to New York, but he was eventually expelled from the Federal Art Project when he signed a petition on behalf of a Communist Party candidate for local elections, although he himself was not a Communist.

Vogel moved to Los Angeles and, after the Japanese attack on Pearl Harbor, he enlisted in the US Army as a combat cameraman in 1943. He was initially stationed in Europe, where he photographed the concentration camps at Auschwitz, and then in Japan and the Philippines. After the war Vogel returned to California, where he taught documentary film at the University of Southern California from 1947 until 1948. In 1948 he went to Paris where he enrolled at La Grande Chaumière and the Académie Julian and became a friend of Tristan Tzara and Man Ray. On his return to California he taught at the Chouinard Art Institute, Los Angeles, and also worked as a filmmaker and wrote television scripts.

It appears that most of Vogel's printmaking was confined to his WPA/FAP years, and the Smithsonian American Art Museum, Washington, DC, holds several of his prints from this period.

BIBLIOGRAPHY

Smithsonian Archives of American Art, oral history interview with Joseph Vogel, 5 January 1965, interviewer Betty Hoag

Elizabeth Compa and James D. Fernández, 'The Cultural Legacy of the Abraham Lincoln Brigade', *The Volunteer, Journal of the Veterans of the Abraham Lincoln Brigade*, vol. 27, no. 3 (September 2005), pp. 3–7

C.N. Ruby and V.W. Julius, *The Federal Art Project: American Prints from the 1930s*, exh. cat., Ann Arbor: University of Michigan Museum of Art, 1985 (for Vogel, see p. 206)

93 Football

*c.*1938–41

Lithograph

Signed and titled in pencil. Stamped in ink 'New York City WPA Art Project'. Label of Federal Works Agency – Works Project Administration pasted on verso. 324 x 456 mm

2006,1030.5. Presented by Patricia Hagan through the American Friends of the British Museum

One footballer hurls the ball down the pitch, the other leaps up to block it. This lithograph shows the tension between the recognizably figurative and the more surrealist, abstract elements in Vogel's work. The footballers recall the free-floating, biomorphic shapes used by Miró, while the floating mannequin-like female bust was also a popular surrealist motif. Nevertheless Vogel has also carefully observed details of American football, such as the studs on the boot of the horizontal figure and details of his helmet, as well as delineating the markings of the pitch itself.

Vogel used tusche for the solid black background while blocking out the white forms of the foot-ballers and pitch. He worked over these areas with lithographic crayon, while other details, such as the profiles of the spectators, were scratched through the tusche onto the stone. The lithograph was published by the New York City WPA Art Project. An enlargement of this image served as the backdrop for a scene in Vogel's 1947 experimental avant-garde film *House of Cards*, which combined live action with animation.

8 ARTISTS OF THE LEFT AND THE SECOND WORLD WAR

Werner Drewes

1899–1985 (for biography see p. 82)

94 It Can't Happen Here

1934
Linocut on thin oriental paper
Rose III 97
Signed, dated mistakenly '43', numbered 'I–XXXV'
and inscribed '#90 – Title page of portfolio:
It Can't Happen Here' in pencil. 155 x 261 mm
1985,1005.43

This linocut was used on the cover of a portfolio of
ten abstract woodcuts by Drewes entitled *It Can't
Happen Here* (Rose III 87–96), which he printed
and published himself in an edition of twenty in
1934. Twenty impressions of the linocut were
reserved for the portfolio cover and a further
fifteen were printed on very fine oriental paper as
independent prints, as in this case. The woodcuts
in the portfolio were among the earliest purely
abstract compositions produced by an artist work-
ing in America. The linocut for the portfolio cover,
however, makes reference to a distorted swastika.
Drewes's emphatic use of an abstract idiom would
have held a particular significance when the port-
folio was published. In his native Germany such
works were being branded as 'entartete Kunst'
(Degenerate Art) by the Nazis, and Drewes's use
of abstraction signified a deeper resistance to the
totalitarianism engulfing Europe in the 1930s.

Joseph Vogel

1911–1995 (for biography see p. 182)

95 The Innocents

c.1938–9
Lithograph
Signed and titled in pencil, and numbered '3'
in pencil lower right corner. 355 x 292 mm
1993,1003.26

In this lithograph Vogel has used an abstract
surrealist idiom to depict victims of war fleeing
from the bombs. His anti-fascist stance grew out
of his first hand experience of the Spanish Civil
War when he served with the Abraham Lincoln
Brigade in 1937. The composition juxtaposes
various elements – falling bombs, a spoon, barbed
wire and skeletons. The fleeing figure is rendered
using an abstracted surrealist mode: the body is
fragmented, with legs, arms and head shown as
separate elements.

Invoking the example of Picasso's *Guernica*, Vogel
adopted a montage approach, as did the political
artist Ben Shahn, with whom he first worked on
murals for the WPA/FAP. Although the technique
was criticized for disorienting the viewer and
so not transmitting a political message effectively,
Vogel showed that political art could be abstract
and still work successfully. In a later interview
recorded for the Smithsonian Archives of
American Art in 1965, Vogel described himself
as a 'black sheep' of the WPA/FAP because the
style of his lithographs was so out of line with
that of his fellow artists.

96 Vision No. 2

c.1939
Lithograph
Signed and titled in pencil, and numbered '18' in pencil
lower right corner. 316 x 460 mm
1988,0618.14

In this lithograph Vogel creates a surrealistic night-
mare scene of fractured and torn bodies. The main
figure wears an eyepatch; both his legs and arms
are amputated. His companion's curvaceous torso
is entangled in barbed wire, her feminine features
fragmented by jagged splinters. To the right a
crow-like bird, with open beak and bared teeth,
wears a shirt collar and tie. Vogel explained in an
interview in 1965 that Surrealism for him took on
a political cast.

This lithograph was published by the New York
City WPA/FAP. A companion lithograph entitled
Vision No. 1 is in the Smithsonian American Art
Museum. The edition size of Vogel's WPA/FAP
prints was probably around twenty-five.

94
Drewes
It Can't Happen Here

95
Vogel
The Innocents

Vision #2 Jn Vogel

Hugh Mesibov

b.1916

Born in Philadelphia, Mesibov won a scholarship to the Pennsylvania Academy of Fine Arts but his studies there were cut short by the Depression and the early death of his father in 1936. Nevertheless, he subsequently attended classes at the Barnes Foundation in Merion, Pennsylvania.

In 1937 Mesibov joined the Fine Print Workshop, a division of the Philadelphia WPA/FAP, where he worked with Dox Thrash and Michael J. Gallagher in experimenting and developing the carborundum print. Thrash discovered that by grinding a copper plate with diamond-hard particles of carborundum a roughened surface could be created. Mesibov went a step further and burnished the plate to create the first carborundum mezzotint, a self-portrait entitled *Mystic*, in 1937. Mesibov also developed the carborundum relief etching and the colour carborundum print at the Fine Print Workshop. In 1940 the Federal Art Project held the world's first exhibition of carborundum prints in Philadelphia. Mesibov's prints from the late 1930s expressed social and political concerns; in the early 1940s his forms became more surrealistic and abstract.

In 1941 Mesibov produced the mural *Steel Industry* for the post office of Hubbard, Ohio, under the auspices of the US Treasury Department. After moving to New York in 1945, he had his first New York solo show at the Chinese Gallery in 1947. In the late 1940s Mesibov became a member of The Club with the abstract expressionist painters and formed friendships with Franz Kline and Ibram Lassaw. In 1955 he had a one-man show at the Morris Gallery. Two years later he moved to Rockland County, New York, where he later joined the teaching faculty of the State University of New York in Rockland. He returned to printmaking in the 1990s with a series of monotypes. In 2006 an exhibition of his paintings and works on paper from 1937 to 1959, covering the period from the Philadelphia WPA/FAP and New York City, was held at the Susan Teller Gallery, New York.

Mesibov's prints are held by the Smithsonian American Art Museum, Washington, DC, and the Philadelphia Museum of Art, and in several other museums in the United States.

BIBLIOGRAPHY

Susan Teller, *Hugh Mesibov: A Ninetieth Birthday Celebration*, exh. brochure, New York: Susan Teller Gallery, 2–30 December 2006

97 The Dictators

1942

Linocut

Signed, dated, titled and inscribed '1of 3 proofs N.F.S'
in pencil. 126 x 181 mm

1992,1003.55

During the Second World War Mesibov was
employed in the shipyards. This linocut shows his
anguished reaction to Europe's Fascist dictator-
ships. Using a surrealistic style, Mesibov portrays
grotesque, cartoon-like dictators strutting on
the world stage. This savage caricature recalls
Picasso's earlier treatment of this theme in his
widely reproduced etching and aquatint of 1937,
Dream and Lie of Franco.

The linocut is one of three artist's proofs and it
is not known whether it was intended for a wider
audience or remained a personal project.

98 Europa

1942

Colour carborundum relief etching

Signed, dated and titled in pencil. 199 x 151 mm

1987,1003.40

This apocalyptic vision of Europe in flames was
produced by the process of colour carborundum
relief etching, a technique which Mesibov pio-
neered at the Fine Print Workshop under the
Philadelphia WPA/FAP. An acid-resist was used to
draw the design on to the carborundum grounded
plate, which was then etched in acid, leaving the
design in relief. The sunken areas were inked in
colour while the raised drawn areas were rolled in
black and printed. Mesibov's technique resulted in
prints with cells of strong colour separated by
thick black lines.

The emaciated shackled figure in the foreground
wears what could be interpreted either as a crown
of thorns or a *corona radiata*. The latter appears
on the Statue of Liberty, the gateway to America
on Ellis Island, New York. By alluding to such an
icon of liberty, Mesibov evoked the situation in
Europe and voiced his fears of a similar fate
befalling America.

Claire Mahl Moore

1917–1988

Sometimes calling herself Clara, Moore also used the surnames Mahl and Millman. Born in New York to working-class Russian immigrants, she was made aware of politics at an early age by her socialist father. While still at school she attended evening art classes given by the Bauhaus-trained Werner Drewes. In 1935 Moore enrolled at the Art Students League and studied with Thomas Hart Benton, Charles Locke and Harry Wickey, who taught her lithography. Through Benton's class at the League she met Jackson Pollock who encouraged her to work as an assistant to David Siqueiros in his 14th Street studio, where she stayed for a year. Siquerios was interested in creating art for the proletariat, and although Moore did not share his political ideas, she was influenced by his unorthodox, experimental approach towards art.

From 1935 to 1942 Moore worked for the Graphic Arts Division of the New York City WPA/FAP, where she is recorded as having produced some twenty lithographs, a woodcut entitled *Blonde Girl*, and at least one colour screenprint entitled *Dancer Resting (Martha Graham)*. Her lithographs use an expressionistic idiom, detailed draughtsmanship and bold composition to address themes of social injustice. Her lithograph *Scene in Texas*, from the late 1930s, depicts the flogging of a coloured man beside an oil-well derrick, witnessed by two horrified bystanders.

During the Second World War Moore worked in Washington, DC, producing maps for the Coast Geodetic Survey. Returning to New York in 1945, she worked briefly with Fernand Léger, who had arrived from France, and her paintings moved towards gestural abstraction. In 1950 Moore left New York and went to California where she taught at the Marianne Hartwell School of Design in San Francisco. She returned in 1963 and taught at the College of Staten Island, City University of New York. From the 1960s her paintings became gestural and figurative, often incorporating words. During this period she also began to print images and books inexpensively using a customized mimeograph machine.

The Mary and Leigh Block Museum of Art at the Northwestern University, Chicago, holds a group of Moore's WPA/FAP lithographs in its collection.

BIBLIOGRAPHY

Sharyn Finnegan, 'Claire Moore', *Woman's Art Journal*, vol. 2, no. 1 (spring–summer 1981), pp. 53–6

Susan Teller, *Claire (Mahl) Moore: A Memorial Exhibition. Work on Paper: The WPA to the 1980s*, exh. brochure, New York: Susan Teller Gallery, 5–29 April 1989

99 Factory (Industry)

*c.*1937

Lithograph

Signed 'Claire Millman' and 'Clara Mahl' in pencil, partially erased. Estate stamp in ink 'CM' and initialled 'NC' by the artist's daughter Nell Cordaro. 382 x 263 mm

2007,7001.3. Presented by Dave and Reba Williams

This lithograph, also known as *The Workplace*, dates from about 1937 and was published in a small edition of eight by the New York City WPA/FAP. Moore has divided the composition into three hierarchical registers that evoke contemporary social structure. The white-collar bosses grasping their set square and blueprint are placed at the top, followed by the cloth-capped male workers busy riveting steel plates with their pneumatic hammers, and finally, at the bottom, the mother who offers up her infant child to the captains of industry. By alluding to the religious gesture of the donor figure, Moore appears to be commenting upon the role of the factory as the new 'cathedral of power' within modern capitalist America.

Jolán Gross Bettelheim

1900–1972

Born in Hungary, Bettelheim trained from 1919 at the Kunstgewerbeschule, Vienna, where she was taught by Emil Orlik, the secessionist etcher and lithographer. She also studied in Berlin at the Akademie der Bilden Kunste under its director, Karl Hofer, a member of Der Blaue Reiter.

In 1925 she married a Hungarian-American psychiatrist and moved with him to Cleveland, Ohio, which had a large Hungarian community. She continued her studies at the Cleveland Institute of Art School. In the mid-1930s she joined the Cleveland WPA/FAP where she worked with the head of the graphics workshop, Kalman Kubinyi, a lithographer, also of Hungarian descent, who taught her the technique. Bettelheim's earliest known prints were drypoints, but she is best remembered for her achievements in lithography. The graphics workshop of the Cleveland WPA/FAP commissioned twelve prints from her in 1935. Between 1928 and 1937 she regularly exhibited in the annual print exhibitions held by the Cleveland Museum of Art. Her industrial images of Cleveland, its factories and bridges were achieved in a cubo-futurist style and share certain affinities with American Precisionism. In 1938 Bettelheim and her husband left Cleveland and moved to Queens, New York.

During the late 1930s Bettelheim produced a series of lithographs in response to the growing political crisis. In her lithograph *Civilization at the Crossroads*, *c*.1936, a skeletal soldier with a swastika emblazoned on his helmet wears two medals, one with a dollar sign, the other with a pound sterling sign: Bettelheim's print is an anti-war comment upon the perceived capitalist collaboration between Germany and the American and British governments. But by the early 1940s she was producing her patriotic lithograph, *Home Front* (cat. 100).

Bettelheim was a committed member of the Communist Party. She may have travelled to the Soviet Union in 1933, the only year in which she did not exhibit at the Cleveland Annual, for in the following year she exhibited a series of prints of Russian churches. After the Second World War, in the climate of Cold War McCarthyism, Bettelheim's politics fell under suspicion. The death of her husband, in 1956, and her alienation from the American way of life compelled her to return to Hungary. Unfortunately she did so on the very eve of the Hungarian uprising of 1956, and once again she found herself alienated from the politics of society. Disenchanted, it seems that she never again made any prints, and she died in Budapest in 1972.

The Cleveland Museum of Art holds her twelve WPA/FAP prints as well as her early drypoints. A few of her lithographs of industrial scenes are held by the Smithsonian American Art Museum, Washington, DC.

BIBLIOGRAPHY

Ellen G. Landau, *Artists for Victory*, exh. cat., Washington, DC: Library of Congress, 1983 (for biography of Gross-Bettelheim, see pp. 42–3)

Reba and Dave Williams, 'Jolan Gross-Bettelheim: A Hidden Life', *Print Quarterly*, vol. 7, no. 3 (September 1990), pp. 303–7

100 Home Front

1943
Lithograph
Signed, dated and inscribed 'Ed. 40' in pencil.
402 x 302 mm
1991,0615.1

This lithograph was shown in the 1943 'America in the War' exhibition, organized by the government-sponsored Artists for Victory organization as a propaganda exercise for the war effort. On 20 October 1943 the exhibition of 100 prints by as many artists opened simultaneously in twenty-six museums across the nation, including the Cleveland Museum of Art. In her contribution Bettelheim showed the bustling interior of a munitions factory with rows of shell-casings and large turbines. The figures of the faceless women workers merge into the shape of the shells on the production line. Bettelheim's prominent positioning of the female figures in the foreground appears to comment upon the social changes taking place in the workplace during the Second World War. As the male workforce was drafted into the army, female workers took their place on the Home Front. A line of male workers marches away from the assembly line and out into the distance, presumably to join the war.

Bettelheim used the lithographic crayon in a very characteristic manner. With the sharpened point of the crayon she built up the composition through a series of finely hatched and cross-hatched lines. This highly precise and defined line was comparable to the linear effects achieved in her earlier drypoints. Although the printer of this lithograph is not known, at least one of Bettelheim's lithographs, *Bridge*, *c*.1935, was printed at the studio of George Miller in New York. It seems likely that, following her move to New York in 1938, she continued working with Miller.

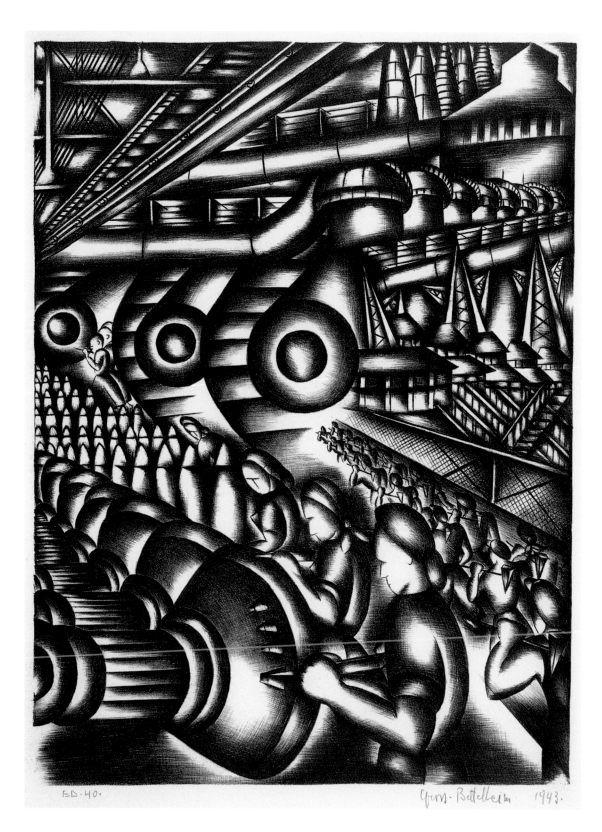

ED.40. Gun. Bettelheim 1943.

Hugo Gellert

1892-1985

Born in Budapest, Gellert emigrated with his family to America in 1906 and settled on the Upper East Side of Manhattan. In 1909 he enrolled at the National Academy of Design, New York, where he studied painting and won several awards, including a trip to Paris in 1914. While in Europe he revisited Hungary, but this coincided with the outbreak of the First World War where he witnessed distressing scenes of young men being drafted into the Austro-Hungarian army. In 1917 his brother, a conscientious objector, refused the draft in America and was imprisoned in Fort Hancock, New Jersey, where he was murdered by prison guards a few months later. These experiences politicized the young Gellert.

He began to produce anti-war cartoons for the Hungarian left-wing newspaper *Elöre* and for the radical periodical *The Masses.* From 1918 to 1924 he was a contributing editor of the *Liberator* and in 1926 was co-founder of *New Masses.* With America's entry into the Second World War, he became in 1942 a founding member and sometime chairman of Artists for Victory, which produced propaganda posters and prints for the war effort.

In 1928 he produced his first mural for the Worker's Cafeteria at Union Square, New York. His most controversial mural was *Us Fellas Gotta Stick Together*, showing America's leading industrial barons assembled behind the gangster Al Capone, which he submitted to the Museum of Modern Art's mural exhibition in 1932. In 1938 Gellert joined the New York City WPA/FAP where he worked for the Project's Mural Division and produced a mural for the Communications Building at the 1939 New York World's Fair.

Gellert's graphic work for the radical magazines exposed him to Social Realism, which was to have a profound effect on his printmaking. He regarded his involvement with the Communist Party from the 1920s as being just as influential in developing his artistic style as his formal training. His most important works in printmaking were issued as portfolios: *Karl Marx Capital in Pictures* (1933), a portfolio of sixty lithographs, with an accompanying text, printed at Atelier Desjobert in Paris in an edition of 133, and also published in book form in New York in 1934; *Comrade Gulliver* (1935), a portfolio of forty-four lithographs, with an accompanying text by him, also published in book form; and *Century of the Common Man* (1943), a portfolio of nineteen screenprints.

Gellert's most prolific period was during the 1930s and 1940s, yet he remained an activist and later produced posters for the Civil Rights movement and against the Vietnam War. His papers are held by the Tamiment Library and Robert F. Wagner Labor Archives, New York.

BIBLIOGRAPHY

Mary Ryan, *Hugo Gellert: A Catalogue of Prints and Drawings*, with an essay by Jeff Kisseloff, exh. cat., New York: Mary Ryan Gallery, 1986

101 The Fifth Column

1943

Colour screenprint on folded sheet

Signed in pencil. Verso of folded sheet entitled 'The Fifth Column' in letterpress with extract of a speech made by Vice-President Henry Wallace. 385 x 330 mm

Ryan 79

1992,1003.182. Presented by Antony Griffiths

The Fifth Column comes from a portfolio of nineteen screenprints entitled *Century of the Common Man*, published in 1943 in an edition of fifty-four. It was inspired by a speech made by Vice-President Henry Wallace before the Free World Association on 8 May 1942 in New York, in which he spoke of an egalitarian future free from Fascism – a 'Century of the Common Man'. Wallace voiced his fears that America was open to infiltration by a Fifth Column of Nazi sympathizers, or an outright uprising by German expatriates, both originating from Latin America. Gellert's screenprint refers directly to this part of Wallace's speech and an excerpt from his text is reproduced in letterpress on the verso. The rat, slowly gnawing away at a rope which holds fast the American flag, symbolizes this fear of a Fifth Column.

As a contribution to the war effort, the screenprints were reproduced in a brochure published in New York by the International Workers Order, Inc., with translations of Wallace's texts in fifteen languages.

Charles Keller

1914–2006

Born in Woodmere, Long Island, to an upper middle-class family, Keller graduated from Cornell University in 1936 and enrolled at the Art Students League from 1937 to 1941, where he studied with Harry Sternberg and the printmaker Will Barnet. Among his first lithographs was a series entitled *Sandhogs*, produced between 1937 and 1941, which showed builders working on the Sixth Avenue Subway in Manhattan.

In 1940 Keller, who always had independent means, joined the Communist Party USA and remained a committed lifelong member. His social realist art arose from his political activism. Together with Gwathmey, Becker and Lozowick, from 1942 to 1949 he was active in running the left-wing Artists' League of America (ALA) whose aim was 'to bring more art to more people through the widest possible extension of both private and governmental sponsorship of art' (Membership flier; cited by Andrew Hemingway, *Artists on the Left: American Artists and the Communist Movement 1926–1956*, New Haven and London: Yale University Press, 2002, p. 192). Keller took part in many ALA exhibitions, most notably in a 1943 group show entitled 'This is Our War' at the Wildenstein Gallery, New York. He was instrumental in organizing exhibitions such as the 1943 group exhibition 'Art, a Weapon of Total War', held at the New School for Social Research, New York. From 1942 to 1945 he ran the ALA's Victory Workshop.

In 1945 Keller joined the Graphic Workshop where he produced his own work and organized group projects, such as the print portfolios *Yes, the People!* and *Negro USA*, which reflected the co-operative nature of the workshop. He also produced posters and leaflets for various labour campaigns and worked with the Progressive Citizens of America organization. In 1945 he became art editor of the Marxist publication *New Masses* until it closed in 1948. He placed a new emphasis upon the visual impact of the periodical, commissioning work from Gwathmey and Harari, as well as contributing his own political cartoons.

In the post-war period, under the climate of McCarthyism, Keller came under political pressure. In 1961 he left America to live and work in Italy, where he was based principally in Rome and where he held several solo exhibitions over the next ten years before returning to the United States. In 1976 a full retrospective of his work was held at the Herbert F. Johnson Museum of Art at Cornell University. Keller died in New York, in 2006, at the age of ninety-one.

BIBLIOGRAPHY

Ellen G. Landau, *Artists for Victory*, exh. cat., Washington, DC: Library of Congress, 1983 (for biography of Keller, see p. 56)

102 People's Meeting

1943
Colour screenprint
Signed and dated in pencil in image, titled below image in pencil. 300 x 454 mm
Beall 1
2003,0131.74. Presented by the British Museum Friends and the Friends of Prints and Drawings

Also titled *Planners for Victory*, Keller's screenprint was included in the exhibition 'America in the War' organized by Artists for Victory to open simultaneously in twenty-six museums and galleries across the United States on 20 October 1943. Keller produced this screenprint at the Victory Workshop, which he ran as its executive secretary from 1942 until 1945. Initially located at 47 East 12th Street in New York City before it finally moved to 182 Third Avenue, the Victory Workshop was a left-wing art collective set up by the Artists' League of America as a more progressive alternative to the government-sponsored organizations for the war effort. Keller has here captured the intensity and fervour of the young activists as they listen to the proceedings of a meeting taking place beneath the prominently displayed American flag. The pose of the young man in blue, his chin resting on hand in concentration as he listens, is particularly well-observed.

The broad and almost calligraphic brushstrokes of colour have been achieved by screenprinting with the tusche and glue method. Black ink was used to create strong contrasts of shadow as well as to describe the contours of the figures. The ideal of social unity is evoked through the use of common colour, predominantly red and blue, to link the figures.

Riva Helfond

1910–2002

Helfond was born in Brooklyn and trained at the School of Industrial Art and at the Art Students League, where she was taught printmaking by Harry Sternberg and painting with William von Schlegel, Morris Kantor and Yasuo Kuniyoshi, who was also a printmaker. In 1933 Helfond began to teach, first at the College Art Association Program and then, from 1936 to 1938, at the Harlem Art Center, New York, where her students included Robert Blackburn and Ronald Joseph. From 1938 to 1941 she was on the staff of the Graphic Arts Division of the New York City WPA/FAP, where she worked in lithography with Louis Lozowick and Jacob Kainen. She also was a pioneer of the screenprint and worked in the Silk Screen Unit under Anthony Velonis with Elizabeth Olds and Harry Gottlieb.

In 1936 Helfond and her fiancé, the sculptor Bill Barrett, whom she had met at the Art Students League and later married, were invited by Harry Sternberg to join him and Blanche Grambs and Hugh 'Lefty' Miller on a trip to the mining area of Lanceford, Pennsylvania. The experience inspired an important series of social realist lithographs, drawings and watercolours on coal miners and their life.

Helfond left the WPA/FAP in 1941 but, unlike Grambs, she continued to make prints. In the 1940s and 1950s her work moved from Social Realism towards abstraction. In 1964 she taught an advanced printmaking course at New York University, and from 1980 she was on the teaching staff at Union County College, Plainfield, New Jersey. She remained active as a printmaker, and in 1991 one of her late monotypes was awarded a prize by the Society of American Graphic Artists. In 1999 Union County College staged a retrospective of seven decades of her printmaking. The checklist published by the Susan Teller Gallery records 220 prints made by Helfond between 1932 and 1994.

The Plainfield Public Library, Plainfield, New Jersey, and the Metropolitan Museum of Art, New York, have holdings of her prints in their collections.

BIBLIOGRAPHY

Ellen G. Landau, *Artists for Victory*, exh. cat., Washington, DC: Library of Congress, 1983 (for biography of Riva Helfond Barrett, see p. 14)

Susan Teller, *Riva Helfond. A Checklist of Prints*, exh. brochure, New York: Susan Teller Gallery, 11 February–18 March 2000

103 On Manoeuvres

1943

Screenprint

Signed in ink and in pencil on image and numbered '39/45' in pencil. 305x 383 mm

Teller 73

2007,7020.1. Presented by Dave and Reba Williams

After America's entry into the Second World War following the Japanese attack on Pearl Harbor in December 1941, many artists were involved in making prints as propaganda exercises for the American war effort. The prominent white stars on the troop carrier and the military jeep identify the army convoy as unequivocally American. Unity of purpose is further strengthened by the overall khaki colour used for the soldiers' uniforms, vehicles and the terrain they traverse.

Joseph Leboit

1907–2002

Born in New York, Leboit studied at the City College of New York and at the Art Students League, where he was taught by Thomas Hart Benton. From 1935 to 1940 he was a WPA/FAP artist where he is recorded to have made some twenty-five socially engaged lithographs, etchings and woodcuts. He also worked as an administrator for the Silk Screen Unit set up by Anthony Velonis in 1938 under the auspices of the WPA/FAP, and later briefly worked for Velonis in his screen-print business after the WPA/FAP ended. Reba and Dave Williams record three screenprints by Leboit on page 311 of their article 'The Early History of the Screenprint', *Print Quarterly*, vol. 3, no. 4 (December 1986), pp. 287–321.

Leboit was affiliated with left-wing art organizations. In 1942 he was involved in the joint meeting of the Artists' Union and American Artists' Congress, from which the Artists' League of America emerged. He became closely involved with the organization Artists for Victory, Inc., when it was formed in January 1942. As the head of the graphics committee for Artists for Victory, he was instrumental in organizing the national print exhibition 'America in the War', which had a synchro-nized opening in twenty-six museums across the United States on 20 October 1943. The theme was interpreted as broadly as possible to show the impact of the war on the people of America, and Leboit proposed the five areas artists might consider: Heroes of the Fighting Front, Action on the Fighting Front, Heroes of the Home Front, The Nature of the Enemy, and The Victory and Peace to Follow. His contribution to the exhibition was the woodcut *Herrenvolk*, depicting the Nazis as bestial and debauched, under the category 'The Nature of the Enemy'.

Leboit also provided illustrations for *New Masses* and *Art Front*. In 1943 he became an official staff artist for the left-wing daily paper *PM*, which was pub-lished in New York. Although this was not openly Communist, many of the staff were Communist Party members. Between 1940 and 1941 Leboit taught at the American Artists School, New York, which advocated a socially relevant art. He also exhibited with the ACA Gallery, New York, which showed Social Realism and politically engaged art.

After the war Leboit gave up printmaking and by the 1950s had re-established himself as a successful psychologist. In 1958 he co-founded the Advanced Center for Psychotherapy in Jamaica Estates and Forest Hills, New York State, and remained its executive director for twenty-five years.

The Smithsonian American Art Museum, Washington, DC, owns two lithographs and two colour woodcuts by Leboit from the WPA/FAP period in its collection.

BIBLIOGRAPHY

Ellen G. Landau, *Artists for Victory*, exh. cat., Washington, DC: Library of Congress, 1983 (for biography of Leboit, see p. 64)

C.N. Ruby and V.W. Julius, *The Federal Art Project: American Prints from the 1930s*, exh. cat., Ann Arbor: University of Michigan Museum of Art, 1985 (for Leboit, see p. 98)

104 Tranquillity

1940
Etching and aquatint
Signed and titled: 'Tranquility' in pencil. 353 x 275 mm
2007,7001.1. Presented by Dave and Reba Williams

During the 1930s and 1940s an artistic debate raged between those artists who advocated a politically engaged Social Realism and those who espoused a modernist abstraction independent of politics. This became particularly heated following the outbreak of the Second World War, and in this print Leboit has entered the fray. He satirizes the abstract painter, protected by his gas mask, as he quietly works at his easel on an abstract canvas while outside the studio warplanes fly over ruined buildings. The dogs at his feet appear to be equally undisturbed by the devastation beyond the tran-quillity of the studio.

This etching with aquatint was printed in an edition of twenty-five while Leboit was still with the New York City WPA/FAP.

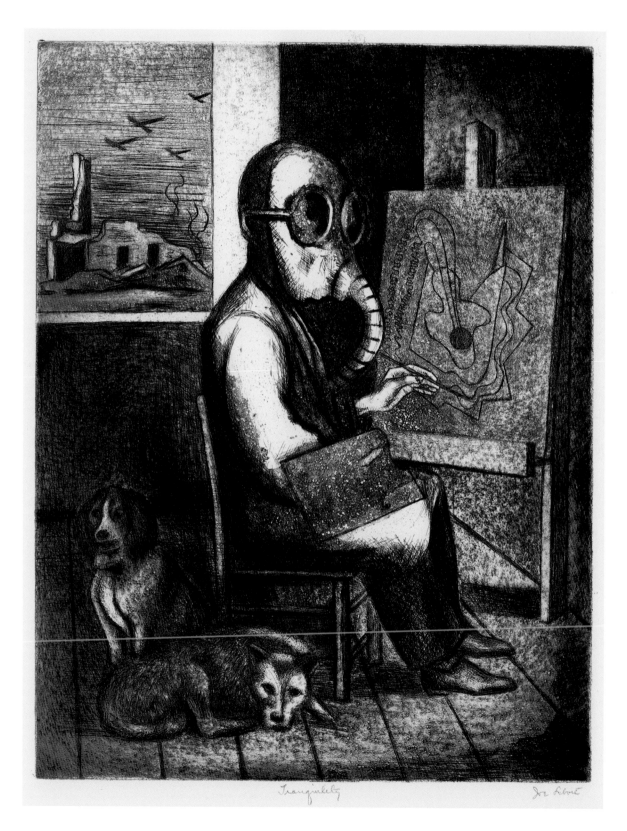

Tranquillity Joe Leboit

George Harris

1913–1991

Harris was born in San Francisco and trained at the California School of Fine Arts from 1929 to 1932, where it is likely that he was introduced to printmaking. He also assisted the Mexican painter Diego Rivera, who was visiting the school. In 1934 Harris was among a large number of artists commissioned under the Public Works of Art Project to paint the mural *Banking and Law* for the Coit Tower in San Francisco. In 1935 he received a solo commission from the US Treasury Department to produce a mural for the post office in Woodland, California. From 1936 to 1941 he was the District Director for the Administration of the Northern California Division of the Federal Art Project. In this role he organized groups of artists to conduct research in different fields, including natural dye colours, weaving-loom construction and designing mosaics for public buildings, as well as the making of murals in fresco and oils.

Harris became a friend of Martha Graham, a pioneer of modern dance, who asked him to produce some 150 drawings illustrating her dance theories; these were subsequently exhibited at the San Francisco Museum of Art in 1937. He was also at this time a close friend of the painter Hilaire Hiler, whose colour theories influenced his own compositions of colour and colour balance. In 1940 he travelled to Mexico where he saw at first hand Mayan and Aztec work. With America's entry into the Second World War, Harris was employed from 1941 to 1944 as a draughtsman in the California shipyards where he produced isometric perspective drawings of naval vessels. It was during this period that he produced his important set of six lithographs called the *War Series* (cat. 105). In 1940 Harris made engravings with S.W. Hayter when the latter visited San Francisco prior to re-establishing Atelier 17 in New York later that year. Harris's lithographs from the 1940s received critical acclaim: in 1945 he was awarded purchase prizes in lithography for his contribution to the National Exhibition of Drawings and Prints at the Library of Congress, and from the Carnegie Institute.

In 1946 the San Francisco Museum of Art gave Harris a retrospective of his work over the previous ten years, which included oil paintings, gouaches and tapestries, as well as lithographs and engravings. In 1944 he was on the staff of the San Francisco Museum of Art where he taught drawing and design. He was also at this time a member of Stanford University's graphic art department and served as acting director of Stanford Art Gallery in 1945. During the 1950s Harris graduated from the College of Marin and gained his doctorate from Stanford University. After having spent his working life in San Francisco, he moved to England in 1970 at the age of fifty-seven, and then to France in 1978.

The Fine Arts Museums of San Francisco holds five of his drawings made between 1937 and 1940 during the San Francisco WPA/FAP period.

BIBLIOGRAPHY

Grace L. McCann Morley and Martin Metal, *George Harris 1936–1946*, exh. cat., San Francisco: San Francisco Museum of Art, 17 September–6 October 1946

105 When?

1940
Lithograph
Signed, titled with sub-number '3' in circle and numbered '19/150' in pencil. 305 x 235 mm
1994,0515.36

When? comes from a set of six lithographs known as the *War Series* which Harris produced between 1940 and 1945. The others were *Why?*, *Where?*, *Spanish Village*, *War Rhythm* and *Roots*. They were printed by Raymond Bertrand, the lithographic printer for the San Francisco WPA/FAP, and published by the *San Francisco Chronicle* in a large edition of 150. They were offered for sale at very low prices to attract a wider audience, but sales proved minimal. All six lithographs were shown in the Harris retrospective at the San Francisco Museum of Art in 1946. In style they range from the abstract to the more recognizably figurative. In this print Harris has shown a bomber plane appearing as a silhouette against the sky, juxtaposed with a walled structure and the sea.

This print shows the use of both lithographic crayon and tusche to create a variety of texture that is typical of Harris's lithographs. The wave-like shapes to the right could be interpreted as referring to the San Francisco Bay and were drawn in crayon. By contrast, the solid black of the wall was achieved with tusche, into which precise lines were carefully scratched to delineate the masonry. The speckled areas towards the top and bottom right were created by spattering tusche on to the lithographic stone.

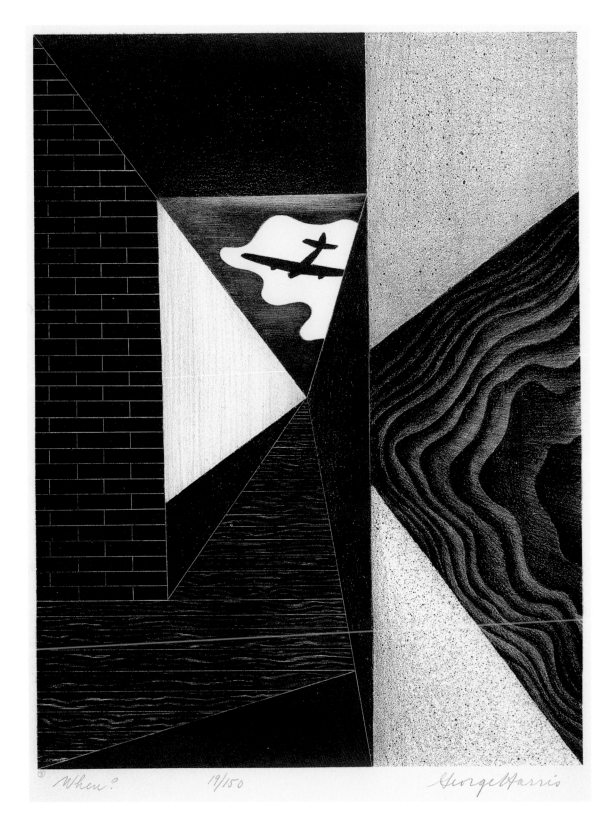

When? 19/150 George Harris

Benton Spruance

1904–1967 (for biography see p. 92)

106 Riders of the Apocalypse

1943

Lithograph

Initialled on stone; signed, dated, titled and inscribed 'Ed 30' in pencil. 323 x 419 mm

Fine and Looney 222

1998,0426.5

This is one of Spruance's best-known works and was made in response to the American war effort in Europe. The massed American bombers demonstrate the force of their superior air power on a carpet bombing raid at night. Spruance has used a cubo-futurist vocabulary of overlapping geometric planes to organize the composition, yet the aircraft are easily recognizable amongst the searchlights.

Spruance's compositions were carefully thought out beforehand. He produced many studies for his lithographs, often using charcoal or graphite to explore tonality or structure.

107 Subway Shift; The Second Front

1943

Lithograph

Initialled on stone; signed, dated, titled 'The Second Front' and inscribed 'Ed 35' in pencil. 259 x 412 mm

Fine and Looney 223

1986,0125.2

The work of civilians at home supporting the American forces on the front line during the Second World War is the subject of this lithograph. The print reflects Spruance's views on a politically engaged citizenship. United in their resolve, the figures address the viewer directly; they wear badges reminiscent of those worn on American political campaigns, but instead of displaying the face of a politician they show the face of the person wearing them. This suggests that the civilians have all signed up for the home front as individuals with a sense of personal commitment.

After being rejected for military service on health grounds, Spruance was employed during the Second World War in labour relations for the American government.

108 Fathers and Sons

1943

Lithograph on chine collé

Initialled and dated on stone; signed, dated, titled and inscribed 'Ed 40' in pencil. 284 x 515 mm

Fine and Looney 226

1987,0516.49

When America declared war on the Axis Powers, after the Japanese bombing of Pearl Harbor on 7 December 1941, Spruance volunteered but was turned down on the grounds of poor health. Although he upheld America's involvement in the Second World War, he had no illusions as to what war entailed. The twisted, agonized forms in this print express his ambivalence. Two snipers confront each other, trapped within a swirling 'figure of eight' that may be likened to a Möbius strip symbolizing an eternal cycle of violence. Beneath the combatants lie the skeletons of two soldiers from the previous generation who had fought in the First World War, one a German beside his spiked helmet, the other an American still wearing his tin helmet.

Spruance scratched into the stone to create the highlights and details of the netting on the American's helmet. He also used tusche for the deepest tones and for the exploding shells. The lithograph was probably printed by Theodore Cuno in Philadelphia.

106
Spruance
Riders of the Apocalypse

107
Spruance
Subway Shift; the Second Front

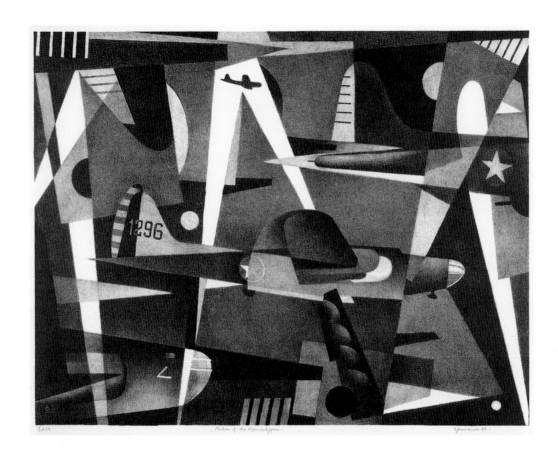

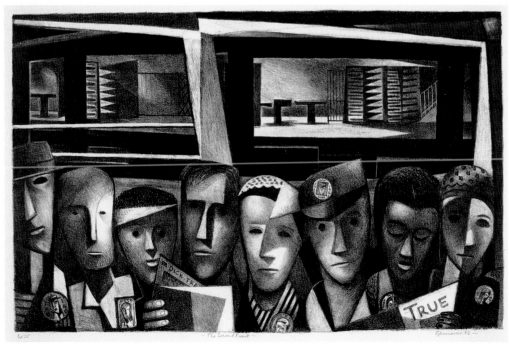

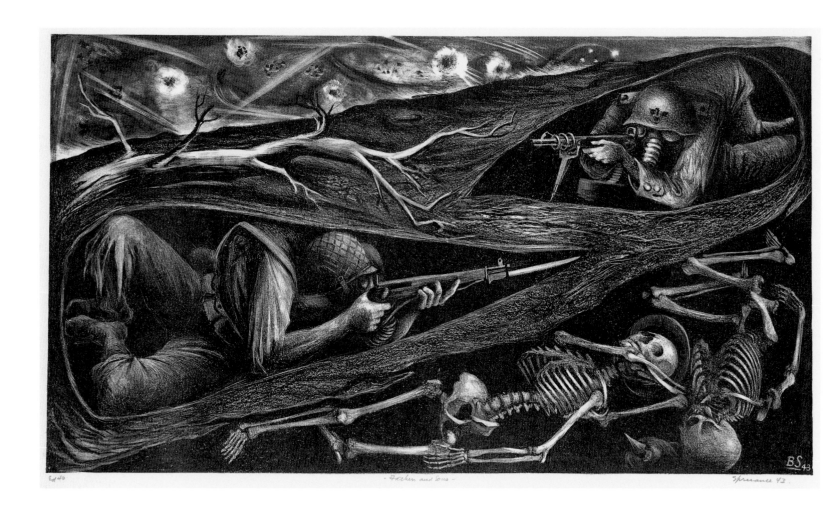

9 JOSEF ALBERS AND GEOMETRIC ABSTRACTION

Josef Albers

1888–1976

Born in Bottrop, Germany, a coalmining area in the Ruhr Valley, Albers started his career there as a primary school teacher. From 1913 to 1915 he studied at the Royal School of Art, Berlin. He returned to Bottrop as a fully accredited art teacher and learnt printmaking in evening classes at the nearby School of Crafts and Applied Arts in Essen until 1918–19. His first prints were expressionistic linocuts of the local sandmines, the Gothic cathedral at Münster and self-portraits, all made in 1916, and from 1916 to 1917 he made lithographs, including a group of theatrical dancers and another of workers' houses.

In 1920 Albers enrolled at the Bauhaus, and three years later was appointed by its founder, Walter Gropius, to teach the compulsory foundation course. In 1925 he married Anni Fleischmann, a Bauhaus student who joined the weaving workshop and became a leading textile artist and later a printmaker. During his thirteen years at the Bauhaus Albers experimented and taught in a variety of media and techniques, including graphic design and typography, but produced no prints. It was only after the Nazis closed down the Bauhaus in 1933 that he took up print-making again.

In 1933 Albers moved to America to take up a position at Black Mountain College, near Asheville, North Carolina, where he and Anni taught until 1949. Although the college did not offer classes in printmaking, Albers produced some fifty-one prints over the next fifteen years, mostly lithographs and relief prints but also his first drypoints. These prints developed abstract geometrical motifs he had explored at the Bauhaus, particularly in his sandblasted glass pictures. In 1935 Albers made the first of several visits to Mexico; he was inspired by the Mayan sites and by the glyphs of Mayan writing, and made prints in Mexico City in 1939–40.

In 1950 Albers was appointed to the chair of the Department of Design at Yale University, New Haven, where he taught on colour and colour relationships. In 1963 his landmark book *The Interaction of Color*, the fruit of his years of teach-ing, was published with two hundred screenprinted colour studies. From 1958 to 1962 he produced a series of inkless intaglio prints of embossed geometric lines. In 1963 he began to make colour lithographs based on his *Homage to the Square* paintings at Tamarind Lithography Workshop in Los Angeles. His close collabora-tion with the printer Ken Tyler continued at Gemini G.E.L., Los Angeles, from 1966 and at Tyler Graphics, Bedford Village, New York, from 1974 until Albers's death in 1976.

Albers's work is represented at the British Museum by seventeen prints and one portfolio, *Formulation: Articulation II*. His extensive archive, including paint-ings, prints and library, is held by the Josef and Anni Albers Foundation, Bethany, Connecticut.

BIBLIOGRAPHY

Brenda Danilowitz, *The Prints of Josef Albers: A Catalogue Raisonné 1915–1976*, New York: Hudson Hills Press, 2001

109 i

1934
Linocut
Signed, dated, titled and numbered '6/20'
in pencil. 202 x285 mm
Danilowitz 77b
1991,0615.180

This linocut was produced shortly after Albers arrived at Black Mountain College, North Carolina, from Germany in November 1933. It continues the geometric abstract ideas found in the eight wood-cuts and five linocuts he made in Berlin in 1933 after the Nazis closed down the Bauhaus. It has been suggested by his cataloguer that the 'i' motif may have been inspired by Kurt Schwitters' 'Das i-Gedicht' ('The i-Poem'), published in his *Die Blume Anna* in 1922, a copy of which Albers owned (see Danilowitz, p. 67). Albers's *i* is very close in form to the large lower-case 'i' that comprises the single line of Schwitters' poem.

Albers made nine linocuts and woodcuts in 1934, and like this example, all were printed at Black Mountain College, mostly in small editions of twenty, using a press for producing college forms and leaflets.

110 Segments

1934
Linocut on oriental laid paper
Signed, dated, titled and inscribed 'Proof'
in pencil. 239 x 284 mm
Danilowitz 79
1991,0615.181

Segments are the curves formed by slicing a circle. Albers has used two continuous lines to describe overlapping segmental shapes, one larger and one smaller. The precisely drawn lines and geometrical shapes recall the 'machine aesthetic' espoused at the Bauhaus. Albers printed this linocut at Black Mountain in two editions, of twenty and twenty-five respectively. In addition there were thirty-four recorded proofs, of which this is one.

111 Inscribed

1944
Cork relief print on oriental laid paper
Signed, dated, titled and numbered '17/25'
in pencil. 222 x 286 mm
Danilowitz 114
2004,0229.2. Presented by the Josef and Anni Albers Foundation

Although Albers had made one print from cork in 1933 (Danilowitz 66) when he was still in Berlin, the only other occasion he printed from this material was in this print and its companion *Involute* (cat. 112), made at Black Mountain College in 1944. Cork crumbles easily when cut, and would therefore appear not to be the most appropriate material for the precise cutting that Albers sought in his woodcuts and linocuts. At Black Mountain College he encouraged his students, in classes known as *matière* studies, to work with unusual materials or to use conventional materials in unusual ways. Here the natural texture of the cork provides a contrast to the narrow white incised line.

Between 1944 and 1948 Albers made use of Biltmore Press, a commercial firm at Asheville near Black Mountain College, for printing his woodcuts, linocuts and the two cork relief prints. The latter were both printed in editions of twenty-five on oriental paper. A related drawing to this print is in the collection of the Albers Foundation.

112 Involute

1944
Cork relief print on oriental nacre kozo paper
Signed, dated, titled and numbered '17/25'
in pencil. 239 x 318 mm
Danilowitz 115
2004,0229.3. Presented by the Josef and Anni Albers Foundation

The movement of a double continuous line forms a spiral whorl around a central axis. By contrast to the rigid geometry of *Inscribed* (cat. 111), Albers endowed this print with a dynamic energy by careful cutting into the cork surface. It was printed on a stiff oriental nacre kozo paper.

113 Multiplex A

1947
Woodcut
Signed, dated, titled, numbered '23/25'
in pencil. 304 x 201 mm
Danilowitz 120
1986,0621.39

In 1947 Albers took a year's sabbatical from Black Mountain College to paint in Mexico. This woodcut dates from this period and was printed in Mexico. It comes from a series of four *Multiplex* woodcuts titled *A* to *D*. The other three (Danilowitz 121–3) were printed on his return to the United States in 1948 at the Biltmore Press, Asheville. Thick and thin lines, precisely cut by hand, contrast with the pronounced grain of the woodblock. In these prints Albers used precisely drawn lines to create illusionistic effects of three-dimensional geometric structures. These ideas were further explored in his *Transformation* engravings (D. 125–8) of 1950 and his inkless intaglio prints (D. 129–50) made between 1958 and 1962.

Multiplex A won the purchase award at the Third International Print Exhibition at the Brooklyn Museum, New York, in 1949.

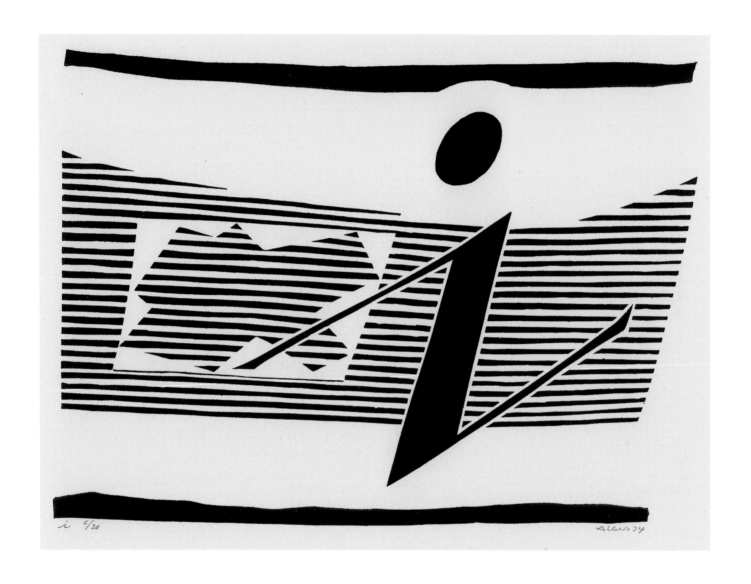

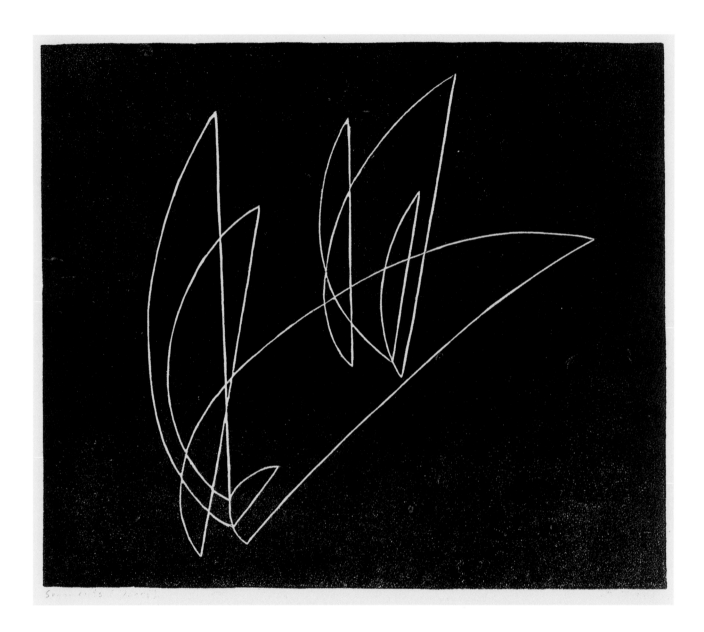

111
Albers
Inscribed

112
Albers
Involute

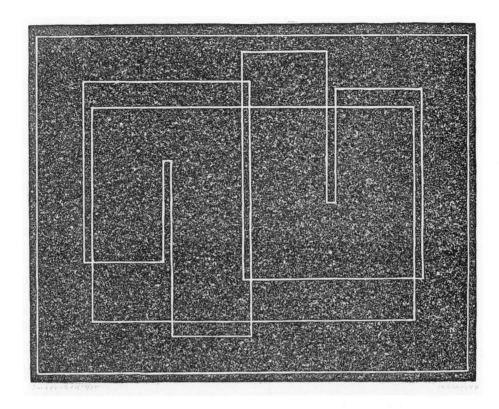

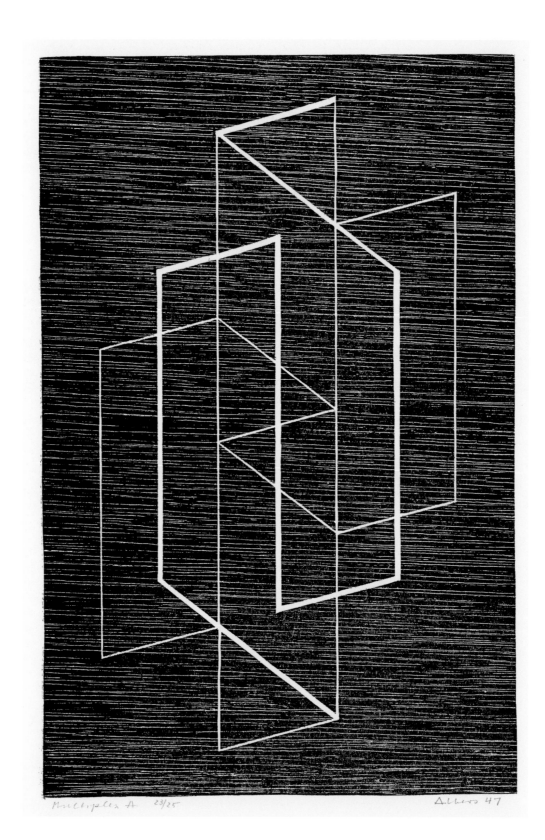

Harry Bertoia

1915–1978

Born near Udine in Northern Italy, Bertoia entered America via Canada in 1930 and arrived in Detroit where his brother lived. In 1936 he was awarded a scholarship to attend the School of the Detroit Society of Arts and Crafts, and in 1937 to Cranbrook Academy of Art in Bloomfield Hills, Michigan, where the architect Eliel Saarinen was its founding president. Although nominally a student of painting, he was immediately appointed, on the basis of his jewellery designs, to revive the metalwork workshop at Cranbrook where he taught metalworking until 1942. He taught himself printmaking at night, and in 1942–3, when the metalwork class had to be suspended because of the scarcity of metal due to the war, he was placed in charge of the graphics class.

Self-taught as a printmaker, Bertoia worked in isolation from professional printmakers, and developed his monotype techniques intuitively and independently. His monotypes from the 1940s were characterized by a linear geometry related to his metalwork. In 1943 over a hundred of his monotypes were purchased by the Solomon R. Guggenheim Foundation's Museum of Non-Objective Painting in New York, to whom he had sent an unsolicited package through the mail. Nineteen of these monotypes were included in the Museum's largest presentation of American non-objective art in the summer of 1943. In the same year the Cranbrook Academy of Art Museum acquired forty-one Bertoia monotypes. From 1945 Bertoia's jewellery and monotypes were regularly shown at the Nierendorf Gallery, New York, until Karl Nierendorf's death in 1947.

In 1943 Bertoia moved to Los Angeles to work with the furniture designer Charles Eames, whom he knew from Cranbrook. He also learnt welding at Santa Monica City College, and from 1947 began making welded sculpture. In 1950 he moved to Pennsylvania to work as a designer for Knoll Associates and two years later released his Bertoia chair. On the recommendation of Josef Albers he was appointed visiting critic in sculpture at Yale University in 1953–4.

Despite his preoccupations with furniture design in the early 1950s and his increasing involvement with sculpture commissions from the late 1950s and throughout the 1960s, Bertoia continued to make monotypes. These were mostly made at night as a means of working out formal ideas for his sculpture. By the end of his career he had produced more than a thousand monotypes, only a fraction of which are catalogued.

The Cranbrook Academy of Art Museum, Bloomfield Hills, Michigan, holds fifty-one Bertoia prints from the early 1940s. The Solomon R. Guggenheim Museum, New York, has retained eighteen prints after more than a hundred were returned to the Bertoia estate in exchange for three of his sculptures.

BIBLIOGRAPHY

June Kompass Nelson, *Harry Bertoia, Printmaker: Monotypes and other Monographics*, exh. cat., Detroit: Wayne State University Press, 1988

114 Monotype

1943
Colour monotype on tissue
Numbered '62' in pencil. 228 x 159 mm
1990,0407.19. Presented by Mrs Brigitta Bertoia

Geometrical abstraction, which Bertoia developed
in his monotypes of the 1940s, remained his pre-
ferred idiom of expression. This monotype is
printed on a tissue-thin sheet of translucent paper.
During this period Bertoia particularly favoured
warm reds, oranges and yellows, which are placed
against a buff background tone in this example.

Bertoia did not usually sign or date his monotypes,
but this print has been ascribed to the year 1943
by his widow Brigitta Bertoia, who presented it to
the British Museum in 1990.

115 Abstract Monotype

1940–49
Colour monotype with hand additions on tissue
Inscribed '1679' in pencil. Inscribed on verso 'HB1679'
in pencil. 458 x 305 mm
Nelson 20
1990,0623.24

Bertoia was interested in manipulating opposites:
light against dark, positive and negative, solid
forms against linear geometric figures. A personal
language of signs is evoked by the glyphic marks
on the lower section of this monotype. The circles
and spidery pictographic lines recall the work of
Paul Klee, which Bertoia admired in the personal
collection of his father-in-law, Dr William R. Valen-
tiner, director of the Detroit Institute of Arts from
1924 to 1945.

The element of unpredictability in making mono-
types suited Bertoia's approach. In this monotype
he first created the white, or negative, lines by
wiping the ink from the glass plate and then traced
the dark, or positive, lines in pen and ink through
the back of the tissue paper.

Dorr Bothwell

1902–2000

Born in San Francisco, Bothwell was brought up in San Diego. Between 1921 and 1924 she attended the California School of Fine Arts, San Francisco, the University of Oregon and the progressive Rudolph Schaeffer School of Design, San Francisco, where Schaeffer's teachings on colour, pattern and design strongly influenced her future direction. She first exhibited her paintings at the Modern Gallery in San Francisco, which she had established with eight other artists in 1925.

On receiving a small inheritance, Bothwell decided to travel to American Samoa in 1928, where she lived for two years and became the adopted daughter of a Samoan chief. In Samoa she produced linocuts, oil paintings, watercolours and drawings of traditional *tapa* cloth designs. These were shown in San Diego and San Francisco and earned her enough income to fund a year's travels and studies in England, France and Germany from 1930 to 1931. She returned to San Diego and then moved to Los Angeles where she joined the mural division of the Los Angeles WPA/FAP from 1936 to 1939. She designed dioramas for the Los Angeles County Museum and a mural for the Manning Coffee restaurant in San Francisco in 1940.

Bothwell first began to make screenprints in 1943 after seeing an exhibition of serigraphs and picking up a copy of Harry Sternberg's recently published manual *Silk Screen Color Printing* (1942). Reba and Dave Williams record eighteen of her screenprints, dated between 1944 and 1949, on page 298 of their article 'The Early History of the Screenprint', *Print Quarterly*, vol. 3, no. 4 (December 1986), pp. 287–321. From 1948 to 1952 she held solo exhibitions of her screenprints at the Serigraph Gallery in New York. Her screenprints often incorporated Native-American motifs and symbolism with abstract surrealist and geometrical influences and strong colour.

From 1959 until 1996 she taught at the San Francisco Art Institute. In 1960 she was invited by Bill Zacha, founder of the Mendocino Art Center, to teach and live in his art colony, where she stayed until the 1990s. In 1968 she was co-author with Marlys Frey of an influential artists' treatise entitled *Notan: The Dark-Light Principle of Design*, which examined positive and negative forces as the basis for compositional design. Bothwell undertook travel studies to Nigeria and Tunisia in 1966–7 and to Bali, Java and Sumatra in 1974, where she documented craft techniques. In 1998 she donated a large archive of her prints to the Mendocino Art Center. Bothwell died in 2000, at the age of ninety-eight.

BIBLIOGRAPHY

David Acton, *A Spectrum of Innovation: Color in American Printmaking 1890–1960*, exh. cat., Worcester, Massachusetts, and New York/London: Worcester Art Museum and W.W. Norton & Company, 1990 (for biography of Bothwell, see pp. 172 and 253)

Dorr Bothwell and Marlys Frey, *Notan: The Dark-Light Principle of Design*, New York: Van Norstrand Reinhold, 1968

116 Winds of Chance

1947

Colour screenprint

Signed and dated twice, titled, and numbered '1/35' in pencil. Titled and inscribed with prices on verso 'Bothwell Ed 35 22 50' and 'DK. 16,70' in pencil. 273 x 215 mm

1990,0519.2

The cone-like shapes, pinned by vertical elements, point in one direction like weather vanes, giving the impression that they are directed by the wind. The openwork of these forms recalls Native American basketry or tribal fetishes, an interest which Bothwell pursued. The patterning on one of these may even be a distant echo of the *tapa* cloth designs that she drew twenty years earlier in Samoa. Her choice of colours and abstract design are also evocative of fashionable interiors in the late 1940s and early 1950s.

The harmonious balance of light and dark elements in the composition followed the Japanese design principle of *notan* which Bothwell later articulated in her primer, *Notan: The Dark-Light Principle of Design*, published in 1968.

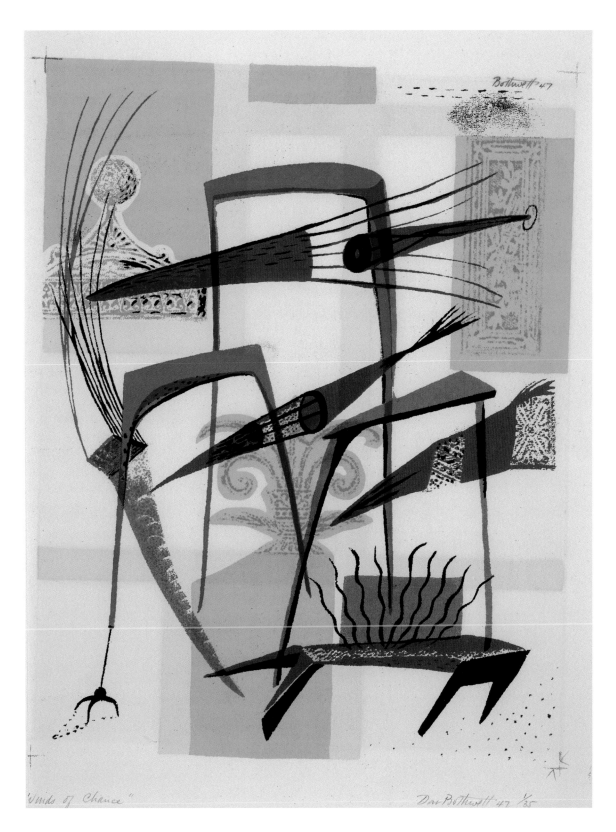

10 S.W. HAYTER AND ATELIER 17 IN NEW YORK

Stanley William Hayter

1901–1988

Born in Hackney, London, Hayter studied chemistry and geology at King's College, London, and then worked for an oil company in Iran from 1922 to 1925. Deciding to become a painter, in 1926 he moved to Paris, where the Polish engraver Joseph Hecht introduced him to engraving. They shared a studio which, in 1927, became a printmaking workshop. In 1933 the workshop relocated to 17 rue Campagne-Première, from which address it took its name, 'Atelier 17'. It rapidly became a centre for experimental engraving, attracting many international artists during the 1930s, including the surrealists Max Ernst and Yves Tanguy, as well as Alberto Giacometti and Alexander Calder. Hayter's experiments with engraving, and with obtaining textures by pressing materials such as gauze onto the soft-ground plate, were highly influential in disseminating surrealist ideas of automatism and of the subconscious.

After the outbreak of the Second World War, Hayter left Paris for London and then moved to America in 1940. He first worked at the California School of Fine Arts before moving to New York, where he re-established Atelier 17 at the New School for Social Research, before it moved, in 1945, to larger premises at 41 East 8th Street. In New York, Atelier 17 became a focus for the émigré artists from Paris, such as Joan Miró, André Masson, Marc Chagall and Jacques Lipchitz, as well as for the younger generation of American artists like Jackson Pollock, Robert Motherwell and Willem de Kooning. In 1944 the printmaking activities of Atelier 17 were the focus of an exhibition, 'Hayter and Studio 17: New Directions in Gravure', at the Museum of Modern Art, which subsequently travelled the United States over the next two years. During the 1940s Hayter developed a method of making the first simultaneous intaglio and surface colour print, which he launched with *Cinq Personnages* (1946). Hayter's background in chemistry gave him an understanding of the different viscosities of the inks he was using. His innovative techniques were published in 1949 in his highly influential book, *New Ways of Gravure*, which was illustrated with the work of Atelier 17 artists.

In 1950 Hayter moved permanently back to Paris and reopened Atelier 17. The New York Atelier 17 continued to operate under a succession of printers, finally closing in 1955. Over the next three decades Hayter continued developing his colour intaglio technique, refining it to achieve various degrees of transparency and tonal modulation. He produced some 452 prints in the course of his long career.

The largest archive of Hayter's prints is at the British Museum, which holds more than four hundred impressions pulled between the early 1930s and 1960, including many trial proofs and states; the archive was purchased from the artist just before his death in 1988.

BIBLIOGRAPHY

Peter Black and Désirée Moorhead, *The Prints of Stanley William Hayter: A Complete Catalogue,* London: Phaidon Press, 1992

S.W. Hayter, *New Ways of Gravure,* London: Routledge & Kegan Paul, 1949

117 Cinq Personnages

1946
Colour engraving with soft-ground etching and scorper, on oriental paper
Signed, dated, titled and numbered '26/50' in pencil.
378 x 603 mm
Black and Moorhead 168.V
1972,1028.4

This is Hayter's first large colour intaglio print and a breakthrough in the development of simultaneous colour printing from one plate combining intaglio and surface inking. Hayter's *Cinq Personnages* is a lamentation for his first son, David, who had recently died of tuberculosis at the age of sixteen. Enmeshed in the network of automatist lines, figures are shown in various attitudes of grief, one spinning on the left and another plunging at the right, over the recumbent body of the dead youth.

Hayter acknowledged the technical importance of this print in his seminal 1949 publication, *New Ways of Gravure*, where he devoted chapter 10 to a discussion of its making. As he explained, *Cinq Personnages* was planned as the synthesis of six components and was printed from a single worked intaglio plate in one passage through the press. Hayter began by using the burin to incise the lines of the composition. A scorper was also used to obtain the raised white relief of the tiny spirit child figure towards the centre. Various textures, including silk, gauze mesh and crumpled brown paper, were then pressed using a roller press on to the soft-ground covered plate, which was then bitten in acid. The plate was first intaglio inked in black for the incised lines, and the surface then wiped clean before transparent layers of orange, red-violet and green ink were separately applied to the surface of the plate through silkscreens. Begun at the end of December 1945 and completed after five states on 7 March 1946, Hayter printed *Cinq Personnages* at Atelier 17 in New York in an edition of fifty with the assistance of Fred Becker, James Goetz, Ezio Martinelli and Karl Schrag.

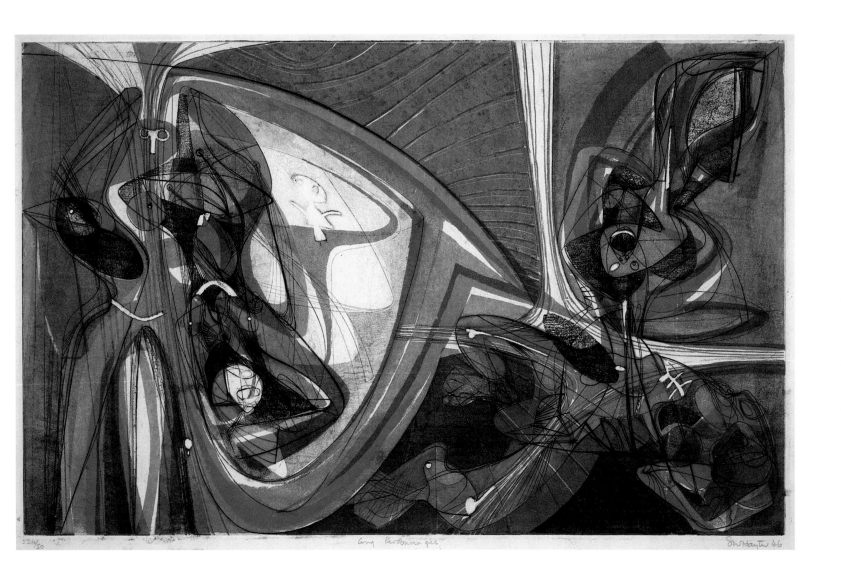

Fred Becker

1913–2004 (for biography see p. 124)

118 Fandango

1949

Colour engraving, etching and soft ground, on stiff
wove paper

Signed, dated, titled, numbered '4/15' in pencil, and
inscribed '43/84' in ink, partially erased. Stamp in ink of
Italian Customs on verso. 452 x 380 mm

1985,0713.43

Made at Atelier 17 in New York, *Fandango* shows
the pervasive influence of the abstract surrealism
and automatism espoused by Hayter. Becker first
met Hayter in 1940 and became one of his first
American students at Atelier 17, where he himself
later worked. The title of this etching refers to
a popular Spanish flamenco dance. Becker's
angular geometrical forms and dynamic linear
movement evoke the frenetic rhythm of the dance.

Becker used two plates to achieve this print: the
first was etched and engraved and printed in red,
leaving a plate tone of pale pink, and then a
second plate was engraved and printed in black.
The deeply engraved lines from the second plate
are heavily embossed on the thick textured paper,
giving the print a tactility that is almost three-
dimensional. Becker printed the etching in an
edition of only fifteen impressions, which was the
upper limit for most of his prints in the late 1940s
and early 1950s.

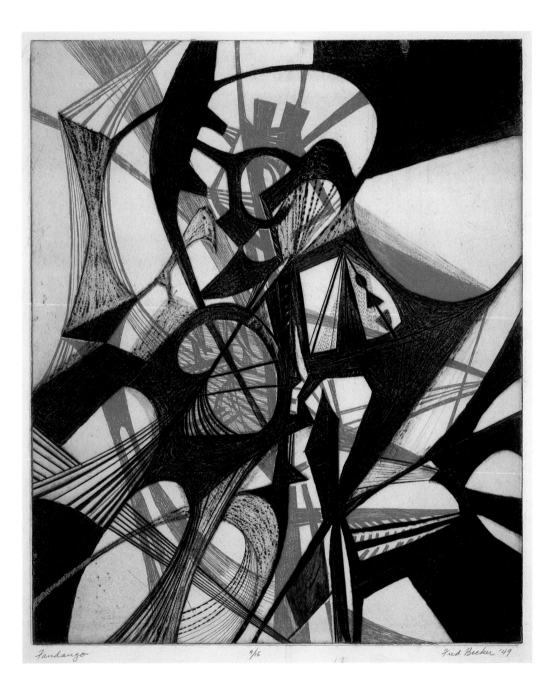

Jackson Pollock

1912–1956 (for biography see p. 256)

119 Untitled

c.1944–5, 1967 restrike

Engraving and drypoint

Numbered '1/50' in pencil. Embossed blind-stamp of the
Estate of Jackson Pollock. Embossed blind-stamp 'ES'
of the printer Emiliano Sorini. 373 x 452 mm

O'Connor and Thaw P.16

1981,0620.61

This and the following three engravings were made
by Pollock at Hayter's Atelier 17 in New York in
1944 and 1945. In all, he engraved eleven intaglio
plates at Atelier 17, but only a few trial proofs
were pulled from the plates and none of them
was printed in editions. The plates were only
rediscovered after the artist's death. In 1967 the
artist's widow, Lee Krasner, and the Museum of
Modern Art published editions of seven of them.
Gabor Peterdi, who had worked with Pollock at
Atelier 17, cleaned the badly corroded plates
and reworked the drypoint before steel-facing
them. The posthumous editions were printed by
Emiliano Sorini. The Museum of Modern Art,
New York, owns Pollock's Atelier 17 trial proofs.

The all-over composition of this print is abstract,
yet embedded within the interwoven lines are
figural motifs, such as eyes, hands and feet, as well
as recognizable objects like the fork at bottom left.
These motifs are related to archetypal symbols
and derive from his drawings used in Jungian
psychoanalysis. However, the web-like linearity
of the engraving, with its interlocking of figure
and ground, anticipates Pollock's move towards
Abstract Expressionism (see cat. 144).

120 Untitled

c.1944–5, 1967 restrike

Engraving and drypoint

Numbered '1/50' in pencil. Embossed blind-stamp of the
Estate of Jackson Pollock. Embossed blind-stamp 'ES'
of the printer Emiliano Sorini. 300 x 227 mm

O'Connor and Thaw P.18

1981,0620.62

Inspired by Hayter's automatist engravings,
Pollock learnt to use the burin and the drypoint
needle at Atelier 17, which was located close to
where he was living in Greenwich Village. His
friend Reuben Kadish, who was then working as a
printer at Atelier 17, showed him how to prepare
and print the plates. Pollock visited the studio at
night when he could work alone and when Kadish
was doing his own commercial printing. In some
cases Pollock engraved on both sides of the copper
to save on materials.

The intaglio print expresses some of the spontan-
eity and energy that would characterize Pollock's
mature painting style. The all-over effect, typical
of his 'drip' paintings, is very evident.

121 Untitled

c.1944, 1967 restrike

Engraving and drypoint

Numbered '1/50' in pencil. Embossed blind-stamp of the
Estate of Jackson Pollock. Embossed blind-stamp 'ES'
of the printer Emiliano Sorini. 297 x 224 mm

O'Connor and Thaw P.15

1981,0620.60

This is the most figurative composition among
Pollock's intaglio prints of 1944–5. Two standing
figures, one clearly female with rounded breasts,
are loosely drawn in outline, their heads reduced
to basic geometrical shapes. The child-like quality
of the composition recalls the drawings Pollock
produced while undergoing Jungian psycho-
therapy with Joseph Henderson. Pollock used
a similar symbolic division of two figures in his
earlier painting *Male and Female*, c.1942
(Philadelphia Museum of Art).

122 Untitled

c.1944, 1967 restrike

Engraving and drypoint

Numbered '1/50' in pencil. Embossed blind-stamp of the
Estate of Jackson Pollock. Embossed blind-stamp 'ES'
of the printer Emiliano Sorini. 302 x 253 mm

O'Connor and Thaw P.13

1981,0620.58

The biomorphic shapes in this print derive from
the abstract surrealism of artists like Miró and
from the work being promoted by Hayter at Atelier
17. Through his expressive handling of line Pollock
energized these forms. Within the web of lines
certain ambiguous details suggestive of eyes or
bodily orifices emerge. These shapes grew organic-
ally out of the process of working on the plate
rather than from some predetermined concept.
Similar motifs, concealed within a dense network
of gestural lines, reappeared in Pollock's 1946
painting *Eyes in the Heat* (Peggy Guggenheim
Collection, Venice).

119
Pollock
Untitled

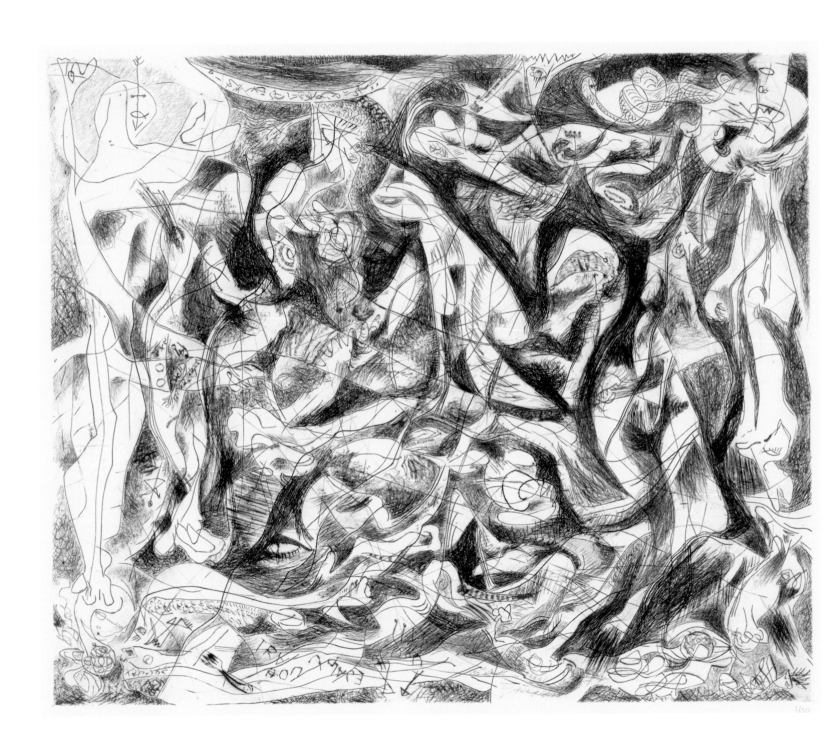

1/50

Alexander Calder

1898–1976

Born to artist parents in Lawnton, Pennsylvania, Calder studied engineering at the Stevens Institute of Technology, Hoboken, New Jersey, graduating in 1919. After various jobs he moved to New York and enrolled at the Art Students League in 1923, where he studied under John Sloan and George Luks. At the League he took classes in etching in 1924 and in lithography the following year with Charles Locke. An assignment to sketch scenes at the Ringling Brothers and Barnum and Bailey Circus for the *National Police Gazette* provided the inspiration for his famous *Cirque Calder*, 1926–30, which he created in Paris following his move there in 1926. The *Cirque Calder*, an assemblage of small pieces made from wire and other found objects, was presented by Calder in many performances in Paris and New York, where he divided his time over the next ten or so years. In 1928 he was given his first solo exhibition at the Weyhe Gallery, New York.

In Paris Calder became friends with many prominent artists, including Marcel Duchamp, Jean Arp, Fernand Léger and Joan Miró. He produced wire sculptures of his friends which were essentially 'drawings' in space. In 1931 he made his first fully abstract kinetic sculptures, which Duchamp called 'mobiles'. Initially these were motorized, but Calder soon allowed them to move of their own accord on currents of air. His kinetic 'mobiles' and his stationary 'stabiles' (so-named by Arp in 1932) made his critical reputation and he continued to develop them over his career. His 'mobiles' also displayed the influence of De Stijl, particularly of Piet Mondrian, and of constructivism. In 1933 Calder exhibited with the *Abstraction-Création* group, whose members included Arp and Mondrian.

Calder's printmaking has been overshadowed by his sculptures, and little has been published on this aspect of his oeuvre. He began to make prints in Paris and contributed a drypoint to the portfolio *23 Gravures de Arp, Calder etc.*, published by G. Orobitz in Paris in 1935, with an introductory text by Anatole Jakovski. Some of his first intaglio prints were made at Atelier 17 in the 1930s, where he formed a close friendship with Hayter, whom he had first met in Paris in 1926. When Hayter moved to New York in 1940, Calder renewed his acquaintance and during the 1940s made a small group of intaglio prints at Atelier 17, where he used the soft-ground technique he had learnt from Hayter. The impact of Calder's 'mobiles', with their openwork forms, also began to be felt in Hayter's prints. From the late 1960s until his death in 1976, Calder produced a substantial series of colour lithographs.

After the Second World War Calder worked on many monumental public sculptures commissioned from as far afield as Chicago and Spoleto. He was given several museum retrospectives, from the Museum of Modern Art in 1943 to the Whitney Museum of American Art in 1976, shortly before his death. The Calder Foundation in New York holds an extensive archive of the artist's life and work.

BIBLIOGRAPHY

For a detailed chronology and bibliography, see the Calder Foundation website www.calder.org

123 The Big I

1944
Soft-ground etching and etching with aquatint
Inscribed 'Caulder' (*sic*) on verso
in blue ballpoint pen. 174 x 221 mm
1992,117.2

Created at Atelier 17 in New York, this is one of Calder's best-known prints. Figural elements, such as the stars, the steering-wheel-like object and the large capital letter 'I', are combined with abstract, biomorphic forms which recall the work of Miró. *The Big I* was included in the Museum of Modern Art's exhibition in 1944, 'Hayter and Studio 17: New Directions in Gravure'.

Hayter reproduced *The Big I* on page 80 of his book *New Ways of Gravure* (first published in 1949) to illustrate different processes by which texture could be incorporated on the plate. The softly modulated grey of the background tone was achieved with soft-ground and stopping out. The granulated texture surrounding the steering-wheel-like shape was produced by deliberately allowing the nitric acid to form bubbles during the biting of the plate, a process recommended by Hayter. The size of the edition is not known.

Louise Bourgeois
b.1911

Born in Paris, where her parents ran a business restoring tapestries, Bourgeois entered the Sorbonne and studied mathematics in 1932. She then decided to take up art and in 1935 enrolled initially at the Ecole des Beaux-Arts and then at a number of studio-schools, including the Académie Julian and the Grand Chaumière. In 1938 she married the American art historian Robert Goldwater, and they moved to New York where she enrolled at the Arts Students League. She studied painting under the Czech modernist Vaclav Vytlacil, and from 1938 until the early 1940s made lithographs with the League's printer, Will Barnet. At home she taught herself to make woodcuts and linocuts. A number of her early prints draw upon domestic life at the family's country house at Easton, Connecticut.

From 1946 to 1949 Bourgeois worked intermittently at Hayter's Atelier 17, where she became friends with Joan Miró and several émigré artists. She sensed Hayter's exasperation with her as a beginner, and later recalled the workshop as 'an anxious environment' (Bourgeois, in interviews with Deborah Wye 1992–3; cited by Wye and Smith, p. 27). She produced some thirty-eight intaglio prints during this period at Atelier 17, the most important of which were her seminal suite of nine engravings from 1947, *He Disappeared into Complete Silence*. After Hayter's return to Paris in 1950, Bourgeois ceased working at Atelier 17, and for the next twenty years concentrated on making sculpture. Her first solo exhibition of sculpture was at the Peridot Gallery, New York, in 1949, with further shows in 1950 and 1953. In 1951 the Museum of Modern Art acquired her narrow, upright wood sculpture, *Sleeping Figure*, 1950.

Bourgeois returned to printmaking following the death of her husband in 1973. To cope with the loss, she taught printmaking at the School of Visual Arts, New York, from 1974 to 1977. She was an unconventional teacher, making the students question their intentions behind the imagery, and left the teaching of the technical aspects of printmaking to an assistant. Although a few prints were made during this period, her return to printmaking became fully engaged from the late 1980s. She began to work with a series of publishers, including Galerie Maeght, Paris, Peter Blum Editions, New York, and latterly Harlan and Weaver in New York. She also began to reissue some of her earlier engravings using photogravure.

Bourgeois continues to be highly active as a sculptor and printmaker. In 1990 she presented her entire printed oeuvre to the Museum of Modern Art, New York, with subsequent additions of new work.

BIBLIOGRAPHY

Frances Morris and Marie-Laure Bernadac (eds), *Louise Bourgeois*, exh. cat., London: Tate Modern, 2007

Deborah Wye and Carol Smith, *The Prints of Louise Bourgeois*, New York: The Museum of Modern Art, 1994

He Disappeared into Complete Silence, Plates 1–9

1947
1987,1003.23(1-9)

This suite of nine intaglio prints is the most important set of prints produced by Bourgeois and a landmark of twentieth-century American printmaking. The engravings are accompanied by Bourgeois's very brief texts that are akin to parables. Marius Bewley, a poet and director of Peggy Guggenheim's Art of This Century Gallery, provided an introductory essay to the portfolio.

Bourgeois described *He Disappeared into Complete Silence* as 'a drama of the self' (Bourgeois, in interviews with Deborah Wye 1992–3; cited by Wye and Smith, p. 72), and declared that engraving allowed her to exorcise emotional anxiety. The parables and the engravings speak of the isolation of the individual. Bourgeois recalled the sense of entrapment she felt as an adolescent in her family home. This is particularly evident in plate 8 (cat. 131): the ladders lead to nowhere; the interior spaces are shown as confined and claustrophobic. While the attenuated structures in some of the engravings recall the skyscrapers of Manhattan, they more closely refer to the narrow wooden sculptures she was also making.

Bourgeois printed the suite herself at Atelier 17 in New York. She reworked the plates many times and pulled successive trial proofs. Bourgeois's parables and Bewley's essay were printed by the Gemor Press, who was also the publisher. The colophon announced a numbered edition of forty-four copies, plus ten additional copies not for sale, lettered A to J. The colophon of the British Museum's copy is numbered '28' in ink and is signed by Bourgeois and Bewley. It appears that only two or three copies were actually issued as complete portfolios in 1947; the other extant copies were only put together by the artist in the 1980s from engravings, texts and covers still in her possession, and the British Museum's copy is one of these.

124 He Disappeared into Complete Silence, Plate 1

1947
Engraving
Signed and inscribed 'Plate 1' in pencil. 197 x 66 mm
Wye and Smith 29.2 III
1987,1003.23(1)

125 He Disappeared into Complete Silence, Plate 2

1947
Engraving
Inscribed 'Plate 2' in pencil. 175 x 136 mm
Wye and Smith 30.1 III
1987,1003.23(2)

126 He Disappeared into Complete Silence, Plate 3

1947
Engraving
Signed and inscribed 'Plate 3' in pencil. 171 x 137 mm
Wye and Smith 31.3 IV
1987,1003.23(3)

127 He Disappeared into Complete Silence, Plate 4

1947
Engraving on orange-brown paper
Signed and inscribed in pencil 'Plate 4'. 175 x 124 mm
Wye and Smith 32.2 III variant (404.93)
1987,1003.23(4)

This is one of three variants of Plate 4 that Bourgeois printed on coloured paper. The other two variants were printed on pink paper and brown paper. None of the coloured paper variants was included in the three portfolios issued in 1947.

128 He Disappeared into Complete Silence, Plate 5

1947
Engraving
Signed and inscribed 'Plate 5' in pencil. 174 x 124 mm
Wye and Smith 33.IV
1987,1003.23(5)

129 He Disappeared into Complete Silence, Plate 6

1947
Engraving
Numbered 'VI' in pencil. 174 x 125 mm
Wye and Smith 34.3 III
1987,1003.23(6)

130 He Disappeared into Complete Silence, Plate 7

1947
Engraving with hand additions in black ink and pencil
Inscribed 'Plate 7' in pencil. Arrow point right, in crayon, bottom right corner, recto. Verso inscribed with artist's instructions in crayon, 'This plate should be replaced by River Print soleil sur river'. Additional drawing on verso in crayon. 177 x 137 mm
Wye and Smith 35.VI
1987,1003.23(7)

This is the unique proof of the sixth state of this plate, which went through eleven states.

131 He Disappeared into Complete Silence, Plate 8

1947
Engraving
Signed and inscribed 'Plate 8' in pencil. 175 x 124 mm
Wye and Smith 36.3 XII
1987,1003.23(8)

132 He Disappeared into Complete Silence, Plate 9

1947
Engraving with hand additions in black ink
Signed and inscribed 'Plate 9' in pencil recto. Verso inscribed 'Spring St' in black crayon. 227 x 100 mm
Wye and Smith 37.I
1987,1003.33(9)

This is the unique proof of the first state of six of this plate.

124
Bourgeois
*He Disappeared into Complete
Silence, Plate 1*

125
Bourgeois
*He Disappeared into Complete
Silence, Plate 2*

Plate 1 Bourgeois

plate 2

Once there was a girl and she loved a man.

They had a date next to the eighth street
station of the sixth avenue subway.

She had put on her good clothes and a new hat.
Somehow he could not come. So the purpose of
this picture is to show how beautiful she was.
I really mean that she was beautiful.

The solitary death of the Woolworth building.

Bourgeois

He Disappeared into Complete Silence, Plate 3

Plate 3 L Bourgeois

Once a man was telling a story, it was a
very good story too, and it made him very happy,
but he told it so fast that nobody
understood it.

Bourgeois

He Disappeared into Complete Silence, Plate 4

In the mountains of Central France forty years ago, sugar was a rare product.

Children got one piece of it at Christmas time.

A little girl that I knew when she was my mother used to be very fond and very jealous of it.

She made a hole in the ground and hid her sugar in, and she always forgot that the earth is damp.

Plate 5 Bourgeois

Once a man was waving to his friend from the elevator.

He was laughing so much that he stuck his head out and the ceiling cut it off.

Bourgeois

He Disappeared into Complete Silence, Plate 6

Leprosarium, Louisiana.

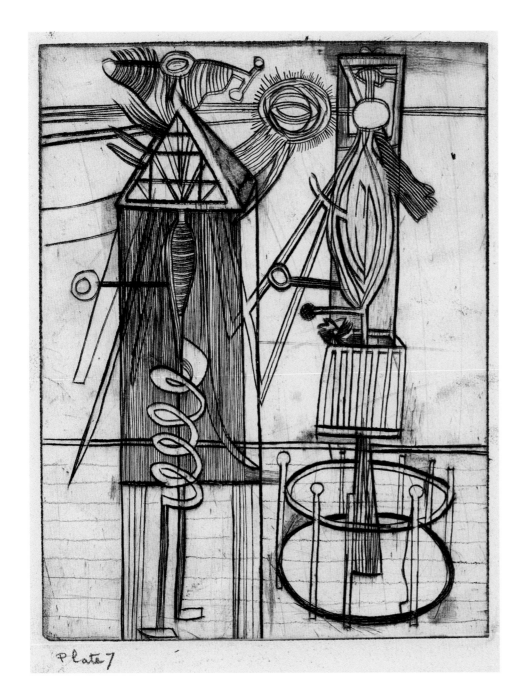

Plate 7

Once a man was angry at his wife, he cut her in small pieces, made a stew of her.

Then he telephoned to his friends and asked them for a cocktail-and-stew party.

Then all came and had a good time.

Once an American man who had been in the army
for three years became sick in one ear.

His middle ear became almost hard.

Through the bone of the skull back of the
said ear a passage was bored.

From then on he heard the voice of his friend
twice, first in a high pitch and then in a low pitch.

Later on the middle ear grew completely hard and
he became cut off from part of the world.

Once there was the mother of a son. She loved him with a complete devotion.

And she protected him because she knew how sad and wicked the world is.

He was of a quiet nature and rather intelligent but he was not interested in being loved or protected because he was interested in something else.

Consequently at an early age he slammed the door and never came back.

Later on she died but he did not know it.

Anne Ryan

1889-1954

Ryan was born in Hoboken, New Jersey, the daughter of a banker, although both her parents died when she was still young and she was brought up by her grandmother. She was educated at the Academy of Saint Elizabeth near Morristown, New Jersey, where she studied literature but left in 1911 to marry William J. McFadden, a lawyer. In 1923 she was legally separated from her husband, who suffered from progressive bouts of instability. Ryan tried to support her young family by writing and moved among the literary circles of Greenwich Village. Her first volume of poetry, *Lost Hills*, was published in 1925, followed by a novel, *Raquel*, in 1926. In 1931 she moved with her children to Majorca, where life was less expensive, and also visited Paris.

She returned to New York in 1933 and became a friend of the sculptor Tony Smith and the painter Hans Hofmann, who encouraged her artistic ambitions. In 1938, aged almost fifty, she began to paint, and in 1941 she began to make her first intaglio prints at S.W. Hayter's Atelier 17 in New York, where she mixed with many of the European émigré artists. Her intaglio prints include *Constellations*, a suite of twenty-five abstract surrealist engravings made in 1945. She was included in the 1944 exhibition 'Hayter and Studio 17: New Directions in Gravure' at the Museum of Modern Art, New York.

From engravings Ryan turned to colour woodcuts, which she learned to make at Louis Schanker's class at Atelier 17 in 1945. She made just over a hundred colour woodcuts in four years, and solo shows of her colour woodcuts were held at the Eli Marquié Gallery, New York and the Philadelphia Art Alliance in 1946. Her woodcut *Fantasia* won a purchase prize at the Brooklyn Museum national print annual. In their imagery her woodcuts ranged from abstract works to more representational still lifes, portraits, and circus and religious themes.

In 1948 Ryan began to make collages after seeing an exhibition of Kurt Schwitters which profoundly inspired her. Over the next six years she made more than four hundred collages, small in scale and delicate in hue, from scraps of different fabric and paper. They were first shown in her solo exhibition at the Kharouba Gallery in Portland, Oregon, in 1949. Collage dominated her final years, when in 1954 Ryan died unexpectedly from a stroke in Morristown, New Jersey.

Ryan's literary papers are held by the Newark Public Library; several of her collages and woodcuts are owned by the Smithsonian American Art Museum, Washington, DC, while the Brooklyn Museum owns the suite of *Constellations* engravings.

BIBLIOGRAPHY

David Acton, *The Stamp of Impulse: Abstract Expressionist Prints*, 2001 (for biography of Ryan, see p. 74)

John Bernard Myers, 'Anne Ryan's Interior Castle', *Archives of American Art Journal*, vol. 15, no. 3 (1975), pp. 8–11

Susan Teller, *Anne Ryan: A Retrospective, 1939 to 1953*, exh. brochure, New York: Susan Teller Gallery, 12 April–12 May 2007

133 Three Figures

1947
Colour woodcut on black packing paper
Signed, titled and numbered '14/20' in white crayon.
291 x 382 mm
1992,1107.5

Made in 1947, when Ryan was preoccupied with the colour woodcut, this print shows her abstract style; three, white biomorphic shapes suggestive of two female torsos and an animal skull are arranged within an armature of reserved black lines. Ryan's approach to the colour woodcut was idiosyncratic and economical. Rather than use a separate block for each colour, she restricted herself to one block of cheap plywood or pine, which she re-inked and overprinted with different colours. A simple design of lines was carved into the block and then separate areas were inked with oil paint using a small roller. She nearly always printed on black paper that came from the packing in which light-sensitive photographic paper was kept. She printed by hand, rubbing the back of the paper with her palm and varying the pressure to obtain heavier or lighter effects. The paper would then be lifted, the block re-inked and reprinted, building up layers of colours in a manner which was improvisational. In *Three Figures*, green, white and yellow oil paints were lightly printed to allow the black paper to show through. The wood grain and the sawn-off ends of the plank also provide texture.

Ryan's woodcuts were usually printed in small editions of twenty, although each impression varied in accordance with the manner of its printing. She signed most of her prints 'A. Ryan' as she felt that being clearly identified as a woman artist was detrimental to her career.

133
Ryan
Three Figures

Leonard Nelson
1912–1993

Born in Camden, New Jersey, Nelson was orphaned as young teenager when both his parents died within six weeks of each other in 1928. After briefly attending Auburn University, Alabama in 1932, he was awarded a scholarship to the Pennsylvania Academy of Fine Arts in 1936, although he had no portfolio or prior formal experience of drawing or painting. His introduction to modern art was through his teacher, Henry McCarter, at the Academy and from a trip to Europe in 1939 on a Cresson Travelling Fellowship, where he had direct exposure to the avant-garde movements. On his return to the Academy he enrolled for additional classes at the Barnes Foundation in Merion, Pennsylvania, from 1939 to 1941. He registered with the Philadelphia WPA/FAP where he became involved in printmaking. Two of his woodcuts, *Dance Tapu* and *Head of a Dancer*, were included in the Brooklyn Museum's first national print annual in 1947. He enlisted in the US Army for a year in 1942, where he was based in Texas and later travelled to Mexico. His encounter with Native American and Pre-Columbian art at this time strongly influenced the motifs in his work. In 1950 he travelled to Haiti where he worked briefly at the Centre d'Art.

Although he viewed himself as a Philadelphia artist, Nelson spent time in New York in the late 1930s and early 1940s. He met Peggy Guggenheim and exhibited at her Art of This Century Gallery, and also made prints at Hayter's Atelier 17 in the mid-1940s. In 1945 he worked on a dance project with John Cage, in which colour and movement expressed the dancers' response to musical rhythm. From 1946 to 1948 he was represented by the Betty Parsons Gallery, where he showed with the newly emergent Abstract Expressionists. After meeting Willem de Kooning (see cat. 145) his printmaking began to incorporate more gestural elements. However, in 1948, Nelson broke with the Betty Parsons Gallery as he wanted to pursue an independent path. His first solo show in New York was held at the Peridot Gallery in 1949 and other exhibitions followed at the Hugo Gallery in 1950 and 1954.

From the late 1940s Nelson's career was based in Philadephia. He regularly exhibited his woodcuts at the Print Club of Philadelphia, where his woodcut *Dance for Midzimue* was awarded the purchase prize in 1948. The first of his eight one-man exhibitions with the Dubin Gallery, Philadelphia, was held in 1944. For thirty years, from 1951 to 1981, Nelson taught at the Moore College of Art, Philadelphia, becoming head of the graphic arts department in 1969. The Moore gave him a full retrospective in 1976. In 1985 he and his wife, Alma Neas, a former Moore student whom he had married in 1963, moved from Philadelphia to build a new studio at Berwyn, Pennsylvania, where he died in 1993. His prints are held by the Philadelphia Museum of Art and the New York Public Library.

BIBLIOGRAPHY

Sam Hunter, *Leonard Nelson: A Life in Art*, New York: Rizzoli, 2001

Susan Teller, *Leonard Nelson: American Abstractionist Retrospective of Prints*, exh. brochure, New York: Susan Teller Gallery, 8 February–2 March 1996

134 Rimba-Rimba (Red)

1946
Colour woodcut on thin oriental paper
Signed in pencil. Inscribed on verso with title in pencil.
458 x 357 mm
2007,7001.5. Presented by Dave and Reba Williams

Nelson often incorporated totemic motifs of dancing figures into his woodcuts and paintings of the 1940s. His hieroglyphic 'fork figures', such as the ones in *Rimba-Rimba (Red)*, derived from his interest in ancient cultures and primitivistic imagery. He admired Native American and Pre-Columbian art, which he first encountered during army service in Texas in 1942–3, and later on a visit to Mexico. Primitive, archetypal imagery was also very much part of the abstract expressionists' exploration of the subconscious by Jungian psychoanalytical drawing. Nelson evokes a ritual dance in which the 'fork figures' are rendered as flame-like forms in red and black. This print was made a year after his collaboration with the choreographer and composer John Cage, where they experimented with music and dance.

For this colour woodcut Nelson used two blocks which were deliberately misaligned to enhance the impression of movement. He first printed in red ink the tone block, roughly cut from the plank to give added texture to the print. Over this he then printed the drawing block in black. Certain areas of the two blocks were reserved to allow the cream colour of the Japan paper to provide highlights in the composition.

This woodcut exists in a few proofs and it is not known whether an edition was ever printed.

Adja Yunkers

1900–1983

Born in Riga, Latvia, Yunkers was brought up in St Petersburg, Russia, where he trained in art around 1916; after the Bolshevik Revolution of 1917 the family fled back to Riga. He left his homeland in 1919 and began a period of restless wandering in Europe during the 1920s and 1930s, including Hamburg, where he had his first exhibition in 1921 at the Maria Kunde Gallery; Cuba in 1926; and shortly after that, Mexico, where he met Diego Rivera. From 1933 he was based in Sweden and during the Second World War published the Swedish surrealist journal *Création* and the *Ars* magazine; he also began to produce albums of original prints called the *Ars-portfolios*, which included his own colour woodcuts, a technique he had first taken up in 1939. After the war he decided to emigrate to America where his work drew a favourable response, but just before his departure from Stockholm a fire in his studio destroyed thirty years' work.

Yunkers arrived in New York in 1947 and produced six woodcuts in his first year. He sometimes combined different blocks from earlier prints to make new compositions. He taught intermittently at the New School for Social Research in New York from 1947 to 1956, and during the summers from 1948 to 1952 at the University of New Mexico, Albuquerque. Inspired by the New Mexico landscape, the forms and the intensity of colour in his woodcuts changed. He also started to experiment with monotypes, often using textures to manipulate the inking. In 1952 he produced a set of five colour woodcuts under the imprint of the Rio Grande Graphics Workshop which he had helped to establish. But after a desert flash flood destroyed his adobe studio with the loss of much of his work, Yunkers left New Mexico and returned to New York in 1952.

He then embarked on the most ambitious print project of his career, the woodcut *Polyptych*, a summation of fifty years of his life and work. It consisted of five large woodcut panels, which were completed in 1953, after the disastrous collapse of his studio ceiling. The central panel alone was printed in fifty-six colours by hand. In 1955, while in Rome, he produced a series of twelve woodcuts and monotypes entitled *Ostia Antica*. Thereafter he abandoned the colour woodcut and concentrated on large-scale pastels until 1962, and then on painting with torn-paper collage. In 1960 he produced at the Tamarind Workshop, Los Angeles, a suite of nine gestural abstract lithographs entitled *Skies of Venice*, one of his most important series of prints.

The British Museum owns fifteen prints by Yunkers, including the Rio Grande Portfolio, two monotypes and seven colour woodcuts. The largest public holdings are to be found in the National Gallery of Art, Washington, DC, and the Philadelphia Museum of Art.

BIBLIOGRAPHY

David Acton, *The Stamp of Impulse: Abstract Expressionist Prints*, 2001 (for biography of Yunkers, see p. 180)

Una E. Johnson and Jo Miller, *Adja Yunkers: Prints 1927–1967*, exh. cat., New York: The Brooklyn Museum, 1969

135 Man Startled by Birds

1954
Colour woodcut on thick oriental paper
Signed, titled and dated in pencil. Stamped in black ink 'Printed in USA' on verso. 473 x 325 mm
Johnson and Miller 76
2004,0731.60. Presented by Patricia Hagan through the American Friends of the British Museum

Yunkers made this woodcut after his return to New York in 1952. The bold intensity of the colours came from his recent experience of living in New Mexico, but the abstract forms and their expressionist treatment point to the influence of the New York Abstract Expressionists. Through the critic Dore Ashton, his fifth wife, Yunkers was introduced to leading painters of the New York School, including Mark Rothko and Philip Guston, who became close friends. This print is one of a small number of colour woodcuts produced between late 1953 and early 1955, when Yunkers was focusing on abstract painting and pastel.

In this work he follows his customary practice of building up layers of colour and tone through repeatedly re-inking and overprinting the blocks. The composition evolved through the creative inking of the blocks, in which inks of different opacity and translucency were applied. In this case masonite was used for one of the blocks to give additional texture to the print. By this process Yunkers succeeds in suggesting the agitated flapping of birds. The woodcut was produced in a small edition of fifteen, several of which the artist destroyed.

135
Yunkers
Man Startled by Birds

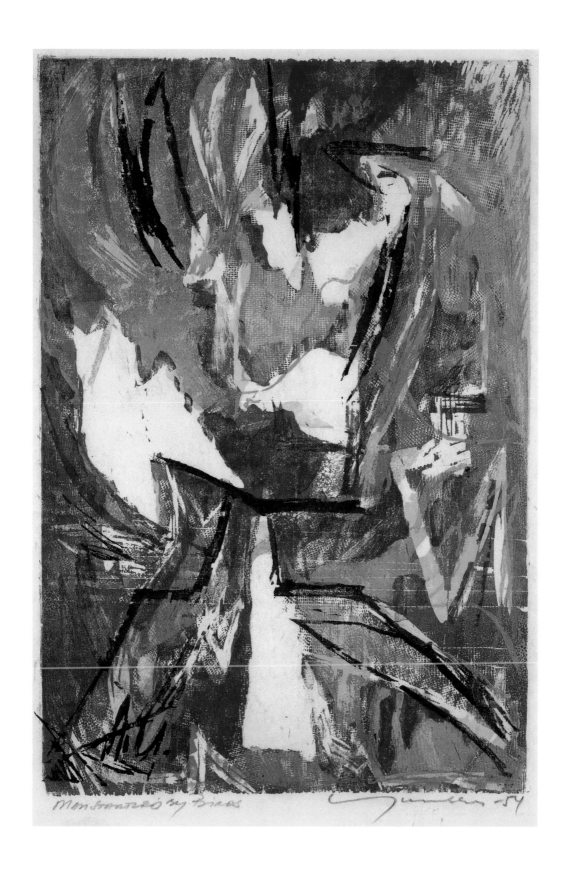

Leonard Baskin

1922–2000

Born in New Brunswick, New Jersey, the son of a rabbi, Baskin was brought up in Brooklyn, New York, where he entered a yeshiva. From 1937 to 1939 he trained in sculpture with Maurice Glickman at the Educational Alliance, New York, and then attended the New York University School of Architecture and Allied Arts for two years. In 1941 he won a scholarship to Yale University, where he developed his interest in printmaking, but he left after two years. After serving in the US Navy during the Second World War, he graduated from the New School for Social Research in New York in 1949. In 1950 he travelled to Europe, studying art in Paris and Florence, where his discovery of late Gothic and Renaissance sculpture was to have a far-reaching effect on his work as a sculptor and printmaker.

On his return to the United States he moved to Worcester, Massachusetts, and in 1951 re-established the Gehenna Press, which he had founded at Yale in 1942. The example of William Blake inspired him to become an artist and printer, producing books illustrated with his monochrome woodcuts and wood-engravings under his own private press imprint. In 1953 Baskin took up a teaching appointment at Smith College, Northampton, Massachusetts, and from there ran the Gehenna Press for the next twenty years. Baskin also produced a group of twelve monumental woodcuts, beginning with *Man of Peace* (cat. 136) in 1952, which gained him wide public attention. However, his emphasis on the human figure and on the figurative tradition in printmaking and sculpture left him isolated among his abstract expressionist contemporaries during the 1950s. From 1971 he showed regularly with the Kennedy Gallery, New York.

In 1974 Baskin moved to England with his second wife, Lisa Unger, and settled in Lurley, Devon, to be closer to his friend the poet Ted Hughes, with whom he later collaborated in producing *A Primer of Birds* under the revived Gehenna Press in 1981. He returned to the United States in 1983 and settled in Leeds, Massachusetts, where he directed the Gehenna Press until his death in 2000.

Although Baskin also made etchings in the 1960s, lithographs in the 1970s and took up monotype from 1982, it is his achievements in woodcut and the private press for which he is best known. Excluding his monotypes, his catalogue raisonné, published in 1984, records some 739 prints.

The British Museum holds twenty examples of Baskin's work. He is represented in numerous collections in America, including the National Gallery of Art, Washington, DC, and the Smithsonian American Art Museum, as well as several museums in Europe and Israel.

BIBLIOGRAPHY

Alan Fern and Judith O'Sullivan, *The Complete Prints of Leonard Baskin: A Catalogue Raisonné 1948–1983*, Boston: Little, Brown and Company, 1984

136 Man of Peace

1952
Woodcut on oriental paper
Signed in pencil. 1581 x 785 mm
Fern and O'Sullivan 180
2005,0331.8. Presented by Lisa Baskin

This is Baskin's first giant-size woodcut. Made in 1952, shortly after his return from Europe where Gothic sculpture had deeply impressed him, *Man of Peace* became one of the most potent images of the post-war era. The monumental figure of a half-naked man holding aloft a dead bird and enmeshed within a fence of barbed wire was a pessimistic response to the symbolism of Picasso's dove of peace. Baskin expressed a mood of despair at the time of the Korean War and the bitter divisions created by the Cold War.

Baskin joined multiple blocks of wood to form one huge matrix which he cut to create *Man of Peace*. His monumental woodcuts, of which he made twelve between 1952 and 1963, were extensions of his life-size figurative sculptures. They were printed on a single, very large sheet of Japan paper, the process of inking the gigantic block and then hand-rubbing the sheet taking several hours to achieve for each print. The number of impressions of *Man of Peace* is not recorded.

136
Baskin
Man of Peace

137 The Hydrogen Man

1954

Woodcut

Initialled on block with monogram; signed in pencil.
1581 x 619 mm

Fern and O'Sullivan 249

2003,1231.4. Presented by Martha Fleischman through
the American Friends of the British Museum

Baskin has created a disturbing image of a human
figure whose flesh has been stripped by the blast
of a hydrogen bomb. It encapsulates post-war
anxieties of nuclear testing and the potential
annihilation of humankind arising from the nuclear
arms race during the Cold War of the 1950s.
Baskin's figure, whose skeins of muscle, nerves
and veins have been exposed by a nuclear blast,
recalls the echorché figures of Renaissance and
later artists in which the flesh covering the body
was partially removed for anatomical study. The
external contours of *The Hydrogen Man* are
described with thick black lines which enclose a
network of finer lines to suggest fibres of burnt
muscle and nerve beneath the skin.

Baskin's monumental figure possesses a sculptural
quality, the network of lines recalling the wire
armature used to support a piece of sculpture.
By isolating the figure from any ground line or
background setting, Baskin has made its direct
confrontation with the viewer all the more
powerful.

Hans Burkhardt

1904–1994

Burkhardt was born in Basel, Switzerland. After his father left the family for America and his mother died a few years later, he was brought up in a Basel orphanage. In 1924 he emigrated to New York and was reunited with his father, a foreman in a furniture factory, where Burkhardt was taken on to paint period decoration, a skill he also formally studied at the Cooper Union, New York. In 1928 he attended the life class taught by Arshile Gorky at the Grand Central School of Art. Gorky became a mentor, introducing him to Cubism and abstraction and giving him private tuition in his studio, where Willem de Kooning was also a visitor. During the Depression years Burkhardt was a relatively well-paid foreman in the furniture company and supported the impoverished Gorky, with whom he collaborated on two paintings in 1936–7.

In 1937 Burkhardt moved to Los Angeles, where he finished furniture while continuing to paint surrealist abstractions. He had his first solo exhibition at the Stendhal Gallery, Los Angeles, in 1939. From the late 1930s he began to produce apocalyptic anti-war compositions, a theme which became particularly pronounced in an abstract expressionist style after the atom bomb was dropped on Hiroshima and Nagasaki at the end of the Second World War. In 1950 he gave away his furniture business and went to paint in Mexico, where he was strongly influenced by Mexican attitudes towards the dead. He produced a series of paintings, including *The Burial of Gorky*, provoked by his mentor's suicide. During the 1950s he lived half the year in Guadalajara, Mexico, and the other half in Los Angeles. In the 1960s he produced paintings in protest against the Vietnam War, some of which incorporated the human skulls he had collected from Mexican graveyards. In 1964 he returned to Basel for the first time in forty years, and from 1966 began making annual summer visits during which he became a friend of Mark Tobey.

Burkhardt first took up printmaking in 1947, when he produced a small group of lithographs in Los Angeles with Lynton Kistler, then the only lithographic printer in Southern California. Although his experimentation with lithography was short-lived, he returned to printmaking in the 1960s when he was professor at California State University, Northridge, where he started to make etchings with the help of Tom Fricano, who taught printmaking there. Around 1969 he took up linocut, which he produced by etching the block with oven cleaner and then inking the block with several colours. Throughout the 1970s and the 1980s Burkhardt made many prints. His final works were a series of paintings entitled *Desert Storms* produced in 1991 in response to the First Gulf War.

BIBLIOGRAPHY

David Acton, *The Stamp of Impulse: Abstract Expressionist Prints*, 2001 (for biography of Burkhardt, see p. 64)

Jack V. Rutberg, *Hans Burkhardt: The War Paintings. A Catalogue Raisonné*, with an interview by Colin Gardner, California State University, Northbridge: Santa Susanna Press, 1984

138 After the Bomb

1948

Lithograph

Signed and dated in pencil. Inscribed 'P.S' beside the embossed blind-stamp 'LK' of the printer Lynton Kistler. Inscribed 'Edition: 6' in pencil lower left. 247 x 363 mm

1993,0620.33

Burkhardt's horror of war and the post-war threat of a nuclear holocaust are expressed in this terrifying vision. The lithograph is one of the first he made with the printer Lynton Kistler in Los Angeles in 1948. It is closely related to the composition of his 1947 oil painting, *Hiroshima, Fear of Tomorrow* (reproduced by Rutberg as cat. 50). The monstrous creature's gaping maw and the broken, twisted wreckage project a vision of nuclear annihilation. The straight road in the background leads directly towards a setting sun. Burkhardt gave his lithograph the alternative titles *Last Sunset of Humanity* and *Destruction*.

Burkhardt exploited the varied effects of crayon and tusche to achieve his personal abstract surrealist style. A sense of urgency is conveyed through his handling of the lithographic crayon and tusche, which is scratched through in rapid strokes to create fine white lines. Lithographic ink was allowed to dribble down the stone to suggest blood dripping from the creature's open maw. Kistler, whose involvement is acknowledged by his embossed blind-stamp, printed for Burkhardt a tiny edition of six impressions. A few of these were printed on red paper to underscore the apocalyptic theme.

139 Black Cloud No. 2

1956

Lithograph

Signed and dated in pencil on image. Embossed blind-stamp 'HB' of the artist. Inscribed on verso 'Black Cloud # 2' in pencil. 265 x 375 mm

1995,0618.23

In this lithograph Burkhardt expressed his fear of nuclear annihilation through a personal abstract style combining gestural marks and loosely geometrical forms. The black cloud of the title refers to the black rain of radioactive debris that fell on Hiroshima shortly after the city was flattened by the explosion of the atomic bomb on 6 August 1945. Burkhardt dropped thinned tusche from a height on to the stone to create an effect of precipitating black clouds of destruction. His fluid handling of the tusche by splattering recalls the uninhibited spontaneity of Jackson Pollock's 'drip' paintings, and of other abstract expressionist works.

Burkhardt used an irregularly shaped lithographic stone for this print. It is not known how many impressions were pulled, but the number must have been very small for such an experimental print. Although the lithograph does not bear Lynton Kistler's blind-stamp, in all likelihood it was produced at his lithographic workshop in Los Angeles, which continued to operate until 1958.

138
Burkhardt
After the Bomb

139
Burkhardt
Black Cloud No. 2

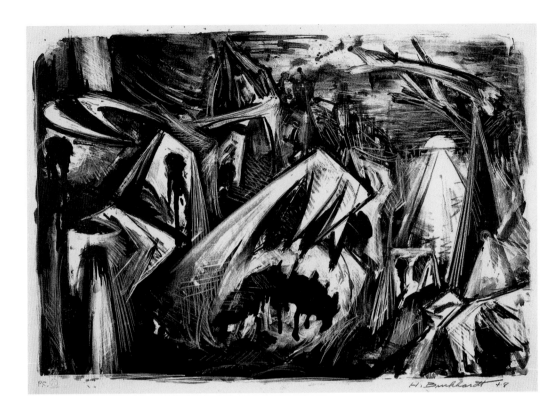

Emerson Woelffer

1914–2003

Born in Chicago, Woelffer attended the School of the Art Institute of Chicago, where he was taught lithography by Boris Anisfeld and Francis Chapin but left in 1936 without taking a degree. He joined the easel painting division of the Chicago WPA/FAP and the mural division of the St Louis WPA/FAP. In 1939 he volunteered for the US Army Air Force, where he was employed as a topographical draughtsman. Following his discharge in 1942, Woelffer was invited by László Moholy-Nagy to teach at the School of Design in Chicago. In the summer of 1949 he taught at Black Mountain College, North Carolina, where his colleagues included Elaine and Willem de Kooning. His paintings of the period displayed cubist and surrealist influences, but after a trip to Mexico in 1949, where he painted at Campeche in the Yucatán, he developed a new improvisational and calligraphic style.

In 1950 Woelffer was appointed Director of the Colorado Springs Fine Arts Center, where he began to produce lithographs using the Fine Arts Center's lithography workshop in the evenings. He also began to experiment with etching and aquatint, but found intaglio printmaking lacked the spontaneity he required. Woelffer became a close friend of Robert Motherwell, who came to Colorado Springs as artist-in-residence in 1954. Through Motherwell he was introduced to Franz Kline, Jackson Pollock and other members of the New York School, and re-acquainted with De Kooning. With Kline's help Woelffer had his first New York exhibition at the Poindexter Gallery, in 1958.

In 1959 he moved to Los Angeles to teach at the Chouinard Art Institute where his students included Ed Ruscha, Joe Goode and Dennis Hopper. Although Pop Art and performance art were to become the prevailing styles, Woelffer never deviated from his commitment to Abstract Expressionism in Los Angeles. In 1961 he was appointed a fellow at the Tamarind Lithography Workshop in Los Angeles, which had been set up the year before by June Wayne whom he knew from Chicago. In 1962 the Pasadena Art Museum held a retrospective of his work, including his prints. Throughout the 1970s he produced lithographs sporadically and worked with the Tamstone Group in Los Angeles, also set up by June Wayne, and then at the Tamarind Institute in Albuquerque, New Mexico.

In 1974 Woelffer was made head of the painting department at the Otis Art Institute, Los Angeles, where he remained until he retired in 1992. His achievements were recognized with an honorary doctorate from the Otis Art Institute in 1991 and a retrospective of his work at the Institute's galleries the following year. Diagnosed with macular degeneration in 1995, he began to paint in white on black prepared canvas and later to draw with white oil stick on black paper, which he continued to do until he died in his eighty-ninth year in 2003.

BIBLIOGRAPHY

David Acton, *The Stamp of Impulse: Abstract Expressionist Prints*, 2001 (for biography of Woelffer, see p. 94)

140 Colorado No. 7

1951
Lithograph
Signed, dated, titled and numbered '5/15' in pencil.
268 x 373 mm
1993,0620.32

In 1950, when he became director of the Colorado Springs Fine Arts Center, Woelffer produced a series of abstract expressionist paintings entitled *Numbers*, in which he developed a personal calligraphic language of gestural, rhythmic marks. From these emerged a series of lithographs, of which *Colorado No. 7* is an example. The prints were made in the evenings in the lithographic studio of Colorado Springs Fine Arts Center. Woelffer's passion for jazz, of which he had an impressive record collection, is evoked by his spontaneous, improvisational mark-making. The pictographic forms also show the influence of ethnographic artefacts from Africa and New Guinea, which he also collected.

In this print Woelffer reversed the usual black on white figure/ground relationship of the lithograph. He created a 'negative' image by applying a resist in a highly gestural manner to create the white brushmarks. Varied and broken in tone, they enhance the effect of spontaneity. The black background tone was achieved using tusche, which was repelled from the areas treated with the resist. Only a small edition of fifteen was pulled.

David Smith

1906-1965

Born in Decatur, Indiana, Smith studied art at Ohio University from 1924–5. He left to work as a riveter for the Studebaker automobile factory in South Bend, Indiana, where he learnt to weld steel. After a brief stay in Washington, DC, Smith moved to New York, and through his future wife, Dorothy Dehner (see cats 142 and 143), joined the Art Students League in 1927. He studied painting with John Sloan and Jan Matulka, who also introduced him to the European avant-garde in private classes. Through the Polish émigré artist and intellectual John Graham he met Stuart Davis, Arshile Gorky and Willem de Kooning.

In 1932 Smith began to make welded steel sculpture. After travelling in Europe with Dehner in 1935, where they met the Paris surrealists, Smith returned to New York. In 1937 he began his important series of fifteen cast bronze medallions, *Medals for Dishonor*, made in response to the rise of Fascism and completed in 1940. That year he settled permanently in Bolton Landing in upstate New York, in an old farm that Smith and Dehner had bought eleven years earlier and where he established his sculpture studio. From the 1940s his sculpture became more abstract and larger in scale, and from the early 1950s he began to work in series over several years, initially with the *Agricola* (1951–7) and the *Tanktotem* series (1953–60). His sculptures filled the fields around his studio home.

In 1952 Smith and Dehner divorced, and he remarried in 1953. In 1957 the Museum of Modern Art, New York gave him a large retrospective of his work; the following year Smith represented the United States at the Venice Biennale. His most famous sculptures were the monumental and geometric *Cubis* series (1961–5) produced from burnished stainless steel. In 1965, at the height of his career, he died in a car crash.

Although eclipsed by his sculpture, Smith's oeuvre of prints, of which thirty-six are extant, was small but significant. He was introduced to printmaking at the Art Students League, where he was taught woodcut by Allen Lewis. His earliest surviving prints are a group of some eleven linocuts, produced between 1928 and 1930, depicting scenes of the Brooklyn neighbourhood where he and Dehner lived. Between 1933 and 1946 he produced seventeen etchings, which showed his response to surrealist abstraction. During his 1935 trip to Europe, Smith met S.W. Hayter in Paris and produced an intaglio work, *Rue de Faubourg St. Jacques* (Schwartz 19), at Atelier 17. His third period of printmaking, from 1952 to 1954, concentrated on lithography. With the printer Michael Ponce de León he made six prints at Margaret Lowengrund's workshop at Woodstock, and these were a natural extension of his brush and ink drawings. *Don Quixote*, 1952 (S. 30), is his first and best-known lithograph.

BIBLIOGRAPHY

David Acton, *The Stamp of Impulse: Abstract Expressionist Prints*, 2001 (for biography of Smith, see p. 114)

Alexandra Schwartz, *David Smith: The Prints*, with an introductory essay by Paul Cummings, exh. cat., New York: Pace Prints, 1987

141 Fishdocks

1952

Lithograph with hand-coloured additions in yellow, violet, blue and pink watercolour

Initialled 'ΣΔ' and dated '52 8 3' on stone. Signed, dated '8/1952' and inscribed 'E22' in pencil. 225 x 570 mm

Schwartz 33

2007,7025.1. Presented by the James A. and Laura M. Duncan Charitable Gift Fund

Made in the summer of 1952, this lithograph is closely allied to the sculptures and drawings Smith was producing in the early 1950s. The open composition of horizontal and vertical marks shows some visual correspondence to the structure of his sculptures, such as *Hudson River Landscape* and *Australia*, both of 1951, made from welded pieces of farm machinery. The whole superstructure of *Fishdocks* is arranged through a careful balance of girder-like elements. These more geometric parts of the composition are contrasted with the looser brushstrokes for the waves and seabirds below the pier.

Working on an irregularly shaped stone, Smith used a thinned tusche for the rectilinear yet painterly marks. As with many of his drawings from this period, Smith initialled the stone with the Greek letters 'ΣΔ' (sigma, delta), in the wave, bottom left, which have reversed in printing. The lithograph was printed with the help of Michael Ponce de León at Margaret Lowengrund's workshop in Woodstock, New York State, in an edition of twenty-five. This impression is one of four which was hand-coloured by Smith with discrete accents of watercolour, in this case in yellow, violet, blue and pink.

141
Smith
Fishdocks

Dorothy Dehner

1901–1994

Born in Cleveland, Ohio, but brought up in Pasadena, California, after the early death of her parents, in 1922 Dehner initially enrolled as a drama student at the University of California, Los Angeles, before moving to New York to study at the American Academy of Dramatic Art. While touring Europe in 1925 she saw the work of Picasso and Matisse in Paris, which inspired her to become an artist. On her return to New York she joined the Art Students League in the autumn of 1925, where she was taught painting by Jan Matulka. At the end of 1926 she met David Smith and encouraged him to enrol at the League in 1927, the year they also married. They settled in Brooklyn and became friends with Adolph Gottlieb and Mark Rothko. In 1929 they bought a farm in Bolton Landing, New York State, where they spent the summers until they permanently settled there in 1940. Difficulties in the marriage resulted in Dehner leaving Bolton Landing in 1950, and two years later they divorced. For a long time Dehner's work was overshadowed by that of her husband.

In 1935 Dehner revisited Paris with Smith, where they met André Breton and visited Hayter's Atelier 17. Returning to Bolton Landing, Dehner began to incorporate surrealist biomorphic, abstract shapes into her paintings. In 1952, the year of her divorce, she graduated from Skidmore College, Saratoga Springs, New York State. In the same year she began to produce intaglio prints at Atelier 17 in New York, which was then run by Peter Grippe. The prints she produced at Atelier 17 were exhibited in 1954 and 1956 at the Wittenborn Gallery, New York, and at the Art Institute of Chicago in 1955. After Atelier 17 closed in 1955, she continued to make a few prints at the Pratt Graphic Art Center, New York. In 1970–71 she produced some twenty lithographs at the Tamarind Centre, Albuquerque, including *The Lunar Series*. She also made her first colour screenprints at this time which were published by the Modern Classics Company owned by her second husband, Ferdinand Mann.

By the mid-1950s Dehner was working in sculpture and her first solo sculpture exhibition was held at the Willard Gallery, New York, in 1957. She had a ten-year sculpture retrospective at the Jewish Museum, New York, in 1965. In the late 1960s and early 1970s she produced simplified, geometric cast bronzes. In 1974 she began to make wooden constructions. From the late 1970s she worked on a monumental scale, fabricating sculptures in Cor-ten steel based on her earlier cast bronzes. In 1993, the year before her death, the Kotanah Museum of Art, New York State, presented a retrospective of her work, which was later shown at the Corcoran Gallery of Art, Washington, DC. A group of her prints and gouaches is held by the Smithsonian American Art Museum, Washington, DC.

BIBLIOGRAPHY

David Acton, *The Stamp of Impulse: Abstract Expressionist Prints*, 2001 (for biography of Dehner, see p. 124)

Joan Marter and Sandra Kraskin, *Dorothy Dehner: A Retrospective of Sculpture, Drawings and Paintings*, exh. cat., New York: Baruch College of the City University of New York, 1991

142 Bird Machine II

1953
Engraving with roulette
Signed, dated, titled and numbered '3/20' in pencil.
202 x 353 mm
2004,0229.25. Presented by Dave and Reba Williams

This was produced at Atelier 17 in New York, where Dehner began to make intaglio prints from 1952. Engraving was her preferred technique, which she also combined with roulette to achieve tonal density. Dehner's composition, with its engraved lines describing movement through three-dimensional space, recalls the stringed elements of constructivist sculpture, such as in the work of Naum Gabo and the mobiles of Alexander Calder. Dehner has juxtaposed the organic form of a bird with the rigid geometrical structure of a taut armature, suggesting a creature that is part-machine and part-bird. The abstract and geometrical forms in *Bird Machine II* prefigured her later sculptural work. The print was pulled in an edition of twenty.

143 Figures in Landscape

1957
Etching and engraving
Signed, dated, titled and numbered '16/35' in pencil.
226 x 303 mm
1987,0516.60

The three personages in this intaglio print recall the sculptures of Dehner's former husband, David Smith. The totem-like figures are constructed from linear elements, some recognizable as antennae. They are analogous to Smith's assemblages made from discarded pieces of agricultural machinery. With their angular forms and stilt-like legs, Dehner has endowed the figures with a primitivistic vitality.

After the closure of Atelier 17 in New York in 1955 Dehner produced fewer prints. In all likelihood this engraving was printed at the Pratt Graphic Art Center, New York, where she made the occasional print. It was included in the fiftieth anniversary exhibition of Atelier 17 held at the Elvehjem Art Center, University of Wisconsin-Madison, in 1977.

142
Dehner
Bird Machine II

143
Dehner
Figures in Landscape

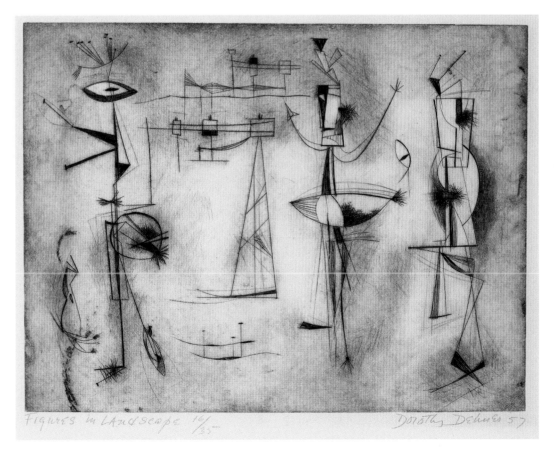

Jackson Pollock

1912–1956

Born on the Watkins Ranch, near Cody, Wyoming, the son of a ranch foreman, Pollock settled with his family in Los Angeles in 1928. He became a schoolfriend of Philip Guston and moved to New York in 1930, enrolling at the Art Students League under Thomas Hart Benton. Benton introduced Pollock to lithography and to Regionalist themes (see cat. 64). At the same time Pollock also came under the influence of the Mexican muralists and in 1936 he frequented David Alfaro Siqueiros's experimental Laboratory of Modern Techniques in Art. In 1935 he joined the New York City WPA/FAP.

After undergoing psychiatric treatment for alcoholism in 1938, Pollock submitted himself to Jungian analysis. Under the influence of psychoanalysis he developed a personal iconography of the unconscious and an interest in psychic automatism. In 1943 Pollock held his first solo exhibition at Peggy Guggenheim's Art of This Century Gallery, and thereafter Guggenheim became his principal patron. Following his marriage to Lee Krasner in 1945, he moved to Springs, near East Hampton, Long Island. There he produced his famous 'drip' paintings from 1947, by flinging and pouring enamel paint on large canvases on the floor. These were first shown at the Betty Parsons Gallery, New York in 1948, and established his reputation as America's foremost abstract expressionist painter. In 1956 he died after his car hit a tree near his home.

Pollock made prints at different periods of his career. His earliest surviving prints were twelve Regionalist lithographs produced under Benton's influence in the studio of Theodore Wahl, New York, between 1934 and 1937. Inspired by S.W. Hayter, he returned to printmaking in the mid-1940s when he made eleven intaglio prints at Hayter's Atelier 17 in Greenwich Village, New York, between 1944 and 1945 (see cats 119–22). Hayter's emphasis on automatism and line in his engravings influenced Pollock's experiments with intaglio printmaking and foreshadowed the development of his mature style. In 1943 Pollock was employed as a 'squeegee man' for Creative Printmakers, a commercial screenprint studio in New York, where he probably made his three colour screenprints which he overpainted with black ink. In 1951 Pollock produced a portfolio of six black-and-white screenprints after his black paintings of the same year (cat. 144).

The Museum of Modern Art, New York, holds the rare Atelier 17 proofs of the 1944–5 intaglio prints and the 1951 screenprint portfolio. The latter is also held by the National Gallery of Art, Washington, DC.

BIBLIOGRAPHY

David Acton, *The Stamp of Impulse: Abstract Expressionist Prints*, 2001 (for biography of Pollock, see p. 44)

Francis Valentine O'Connor and Eugene Victor Thaw, eds, *Jackson Pollock: A Catalogue Raisonné of Paintings, Drawings, and Other Works*, vol. IV, New Haven and London: Yale University Press, 1978, pp. 131–55

Reba and Dave Williams, 'The Prints of Jackson Pollock', *Print Quarterly*, vol. 5, no. 4 (December 1988), pp. 347–73

144 Untitled

1951
Screenprint
Signed, dated and inscribed 'Ed 25/19' in ink.
425 x 560 mm
O'Connor and Thaw P.28
1980,0628.36

The screenprint is based on Pollock's painting *Number 8*, 1951 (National Museum of Western Art, Tokyo). It comes from a portfolio of six screenprints based on six of his black 'drip' paintings of 1951. Pollock's brother, Sanford McCoy, photographed the paintings, prepared the screens and printed the impressions at his commercial studio. While it later became widely used in the 1960s, the adoption of commercial photo-screen-printing by a fine artist in the 1950s was most unusual. Although Pollock's screenprints essentially reproduce the composition of his black paintings, they are quite different in effect by virtue of their reduced scale and solid black printing.

Priced at $200, the screenprint portfolios were offered for sale at Pollock's exhibition of his black paintings at the Betty Parsons Gallery, New York, in 1951. Under the authority of Lee Krasner, a second edition of the portfolio was published posthumously from the original screens in an edition of fifty in 1964. The posthumous edition differs only very slightly in printing from the first, but each impression is numbered out of fifty in pencil and bears the Jackson Pollock estate stamp. The British Museum's Pollock screenprint is from the first edition of between twenty-five and thirty impressions.

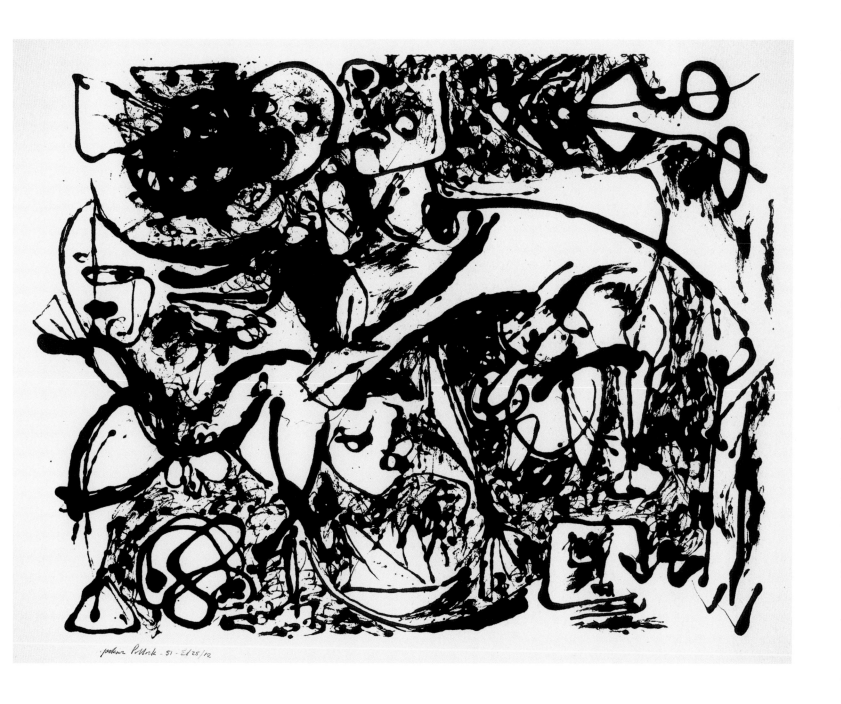

Willem de Kooning

1904–1997

Born in Rotterdam, De Kooning worked as a decorator's apprentice and graduated from the Rotterdam Academy as an academically trained painter. In 1926 he stowed away on a ship to America and arrived in New York. He became a friend of Arshile Gorky and the émigré intellectual John Graham, and began to paint in a surrealist and experimental manner. He joined the mural division of the New York City WPA/FAP and worked on a mural for the 1939 New York World's Fair.

In 1942 De Kooning became a friend of Jackson Pollock and Franz Kline, and later a stalwart of The Club, the meeting place for the young abstract expressionist painters. Discussions on psychoanalysis and Surrealism inspired De Kooning to pursue these ideas in his own paintings. In 1947 he had his first solo exhibition at the Charles Egan Gallery, New York, at which the Museum of Modern Art purchased a painting. The following year he taught at the progressive Black Mountain College, North Carolina. In 1950 he painted the first of his gestural and highly charged canvases in the *Woman* series, for which he would become best-known. In the same year he was selected to represent the United States at the Venice Biennale. In 1957, having separated from his wife, the painter Elaine Fried, whom he had married in 1943, De Kooning spent time with Pollock, Lee Krasner and friends at East Hampton on Long Island. In 1968 the Museum of Modern Art honoured him with a retrospective, which then travelled to the Stedelijk Museum, Amsterdam, and provided the occasion for the artist's first return visit to Holland.

De Kooning was first introduced to printmaking at Hayter's Atelier 17 in New York, where he worked briefly in about 1943, although no prints have survived. His first recorded etching was made in 1957, when he was invited by Peter Grippe to contribute to the portfolio, *21 Etchings and Poems*, published by the Morris Gallery in 1960. In 1960 De Kooning made his first abstract expressionist lithographs at the University of California, Berkeley. Produced with the aid of a mop, they were over a metre in height and at that time the largest artist lithographs. From 1970 to 1971, following a trip to Japan where he was inspired by Sumi calligraphy and Zen Buddhism, he produced twenty-four monochrome lithographs in editions with the printer Fred Genis at Irwin Hollander's workshop in New York. De Kooning also experimented with colour lithography at Hollander's at this time, but rejected the results as failures.

De Kooning returned to his wife Elaine in 1975, and they moved to East Hampton, Long Island. After his retrospective at the Whitney Museum in 1984, he was diagnosed with Alzheimer's disease; he died at East Hampton in 1997.

The National Gallery of Art, Washington, DC, and the National Gallery of Australia, Canberra, both hold large collections of De Kooning's lithographs.

BIBLIOGRAPHY

David Acton, *The Stamp of Impulse: Abstract Expressionist Prints*, 2001 (for biography of De Kooning, see p. 172)

Lanier Graham, *The Prints of Willem de Kooning: A Catalogue Raisonné. I. 1957–1971*, Paris: Baudoin Lebon, 1991

145 Revenge

1957
Etching and aquatint
Titled on plate; signed and numbered '16/50' in pencil.
302 x 343 mm
Graham 1
1987-04-11-14

Revenge is De Kooning's earliest surviving etching. It was produced in 1957 to accompany a poem of the same title by Harold Rosenberg for the portfolio *21 Etchings and Poems*. Inspired by William Blake's illuminated books, *21 Etchings and Poems* was a collaborative project between painters and poets to produce a pictured poem on the intaglio plate. The poets and writers included Dylan Thomas, Frank O'Hara, Sir Herbert Read and Harold Rosenberg. Contributing artists included Franz Kline (cat. 146), Adja Yunkers, S.W. Hayter, Fred Becker and Ben Nicholson. Begun in 1951, after Peter Grippe took over Atelier 17 in New York following Hayter's return to Paris, the portfolio was eventually published in an edition of fifty by the Morris Gallery, New York, in 1960. With the exception of one plate which the artist André Racz printed himself, the printing of the edition was done by the firm Anderson and Lamb in Brooklyn.

As well as writing poetry, Rosenberg was better known as the champion of Abstract Expressionism, for which he coined the term 'action painting'. He and De Kooning were lifelong friends. Rosenberg's handwritten poem appears in the upper register of De Kooning's vigorously gestural etching, beneath which is scrawled the word 'revenge' over the figural vestiges of a female form.

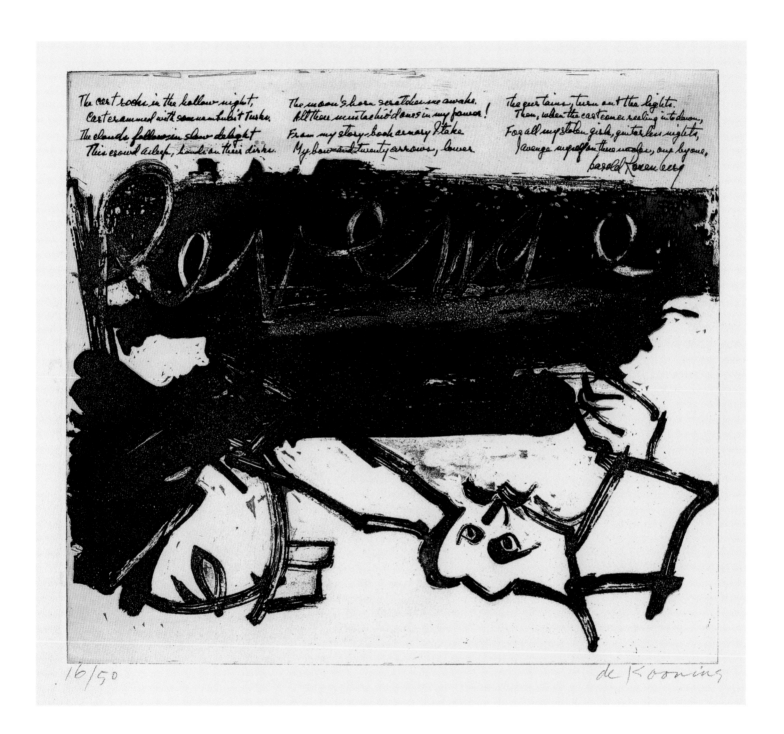

16/50

de Kooning

Franz Kline

1910-1962

Born in Wilkes-Barre, Pennsylvania, Kline was brought up in a charitable boarding school for fatherless boys in Philadelphia after his father, a bar proprietor, committed suicide when his son was seven. From 1931 to 1935 he studied at Boston University and attended evening classes at the Boston Art Students League, where he was taught drawing. In 1935 he moved to London to further his studies as an illustrator at Heatherley's School of Fine Art, where his teachers included Bernard Adams and Steven Spurrier. In England he met the art school model Elizabeth Parsons, whom he married on his return to New York in 1938. Back in the United States, Kline began to produce social realist paintings of urban scenes and rural poverty, such as *Palmerton, Pa.*, 1941 (Smithsonian American Art Museum, Washington, DC). Between 1939 and 1942 he also painted murals for bars and nightclubs in New York.

From the mid-1940s the direction of Kline's work changed irrevocably when he became a close friend of Jackson Pollock and Willem de Kooning, who regularly met at the Cedar Tavern in Greenwich Village. With De Kooning's encouragement Kline produced his first abstract work in 1947. Around 1948 his big breakthrough came when he and De Kooning were experimenting with the projection of enlargements of their drawings on to the walls of De Kooning's studio using an early type of overhead projector. Kline discovered that he could create large, gestural abstract paintings in black and white from his small, immediate sketches. His large, dramatic canvases of black paint boldly and energetically brushed on to a white ground became the hallmarks of abstract expressionist painting. His critical reputation was established with his first solo shows at the Egan Gallery, New York, in 1950 and 1951.

Kline was a founder and leading member of The Club, established in 1949 as a discussion centre by the New York School of abstract expressionist painters and poets. In 1951 he was a co-organizer of the 'Ninth Street Show', which brought Abstract Expressionism to a wider audience. His paintings were shown at the Venice Biennale in 1954 and 1960. From the mid-1950s colour began to appear in his work. His career was cut short when, aged fifty-one, he suffered a heart attack in late 1961, and died the following year.

After he had become famous as an abstract expressionist painter, Kline took little interest in printmaking. The etching *Poem* (cat. 146) is his only known print from his mature period. A few early prints were made in 1938 after his return to New York from London, when he purchased a table-top printing press, but all that appears to survive are works of an ephemeral nature, such as greeting cards. A few of these are held by the Smithsonian American Art Museum, Washington, DC.

BIBLIOGRAPHY

David Acton, *The Stamp of Impulse: Abstract Expressionist Prints*, 2001
(for biography of Kline, see p. 140)

146 Poem

1957
Etching and aquatint
Titled on plate; signed and numbered '16/50' in pencil.
210 x 367 mm
1987,0411.18

Kline's only mature etching was made in response to a love poem by Frank O'Hara, curator at the Museum of Modern Art, New York, and a close personal friend of the artist. Kline selected the poem from a number sent to him by O'Hara. The etching is based on a Kline collage overworked with black ink, which was transferred photographically on to the copper plate by the printer Peter Grippe. O'Hara's handwritten poem was similarly transferred to the copper and conjoined with Kline's image. *Poem* was one of the last plates to be made for Grippe's portfolio, *21 Etchings and Poems*, which was finally published by the Morris Gallery, New York, in 1960.

The *Poem* collage was a study for Kline's 1958 painting *Elizabeth,* dedicated to his wife, who began to suffer recurrent bouts of mental illness from 1946. The collage study and the oil painting suggest that the subject of Kline's etching for *21 Etchings and Poems* was the artist's abiding love for his wife.

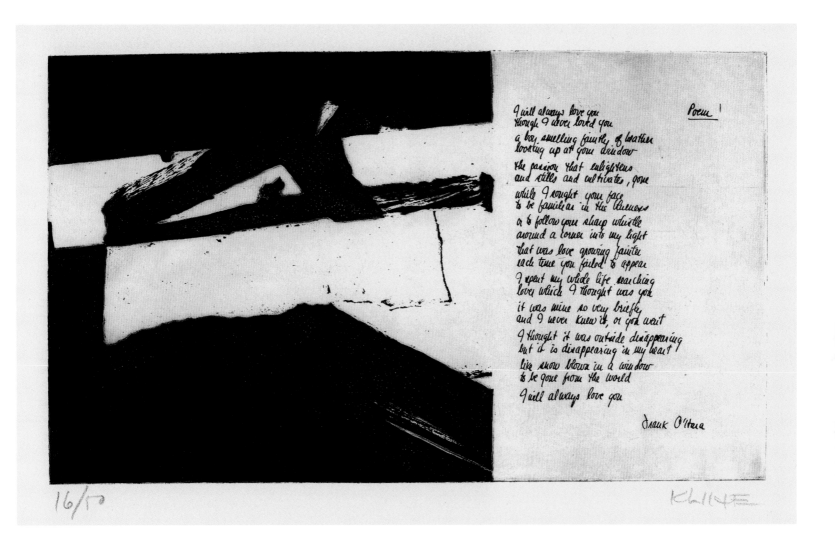

16/50

Joan Mitchell

1926-1992

Mitchell was born in Chicago. Her father was a distinguished physician; her mother, Marion Strobel, was a poet whose circle of friends included Ezra Pound and Dylan Thomas. From an early age Mitchell developed a lifelong love of poetry which later fed into her painting and printmaking. After two years at Smith College, Northampton, Massachusetts, Mitchell in 1944 transferred to the School of the Art Institute of Chicago, where she was taught lithography by Francis Chapin and produced several figurative prints. After graduating in 1947, she moved to New York and briefly studied with Hans Hofmann.

On her return from France on a travelling fellowship in 1950, she set up a studio in Greenwich Village and met Willem de Kooning through whom she soon joined the circle of abstract expressionist painters at the Cedar Tavern and became a member of The Club. Her gestural abstractions were included in the landmark abstract expressionist 'Ninth Street Show' in 1951. From 1953 she had regular solo shows with the Stable Gallery, New York. Spontaneity and expressive gesture were characteristic of her lyrical paintings that expressed her feelings towards nature rather than emotional states.

In 1955 Mitchell revisited Paris, where she began a long-term relationship with the Canadian-born gestural painter Jean-Paul Riopelle. After spending several summers in France, she moved to Paris in 1959, and in 1967 bought a house at Vétheuil, near where Monet once lived. In 1974 the Whitney Museum of American Art gave her a retrospective, followed by the Musée d'Art Moderne de la Ville de Paris in 1982. Mitchell divided much of her time between Paris and New York.

After her initial experiments with lithography as a student, Mitchell returned to printmaking seriously in 1959, although it always remained an intermittent activity. That year she produced a small group of screenprints at the Tiber Press in New York in a collaborative project with the poet John Ashbery. In 1964 she was one of twenty-eight artists who contributed lithographic illustrations to a volume of poems by Walasse Ting, *1 ¢ Life*. In 1972 she worked with Adriaen Maeght, Paris, on a series of sunflowers in colour etching, and in 1981 with Ken Tyler at Mount Kisco, New York, on a series of colour lithographs, including the *Bedford Series*. In 1992 she returned to Tyler Graphics to produce a suite of colour lithographs illustrating the poems of Nathan Kernan, as well as another series of prints which she completed prior to her death from lung cancer in Paris in October 1992.

Mitchell's early abstract expressionist screenprints are held by the National Gallery of Art, Washington, DC.

BIBLIOGRAPHY

David Acton, *The Stamp of Impulse: Abstract Expressionist Prints*, 2001 (for biography of Mitchell, see p. 168)

Susan Sheehan, *Joan Mitchell Prints and Illustrated Books: A Retrospective*, exh. cat., New York: Susan Sheehan Gallery, 1993

147 Untitled (Green, Black, White)

1959–60
Colour screenprint
Numbered '1/1' on verso in pencil. 443 x 371 mm
1995,0402.2

This is one of Mitchell's earliest abstract expressionist prints and was made in response to the poetry of her friend John Ashbery. It was produced over the period 1959–60 as part of the collaborative project entitled *The Poems*, in which four screenprints and a cover by Mitchell were paired with Ashbery's poems. This print is one of several she made but ultimately did not use in the publication. *The Poems* was one of four volumes uniting poet and painter published in 1960 by the Tiber Press, New York, in editions of two hundred. The other three volumes were James Schuyler's *Salute* with screenprints by Grace Hartigan; Kenneth Koch's *Permanently* with screenprints by Alfred Leslie; and Frank O'Hara's *Odes* with screenprints by Michael Goldberg. Floriano Vecchi, co-owner of the Tiber Press with the poet Daisy Aldan and Richard Miller, supervised the printing and encouraged Mitchell and the other artists with their experiments in making abstract expressionist screenprints.

Despite their apparent spontaneity and gestural freedom, Mitchell took great pains over the composition of her prints. Her first screenprints at Tiber Press were made with tusche and crayon on the screens. She soon painted with tusche on sheets of transparent mylar, which gave her more freedom in making painterly brushstrokes, and these Vecchi then transferred photographically on to the screens. Mitchell also painted on to her trial proofs to see how subsequent layers of colour would work. For *Untitled* she used three screens, printing first in black, then white and finally overprinting in green. Only one impression of this print was made.

147
Mitchell
Untitled (Green, Black, White)

GLOSSARY

The main printmaking techniques and terms referred to in this publication are described below. Fuller explanations are given in Antony Griffiths, *Prints and Printmaking: An Introduction to the History and Techniques* (1980), 2nd edn, London: British Museum Press, 1996; and Paul Goldman, *Looking at Prints, Drawings and Watercolours: A Guide to Technical Terms* (1988), 2nd edn, London: British Museum Press, 2006.

Aquatint

A variety of etching used to create tone, originally to imitate the effect of a watercolour wash. Within a dust-box, fine resin particles are shaken and allowed to fall as a thin layer on to a metal plate; this is then heated until the resin melts and fuses to the surface, forming a porous ground. During immersion in an acid bath, the acid bites into the minute channels around each resin particle. These hold sufficient ink to print as an even tone. Highlights can be obtained by 'stopping out' with an acid-resistant varnish (see under *etching*).

Drypoint

The line is drawn directly into a metal plate with a sharp point held like a pencil, which throws up a metal burr along the incision. Ink is retained in the burr, producing a rich feathery line when printed. Because the burr wears down easily under pressure from the press, only a few impressions showing the full richness of the drypoint line can be pulled. The plate is sometimes steel-faced to protect the burr from wearing and so allow a larger number of impressions to be printed.

Engraving

Lines are cut cleanly and directly into the bare metal plate using a V-shaped tool called a *burin*. S.W. Hayter and artists associated with Atelier 17 also used a *scorper*, or gouge, to remove small parts of the plates; these would then print as raised white areas.

Etching

A needle is used to draw freely through a hard, waxy acid-resistant ground covering the metal plate. The exposed metal is then 'bitten' by acid, creating the lines. This is done by immersing the plate in an acid bath; the longer the acid bites, the deeper the lines become and the darker they print. The plate can be bitten to different depths by 'stopping out'

the lighter lines with a varnish before returning the plate to the bath. The ground is then cleaned off before printing.

Intaglio printmaking

The traditional hand-drawn techniques of *etching*, *aquatint*, *drypoint* and *engraving* are all intaglio processes. The methods of printing are the same, but the result of each technique is different. The basic principle is that the line is incised into the metal plate, which is usually copper or zinc. Ink is rubbed with a dabber into the recessed lines and the surface of the plate wiped clean. Printing is achieved by placing a sheet of dampened paper over the inked plate, which is then passed through the press under heavy pressure. Characteristic of intaglio printmaking is the plate mark impressed into the paper.

Linocut

The same process as for *woodcut*, except that linoleum is used instead of wood.

Lithography

The technique of printing from stone or specially prepared zinc plates which relies on the antipathy of grease and water. An image is drawn on the printing surface with a greasy medium, such as crayon or a lithographic ink containing grease, known as *tusche*. The printing surface is then dampened so that when greasy ink is applied it will adhere only to the drawn image and will be repelled by water covering the rest of the stone or plate. The ink is transferred to a sheet of paper by passing paper and printing surface together through a flat-bed scraper press.

Monotype

A flat surface, such as a piece of glass or an unworked metal plate, is painted with ink by the artist and printed. Only one strong impression can be printed; a second, weaker impression can sometimes be taken from the residual ink.

Proof

An impression outside the edition, usually pulled during the process of working on the plate and sometimes called a *trial proof*. An *artist's proof* is one from a small number of impressions reserved for the artist outside the edition.

Roulette

Wheeled tools are used directly on to the metal plate, producing fine, track-like dots.

Screenprint

A mesh is attached tautly to a frame to form a screen, and a stencil, made of cut paper or film, or a photographically developed film of gelatine, is fixed to the mesh, masking it in some places and leaving it open elsewhere for the passage of ink. To make a print, a sheet of paper is placed underneath the frame, and ink is forced through the screen with a rubber blade, known as a *squeegee*. In the 1930s and 1940s artists in America particularly favoured painting their designs on to the screen with a greasy lithographic tusche and then covering the entire screen with a water-based 'block-out' glue; this substance was repelled by the grease-drawn areas, leaving it open for the passage of ink, while blocking out the rest of the mesh.

Soft-ground etching

A drawing is made on a sheet of paper laid on to a plate covered with a crumbly, soft ground. The ground clings to the underside of the paper when the sheet is lifted, exposing the plate wherever contact has taken place. The plate is then etched in the usual way. S.W. Hayter and artists at Atelier 17 were particularly interested in using this method for impressing the textures of different materials on to the soft-ground coated plate.

States

While the artist works on the plate, proofs are taken which record the different stages, or *states*, in the development of the print.

Woodcut

A block, usually of plank wood revealing the grain, is cut with chisels and gouges so that the areas to be inked stand in relief. Ink is then rolled on to the surface of the block, which is printed on to a sheet of paper, either in a press under vertical pressure or by hand-rubbing the back of the paper.

Wood-engraving

A version of *woodcut*, in which a very hard wood, like boxwood, cut across the grain is used. The close grain of the end-block permits the cutting of very fine lines; these are achieved with a *graver* tool that is similar to the engraver's *burin*. This enables work of greater detail to be created than in a woodcut. A *multiple tool* can also be used on the end-block to produce fine, parallel lines.

SELECT BIBLIOGRAPHY

The literature on American art of the twentieth century is voluminous. The following select bibliography is divided into two sections, and is largely restricted to American printmaking covering the period between 1905 and 1960, from the Ashcan School to Abstract Expressionism.

SECTION 1

GENERAL BOOKS AND EXHIBITION CATALOGUES

Acton, David, *A Spectrum of Innovation: Color in American Printmaking 1890–1960*, with contributions by Clinton Adams and Karen F. Beall, exh. cat., Worcester, Massachusetts and New York/London: Worcester Art Museum and W.W. Norton & Company, 1990

___ , *The Stamp of Impulse: Abstract Expressionist Prints*, with essays by David Amram and David Lehman, exh. cat., Worcester, Massachusetts: Worcester Art Museum, in association with Snoeck-Ducaju & Zoon, 2001

Adams, Clinton, *American Lithographers 1900–1960: The Artists and Their Printers*, Albuquerque: University of New Mexico Press, 1983

___ , *Crayonstone: The Life and Work of Bolton Brown, with a Catalogue of his Lithographs*, Albuquerque: University of New Mexico Press, 1993

Ashton, Dore, *The New York School. A Cultural Reckoning*, Harmondsworth: Penguin Books, 1979

Barron, Stephanie, et al., *Exiles and Emigrés: The Flight of European Artists from Hitler*, exh. cat., Los Angeles and New York: Los Angeles County Museum of Art and Harry N. Abrams, Inc., 1997

Beall, Karen F., *American Prints in the Library of Congress. A Catalog of the Collection*, with an introduction by Alan Fern and a foreword by Carl Zigrosser, Baltimore and London: The John Hopkins Press, for the Library of Congress, 1970

___ and David W. Kiehl, *Graphic Excursions: American Prints in Black and White 1900–1950. Selections from the Collection of Reba and Dave Williams*, exh. cat., Boston: David R. Godine, Publisher, Inc., in association with the American Federation of Arts, 1991

Brown, Milton W., *The Story of the Armory Show*, New York: The Joseph H. Hirshhorn Foundation, 1963

Carey, Frances, and Antony Griffiths, *American Prints 1879–1979*, exh. cat., London: British Museum, 1980

Castleman, Riva, *American Impressions: Prints since Pollock*, New York: Alfred A. Knopf, 1985

Field, Richard, et al., *American Prints 1900–1950*, exh. cat., New Haven: Yale University Art Gallery, 1983

Flint, Janet A., *George Miller and American Lithography*, exh. cat., Washington, DC: Smithsonian Institution, 1976

___ , *Provincetown Printers: A Woodcut Tradition*, exh. cat., Washington, DC: Smithsonian Institution Press for the National Museum of American Art, 1983

Graham, Lanier, *The Spontaneous Gesture: Prints and Books of the Abstract Expressionist Era*, exh. cat., Canberra: Australian National Gallery, 1987

Hemingway, Andrew, *Artists on the Left: American Artists and the Communist Movement 1926–1956*, New Haven and London: Yale University Press, 2002

Homer, William Innes, *Robert Henri and his Circle*, with the assistance of Violet Organ, Ithaca and London: Cornell University Press, 1969

Ittmann, John (ed.), *Mexico and Modern Printmaking: A Revolution in the Graphic Arts, 1920 to 1950*, exh. cat., with contributions by Innis Howe Shoemaker, James Wechsler and Lyle Williams, Philadelphia: Philadelphia Museum of Art and San Antonio: McNay Art Museum, in association with Yale University Press, 2006

Johnson, Deborah J., *American Prints 1870–1950: Whistler to Weidenaar*, exh. cat., with the assistance of Lora S. Urbanelli, Providence, Rhode Island: Museum of Art, Rhode Island School of Design, 1987

Johnson, Una, *American Prints and Printmakers: A chronicle of over 400 artists and their prints from 1900 to the present*, New York: Doubleday & Company, 1980

Landau, Ellen G., *Artists for Victory*, exh. cat., Washington, DC: Library of Congress, 1983

O'Connor, Francis V. (ed.), *The New Deal Art Projects: An Anthology of Memoirs*, Washington, DC: Smithsonian Institution Press, 1972

Ruby, Christine Nelson, and Victoria Weston Julius, *The Federal Art Project: American Prints from the 1930s, in the Collection of the University of Michigan Museum of Art*, exh. cat., Ann Arbor: University of Michigan Museum of Art, 1985

Smith, Jessica Todd, and Kevin M. Murphy, *Pressed in Time: American Prints 1905–1950*, exh. cat., San Marino, California: Huntington Library, Art Collections, and Botanical Gardens, 2007

Watrous, James, *American Printmaking: A Century of American Printmaking 1880–1980*, Madison: University of Wisconsin Press, 1984

Williams, Reba White, 'The Weyhe Gallery between the Wars, 1919–1940', Ph.D, The City University of New York, 1996

___ and Dave Williams, *American Screenprints*, exh. cat., New York: National Academy of Design, 1987

___ , *The Mexican Muralists and Prints*, exh. cat., New York: The Spanish Institute, 1990

___ et al., *Alone in a Crowd: Prints of the 1930s–40s by African-American Artists. From the Collection of Reba and Dave Williams*, exh. cat., [New York], 2nd rev. edn, 1993

___ , *Mexican Prints from the Collection of Reba and Dave Williams*, with contributions by Starr Figura and James Wechsler, [New York], c.1998

ARTICLES

Kiehl, David, 'American Printmaking in the 1930s: Some Observations', *Print Quarterly*, vol. 1, no. 2 (June 1984), pp. 96–111

Medley-Buckner, Cindy, 'Carborundum Mezzotint and Carborundum Etching', *Print Quarterly*, vol. 16, no. 1 (March 1999), pp. 34–49

Moser, Joann, 'The Impact of Stanley William Hayter on Post-War American Art', *Archives of American Art Journal*, vol. 18, no. 1 (1978), pp. 2–11

Williams, Reba White, 'Prints in the United States, 1900–1918', *Print Quarterly*, vol. 14, no. 2 (June 1997), pp. 151–73

___ and Dave Williams, 'The Early History of the Screenprint', *Print Quarterly*, vol. 3, no. 4 (December 1986), pp. 287–321

___ , 'The Later History of the Screenprint', *Print Quarterly*, vol. 4, no. 4 (December 1987), pp. 379–403

Zigrosser, Carl, 'The Serigraph, A New Medium', *The Print Collector's Quarterly*, vol. 28, no. 4 (December 1941), pp. 443–77

TECHNICAL TREATISES

Barrett, Lawrence, and Adolf Dehn, *How to Draw and Print Lithographs*, New York: American Artists Group, 1950

Biegeleisen, B. I., and Max Arthur Cohn, *Silk Screen Stencilling as a Fine Art*, New York and London: McGraw-Hill Book Company, Inc., 1942 (2nd edn as *Silk Screen Techniques*, New York: Dover Publications, Inc., 1958)

Bothwell, Dorr, and Marlys Frey, *Notan, The Dark-Light Principle of Design*, New York: Van Norstrand Reinhold, 1968

Gwathmey, Robert, 'Serigraphy', *American Artist*, (December 1945), pp. 8–11

Hayter, S.W., *New Ways of Gravure*, London: Routledge & Kegan Paul, 1949

Shokler, Harry, *Artists Manual for Silk Screen Print Making*, New York: American Artists Group, 1946

Sternberg, Harry, *Silk Screen Color Printing*, New York and London: McGraw-Hill Book Company, Inc., 1942

Velonis, Anthony, *Technical Problems of the Artist – Technique of Silk Screen Process*, Works Progress Administration/ Federal Art Project, New York, 1938

WEBSITES

MUSEUMS

Achenbach Foundation for Graphic Arts, Fine Arts Museums of San Francisco: www.search.famsf.org

The British Museum: www.britishmuseum.org

Smithsonian American Art Museum: www.americanart.si

Archives of American Art, Smithsonian Institution: www.aaa.si

ARTISTS

www.leonbibel.com

www.calder.org

www.mesibov.net/hugh

SECTION 2

This includes artists in the present exhibition and publication, and mostly cites works relating to their printmaking.

JOSEF ALBERS
Danilowitz, Brenda, *The Prints of Josef Albers: A Catalogue Raisonné 1915–1976*, New York: Hudson Hills Press, 2001

JAMES E. ALLEN
Ryan, Mary, *James E. Allen*, with brief texts by Elisa M. Rothstein and David W. Kiehl, exh. cat., New York: Mary Ryan Gallery, 1984

MILTON AVERY
Lunn, Jr, Harry H., *Milton Avery: Prints 1933–1955*, with introduction by Frank Getlein and a technical note by Alan Fern, Washington, DC: Graphics International Ltd, 1973

PEGGY BACON
Tarbell, Roberta K., *Peggy Bacon: Personalities and Places*, with a checklist of the prints by Janet Flint, exh. cat., Washington, DC: National Collection of Fine Arts, 1975

LEONARD BASKIN
Fern, Alan, and Judith O'Sullivan, *The Complete Prints of Leonard Baskin: A Catalogue Raisonné 1948–1983*, Boston: Little, Brown and Company, 1984

FRED BECKER
Fred Becker: Prints 1939–99, exh. cat., Amherst: Herter Gallery, University of Massachusetts, 1999

GEORGE BELLOWS
Atkinson, D. Scott, and Charlene S. Engel, *An American Pulse: The Lithographs of George Wesley Bellows*, exh. cat., San Diego, California: San Diego Museum of Art, 1999.

Mason, Lauris, *The Lithographs of George Bellows: A Catalogue Raisonné* (1977), assisted by Joan Ludman and with a foreword by Charles H. Morgan, rev. edn, San Francisco: Alan Wofsy Fine Arts, 1992

THOMAS HART BENTON
Benton, Thomas Hart, *An Artist in America* (1937), 4th rev. edn, Columbia and London: University of Missouri Press, 1983

Fath, Creekmore, *The Lithographs of Thomas Hart Benton*, Austin and London: University of Texas Press, 1969

HARRY BERTOIA
Nelson, June Kompass, *Harry Bertoia, Printmaker: Monotypes and other Monographics*, exh. cat., Detroit: Wayne State University Press, 1988

JOLÁN GROSS-BETTELHEIM
Williams, Reba and Dave, 'Jolan Gross-Bettelheim: A Hidden Life', *Print Quarterly*, vol. 7, no. 3 (September 1990), pp. 303–7

JULIUS BLOCH
Likos, Patricia, 'Julius Bloch: Portrait of the Artist', *Philadelphia Museum of Art Bulletin*, vol. 79, no. 339 (summer 1983), pp. 3–24

LOUISE BOURGEOIS
Morris, Frances, and Marie-Laure Bernadac, eds, *Louise Bourgeois*, exh. cat., London: Tate Modern, 2007

Wye, Deborah, and Carol Smith, *The Prints of Louise Bourgeois*, New York: The Museum of Modern Art, 1994

HANS BURKHARDT
Rutberg, Jack V., *Hans Burkhardt: The War Paintings. A Catalogue Raisonné*, with an interview by Colin Gardner, California State University, Northbridge: Santa Susanna Press, 1984

HOWARD COOK
Duffy, Betty and Douglas, *The Graphic Work of Howard Cook*, with an essay by Janet A. Flint, Bethesda, Maryland: Bethesda Art Gallery, 1984

JOHN STEUART CURRY
Cole, Sylvan, *The Lithographs of John Steuart Curry*, with an introduction by Laurence Schmeckebier, New York: Associated American Artists, 1976

Czestochowski, Joseph S., *John Steuart Curry and Grant Wood: A Portrait of America*, Columbia and London: University of Missouri Press, with the Cedar Rapids Art Association, 1981

STUART DAVIS
Cole, Sylvan, and Jane Myers, *Stuart Davis Graphic Work and Related Paintings with a Catalogue Raisonné of the Prints*, with an essay by Diane Kelder, exh. cat., Fort Worth, Texas: Amon Carter Museum, 1986

ADOLF DEHN
Lumsdaine, Joycelyn Pang, and Thomas O'Sullivan, *The Prints of Adolf Dehn: A Catalogue Raisonné*, with essays by Richard W. Cox and Clinton Adams, St Paul, Minnesota: Minnesota Historical Society Press, 1987

DOROTHY DEHNER
Marter, Joan, and Sandra Kraskin, *Dorothy Dehner: A Retrospective of Sculpture, Drawings and Paintings*, exh. cat., New York: Baruch College of the City University of New York, 1991

WILLEM DE KOONING
Graham, Lanier, *The Prints of Willem de Kooning: A Catalogue Raisonné. I. 1957–1971*, Paris: Baudoin Lebon, 1991

WERNER DREWES
Norelli, Martina Roudabush, *Werner Drewes: Sixty-five Years of Printmaking*, exh. cat., Washington, DC: Smithsonian Institution Press for the National Museum of American Art, 1984.

Rose, Ingrid, *Werner Drewes: A Catalogue Raisonné of his Prints*, Munich and New York: Verlag Kunstgalerie Esslingen, 1984

WANDA GÁG
Winnan, Audur H., *Wanda Gág: A Catalogue Raisonné of the Prints*, Washington and London: Smithsonian Institution Press, 1993

HUGO GELLERT
Ryan, Mary, *Hugo Gellert: A Catalogue of Prints and Drawings*, with an essay by Jeff Kisseloff, exh. cat., New York: Mary Ryan Gallery, 1986

BLANCHE GRAMBS
Wechsler, James, 'The Great Depression and the Prints of Blanche Grambs', *Print Quarterly*, vol. 13, no. 4 (December 1996), pp. 376–96

ROBERT GWATHMEY
Kammen, Michael, *Robert Gwathmey: The Life and Art of a Passionate Observer*, Chapel Hill and London: The University of North Carolina Press, 1999

Williams, Reba White, 'The Prints of Robert Gwathmey', *Hot off the Press: Prints and Politics*, ed. by Linda Tyler and Barry Walker (vol. 15 of *The Tamarind Papers*), 1994

HANANIAH HARARI
Stavitsky, Gail, *Hananiah Harari: A Personal Synthesis*, exh. cat., New Jersey: Montclair Art Museum, 1997

GEORGE HARRIS
McCann Morley, Grace L., and Martin Metal, *George Harris 1936–1946*, exh. cat., San Francisco: San Francisco Museum of Art, 1946

STANLEY WILLIAM HAYTER
Black, Peter, and Désirée Moorhead, *The Prints of Stanley William Hayter: A Complete Catalogue*, London: Phaidon Press, 1992

RIVA HELFOND
Teller, Susan, *Riva Helfond. A Checklist of Prints*, exh. brochure, New York: Susan Teller Gallery, 2000

EDWARD HOPPER
Levin, Gail, *Edward Hopper: The Complete Prints*, exh. cat., New York: Whitney Museum of American Art, 1979

___, *Edward Hopper: The Art and the Artist*, exh. cat., New York and London: W.W. Norton & Co. in association with the Whitney Museum of American Art, 1980

Wagstaff, Sheena, et al, *Edward Hopper*, exh. cat., London: Tate Modern, 2004

JACOB KAINEN
Flint, Janet A., *Jacob Kainen: Prints, a Retrospective*, exh. cat., Washington, DC: National Collection of Fine Arts, Smithsonian Institution, 1976

LAWRENCE KUPFERMAN
Dunn, Roger T., *Lawrence Kupferman: A Retrospective Exhibition*, exh. cat., Brockton, Massachusetts: Brockton Art Center (Fuller Museum of Art), 1974

ARMIN LANDECK
Kraeft, June and Norman, *Armin Landeck, The Catalogue Raisonné of his Prints*, 2nd edn, Carbondale and Edwardsville: Southern Illinois University Press, 1994

EDWARD LANDON
Wechsler, James, *Edward Landon (1911–1984): Silkscreens*, exh. cat., New York: Mary Ryan Gallery, 1994

BLANCHE LAZZELL
Shapiro, Barbara Stern, *From Paris to Provincetown: Blanche Lazzell and the Color Woodcut*, exh. cat., Boston: Museum of Fine Arts, 2002

DORIS LEE
Lee, Doris, *Doris Lee*, New York: American Artists Group, 1946

Smith, Todd D., 'Painting for the Middlebrow: Doris Lee and the Making of a Popular Artist', in *American Art from the Dicke Collection*, exh. cat., Dayton: The Dayton Art Institute, 1997, pp. 34–65

MARTIN LEWIS
McCarron, Paul, *The Prints of Martin Lewis, A Catalogue Raisonné*, Bronxville, New York: M. Hausberg, 1995

McKay, Kirsten, *Martin Lewis: Stepping into the Light*, exh. cat., Castlemaine, Victoria: Castlemaine Art Gallery and Historical Museum, 2002

LOUIS LOZOWICK
Flint, Janet, *The Prints of Louis Lozowick, A Catalogue Raisonné*, New York: Hudson Hills Press, 1982

Hagelstein Marquardt, Virginia Carol, *Survivor from a Dead Age: The Memoirs of Louis Lozowick*, Washington, DC: Smithsonian Institution Press, 1997

JOHN MARIN
Zigrosser, Carl, *The Complete Etchings of John Marin, Catalogue Raisonné*, exh. cat., Philadelphia: Philadelphia Museum of Art, 1969

REGINALD MARSH
Sasowsky, Norman, *The Prints of Reginald Marsh*, New York: Clarkson N. Potter, 1976

JAN MATULKA
Sims, Patterson, and Merry A. Foresta, *Jan Matulka 1890–1972*, with a memoir by Dorothy Dehner and a checklist of the prints by Janet Flint, exh. cat., Whitney Museum of American Art and the National Collection of Fine Arts: Smithsonian Institution, Washington, DC, 1980

JOHN MCCLELLAN
Conway, Robert, *John McClellan Prints and Drawings 1927–1970*, exh. brochure, New York, Associated American Artists, 1988

HUGH MESIBOV
Teller, Susan, *Hugh Mesibov: A Ninetieth Birthday Celebration*, exh. brochure, New York: Susan Teller Gallery, 2006

JOAN MITCHELL
Sheehan, Susan, *Joan Mitchell Prints and Illustrated Books: A Retrospective*, exh. cat., New York: Susan Sheehan Gallery, 1993

CLAIRE MAHL MOORE
Finnegan, Sharyn, 'Claire Moore', *Woman's Art Journal*, vol. 2, no. 1 (spring–summer 1981), pp. 53–6

Teller, Susan, *Claire (Mahl) Moore: A Memorial Exhibition. Work on Paper: The WPA to the 1980s*, exh. brochure, New York: Susan Teller Gallery, 1989

LEONARD NELSON
Hunter, Sam, *Leonard Nelson: A Life in Art*, New York: Rizzoli, 2001

Teller, Susan, *Leonard Nelson: American Abstractionist Retrospective of Prints*, exh. brochure, New York: Susan Teller Gallery, 1996

JACKSON POLLOCK
O'Connor, Francis Valentine, and Eugene Victor Thaw, eds, *Jackson Pollock: A Catalogue Raisonné of Paintings, Drawings, and Other Works*, vol. IV, New Haven and London: Yale University Press, 1978, pp. 131–55

Williams, Reba and Dave, 'The Prints of Jackson Pollock', *Print Quarterly*, vol. 5, no. 4 (December 1988), pp. 347–73

ROBERT RIGGS
Bassham, Ben, *The Lithographs of Robert Riggs, with a Catalogue Raisonné*, London, Philadelphia and Toronto: The Art Alliance Press and Associated University Presses, 1986

ANNE RYAN
Myers, John Bernard, 'Anne Ryan's Interior Castle', *Archives of American Art Journal*, vol. 15, no. 3 (1975), pp. 8–11

Teller, Susan, *Anne Ryan: A Retrospective, 1939 to 1953*, exh. brochure, New York: Susan Teller Gallery, 2007

CHARLES SHEELER
Troyen, Carol, and Erica E. Hirshler, *Charles Sheeler: Paintings and Drawings*, exh. cat., Boston: New York Graphic Society and Little, Brown and Co., 1987

JOHN SLOAN
Morse, Peter, *John Sloan's Prints: A Catalogue Raisonné of the Etchings, Lithographs, and Posters*, London and New Haven: Yale University Press, 1969

Sloan, John, *Gist of Art* (1939), 2nd edn, New York: American Artists Group, 1944

DAVID SMITH
Schwartz, Alexandra, *David Smith: The Prints*, with an introductory essay by Paul Cummings, exh. cat., New York: Pace Prints, 1987

BENTON SPRUANCE
Fine, Ruth E., and Robert F. Looney, *The Prints of Benton Murdoch Spruance: A Catalogue Raisonné*, with an introduction by Ruth E. Fine, Philadelphia: University of Pennsylvania Press, 1986

GRACE MARTIN TAYLOR
Grace Martin Taylor (1903–1995): An American Modernist, exh. cat., New York: The Orange Chicken, 2001

DOX THRASH
Ittmann, John, *Dox Thrash: An African American Master Printmaker Rediscovered*, exh. cat., Philadelphia: Philadelphia Museum of Art, 2001

GRANT WOOD
Cole, Sylvan, with Susan Teller, *Grant Wood: The Lithographs. A Catalogue Raisonné*, New York: Associated American Artists, 1984

Corn, Wanda M., *Grant Wood: The Regionalist Vision*, exh. cat., New Haven and London: Yale University Press for the Minneapolis Institute of Arts, 1983

Czestochowski, Joseph S., *John Steuart Curry and Grant Wood: A Portrait of America*, Columbia and London: University of Missouri Press, with the Cedar Rapids Art Association, 1981

ADJA YUNKERS
Johnson, Una E., and Jo Miller, *Adja Yunkers: Prints 1927–1967*, exh. cat., New York: The Brooklyn Museum, 1969

WILLIAM ZORACH
Burk, Efram L., 'The Prints of William Zorach', *Print Quarterly*, vol. 19, no. 4 (December 2002), pp. 353–73 (with 3 appendices of Zorach's prints)

Nicoll, Jessica, and Roberta K. Tarbell, *Marguerite and William Zorach: Harmonies and Contrasts*, with annotated chronology by Margaret MacDougal, exh. cat., Portland Museum of Art, Maine, 2001

Zorach, William, *Art is My Life*, Cleveland and New York: The World Publishing Company, 1967

COPYRIGHT CREDITS

INDEX

This index contains personal names and a selection of galleries, institutions, techniques and subjects. References are to page numbers. Those in **bold** refer to artists in the catalogue.